LIVING
WITH
LEONARDO

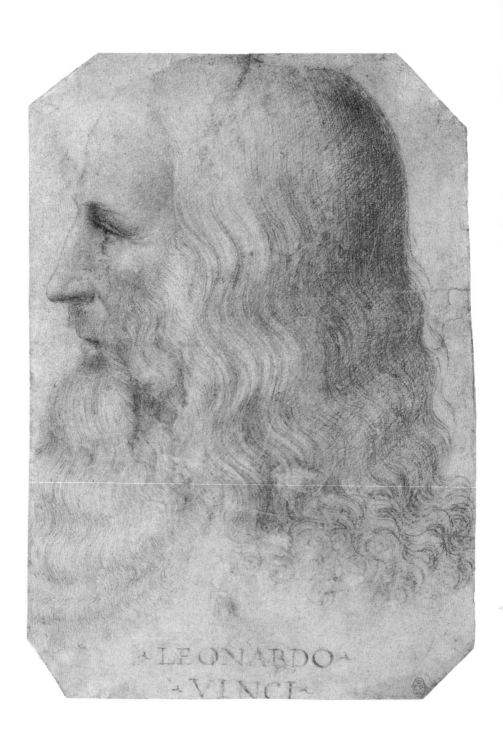

·LEONARDO·
·VINCI·

MARTIN KEMP

LIVING WITH LEONARDO

Fifty Years of Sanity and Insanity
in the Art World and Beyond

105 ILLUSTRATIONS

 Thames & Hudson

Frontispiece: Follower of Leonardo, *A portrait of Leonardo in profile, c.* 1515. Red chalk, 27.5 × 19 cm (10⅞ × 7½ in.).

First published in 2018 in the United States of America by Thames & Hudson Inc., 500 Fifth Avenue, New York, New York 10110

www.thamesandhudsonusa.com

Library of Congress Control Number 2017958126

ISBN 978-0-500-23956-8

Printed and bound in China by C&C Offset Printing Co. Ltd

CONTENTS

AUTHOR'S NOTE 6

INTRODUCTION: ART HISTORY IN ACTION 8

PROLOGUE: A SKETCH OF LEONARDO 13

1 THE *LAST SUPPER* AND THE FIRST STEPS 24

2 THE 'ORIGINAL' *LAST SUPPER* 54

3 LOOKING AT LISA 70

4 THE STOLEN MADONNA 102

5 THE BEAUTIFUL PRINCESS 136

6 UGLY ARGUMENTS 158

7 THE SAVIOUR 184

8 SCIENCE AND SEEING 210

9 CODICES AND COMPUTERS 236

10 EXHIBITIONS 254

11 CODES AND CODSWALLOP 280

NOTE ON SOURCES 309
PICTURE CREDITS 311
ACKNOWLEDGMENTS 312
INDEX 314

AUTHOR'S NOTE

My first thanks go to those friends who have kept faith with the idea of this book as it underwent its protracted evolution. It was not easy explaining what it was to be, since there is no obvious model. For my part I had a strong sense that it was worth doing a personal account of Leonardo and that it would command a reasonable degree of professional and public interest, but my confidence was far from unassailable. The earliest formal outline I can find is dated December 2011, but there were outlines before this. The guiding voice as the idea developed was Caroline Dawnay, my long-term agent. We did not always see things in quite the same light, but we shared a conviction that a personal view of the inner workings of the Leonardo business would be informative and entertaining. I strove to take her points on board, much to the benefit of the text.

From the first stages of commissioning to the final production, Sophy Thompson has provided enthusiastic backing and incisively critical editing that has helped the text to work to its best effect. Camilla Rockwood, Amanda Vinnicombe and Jen Moore worked valiantly and effectively in the detailed editing of the chapters. They are not, of course, to blame for those things that do not work. Poppy David was a superb picture researcher, without whom the visual appearance of the book would have been much poorer. Nicola Chemotti has designed the book with flair and Kate Thomas expertly proofed the illustrations.

Not the least advantage of publishing with Thames & Hudson, as one of the great and enduring art publishers, is that they are not scared by plates. When as a student of science I was scrambling to educate myself in the Story of Art (the title of E.H. Gombrich's remarkable bestseller), the two rival giants of British art publishing, Thames & Hudson and Phaidon, stocked my nascent library. I have always respected those who try to communicate ideas beyond a professional audience. Having come to art history from the outside, I am ever grateful to those authors who are sometimes denigrated in academia as 'popularizers'.

Marina Wallace was a vital presence during the period marked by our exhibitions at the Hayward and Barbican Galleries, 'Spectacular Bodies' and 'Seduced'. She was central to the Universal Leonardo project based in Central St Martin's College of Art, where she was professor. My focus on Leonardo does not adequately reflect the broader importance of our partnership over more than two decades.

Concentration on my relationship with Leonardo provides little or no insight into my family life. I cannot conceive what my life would have been like without my former wife, Jill; my children, Joanna and Jonathan; and now my grandchildren, Etienne, Alice, Louis and Magnus. It certainly would have been immeasurably poorer.

I owe a debt to everyone who features in the stories that follow, even when the intentions of the participants have not been friendly. Some of the hostile comments that my work has elicited have been creative and funny. Even those that have been bluntly unpleasant have been integral to the tapestry of experiences upon which I have drawn here. A colleague who published a particularly unfavourable review of one of my books said to me that reviewing is a 'contact sport'. It can feel like that, though I would rather it resembled tennis than boxing or mixed martial arts.

There are many who have played constructive and directly helpful roles in my engagement with Leonardo. In almost all the episodes in that follow, I have enjoyed many collaborations without which key projects could not have been realized. At the end of the book, I have compiled a short list of those who have collaborated directly in my Leonardo enterprises, along with acknowledgments to some of the many people who have given me help in a particularly sustained capacity over the years.

My excellent personal assistant, Judd Flogdell, has been working for me during the protracted period of the book's writing and production. That my schedule has sufficient order and structure to function professionally is in large measure thanks to her sterling efforts and commitment. Her friendship has been an important feature in my life over the last few years.

INTRODUCTION

ART HISTORY IN ACTION

This book is an account of my personal relationship with Leonardo da Vinci, covering half a century in the Leonardo business. It is not an autobiography, and even in terms of my academic career, it is very selective; it might best be characterized as a set of highly focused memoirs.

I do not know of anything quite comparable. In 2008 Carlo Pedretti, who knows more about Leonardo than anyone ever has or probably ever will, published a book of over 700 pages entitled *Leonardo & io* (Leonardo and I). This contains an extraordinary treasury of research interlaced with insights into Carlo's personal engagement with Leonardo's writings, drawings, paintings and documentation. Carlo, however, does not aspire to present the broader picture of people, institutions, events and skulduggery that follows here.

Leonardo is without rival in the history of art – and beyond. He is one of the best known of all pre-20th-century personalities. In a 2013 study measuring historical reputation by means of quantitative analysis, Leonardo was ranked first among pre-20th-century artists (with Michelangelo second) and twenty-ninth in the 'overall top thirty', a list headed by Jesus and Napoleon. Adolf Hitler came seventh.

All the bookable tickets for 'Leonardo da Vinci: Painter at the Court of Milan', held at the National Gallery in London during the winter of 2011–12, sold out well in advance, with many resurfacing online at astronomically inflated prices. This type of response to an art show was unprecedented, as was Leonardo's appearance on ticket agency websites among the 'hottest artists' – the rest of whom were not painters or sculptors but performers such as Bruce Springsteen, 'the Boss', who registers a mighty 19 million hits on Google. At the time of writing, Leonardo himself

is nudging 10 million hits, while his proxy, the *Mona Lisa*, reaches a notable 28.5 million.* Such a huge popular appetite is more than remarkable for an artist-engineer from half a millennium ago who is renowned for not finishing anything – except, of course, both the world's most famous painting and what is probably the second most famous, the *Last Supper*. He was also responsible for the world's best-known drawing: the naked man with four arms and legs, spread-eagled inside a circle and a square (based on the prescription of the ancient Roman architect Vitruvius).

Leonardo inspires studious devotion and untrammelled fantasy in equal measure. Some of this attention is because he is famous for being famous, but it ultimately feeds upon the unique depth, range and imaginative reach of his work across the arts, sciences and technologies. Along the way, his life and works have also become repositories for wild theories to a degree that is not matched by any other figure. Would *The Michelangelo Code* have sold anything like as well? The Leonardo business is unlike any other, and it is easy for aficionados to become obsessed.

Having been in this business for about fifty years, I have seen it all. I have dealt with great and lesser academics, collectors and curators. I have grappled with inflated art-world egos, with devious dealers and unctuous auctioneers. Major scholars and authors, pseudo-historians and fantasists have crossed my path. I have corresponded with obsessives and been verbally beaten up in private and in public. I have grappled with swelling legions of 'Leonardo loonies'. I have walked on eggshells around vested interests in academia and museums. Fusillades of non-Leonardos have been pressed on me, sometimes more than one a week. I have been intimately involved with the two major Leonardo discoveries of the last hundred years, one of which plummeted into rancour and controversy while the other underwent an apparently irresistible ascent into fame and worth. Ingenious forgeries have tested my ability to tell the real from the spurious. The multi-million-pound market for Leonardos has involved me directly or indirectly in prominent and expensive court cases. The police have come calling when a

* Somewhat disconcertingly for a Leonardo scholar, the actor Leonardo DiCaprio scores over 23 million hits and Dan Brown, author of *The Da Vinci Code*, a scarcely credible 345 million.

Leonardo *Madonna* was stolen from a castle in Scotland. I have mounted major Leonardo exhibitions, with all the attendant horse-trading, and appeared on numerous radio and television programmes. Publishers and editors have made demands that have served me well – for the most part. I have served on the boards of national collections, and witnessed diverse aspects of the art world in action. And, along the way, I have researched.

None of this was even vaguely anticipated when I first became involved with Leonardo in the late 1960s via his anatomical drawings. On a number of occasions I have felt that I have finished with him, thinking that I have said all I want to and that it is time to move on. This was certainly the case in 1981 with the publication of my first monograph, *Leonardo da Vinci: The Marvellous Works of Nature and Man*. There is a danger of being typecast. In retrospect I welcome the fact that he has never finished with me. He continues to make compelling posthumous demands on those who engage with him.

It would be easy to become irritated by some of the nonsense that Leonardo attracts like a magnet, but it is a privilege to have engaged with a character from five hundred years ago who still lives in the minds of people today. It is worth remembering that many of those who have developed untenable Leonardo theories have invested a large amount of time and emotional commitment in their researches. I have endeavoured to respond in an understanding manner, although I fear I may have been overly abrupt on occasion. Leonardo's enduring presence has ensured high levels of public interest in the research I have pursued and with the various media through which I have communicated. I have also enjoyed enriching contact with a wide range of international friends and colleagues who have been integral to the quest to elucidate the wonders of his work. Teaching Leonardo to eager students has been a sustaining delight over the years, and it has been a pleasure to hear from Leonardo 'fans' who have been kind enough to contact me.

Many stories involving Leonardo, while picturesque and revealing in themselves, also demonstrate a wider historical truth: the knowledge we possess and the opinions we form are significantly shaped by our specific circumstances. To put it more simply, how we encounter

something colours what it looks like. There is some affinity with the notion, in modern physics, of the intrusion of the observer and the means of observation into the systems under observation. In my teaching I have on a number of occasions conducted seminars under the rubric of 'Art History in Action', in which we have discussed the range of circumstances that give rise to art-historical knowledge. Awareness of these circumstances is informative in its own right, and presents some insights into what might lie in store for students hoping to enter some aspect of the art world.

Beneath the surface of that world, masked by a layer of objective analysis and professional language, the insider is aware of a messy and sometimes turbulent tangle of wishful thinking, prejudice, vested interests, national characteristics, and rigged arguments. Tottering piles of hypotheses can be constructed to prop up cherished theories. An emphasis on connoisseurship can prevent sufficient attention being paid to 'difficult' scientific evidence. Claims to have 'an eye' can too easily shift into denigration of other modes of analysis. The business of attribution is in an unfortunate state. In extreme cases, curators of exhibitions might fix catalogue entries in the service of loans; museum directors and boards might bend their own rules.

There is a strong temptation for those writing or broadcasting about Leonardo to confect new theories simply in order to attract attention. The media are drawn to his supposed heresies and allegiances to arcane sects. Journalists play to the public taste for experts to be humiliated, particularly by forgers; TV companies use the criterion of 'balance' to justify focusing on outlandish ideas that might help sell programmes. It has been claimed that Leonardo himself posed for the *Mona Lisa* in drag, or more recently, that his pupil Salaì did the cross-dressing. Maybe the masterpiece is not by Leonardo at all; I have been told that it is actually a Tahitian princess by Titian. The famed 'self-portrait' drawing in Turin is nothing of the sort, but nothing will shift it in the public imagination – and so on. New absurdities arise every month to join the old ones. It would be easy to slip into self-justificatory mode, standing serenely above the mayhem and making Olympian judgments. But I am clearly part of the complex network of interests and biases, and cannot claim

to have some unique access to infallible truths. I have done my best to become aware of where my own viewpoints might be skewed.

The organization of what follows is broadly thematic rather than chronological. The Prologue contains a compact overview of Leonardo's career, to provide a context for the works of art on which I concentrate. The first seven chapters are built around the *causes célèbres*: the *Last Supper*, the *Mona Lisa*, and other individual paintings with which I have enjoyed especially intense engagements, not always in a comfortable manner. The following four chapters look thematically at wider facets of the Leonardo business. Each is intended to illuminate a particular aspect of modern art-historical practice. The nature of what I am doing is not biographically framed, and does not span all of Leonardo's relatively small *oeuvre* of paintings.

When I began to research Leonardo, I had no idea what I was getting into. However, he has been good to me over the years. This book offers unreserved thanks to him.

A SKETCH OF LEONARDO

Over the years, I have tried to construct a picture of Leonardo that embraces his full range of activities and shows how they relate to his core beliefs. Since the chapters that follow cover his major achievements in a very incomplete manner, I hope it will help to offer a short biographical sketch here.

Leonardo was the illegitimate son of a penniless orphan called Caterina di Meo Lippi and a notary from the small Tuscan hill-town of Vinci. At the time of his birth, in April 1452, his father was forging a prominent career in Florence, some twenty miles to the east. Leonardo was readily welcomed into his grandfather's household in Vinci, and seems to have received a decent education.

We do not know exactly when he moved to Florence to be trained by Andrea Verrocchio, a leading sculptor, metalworker, painter and designer. Presumably the young Leonardo had shown some kind of artistic promise, and as a bastard, he was prohibited from following his father's legal profession. He was first obligated to pay his individual dues to the painter's Company of St Luke in 1472, but by 1476 he was still operating within Verrocchio's busy and versatile workshop. That same year, he and some others were accused anonymously of homosexual activities, but the charges were not pursued.

The most obvious work of collaboration between Verrocchio and Leonardo is the *Baptism* in the Uffizi, in which the sinewy and sculptural figure style of the master has been endowed with a new kind of surface scintillation using the then unfamiliar medium of oil. The hazy landscape and trickling waters exhibit a tingling vitality that we recognize in Leonardo's first dated drawing, the mountainous landscape drawn on

'the day of S. Maria della Neve [Holy Mary of the Snows] on the 5 August 1483'. The works attributed to him in the mid-1470s – the *Annunciation*, the *Munich Madonna* and the portrait of Ginevra de' Benci – carry strong imprints of his training with Verrocchio but also possess a compelling individual strangeness, above all in their intense scrutiny and rendering of the appearance of things. The third of his small paintings, the *Benois Madonna*, shows him forging something like his own style, characterized by physical dynamism and psychological interplay.

The scope of Verrocchio's activities, which included the manufacture and erection of the hollow copper ball on the top of Brunelleschi's Dome of Florence Cathedral, naturalized Leonardo in the polymathic tradition of major Tuscan masters; he learned to embrace the painters' sciences of perspective and anatomy, and cultivated skills in a wide range of artistic media, civil and military engineering, and ceremonial design. Some of the few surviving drawings from the 1470s show him thinking on his own account about military and hydraulic engineering, mechanical devices, weapons design, gearing, geometry and the measurement of time. There is at least one early memorandum mentioning people and books to be consulted that hints at a broader interest in science. The pickings for this early period are quite slim, but they do provide clues that his extensive curiosity and visionary inventiveness were there from the first, at least *in nuce*.

His first recorded commission for a painting indicates that his high promise was recognized early. In 1478 he received the commission for the prestigious altarpiece of the Madonna and Saints for the Council Hall of the Florentine republic. Unhappily, this introduces us to a *leitmotif* in his career, namely a project that never reached completion. The same is true of the *Adoration of the Magi*, a large square altarpiece begun for a monastery just outside Florence – but at least in this case we have the magnificent underpainting in the Uffizi. Leonardo revolutionized what was a standard Florentine subject. The advent of Christ precipitates an urgent chaos of devotion, contemplation, bewilderment and awe, underscored enigmatically in the perspectival background by fighting horses, exotic animals and people engaged in various physical pursuits on and in a ruined building. Florentine narrative painting was radically affected by the drama of the unfinished painting.

We first learn in April 1483 that Leonardo was no longer in Florence, when he was commissioned with two Milanese brothers to provide paintings, colouring and gilding for a large and complex altarpiece in Milan, which was to include the central panel of *Virgin of the Rocks*. He may have initially arrived in the city as an artistic emissary from Lorenzo de' Medici to Ludovico Sforza, the Duke of Milan. It is unclear when Leonardo officially entered the service of Sforza, but after his arrival he drafted a long letter of recommendation to the Duke promising an unrivalled mastery of military engineering, with plentiful 'secrets' of his own invention. At the end of the job application, he mentions that his artistic accomplishments could 'bear comparison with any other'.

The altarpiece commission unexpectedly resulted in two paintings, one of which is now in the Louvre and the other in London. However, this was not efficiency on the artist's part. In 1506, the confraternity who had commissioned the work were still awaiting the *Virgin of the Rocks*. It seems likely that Duke had commandeered the first version (in the Louvre) as a gift on the occasion of the marriage of Bianca Maria Sforza to the Holy Roman Emperor Maximilian, in 1493. This left the artists to fulfil their initial obligation, which they eventually did in 1508. The two versions of the *Virgin* tell of the meeting of the infants Christ and St John the Baptist on the Holy Family's flight into Egypt. St John was under the guardianship of the angel Uriel. The cat's cradle of emotional interchanges is as novel as the system of shadowy colouring. The botanical and geological profusion in the fantastic grotto against which the figures are set again evinces Leonardo's rethinking of how the representation of nature can recharge spectators' engagement with a devotional image.

Looking only at the artistic output of Leonardo's eighteen or so years at the Sforza court, the results are as striking in innovation as they are few in number. There are three notable portraits, one unfinished. The most remarkable is that of *Cecilia Gallerani*, painted in or around 1490. The Duke's teenage mistress cradles an unnaturally large but svelte ermine – a symbol of moderation and purity – while she turns with a slight smile to greet an unseen companion (by implication, the Duke). Again, a seemingly static subject had been endowed with an implied

narrative. The only time Leonardo undertook an orthodox profile of an inner member of the Sforza family was his provision of a portrait in ink and chalks of Bianca Sforza for a presentation book on vellum of a laudatory biography of the Duke's father, Francesco.

The *Last Supper*, commissioned by the Duke for the refectory of Santa Maria delle Grazie and under way in 1497, is the subject of my first two chapters. The most ambitious project of the Sforza years was the huge equestrian memorial to Francesco Sforza. Leonardo devoted intensive labours to the making of a full-scale model, incorporating detailed studies of horse anatomy and proportions, and to the immense task of casting such a colossus in bronze. In the event, the hugely expensive endeavour was fatally curtailed by the fall of Ludovico to the invading French in 1499.

This meagreness of output is deceptive. Leonardo served the court in various functions, not least as a Milanese civil and military engineer. We have plentiful evidence of his visionary inventions, which are best recognized as the kind of visual boasting that engineers reserved for their treatises. The more workaday activities are less well documented and do not survive. The grandest of his realized structures were the scenic machines for major celebrations – above all, for magnificent dynastic marriages. Leonardo created astonishing theatrical illusions of domed heavens and opening mountains. These were massive in scale and extremely expensive, and necessarily had to be completed on time. Some idea of his inventiveness in this courtly mode is provided by his *Sala delle Asse*, a large corner hall in the Sforza Castle decorated on all four walls and ceiling with a complex bower of interlaced trees and knots of golden rope.

Leonardo also served more generally as an impresario of artistic delights for the entertainment of indolent courtiers. He could turn water into wine, create clever rebuses in the manner of modern emojis, play music on a kind of violin, declaim paradoxical parables and prophecies, devise portable outdoor pavilions, and discourse with complex erudition on why painting was superior to every other kind of artistic pursuit. There are signs of frustration in his notebooks that he was being diverted away from works that would grant him enduring fame.

His burgeoning science found scope to flourish in the court environment, and he undertook campaigns to educate himself in the Aristotelian tradition of book learning. Most visually conspicuous is his anatomy, in which he mingled data from animal dissections with traditional wisdom and with some input from scarce human material. The greatest of his early achievements in anatomy centred on his studies of a human skull in 1489, in which he was concerned at least as much with brain function as bone structure. Another of Leonardo's major concerns was optics, as an extension of perspective into a series of complex demonstrations of light and shade from varied sources and on bodies of varied shape. His growing fascination with the mathematics of natural phenomena manifests itself in his studies of statics (such as balances) and dynamics (as in the ballistics of weapons). He devoted increasing efforts to the physics of water in motion, which comprised the theoretical dimension to the hydraulic engineering that he extensively discussed and illustrated in his Milanese notebooks. Underpinning these interests was geometry itself, culminating in his illustrations of the regular and semi-regular 'Platonic' solids for the treatise *On Divine Proportion* by his mathematician colleague Luca Pacioli. The strong impression is that Leonardo was never idle, and that he was prized in the court for far more than completing a few paintings.

His years of diversification in the Sforza court ended in 1499 with the arrival of the French troops of Louis XII, after Ludovico had played his complex hand of diplomatic and military cards in too slippery a manner. Leonardo's immediate port of call was Venice, the maritime republic for which he devised some hydraulic measures to enhance the city's defence against the threatening Turks. By February 1500 he was in Mantua, where Isabella d'Este, sister of Ludovico's deceased wife, had already expressed interest in Leonardo's achievements as a portraitist. He produced a cartoon for an intended portrait of Isabella, but by April he was back in Florence. His promise to turn the cartoon into a painting was never to be realized, and, in spite of her best efforts, the marchioness could not extract a painting of any sort from him. Her representative in Florence reported that Leonardo was working on a cartoon for the *Madonna and Child with St Anne and St John*, and a small painting of the

Madonna of the Yarnwinder. Otherwise, his life was described as unsettled. Searching for new opportunities, he spent nine months or so in the service of the ruthless Cesare Borgia, who was at that point rampaging across central and north Italy to subjugate the so-called Papal States on behalf of the Borgia Pope, Alexander VI.

Back in Florence in February 1503, Leonardo was engaged by the government in schemes to bring the siege of Pisa to a rapid conclusion, most notably through an ill-fated plan to divert the River Arno around the stubbornly resistant city. The most productive aspect of his involvement with the geology of the Arno valley was his growing conviction that the 'body of the earth' must have undergone massive transformations over a vast range of time. His chief evidence came from the layered strata of fossils that were disclosed by the cuttings of the rivers.

Painting suddenly resumed priority. In July 1503 he was re-inscribed in the ledger of the Company of St Luke, an event triggered by the government's intention to commission a great battle scene for their new council hall. The subject was to be the Florentine victory over the Milanese at Anghiari. To produce the cartoon he was granted rights to a large hall in Santa Maria Novella, and he was subsequently provided with a series of payments for materials and components for his innovatory scaffolding. An interim agreement between the painter and the government in May 1504, signed by Machiavelli, suggests that things were not going completely to plan. By this time he had been uncomfortably joined by his powerful younger rival, Michelangelo, who had been commissioned to portray the battle at Cascina against the Pisans. We know that a little over a year later, Leonardo was painting on the wall in the council hall, because he recorded that his work was severely disrupted by a violent summer storm. He was using an experimental method of oil painting on plaster to depict the central motif of the tangled knot of warriors contesting the Milanese standard. It seems that this new technique was not working out as he had hoped.

In March 1506 we see the first signs of a tug-of-war for Leonardo's prized services between the Florentine Republic and the French authorities in Milan. It was not a battle the Florentines were politically equipped to win, given their dependence on French goodwill. Leonardo and his household shuttled between the two cities during the course of 1506–7,

but by April 1508 the painter was effectively lost to Florence as a resident artist. His unfinished mural of the *Battle of Anghiari*, which depicted enraged warriors and savage horses with unprecedented levels of dynamic ferocity, remained as one of the wonders of the government palace until it was covered with Medicean frescoes in the 1560s. Michelangelo's matching project did not progress beyond a cartoon before he too was drawn away from Florence, going instead to work for Pope Julius II in Rome.

Leonardo being Leonardo, there were many other things on his plate in Florence around this time. There were other paintings. The portrait of Lisa del Giocondo known as the *Mona Lisa* was under way by 1503, though not completed until much later. The newly discovered *Salvator Mundi* was probably begun in this period, as was the lost *Leda and the Swan*, Leonardo's most highly valued painting in his lifetime. And the second version of the *Virgin of the Rocks* eventually found its way into its designated altarpiece in Milan.

Alongside the paintings Leonardo was much engaged with geometry, including the time-honoured task of defining a square that would be equal in area to a given circle. He was also digesting the results of his geological observations, which culminated in the *Codex Leicester*, now owned by Bill Gates. Anatomy came to the fore in the winter of 1507–8 when he had returned to Florence, where he was granted permission in the Hospital of Santa Maria Nuova to dissect a man who had claimed to have been one hundred years old. In this, his most important and best-documented human dissection, he concentrated on the 'irrigation' systems of the body – vascular, bronchial and urino-genital – deciding that the old man's blood vessels had become tortuous and silted up in a way that was analogous to the silting of rivers. This was in keeping with his doctrine of the microcosm, in which the 'lesser world' reflects in the operation of its whole and its parts the larger world of the 'body of the earth'.

The French in Milan, including the king himself, clearly regarded Leonardo as a great catch. He was granted various privileges and a substantial salary. He re-engaged with the subject of the Madonna and St Anne, starting on a painting probably intended for the king. However, the finished work only entered the French royal collection

after Leonardo's death. He was diversely engaged in various courtly tasks including architectural projects, spectacular theatrical designs and the planning of a bronze equestrian monument to the Milanese general Gian Giacomo Trivulzio.

The element of reprise at the Milanese court embraces the geometry of volumes and areas; attempts to 'expedite all this anatomy'; the furthering of plans for a treatise on water (spanning theory and practice); the development of his ideas about the ancient history of the earth; a treatise on bird flight that served to refine his designs for a flying machine; and an intense study of the internal optics of the eye, in the course of which he came to regard seeing as a more ambiguous business than he had previously assumed.

There are two main achievements in Leonardo's later anatomical researches. The first comprises the magnificent studies of the organic form and complex mechanics of the skeletal and muscular systems, undertaken around 1510. The second concerns the heart, in which he explored the relationship between the heart's fleshy interior and the geometrical motions of the blood. He showed that the aortic valves exploit the curvilinear turbulence of the blood to fill the three concave cusps of each valve, so that the blood expelled into the vessels with each pumping contraction will not reflux. Well might he write, 'Let no-one who is not a mathematician read my principles.'

After about five years serving the French in Milan, he transferred to Rome, where the Florentine Giovanni de' Medici had recently been elected Pope as Leo X. He entered the household of the Pope's brother Giuliano, and was lodged prestigiously in the Vatican. He may have begun his *St John the Baptist* in Rome. The prophetic saint, in a sea of dense shadow, points heavenwards to the ultimate source of spiritual power, smiling with the conspiratorial knowingness that Leonardo reserved for figures who hold the secrets. It may be that Giuliano was responsible for Leonardo resuming work on the *Mona Lisa*. Other partially finished paintings, such as the *Leda* and *St Anne*, were probably also the subjects of continued attention. However, his primary role for Giuliano seems not to have been as a painter. He was involved in projects of hydraulic and maritime engineering, and strove to perfect huge concave 'burning'

mirrors that could act as intense sources of heat – not least for the incineration of enemy ships. One of the German craftsmen employed by Leonardo as a mirror-maker denounced him for undertaking anatomies, which he was still pursuing avidly. Geometrical conundrums continued to occupy him, but what seemed to be solutions to the squaring of the circle failed to hold up after his initial excitement.

In the winter of 1515 he went with Giuliano to Florence for the triumphal entry of Leo X, and began to draw up plans for a grand new Medici palace in the city. But he may have travelled on to Bologna, where the Pope was to conduct a hugely important summit with Francis I. Leonardo's famous drawing at Windsor of the Roman wolf in a boat navigating towards an imperial eagle may well be an allegory of the resulting *Concordat*. With the unexpected death of Giuliano in March 1516, Leonardo was left without an employer. In a declamatory note, he lamented that 'the Medici made me and destroyed me'.

Leonardo was, of course, well known to the French from his service in Milan, and he might have encountered the new king, Francis I, at the Bologna summit. At some point in 1516 he took up Francis's offer of lucrative patronage and moved to France. He was grandly ensconced in the manor house of Clos Lucé at Amboise, below the imposing royal château, and accorded a huge salary with proportionately substantial stipends for the members of his household. The king was buying into Italian Renaissance culture, and Leonardo's presence was valued as such. One witness recorded that:

> King Francis, being enamoured to the very highest degree of Leonardo's supreme qualities took such pleasure in hearing him discourse that he would only on a few days in the year deprive himself of Leonardo....He said that he did not believe that a man had ever been born in the world who knew as much as Leonardo, not only of sculpture, painting and architecture, but also that he was a very great philosopher.

Leonardo was displayed to visiting dignitaries, as recorded in October 1517 in the travel diaries of Antonio de' Beatis, who was accompanying the

Cardinal of Aragon on his European tour. The visitors were shown paintings, including the *Mona Lisa* and the *Virgin Child and St Anne*, and the remarkable collection of manuscripts, of which those devoted to anatomy made the most powerful impression. By this time Leonardo was reportedly suffering paralysis in his right side, presumably induced by a stroke.

The king did expect some work from Leonardo. He was rewarded with such wonders as an automated lion that strode forward to open its breast, revealing French *fleurs-de-lys* against a blue background – apparently signifying peace. For the celebrations of the wedding of young Lorenzo de' Medici and the king's niece, Leonardo staged a heavenly 'Paradise' related to that originally devised for Milan in 1490. He was also deeply engaged with a hugely ambitious project for a castle/palace at Romorantin, involving hydraulic engineering and ornamental waterworks. His extensive studies, including extended site visits, did not immediately bear fruit, but the cluster of glorious French châteaux in the Loire region testifies to Leonardo's impact in synthesizing new Italian Renaissance design with the traditional morphology of French castles.

In spring 1519, Leonardo deemed it prudent to draw up his will. Certified in Amboise on 23 April, it details his legacies, with the appurtenances of his art and his writings left to Francesco Melzi, 'nobleman of Milan', his well-educated Lombard pupil. The rascally Salaì, referred to as a 'servant', was given half of Leonardo's 'garden' in Milan (on which Salaì had already built a house). Leonardo's careful provisions for an elaborate funeral and pious masses confirm his orthodox devotion to 'Our Lord Almighty God' and the saints. Although he clearly harboured doubts about how some holy men and women conducted their affairs, he did not doubt the existence of God. His researches testified definitively that the wonderful design of nature, particularly the 'microcosm', could only be the product of the ineffable Creator of the world.

Soon after the master's death on 2 May 1519 at the age of sixty-seven, Francesco Melzi wrote movingly to Leonardo's half-brothers in Florence:

> I understand that you have been informed of the death of Master Leonardo, your brother, who was like an excellent father to me.

It is impossible to express the grief I feel at his death, and as long as my limbs sustain me I will feel perpetual unhappiness, which is justified by the consuming and passionate love he bore daily towards me. Everyone is grieved by the loss of such a man whose like Nature no longer has it in her power to produce. And now Almighty God grants him eternal rest.

Leonardo's 'eternal rest' in his tomb at Saint-Florentin at Amboise was to be disturbed when the graveyard was desecrated in 1802. It is unclear whether the human remains that were subsequently reburied in the castle's Chapel of St Hubert are actually Leonardo's.

Melzi and Salaì returned to Lombardy. Given the terms of the will, we might expect Melzi to have inherited all Leonardo's works of art. He certainly cherished the considerable stock of manuscripts and drawings. It is therefore puzzling to find on the violent death of Salaì in 1524 that he, not Melzi, had seemingly come into possession of the group of paintings that Leonardo had never passed on to his patrons – including the *Leda*, the *St Anne*, the *Mona Lisa* and the *St John*. All of these, at some point or points, were acquired for the French Royal Collection under circumstances that remain to be clarified.

Leonardo's precious legacy of paintings, drawings and writings were about to embark on their extraordinary and tortuous journeys of attrition and survival, ascending unevenly but remorselessly to their present state of near-deification.

CHAPTER 1

THE *LAST SUPPER*
AND THE FIRST STEPS

When I first saw the *Last Supper* in the flesh I found it difficult. I recognized, of course, that it is the most iconic of narrative paintings, rivalled only by Michelangelo's *Creation of Adam* on the Sistine Ceiling in Rome. But really engaging with it was a different matter.

My first encounter with what remained of Leonardo's masterpiece was in 1964, during my first visit to Italy. This was in the summer vacation between the two years of my studies for the Postgraduate Diploma in the History of Art at the Courtauld Institute in London, following my conversion from Natural Sciences to Art History at Cambridge. It would be worth saying a little about how I arrived at this point.

I had 'gone up' to Downing College at Cambridge from Windsor Grammar School, intending to become a biologist. I steadily lost impetus in my studies of science, and (courtesy of fellow students) was drawn into unimagined worlds of foreign films, the visual arts and music. The college cabarets featured John Cleese, while Trevor Nunn was producing the plays. I had no criteria with which to judge that they were special. I played a lot of sport. I joined with John Sharp, a friend who was studying to be a mathematician, in haunting the lecture series in the nascent Department of the History of Art. One evening John asked, 'Would you like to hear Pevsner speaking on William Morris?' Not wishing to admit that I knew of neither, I said 'Yes'. We also spent a magical afternoon looking privately at the Turner watercolours in the study room of the Fitzwilliam Museum. The cumulative result of these little moves was that I decided to thrust the prow of my tiny boat into the new Part II in

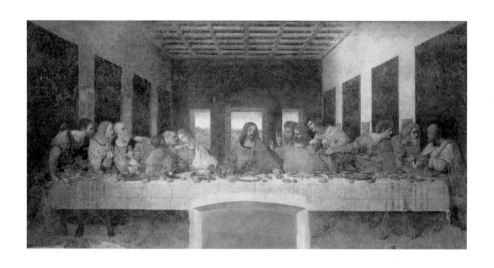

Drama in the 'upper room':
The Last Supper, 1495–8. Tempera on gesso, 460 × 880 cm (181 × 346 in.).

CHAPTER 1

the History of Art (the third-year course) under the redoubtable Michael Jaffé. There was no Part I at that point.

To enter the Part II, an aspiring student needed to gain the assent of 'Professor' Jaffé in person. He had the aristocratic air of an English milord, combined with the doctrinal gravitas of a senior rabbi. I was summoned to see him in his grand rooms in the Gibbs' Building at King's. I knocked on the outer door. A brusque 'Come in' wafted distantly from an inner sanctum. The next door I tried proved to be the bathroom. Third time lucky, I entered a large room of splendiferous objects – elegant bronze statuettes, historic oil sketches, French furniture. Michael was seated at a Louis XV desk, his eyebrows ascending. 'Sit down.' I'd only seen such chairs in museums, with ropes across their arms. I chose a sofa that looked not too ancient and sank deeply into a sea of soft cushions. Struggling up, I said that I wanted to take the one-year course in art history. 'I think you had better,' he responded. Presumably he had seen me lurking with John in the back of his lectures. We exchanged a few further words, and I went on my way duly admitted.

Michael's classes in front of paintings in the Fitzwilliam were thrilling. For good measure there were a number of distinguished guest lecturers, including a revelatory series on Raphael by John Shearman, with whom I was later to study. Then, as the result of a suggestion from another friend, Charles Avery, who was also studying the Part II, I applied for postgraduate study at London's Courtauld Institute of Art. When I was interviewed for admission Sir Anthony Blunt, head of the Institute, asked what I 'collected'. Without thinking I responded, 'my next lunch'. The other members of the interviewing panel seemed amused. Again I was admitted, and was on my way.

The small-town middle-class community from which I came was deeply suspicious of foreigners, regarding them as by nature untrustworthy, especially where money was concerned. This was particularly the case with Italians, who, as my father declared, had 'swapped sides in the war'. The only Italian I had encountered at Windsor Grammar School was Tony Vettise, a boy a little older than me. His ancestors had come to Windsor in the 19th century to work as craftsmen on the Albert Memorial Chapel, within the castle precincts. Artistically inclined and

prone to amiable roguishness, Tony seemed distinctly non-English. I was studying sciences (which were deemed to be serious) and progressively dropping arts subjects, including Art. We had to make such choices at an absurdly early age. The Vettise family had become shopkeepers who were (stereotypically) makers and vendors of ice-cream. The sign above the door to one of their small shops displayed an enticing girl in a swimsuit, who encouraged us to 'Dive in for Ices'. I was warned by my parents not to buy their home-made potions, which were not 'hygienic' compared to the glutinous products of Wall's and other branded manufacturers. Deeply indoctrinated with a fear of germs, I greatly regret that I did not 'dive in'.

A small grant from the Courtauld subsidized my 1964 visit to Italy in the company of Charles Avery and our future wives, Jill and Mary. We arrived in Venice after more than two days of dispiriting travel. First came the deck of the packed student ferry at night. The earliest to embark were instructed to pile their luggage in the middle of the deck. They naturally claimed deck chairs close to the scruffy mountain of baggage. And so the mountain grew. At disembarkation in Calais, those closest to the pile could not make contact with their buried bags. The latecomers, whose visible baggage was avalanching down the steep incline of the pile, could not press through the throng of those nearer, who began desperately tunnelling for their possessions. The pile flowed like lava, trampled by agitated searchers. We eventually grabbed our cases after a hideous scramble. This was followed by an endless, grimy train journey at snail's pace via Germany, collecting other carriages crammed with ragged youths humping huge rucksacks and careworn cases.

The long snake of carriages ground towards Verona, where we were meant to change for Venice. It halted for some ten minutes or so, apparently waiting to enter the station. Then it headed off decisively in the reverse direction. As we explained to the ticket inspector who demanded extra fares from us, *non arrivare a Verona* (not grammatical, but eventually comprehended). His mimed gestures indicated that we should have disembarked and walked down the actual track – the train was too long to fit in the station. We finally alighted at Padua, where we waited for a slow train in the reverse direction to Venice. I can't recall if we were forced

to pay extra. In any event, the conviction that foreigners were chaotically inclined and had designs on my meagre stock of *lire* was reinforced.

Exhausted, we eventually found ourselves standing in the bright morning of the Piazza San Marco, listening to an Italian brass band enthusiastically playing Wagner's *Tannhäuser* overture. I hate Wagner, musically and ethically, and rather dislike brass bands. It was not a good start.

Redemption came through the visual magic of Venice. 'The Most Serene Republic' took seductive hold. The shimmering facades, part Gothic, part Turkish, part classical; the slap of water against stone and brick as the motor-driven craft churned abruptly along narrow canals built for craft propelled by oars. The odour of salty seawater and dubious drainage mingled with exhaust fumes. The humpbacked bridges that propelled us into narrow alleys leading nowhere. The great 'S' of the Grand Canal with its sumptuous facades, parading the egos of ancient families and the prestigious warehouses of foreign traders. Torn posters lamented the death of the Italian Communist leader Palmiro Togliatti – '*Togliatti è morto*', they shouted. My embryonic Italian could understand that. And of course the paintings, those transcendent miracles of singing colour, voices still clearly audible from half a millennium ago: Bellini, Cima, Giorgione, Titian, Tintoretto and Veronese. This was quite a roll-call of enduring geniuses from a city with a population about the same size as modern Oxford. The slides and photographs of my London studies came to life as only the real things can do.

I gained a particular affection for Cima da Conegliano, whose reputation was and is cast into shade by the mighty Bellini. He seemed to me a wonderfully 'perfect' picture-maker, with a refined naturalism that spoke of intense scrutiny of nature. For a young man with aspirations, acquiring a favourite about whom few were informed seemed a smart thing to do. That one of his most sparkling pictures, the serene and communicative *Baptism*, was in the relatively obscure church of San Giovanni in Bragora, off the beaten tourist routes, helped a good deal. I was later to write my first little book on Cima.

Next was Florence. We did the obvious things, and were dutifully awed. I sensed a historical hardness and present resentment in Florence – a feeling that has never quite left me, even though I now feel

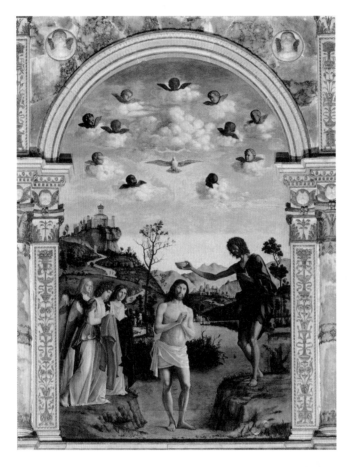

Cima da Conegliano, *Baptism of Christ*, 1492. Oil on panel, 350 × 210 cm (140 × 83 in.).

at home there. We then moved on to Milan, which was very different. It exuded an aura of 'Victorian' grandeur, with wide streets flanked by heavy buildings, dense with grand columns, pilasters, capitals, plinths, mutules, pediments, balustraded balconies, friezes, and overhanging cornices with dentils and triglyphs – a plastic litany of the architectural terminology I was striving to acquire. The metallic grind of trams was new to me. Articulated in three sections, they clanked past with ponderous insistence, jerking round obligatory corners. Not knowing how to buy tickets, and conserving my student budget, I preferred to walk.

As dark descended, the grand city retreated into the 19th century; grainy, massive, cavernous, like one of the Alinari Brothers' old monochrome photographs of Italian architecture at night. These were familiar from the serried ranks of box files at the Courtauld, from which we pillaged mounted photographs to illustrate our spoken seminar papers, sitting round a big table. Art history indoors was still predominantly a black-and-white pursuit. There was a sense that really good black-and-white photographs, full of high-resolution detail and replete with velvety tones, were better than colour slides, which were of dubious accuracy, particularly since the films degenerated to pink and violet as they were toasted in projectors. This was true to a degree, but the preference relied a good deal on the kind of austere snobbery at which academics excel. I liked to get at least some sense of colour, so I bought colour postcards as a cheap personal archive. In any event, Milan was a black-and-white city compared with Venice.

The immense Sforza castle seemed oddly 19th-century, with its rhetorical array of abrasive walls topped by battlements and punctuated by belligerent towers. I later learned that much of what immediately

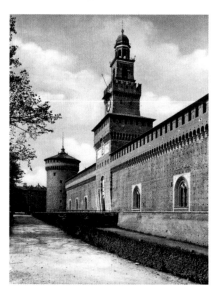

The 19th-century castle:
the Castello Sforzesco, Milan.

meets the eye is the result of 19th-century restoration and construction – like the castle at Windsor, which I had haunted as a child when living in the small town that clung to the skirts of Castle Hill. Milan was impressive, but it was not immediately loveable in the same way as Venice, Florence or other historical towns in Italy that had become picturesquely stranded in ages past.

We looked, of course, at Leonardo. After progressing though the sequence of massive ground-floor rooms in the castle, stylishly converted into a museum of architecture and sculpture, we entered the Sala delle Asse (room of the boards) in the square tower on the north corner.

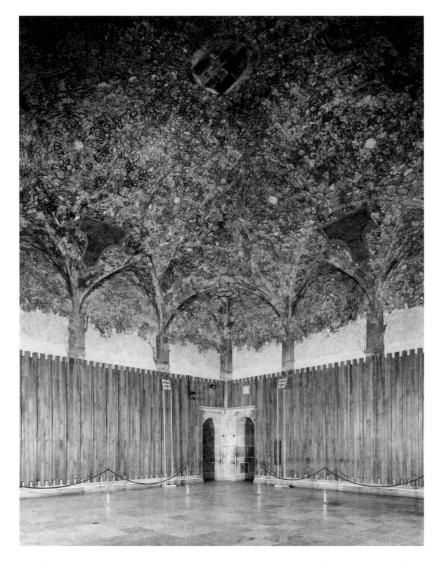

The battered bower: the Sala delle Asse in the Castello Sforzesco before recent restoration.

Decorated by Leonardo and his studio for Duke Ludovico Sforza in the later 1490s, it presented us with an ambiguous experience. Damage and successive restorations of the ceiling vault had reduced the elaborate interlace of branching trees and knotted gold rope to a soup of cold minestrone. Nevertheless, a sense of the ingenuity of its conception

could still be extracted from the blurry confusion, and there were some slight hints of freshly observed botanical verities that would have raised the leafy bower above the merely decorative.*

I had little framework for making sense of what I was looking at. The course at the Courtauld was devoted to Italian art of the 16th century, which meant that Leonardo's career was cut in half. All his work for Ludovico in Milan belonged to the previous century. This gave me a convenient excuse for not studying him. He looked big and difficult – the sort of figure you should either do wholeheartedly, or not at all. I felt the same about the artist's science of linear perspective, another topic to which I was subsequently much drawn.

I had, however, already seen two Leonardos in the flesh. Both were in the National Gallery, which became a regular destination for repeated and deeply satisfying pilgrimages – Masaccio, Uccello, Piero della Francesca, Botticelli, Verrocchio, Raphael, Michelangelo, Mantegna, Bellini, Giorgione, Titian, Tintoretto, Veronese...to limit the roll call only to major Italian Renaissance masters. There was Leonardo's *Virgin of the Rocks*, looking strangely alien among the Renaissance works that preceded it, and even among the later paintings that were deeply affected by Leonardo's innovations. Its oddness extended from the deeply shadowed colouring to the tense spiritual communication between the actors in the mute drama that had he set in a strangely exotic grotto.

The other was the 'Burlington House Cartoon' of the *Virgin, Child, St Anne and St John the Baptist*, a full-scale drawing in chalk on eight large sheets of pasted paper. Leonardo seems never to have turned it into a painting. The memory of its rescue for the nation was still fresh. In 1962, the Royal Academy of Art (based in Burlington House) had controversially decided to reduce its growing overdraft by selling the treasure that it had

* Decades later, looking at the vault from the restorers' scaffolding in 2016, I was able to see more clearly that these shards of original paint are few and far between. Towards the bottom of one of the corners of the room, not masked by the palisades of wooden planks that lined most of the walls, are rough underdrawings of roots insinuated through rocky strata. Again an extraordinary conception, but I could not really correlate lower parts of the trunks arising from the roots and the trees in the vaults. Recent removal of the panelling has revealed other underdrawings that might help relate the painted trunks with the sketches below. Leonardo seems to have thought at one stage of setting us below ground level. I speculate, not on firm grounds, that the Duke might have objected to being in a painted pit.

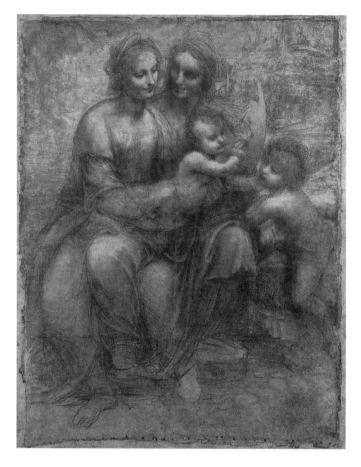

Tender mothers and touching children: *Virgin, Child, St Anne and St John the Baptist*
(the Burlington House Cartoon), *c.* 1499. Charcoal (and wash?) heightened with white chalk
on paper, mounted on canvas, 141.5 × 104.6 cm (55⅝ × 41⅛ in.).

owned since the late 18th century. A public appeal emerged from the
protests, aiming to raise what then seemed the huge sum of £800,000.
An American gallery was said to be willing to pay £2.5 million – more
than twice what any painting had then fetched. I think it was my uncle
Jack who gave me one of the cheap reproductions that were being mar-
keted by *The Times* to help raise money. Public support was high, and the
Macmillan government topped off the appeal with £350,000. The name of
Leonardo already carried its aura of magic. The communicative subtleties
of the tender mothers and touching children – sometimes suggestively

definitive and sometimes barely emergent in Leonardo's unique drawing style – stirred in me the glimmers of something more than admiration.

If I knew about the *Last Supper* at all at this stage, it was via Kenneth Clark's mellifluous 1939 monograph (of which I was to produce a new edition in 1987). I recalled what Clark said about the state of the mural – a 'tragic ruin' in which the heavy hands of successive restorers predominated over the 'ghostly stains' that bore elusive traces of Leonardo's magic. Clark's account, read today, is magnificently eloquent in its praise for what could still be discerned of the mural.

Leonardo put an enormous amount of intellectual, imaginative and technical effort into the *Last Supper* – and perhaps even more into the *Mona Lisa*, which became a kind of painted manifesto for him. He kept hold of the *Mona Lisa* from 1503 until his death in 1519. However, a portrait of a bourgeois woman could not accomplish what he and his contemporaries regarded as the highest aspirations for art. These aspirations involved the depiction of momentous subjects, such as an altarpiece of the Madonna and Child in the company of various saints. In 1478, when he was twenty-six, Leonardo had been commissioned to paint just such a picture for the palace of the Florentine government; but he never did so, for reasons that are unclear. Even more demanding were great 'history paintings': narratives of highly significant events like the Last Supper, recounted through the postures, gestures and expressions of the main actors. Leonardo claimed that a painter can 'make a story that signifies great things', just like a writer.

The Biblical story of the Last Supper – the meeting of Christ and the disciples in an upper room on the evening before Judas's betrayal and Christ's arrest – is indisputably momentous. It was when Christ instituted the sacrament of the Eucharist, the sharing of bread and wine as representative of his body and blood. It was also the occasion on which he announced that one of their number would betray him. With the wine and bread much in evidence on the table, all but two of Leonardo's disciples rise from their seats. They 'say unto him one by one, is it I? and another said, is it I?' Leonardo set his urgent drama in the 'upper room' as recounted in St Mark's gospel, inventing a spatial setting of compelling power. This rendering of space, motion and emotion is

Geometrical solids by Donato Bramante in Santa Maria delle Grazie, Milan.

central to Leonardo, and it would come to play a particular role in my initial engagement with him.

But my first visit to the *Last Supper* in Milan was as much a duty as a personal commitment. Fuelled by espressos drunk standing up (it was more expensive to sit), we approached the refectory along the noisy Corso Magenta, passing the monumental east end of the church of Santa Maria delle Grazie added by Donato Bramante, Leonardo's colleague at court. This domed structure was undeniably impressive in its volumetric rhetoric. The dome, crossing and apses were conceived as a series of abutting geometrical solids with decorative motifs on the exterior, and realized inside as a harmonic sequence of Euclidian hemispheres, circles and squares. I *had* studied Bramante, since his great project for St Peter's in Rome fell definitively into the 16th century. Although I could not then articulate it, I was drawn to this kind of design because it related to what had attracted me to study biology at school and natural sciences at Cambridge. What abilities I had in science were drawn from an instinct for visual structures in nature – the geometries of natural design, such as shells and pine cones. Now I was looking at what one

of the most inventive of humans could make of the basic elements of such structures.

We joined a small gaggle of visitors to buy tickets for the refectory. Our student discount cards were scrutinized with bored scepticism by the woman behind the big oak counter. We paid what was deemed to be the right price. As ever, I harboured an underlying suspicion that we were being fleeced. The ticket when it came was notable, decorated in the manner of an Edwardian bank note and embossed with an official seal. Italians like stamping documents.

Seeing the *Last Supper* was a cultural event rather than a deep experience of Leonardo. Entering into the real presence of an image that had transcended time and space was momentous in itself, but the actual painting refused to thrill. I knew it should have been special to experience Leonardo's 'upper room' within the actual space of the long rectangular hall in which the monks would have dined, sometimes in the company of Duke Ludovico. It was difficult, though, to get past the perceived status of the mega-masterpiece – and even more difficult to

The *Last Supper* as it was before the Second World War.

move beyond the pictorial wreckage. The surface was as rough as an alligator's skin, a patchwork of dark blotches and fragments of diminished colour interspersed with frequent tracts of bare plaster. There were some dark, high-backed pews set against the lateral walls of the refectory, which served to rest the feet of weary tourists but did nothing to lift the visitors' spirits in what was a depressing environment. As we left, I felt that there should be something more, that I should be able to do better with the patchy remains of Leonardo's masterpiece.

The following summer I graduated with the Diploma and entered the Blunt placement service. Sir Anthony Blunt was director of the Courtauld, and was consulted on the majority of academic art history appointments in Britain and the Commonwealth. He was lofty, slim, aristocratic, remote and distracted in manner, with an unusually long face and a stiff upper lip of a non-metaphorical kind. He was the very image of attenuated *hauteur*. I had no reason to think that he knew anything about me.

When he called me to his elegant office in the Robert Adam house in Portman Square then occupied by the Institute, it rapidly became evident that he had filed a workable number of details in his mental reference system without seeming to do so – one of the attributes that made him such an effective intelligence agent and spy during the war. It later transpired that my time at the Institute had coincided with his confession in April 1964 to the security services that he had acted as a Soviet agent – though he was not immediately unmasked in public.*

There was talk among the students of Blunt's involvement with those already unmasked as spies; most notably Donald Maclean and Guy Burgess, known communists and homosexuals from Cambridge University, who had defected to Russia in 1951. It was rumoured that Burgess had 'shacked up' with Blunt in the flat above the Institute. This generated a *frisson* that was appealing to students in the 1960s. Someone pointed out to me that Blunt's art history before the war had

* It was reprehensible that the deal struck with Blunt did not include his stepping down from his official positions as director of the Courtauld and, more pertinently, as Surveyor of the Queen's Pictures. The irony of his continued service to the Crown has been brilliantly exploited by Alan Bennett in his short play *A Question of Attribution*.

been communist in tone. After the war he had hidden behind art history of a more traditional kind, becoming famous for his studies of the cerebral French painter Nicolas Poussin. Poussin, appropriately enough, is an artist of masks. Blunt was surreptitiously intimidating, intellectually and personally.

The upshot of my interview in the Director's office was that he 'recommended me to apply' for the one-year post of lecturer at Dalhousie University in Nova Scotia in Canada. That was duly where I went. The brief was to teach two courses of art history – one from Egypt to the Baroque, and the other from the Baroque to today – to four students. Two years of courses in one year! They had been enrolled in a joint degree offered by the University and the Nova Scotia College of Art, without any arrangement having been made for the University to teach them anything.

Possessing a degree in natural sciences with a bit of aspiring art history and having studied some specialized post-graduate courses did not qualify me to cover the wide range of material in the stipulated syllabuses. In the middle of both terms I staged a tactical illness to catch up on basic reading in order to keep my nose just in front of my four eager pupils. It was a condensed apprenticeship. Early the following summer, a note arrived. Anthony Blunt 'advised me to apply' for a lectureship at the University of Glasgow, where I was again appointed without an interview. At the age of twenty-four I was in a tenured post, with no obvious reason (beyond the inherent corruption of the system) why I should have been.

It was during that summer interlude between teaching posts that Leonardo arrived in the foreground of my life. I was contacted by a trainee television producer at the BBC and his designated assistant, who were working towards his graduation programme on Leonardo's studies of water in motion. I am ashamed to say I can no longer remember their names, nor recall why they chose this unusual subject. They had obviously done the rounds of qualified specialists who could contribute, presumably headed by Sir Ernst Gombrich, then director of the Warburg Institute, and John Shearman at the Courtauld. Shearman, coyly precise and meticulously methodical, with a trim moustache that he puffed out in moments of assertion, had been my main instructor at the Courtauld. He was an inspiring if emotionally remote teacher. I imagine that neither

of the august professors was inclined to spend time on a programme that was not going to be transmitted. Somewhere, far down the line, the producers reached me and I said I would help them, without knowing how. They had also recruited a real expert on hydraulic science from London University, who skilfully conducted experiments to recreate the phenomena of flow and turbulence drawn so wonderfully by Leonardo. The redeeming feature from my point of view was that Gombrich very generously lent us his then unpublished paper on 'The Form of Movement in Water and Air', delivered at an international symposium on *Leonardo's Legacy* at the University of California in Los Angeles. It was later included in *The Heritage of Apelles*, one of the collections of Gombrich's superb essays. Reading the paper, I felt that I had come home.

Gombrich had decided to look at Leonardo's studies of the dynamic geometry of water and air in their myriad varieties of motion. The drawings, especially those at Windsor, were famous, but they were not well understood. Even though the formal nature of the draughtsmanship was evident – particularly what Clark described as 'visible linear curves' akin to 'the great Chinese paintings of cloud and storm' – they tended to

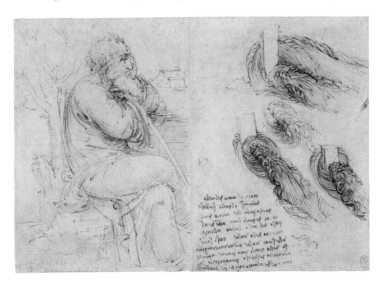

Water curls like hair:
A seated man (St Joseph?), and studies and notes on the movement of water, c. 1510.
Pen and ink on paper, 15.4 × 21.7 cm (6⅛ × 8½ in.).

be treated as if they were direct records of observation, like miraculous snapshots. Gombrich came at them from a different standpoint:

> What prompted me to take up the study of these astonishing drawings was the relation between seeing and knowing or more accurately between thought and perception, to which I have devoted my book, *Art and Illusion*. There can be no more important witness for the student of this problem than Leonardo. He represents a test case for those of us who are interested in the interaction of theory and observation and are convinced that the correct representation of nature rests on intellectual understanding as much as on good eyesight.

During my studies in science I had become aware that we tend to see what we expect to see, rather than just opening our eyes and seeing what's there. I learned this most memorably at Windsor Grammar School while dissecting a range of unfortunate animals for A-level biology under the watchful eye of Dennis Clark, a remarkable teacher. We had dissected a succession of victims. Next came rats. As we opened our rats' abdomens, he asked us to find the gallbladder. After a decent interval, he invited us to raise our hands if we had found it. I rather fancied myself as a dissector and keenly raised my hand, along with a few other boys. 'It's a funny thing,' he said, 'rats don't have one.'

Gombrich's stance was more philosophically subtle than this blunt lesson. His views as to how we acquire visual knowledge corresponded closely to the theories of scientific knowledge advanced by the philosopher Karl Popper, Gombrich's friend and fellow émigré from Austria in the face of Hitler's tyranny. As Gombrich says in the paper on motion, specifically referring to Popper: 'It is increasingly recognized that science does not progress by looking, but by taking thought, by the testing of theories and not by the collection of random observations.'

At that time I did not fully appreciate the poignant juxtaposition of the two directors of the London Institutes: Blunt the aristocratic spy, and Gombrich the Jewish exile from Vienna. The Courtauld, housed in its gracious Robert Adam house, exuded the traditional air of art history

in England – elegant, posh, privileged and self-consciously cultured in its effortless command of connoisseurship and claims to superior sensibility. The Warburg, housed by contrast in a London University building of restrained functionality, could hardly have been more different in ethos. With its irredeemably bookish character, it intimidated through Germanic erudition rather than social class.

I did not at that stage really know Ernst Gombrich. I had heard him lecture to a large audience on Leonardo when he was visiting Cambridge as Slade Professor; and I had attended a smaller talk he gave at Downing College while I was still supposedly focusing on biology. Much taken at that point with the formalist implications of writings by Roger Fry and Clive Bell, I asked after the Downing talk whether Gombrich thought that content got in the way of our discernment of 'significant form'. 'Ah,' he said in his lispy Viennese accent, 'if a painter was asked to portray a Madonna, I think that is what he meant to do.' He did not suffer fools gladly.

I had subsequently attended three or four seminars Gombrich ran on northern 16th-century artists as part of the postgraduate course at the Courtauld. In the class on Albrecht Dürer, he asked the four of us what was the central motivation of Renaissance artists. We all came up with what we thought were 'clever' answers. Fortunately I don't remember mine. 'The imitation of nature,' was his answer. This seemed indisputably right. His thinking corresponded with the conviction I had acquired at school that we should always opt for the simplest answer in the first instance, and only embark on more complex explanations when the first answer breaks down decisively or needs heavy qualifications. Mr Sidney ('Sunny') South, the history master in charge of the Nature Club at my school, had always insisted that we assume the bird we were seeing was the most common type possible. Only if that really did not work could we pass on to the rarer birds we were hoping to add to our schoolboy lists. This parsimony remains good advice in all areas of intellectual enquiry.

In Gombrich's paper on Leonardo's drawings of motion in water and air, he set the drawings within the framework of Leonardo's voluminous, tangled and often frustrating writings on the movement of fluids. His knowledge of Leonardo's writings was extensive, founded not least on

the truly superb indices he created for the two-volume edition of Jean Paul Richter's *The Literary Works of Leonardo da Vinci* in 1939. There is something humbling in the image of the mighty EHG as an anonymous indexer. His exposition of the water drawings made it evident that they were constructed on the basis of the theory of how water moved – what Leonardo called its 'impetus' – in a constant conversation with observation and experiment.

In the note beside the tangled skeins of water in the drawing illustrated above, Leonardo observes that the motion of water is analogous to the curling of hair. The weight of the hair corresponds to the impetus of the water, while both hair and water have a natural tendency to curl in a circular manner. The resulting configuration in both cases is a helix. As I progressively came to see, such underlying laws were central to Leonardo's quest to understand nature. Leonardo's expression of underlying order through the eloquence of drawing resonated with the instinct for natural pattern and processes that had drawn me into the natural sciences. I later came to attribute this instinct to what I have called 'structural intuitions'.

One door was opened into Leonardo studies that summer. But which of the many possible doors should I personally go through? I was then mainly looking at French art of the Neoclassical and Romantic period, on which I published bits and pieces. Where to start with Leonardo? As I was a biologist of sorts, the great series of anatomical drawings at Windsor seemed a good place. On drafty evenings in our Glasgow tenement flat, hunched in front of a gas fire in a lofty sitting room, I worked systematically through Clark's remarkable catalogue of all the Windsor drawings, which had been productively expanded by Carlo Pedretti in the second edition. I read what had been written by previous students of Leonardo's anatomies. They tended to focus on what Leonardo got right, or almost right. They were seeking a modern Leonardo whom they could endorse. This imposition of the arrogance of the present seemed not the right way to understand Leonardo.

I was particularly attracted to a series of studies of the human skull, drawn in 1489 with extraordinary refinement and delicate precision. Some showed the outer contours of the bony shell; others literally delved inside

the structure. Leonardo sectioned the actual skull that he must have placed on the workbench in front of him. He sawed it vertically and horizontally, disclosing the inner architecture of the cranial cavity and its hollow sinuses. He analysed the dome of the skull much as he would scrutinize a Roman temple, probing not only its structure but also its geometrical proportions. For the first time, I felt that I was getting to know Leonardo – entering a real dialogue with him over the gap of five hundred years.

The big surprise that emerged from my looking and reading was that these masterpieces of anatomical observation could not be wrenched away from some of the most schematic and diagrammatic drawings of anatomy that Leonardo ever made. These showed the cavities or 'ventricles' within the brain where the varied mental activities were believed to occur. He drew them in an entirely traditional array, as a series of internal flasks. This was not a daft idea. The grey matter of the brain did not look at all promising in the era before high magnification and selective staining.

I came to understand that Leonardo was showing how impressions from all five senses were funnelled into the first chamber – the 'receptor of impressions'. In the second ventricle the impressions were correlated by the *sensus communis*, the ancestor of our common sense. The second ventricle was also where all the main mental functions were performed: intellect, imagination, the commands of voluntary and involuntary motion, all directed by the resident soul. Finally, the results were stored in memory within the last of the three flasks. Although the physiology is wrong, the principle that brain activity is localized into a series of zones with specific functions made, and makes, a lot of sense.

What did this have to do with his art? I stumbled on the idea that the system of sensory inputs and mental outputs was the driving force behind what was happening in the *Last Supper*. Christ's shocking announcement of the impending betrayal brutally intrudes into each disciple's 'common sense'. It is immediately grasped by the adjacent intellect, which commands the urgent sensory output via the nerves into the organs of expression: the eyes, the mouth, the hands and the whole body. The whole organism cannot but express what Leonardo called '*il concetto dell'anima*'; roughly, the 'intention of the mind' (or 'soul').

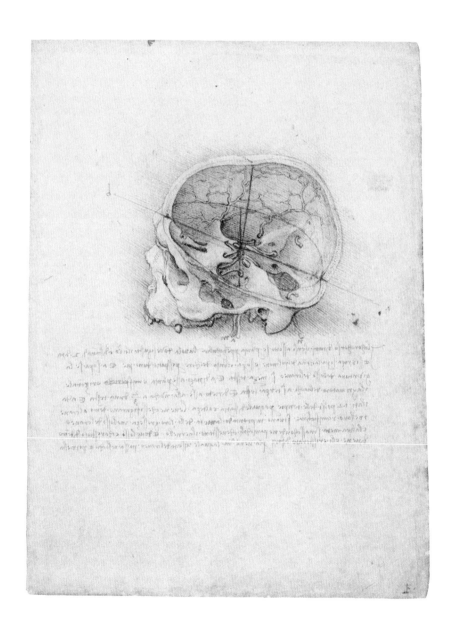

Searching for the centre of the cranium: *A skull sectioned*,
1489. Pen and ink over black chalk on paper, 19 × 13.7 cm (7½ × 5⅜ in.).

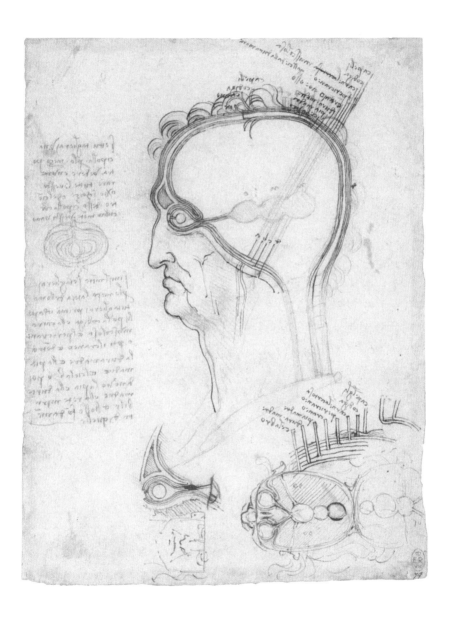

The eye as window of the soul: *Sections of the Human head and an onion*,
c. 1490–93. Pen and ink and chalk on paper, 20.3 × 15.2 cm (8 × 6 in.).

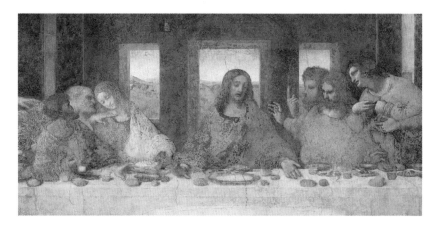

Il concetto dell'anima in the *Last Supper*.

No previous artist was as concerned with such deep causes, but Leonardo was always compelled to ask what lay behind any surface effect with which he was engaged. I was able to argue that he had provided a psychological basis for motion in his science of art and his art of science.

Since each mind and each divinely created soul differs, the concerted action of the disciples must vary individually. The characterizations range from the fierce dismay of St Peter on the left, holding the knife with which he was to cut off the soldier's ear during the arrest of Christ, to the gentle drowsiness of the notably young and beloved St John, who is about to regain his senses after slumbering. Judas lurches backwards, his body clenched with foreboding. To the right of the calm Christ, St Thomas raises the finger with which he will probe Christ's wound after the Resurrection, while St Philip thrusts his hands into his own breast and asks, 'Lord, is it I?' St James the Greater throws his arms wide in alarm, staring at the prophetic bread and wine.

Heeding the example of John Shearman, who had always insisted that we should look at the original whenever possible and repeatedly, I arranged to visit the Royal Library at Windsor to see the anatomical drawings. I have learned over the years that only looking at the real thing reveals the archaeology of a drawing – the sequence of marks made by the artist, including, in Leonardo's case, guidelines incised into the surface with a blank stylus.

To be judged as a fit and proper person to enter what was then a very reserved inner sanctum, I was examined for twenty austere minutes by the then Librarian, Sir Robin Mackworth-Young. It was said locally that his main mission in life was to invent improved systems for the tuning of keyboard instruments. I had been brought up in Windsor and had a few mutual contacts with impeccable credentials, which seems to have helped. Over the next few days, seeing at first hand the extraordinary intensity and minute subtleties of Leonardo's actual drawings was an intensely vivid experience. This feeling of intensity has never faded. It was entering the presence of the real things that decisively moved my relationship with Leonardo onto another plane.

The immediate result was an article called '"*Il concetto dell'anima*" in Leonardo's Early Skull Studies', submitted to the *Journal of the Warburg and Courtauld Institutes*. The acceptance letter came from Gombrich himself, who expressed pleasure that its arguments were in keeping with 'his book'. If that meant that he was himself finishing a book on Leonardo, it would have acted as something of a deterrent for a young scholar embarking on Leonardo studies. But it seemed that he was referring to his magnificent *Art and Illusion*. The article was published in 1971. It seemed to have taken a long time to emerge in print.

Leonardo's skull and brain studies were at the start of his sustained work as an anatomist. As I studied his drawings, I also became aware of the rather different nature of the investigations he undertook some twenty years later. Around 1510, he embarked on an intense examination of the bones and muscles that operated the motion of the body. He remorselessly scrutinized the full organic complexity of the bones, muscles and other components of the wondrous bodily machine. This was closer in spirit to the biology that I had studied. His new researches were driven by his conviction that nature (or God) does nothing in vain, which meant that even the smallest features of created structures should be capable of precise functional explanation. Ideally, the physical action of the parts should be explicable through mathematical analyses of their statics and dynamics. 'Let no-one who is not a mathematician read my principles,' as Leonardo insisted on a page of anatomical studies. The result was a second article in the *Journal of the Warburg and Courtauld*

Institutes, 'Dissection and Divinity in Leonardo's Late Anatomies', published two years after the first.

I next turned to the eye, 'the window of the soul', which provided the chief sensory input into the system of ventricles. At the time of the skull studies Leonardo believed that the eye operated in a straightforward way, receiving within itself a cone or pyramid of rays from an object seen in the outside world. The angled rays acted like geometrical dividers, measuring the width of things at diverse distances, so that an object would look smaller when viewed from further away. The coffers in the ceiling of the *Last Supper*, for instance, diminish as they move further from the observer, and the width of the front of each square unit is larger than its rear width. Ultimately the widths will become so narrow that they effectively disappear at the central 'vanishing point'.

The neatness of this theory was not to endure. He came to view the optics of seeing as far more complex than the action of a visual pyramid. Around 1507, he even wrote that the 'eye does not know the edge of any body'. He became increasingly alert to the slippery deceptions of vision that find expression in the *Mona Lisa* and other later paintings. But at the time of the *Last Supper*, geometry directed seeing in a relatively straight-forward manner. I looked at this changing perspective in the third of my articles, 'Leonardo and the Visual Pyramid', in 1977.

It was on the strength of this inadvertent trilogy of essays that I was approached by Malcolm Gerratt of J.M. Dent about the possibility of writing a rounded monograph on Leonardo. He had heard Gombrich speak on Leonardo at Cambridge, and I imagine that he harboured ambitions to have Sir Ernst write the book. In any event, he ended up with me. Knowing nothing about publishing books, I sought the advice of Charles Avery, who had already authored a book on Italian Renaissance sculpture and had acquired an agent. Charles had a job at the Victoria and Albert Museum. He recommended me to Michael Sissons at A.D. Peters, who diplomatically informed me that he was not taking on any new authors, but suggested that I might in due course send the typescript – just in case. I was passed on to the excellent Caroline Dawnay, who had just joined the firm. From the first she responded positively and, as I now know, with characteristic buoyancy.

Writing specialized studies on Leonardo's art-science was one thing. Tackling everything he did was very much another. But that is what I decided to do, relying upon Gombrich's principle that there was unity at the heart of Leonardo's diversity. A major campaign was needed. This became possible courtesy of a sabbatical year from Glasgow and finance from the Carnegie Trust for the Scottish Universities and the British Academy. I worked through as many of the published drawings and manuscripts as I could.

Milan seemed to offer the key. My aim was to naturalize myself as far as possible in Leonardo's Lombard environment. The present and past irresistibly merged: my earlier impressions of the city did not fade, but I grew to like Milan greatly. It has history, but is not parasitic on its past. It gets on with its business, and individual foreigners with briefcases are likely to be seen as purposeful visitors rather than tourist invaders. It also boasts the best-dressed women in the world. To eke out my grant funding I stayed in a cheap and centrally located hotel on the Piazza Mentana (not to be confused with the present designerized Hotel Mentana, which could be anywhere). It was what the Italians might euphemistically term *suggestivo* (evocative) rather than *internazionale*.

Although I had worked hard to teach myself the early Italian of Dante and the Renaissance, my everyday Italian was (and still is) shameful. This has stimulated rather than deterred my interest in translation. Walking across the dimly lit piazza on my first night, I was surprised to be addressed by a matronly woman. The only word I caught was *regola*, which I knew from Leonardo meant 'rule'. Was I breaking a rule? I said I did not understand, and dived into the hotel. The next evening she was still there, but must have recognized me as a lost cause. What was she doing? The penny dropped. *Regola* was actually *regalo* ('gift'). Why did she expect a gift from me? Could she possibly be a prostitute? She was the same age and build as my mother. Was this what Italian men liked – having sex with someone who could be their mother? I preferred not to think about it; but it did drive home the fact that there were substantial cultural differences between England and modern Italy, to say nothing of the Milan of half a millennium earlier.

I carried my fumbling Italian into the Biblioteca Ambrosiana, home of the huge compilation of Leonardo sheets and dismembered

manuscripts called the *Codex Atlanticus* (on account of its 'Atlantic' dimensions, i.e. those commonly used for atlases of the period). The library also holds the prime manuscript of Luca Pacioli's treatise *De divina proportione* (On Divine Proportion), in which I was much interested. This is a book on the five regular (or 'Platonic') solids and their variants, which Leonardo had brilliantly illustrated on vellum for his mathematician friend in 1498. The black crows who acted as custodians of the antiquated reading room insisted that I look at the facsimile of Luca's treatise. I already knew it from the Warburg Library. Either my Italian protestations were incomprehensible, or the crows did not wish to hear. I spent two days faithfully studying the facsimile before they relented, and I was able to inspect the parchment pages of the original for signs of how the geometry had been mapped out using rulers and compasses. A separate publication eventually resulted.

The Archivio di Stato in Milan was very different from that in Florence. My first experience of an archive had been in the halls above the Uffizi, where the Florentine state archives were then housed. After three days of waiting to see documents related to Botticelli, I had received a bundle of papers written in various lawyers' crabby hands. I could read almost nothing, and had decided that I was not cut out for archival research. Part of the Milanese archive was the Biblioteca Trivulziana, a great collection of codices left to the city by the ancestors of one of Leonardo's patrons, Gian Giacomo Trivulzio. My immediate focus was the Leonardo manuscript they held, in which he was, among others things, tabulating Latin words and a range of technical terms. In spite of his efforts, here and elsewhere, Leonardo seems never to have become fluent in Latin, and only read it when he had to – a limitation with which I sympathize.

The book that emerged from this research in 1981, drafted by hand in semi-legible micro-writing and then typed on a portable typewriter, was *Leonardo da Vinci: The Marvellous Works of Nature and Man*. The subtitle comes from Leonardo's ambitious statement that 'the human race in its marvellous and varied works seems to reveal itself as a second nature in this world'. This was also the year in which I was appointed Professor of Fine Art at the University of St Andrews. I had set myself

the goal of becoming a professor before I was forty, and just made it. Published after the appointment, *Marvellous Works* won the annual Mitchell Prize for the best first book in art history. There may not have been much competition that year. More importantly, at least to me, it received a warm review from Gombrich in the *Times Literary Supplement*.

In addition to an expanded discussion of the implications of the *concetto dell'anima* for our reading of character and narrative in the *Last Supper*, my account of the painting in *Marvellous Works* includes an analysis of perspectival space and other potential geometries in its composition. The basis of what Leonardo has done is clear enough: he has used the assertive perspective of the coffered ceiling to convey a strong sense of the depth of the 'upper room'. But he has isolated the ceiling – a kind of island of space – in order that its relationships with the mural as a whole and the space of the refectory are not tied

in too rigidly. This is why the illusion remains quite robust as we move in the refectory. Although its nominal viewpoint (at the level of the vanishing point of the perspective) is high above our head, we readily accommodate the discrepancy. The more definitely a perspectival illusion is optically locked into the boundaries of our actual space, the more vulnerable it becomes to less-than-perfect viewing positions.

There also appears to be some proportional geometry involved in the overall dimensions of the painted surface and in some of the component parts, as I described in a rather technical passage liable to cause those without a taste for such things to glaze over:

An island of painted space in the refectory.

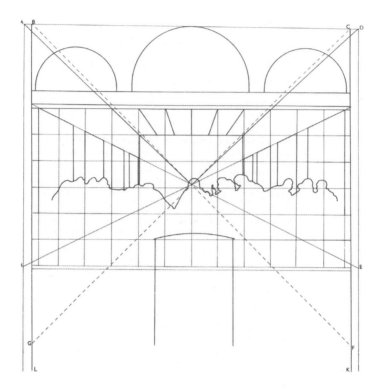

Musical geometries: my analysis of the *Last Supper* in 1981.

The basic interval is the width of one of the ceiling coffers at the optical intersection of the cornice. This interval or 'module' is expressed twelve times in the width and six times in the height of the painting....The resulting grid of longitude and latitude provides the location for many of the straight edges of prominent objects, including the junction of ceiling and rear wall, the top and bottom of the table, and the forward edges of two tapestries. The tapestries also appear to diminish in size according to the ratios 1:½, 1:⅓, 1:¼; or to express it in whole numbers, 12:6:4:3. In musical terms 3:4 is the tonal interval of a fourth, 4:6 is a fifth and 6:12 is an octave.

In fact, if the 'actual' widths of each tapestry were to be reconstructed, each would become progressively wider into the depth of the room.

I still stand by this – I think. Generally, I am not disposed to the detection of surface geometry in Renaissance paintings, which involves external imposition by the drawers of lines rather than empirical extraction of what an artist actually put into a design. Nevertheless I am bombarded with correspondence from strangers containing elaborate diagrams of supposedly 'secret' geometry in Leonardo's works – and those of other artists. The *Mona Lisa* in particular provides a field day for aficionados of golden sections, pentagrams and so on. Fat lines are drawn on small reproductions. Draw enough lines, and it is impossible *not* to hit some 'significant' point such as an eye, ear or elbow. The internet now regales us with many such 'revelations', based on the manipulation of digital images.

We now have a huge body of evidence of preparatory stages in Renaissance paintings – not only drawings, but also the underdrawings and underpaintings revealed by X-rays and infrared – and there are no signs of elaborate surface geometry being used. Nor is there any discussion of it in writings from the period. So where is the evidence? 'Ah,' I am told, 'the whole thing is secret' – involving some kind of mysterious communication, to be decoded by a smart-arse some 500 years later. On that basis, I could argue that Leonardo was a woman.

I thought that the monograph, close to 500 pages in length and the culmination of fifteen years of concentrated effort, represented a natural conclusion. I had other things to do. I was already keenly involved with studies of the artists' sciences of perspective and colour, and I was thinking about a possible book on art in Urbino and its surrounding territory during the 15th and 16th centuries. I had not yet realized that the *Marvellous Works* book was providing the framework for a lifetime's dialogue with Leonardo, and with the Leonardo industry – including the *Last Supper* and its conservation.

CHAPTER 2

THE 'ORIGINAL' *LAST SUPPER*

The most controversial and enduring issue with the *Last Supper* concerns what we are actually looking at. Can we see the 'original' at all? This question disturbed me from my very first encounter with the mural in the refectory.

The *Last Supper* is a wreck, and deteriorated early in its life. The prime reason is Leonardo's experimental technique. His approach to the job of painting was ill-suited to the normal technique of fresco, in which a pre-planned composition is painted at some speed onto patches of wet plaster before they dry. His answer was to treat the wall more or less as if it were a wooden panel, sealing the surface with a layer of white lead paint and using egg as a binder to secure his pigments. This allowed a wider range of colouristic effects and a slower, more contemplative pace of execution. Leonardo's pace, or rather the lack of it in the years around 1497, tested the patience of the Duke, who was simultaneously paying for an extensive series of architectural and sculptural works at Santa Maria delle Grazie, including Bramante's dome and crossing. Leonardo was unlucky. The high water table in that part of Milan and a sealed space behind the wall encouraged dampness to rise behind his primed surface. Adhesion was severely compromised from an early date. We can imagine what would happen if we were to paint gloss paint onto the plaster of wall with no damp-proof course. I have enough trouble with my old house, using paints that let the wall 'breathe'.

A long series of interventions has occurred over the centuries, pious attempts to resurrect Leonardo's crumbling masterpiece. The early restorations relied on filling in lost areas and substantial repainting to enhance what remained. I was introduced to the image of what remained

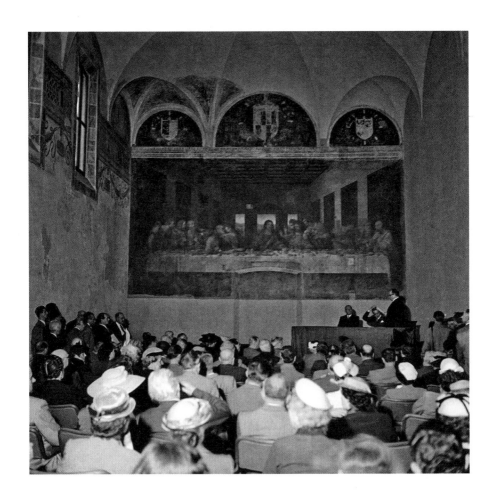

Reopening of Leonardo's *Last Supper* in Santa Maria delle Grazie
after the 1951–4 restoration.

on the wall via black-and-white reproductions in books, and a few low-quality colour images. These showed the mural as it looked after Mauro Pellicioli's restorations, conducted before and after the Second World War. The prevailing impression of blotchy ghosts was not encouraging.

By the time he worked on the *Last Supper* Pellicioli was vastly experienced, having worked on murals by Giotto, Mantegna and Perugino. He had been trained as a painter, like most restorers of his and earlier times – which naturally led them to see themselves as collaborators in re-establishing the painter's original artistry. How they were to realize this varied hugely over the ages. When Pellicioli came to work on the wall, priorities had changed. Restorers then aspired (in theory at least) to strip off the extensive repaintings that had previously been the norm. The idea now was to allow the 'original' to shine through, however battered.

Between Pellicioli's two campaigns, the refectory was almost demolished as the result of a massive campaign of incendiary and explosive bombing in mid-August 1943 by Anglo-American air forces. When one of the bombs exploded on 15 August less than thirty yards away, the roof and one lateral wall were reduced to jagged piles of rubble and fractured beams. The wall adorned with what remained of Leonardo's fragile painting had been protected by sandbags and braced scaffolding. Somehow this wall and the opposite end wall carrying the large fresco of the *Crucifixion* by Montorfano stood firm. Profile portraits of Duke Ludovico and his family added to Montorfano's finished painting before 1500, probably by an artist other than Leonardo, had long since flaked away. The shock-waves of the bomb dislodged further fragments of paint and priming from the *Last Supper*, but the losses were less fatal than was at first feared.

What I saw on my first visit was the pellicle of Pellicioli, with islands of pigment secured in a sea of shellac, some of the old overpaints picked away and a good deal of his filling in the gaps. Little more than ten years after Pellicioli had completed his patient task, the effect was patchy in the metaphorical and literal senses. The colours seemed heavy and lifeless. To sense its residual wonder required Clark's perception.

The next and even more radical intervention occurred less than twenty-five years after Pellicioli's. Further paint losses were occurring, apparently because of tension within the layers that remained – the

final layer of fine plaster, the white lead priming, the layers of pigment added by Leonardo, the glues, waxes and repaints of earlier restorations. The tension was causing the remaining flakes to 'cup'; that is, to turn up at the edges to form concave scales. I personally have no first-hand evidence to confirm this diagnosis, but I am inclined to trust what was being said. It was decided that another complete campaign should be undertaken, backed up by optical, physical and chemical technologies that had not been available to Pellicioli.

There were two main declared aims: to secure Leonardo's paint for future generations, and to strip off every last trace of earlier repainting. The restorer in charge was Dr Pinin Brambilla Barcilon, a woman of poised refinement, studious skill and enduring patience. Her labours, and those of her young team, were to occupy long years from 1977 to 1999.

My first time on the scaffolding – echoes of historic executions are poignant – was on the occasion of a conference in Milan, *Leonardo e l'età della ragione* (Leonardo and the Age of Reason). The resulting collection of papers was published in 1982. My talk, delivered in English, looked at the erosion of old certainties in Leonardo's thought from about 1507 onwards. When I realized that the talk was to be simultaneously translated, a new experience for me, I worked late into the night to replace the trans-lations of Leonardo's writings with the original Italian. The prospect of modern translations being rendered back into Italian was ludicrous.

Speakers at the conference were invited to visit the restoration. Exempt from the notice '*Vietato Salire*' (it is forbidden to climb up), we ascended the rough-and-ready steps through a rickety construction of bolted metal poles to stand on the creaking boards that formed the plat-form for the restorers. I recalled that Leonardo had invented a scaffold-ing more technologically advanced

The refectory bombed.

than this when painting his *Battle* in the Florentine Council Hall. Pinin Brambilla greeted us and said a few polished if world-weary words. I sensed that she had experienced more than enough unwanted visits. Her young women assistants, wearing the white coats of medical technicians, strove not to notice us as they bent over their assigned sections, picking at the scabs of pigment with surgical scalpels of the kind I had once used to dissect animals. Seeing the surface close up was even more distressing than viewing at a distance.

The restoration had begun on the right, with a section that was in the least bad condition. Each shard of paint was visibly separate in a scattered mosaic, often fringed by a white edge from the priming layer. There were more areas of exposed plaster than I had guessed from reproductions. I stared with increasing dismay as I wandered across the uneven platform, surveying the relatively small portions that had been cleaned and the as yet untouched surfaces in the middle and at the left. Close to the mural, only the ravages of decay were readily apparent. It was impossible to tell whether the whole would retain any sense of coherence. All I could do on that first close-up inspection was to gain a better understanding of the archaeology of the ravaged strata of pigments and priming. I left as soon as I felt I could learn no more. I could not speak to anyone. It was a low moment.

Picking at the scabs.

My second visit to the scaffolding, almost ten years later, felt less like witnessing an execution. It was again occasioned by a conference in Milan, this time devoted to Leonardo's Milanese studio and followers, where I spoke on what was emerging from my research into the two versions of the *Madonna of the Yarnwinder* (see Chapter 4). This

time I was able to engage more productively with what I saw – and to admire a new hydraulic platform of a kind Leonardo would have appreciated. The shock of paint loss had dimmed. It was now easier to appreciate how complex were the layers of Leonardo's original paint surface. There were large areas more or less devoid of modelling, but in which at least one layer of original pigment remained. This was particularly true of the heads of the disciples. The general laying-in of the flesh tones over the priming had survived across quite wide areas, albeit in a very cracked state; but much of the darker modelling of such features as eyes and mouth had been lost. The highlighting of features such as foreheads and noses had survived somewhat better. Some of what we were seeing was from lower layers and some from higher. This issue presents a real dilemma. We are not able to gain any consistent impression of what remains of the 'original' Leonardo.

By the time of this second visit, the coloured flakes of restored pigment were beginning to be pulled together into a narrative whole by procedures designed to reduce the effects of the many exposed sections of plaster. The initial intention was to undertake as little neutral infilling as possible, but it became apparent as the restoration progressed that nothing coherent would remain in the worst damaged sections. It was decided that fields of unassertive colour should be added to areas of pigment loss, to give some overall form to areas such as the draperies. The colours were not to be as intense as the remaining shards of Leonardo's paint, and they were applied with a technique of hatching rather than in solid patches. No sustained attempt was made to reconstruct the internal modelling of such features as folds. I could not at this stage tell how far this infilling would actually work when the platform came down and the finished restoration was unveiled.

During the course of the protracted restoration, massive publicity ensued; some wanted, some unwanted, some self-generated, some imposed, some laudatory and some vitriolic, and always arousing intense debate. Only the cleaning of Michelangelo's Sistine Ceiling generated as much coverage and occasioned as much aggravation. In the Milanese firing line was the regional 'Superintendent of Cultural Assets', responsible to the national minister for culture in Rome, and, of course, Pinin

Brambilla. Since there were no fewer than eleven government ministers during the years of the restoration and five Superintendents, Brambilla held the continuity in her hands. It was she who ultimately had to account for the conduct of her radical intervention.

The Milanese authorities promoted their own news stories, features and technical publications, not least to fortify themselves against constant sniping from various factions in the art world, and to encourage the sponsors. Prominent in the international promotion of the project was Carlo Bertelli, Soprintendente per i Beni Culturali from 1978 to 1984, who played a crucial role in the decision to push the radical restoration as far as possible. He provided an extended account of what was being done in *National Geographic* magazine in November 1983. The cover story promises us that 'restoration reveals Leonardo's masterpiece'. The picture is said to be 'reborn'. Bertelli's lively and picturesque essay, extending over twenty-one pages, highlights the art and science of the enterprise. 'You have to think like an artist,' Brambilla is quoted as saying. The text speaks of the 'artistic surgery' she conducts under the eye of her microscope. The tone of the pronouncements, like those made by the officials responsible for every prominent public restoration, is definitive and not subject to qualification or doubt. Finally, we are to be presented with the true Leonardo.

The article is illustrated with striking photographs, including a fold-out plate of the whole mural and some vivid details of cleaned sections together with discouraging close-ups of uncleaned portions. As is normal with the printing of such photographs, the contrast between abutting cleaned and uncleaned surfaces is exaggerated to make the dirty look very dirty, and the clean very clean. We saw the same with the hugely controversial cleaning of the Sistine Ceiling; similarly contrived photographs were used by those promoting the restoration, and those who claimed that Michelangelo's frescoes were being disastrously scrubbed of their surface modelling.

In the magazine, we see Brambilla in action in her artistic and surgical guises. One photograph shows perpetually frustrated crowds milling around in the refectory and trying to catch some glimpse of the painting above the scaffolding and restorers' platform. Given the character of *National Geographic*, the magazine's tone is highly sympathetic to the

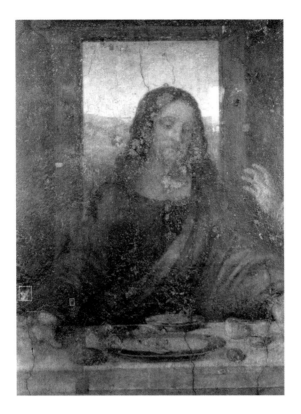

The *Last Supper*, early in the course of restoration.

role of scientific technologies in the process. The whole piece expresses what was then the official view.

There was no attempt to conceal the difficulties of the job – rather the reverse. In 1995 Brambilla provided a vivid account to *ARTnews*.

> Here we have a surface that is completely ruined, disintegrated into tiny scales of colour that are falling off the wall. We have to clean each one of these scales six or seven times with a scalpel, working under a microscope....Here I can clean an area one day and still not be finished, because when the solvent dries it brings out more grime from beneath the surface. I often have to clean the same place a second time, or even a third or a fourth. The top section of the painting is impregnated with glue.

The middle is filled with wax. There are six different kinds of plaster and several varnishes, lacquers and gums. What worked on the top section doesn't work in the middle. And what worked in the middle won't work on the bottom. It's enough to make a person want to shoot herself.

Brambilla was not shy about revealing the personal toll that the restoration and remorseless public attention was taking. In *National Geographic* she had confessed,

It's difficult....The work is hard and tiring. It creates much physical tension bending over the microscope. After a few hours my eyes grow blurry. I may come every day for months. Then I must take an extended break. There is also the psychological tension. All the eyes of the world that know Leonardo are watching what I do. Some nights I do not sleep.

The mixed reception when the restoration was completed is likely to have resulted in more disturbed nights.

Leading the public criticism was ArtWatch International, renowned for its vocal campaigning against almost every prominent campaign of restoration. It was born from rancour. James Beck, late professor of art history at Columbia University in New York, had been unsuccessfully sued in 1991 for his strong criticism of conservation work on a marble tomb sculpture by Jacopo della Quercia in Siena. This experience motivated him to set up ArtWatch in 1992. He was joined by Michael Daley, artist and writer, who is now director of ArtWatch UK. Theirs has been the most sustained and fully researched of the hostile polemics. Having noted that the $8-million restoration was a commercial enterprise sponsored by Olivetti, the ArtWatch website railed against the 'traumatic production' of a 'mongrel work', with little original paint and a great deal of 'alien' additions.

ArtWatch has repeatedly questioned the underlying premise of those modern restorations that aspire to reveal the true 'original'. The question, in the case of the *Last Supper*, is less whether the 'original' has survived in anything like its original form, taking into account considerable changes

over time, than what the total removal of earlier infillings and retouchings means for the coherence of the image. ArtWatch has asserted that the archaeological shards of the mural have been 'remorselessly stripped down to the sum total of all previously accumulated injuries in order that the resulting wreck might then be put back into some presentable aesthetic form more suited to today's tastes'. Despite its polemic expression I have some sympathy for this view, on two counts.

The first is that conservators in each age inevitably achieve ends that fit with the then-current assumptions of what is valuable in a work of art. We tend now to be big on authentic detail, photographed and reproduced in spectacular colour. We feel close to an artist when we see the brushstrokes. Museum websites now offer high-resolution images into which we can zoom in incredible detail. All this corresponds very much to the conservator's close-up viewpoint, whether on scaffolding or in a conservation studio. Current tastes and procedures in restoration play towards surgical viewing and technical publications.

The whole process is imbued with science, both in the examination of paintings using a battery of optical and physical techniques, and in the actual interventions in the layers of the painting. With the technologies comes an air of scientific certainty and modern superiority. We can readily point out how the past has been wrong. The new information we gain can be thrilling. I have been drawing upon scientific examination throughout my career to further our understanding of how particular works have been made, and how we can better understand why they now look like they do. However, no amount of scientific data can definitively answer the difficult question of how we should intervene in a specific work of art – or if we should intervene at all. Our current answers inevitably correspond with specific modes of modern looking.

When we visit exhibitions we expect artworks to be clearly spotlighted, with even and unvarying light. Paintings can be scrutinized like patients in an operating theatre. We can dissect the artists' acts of making, and it is thrilling to see the handiwork of the painter in close-up. But we lose the magic of variable lighting in which hot and cold colours, glazes and scumbles (broken layers of pigment) all respond in a living way to changes in the intensity and hue of the impinging light.

I recall two Rembrandt exhibitions at the National Gallery in London. The portraits were gloriously visible, but only in the 'intense scrutiny' mode. The great self-portrait from Kenwood House was fully visible, but somehow flattened. In its long-term home in Hampstead, Rembrandt's masterpiece used to be seen to extraordinary effect as the natural light streaming through an adjacent window varied in intensity and hue. As the sun slipped behind clouds, the responsiveness of his varied kinds of paint came into magical play. The world-weary old master seemed to breathe again in the same air as us.

The second issue raised by ArtWatch concerns the removal of all retouchings. I wrote an open letter to Pietro Marani, the greatest of his generation of Italian Leonardisti, who had shared responsibility for the historical direction of the restoration since 1993. He was gracious enough to publish it in the 1995 edition of *Raccolta Vinciana*, the Milanese journal he edits. I argued that the removal of all later additions appealed to our modern ideas about authenticity, but that the authenticity of the wall painting as a functioning religious image of men sitting behind a table set up different criteria. In my face-to-face discussions with Pietro, I set up a fictional scenario. At some point, one third of a painting is lost. The losses are filled in on the basis of what remains. Next, the second third is lost and reconstituted. Finally, the remaining third of the original is lost and touched in. If we decide to remove all repaints, nothing is left. This scenario is of course exaggerated, but it does highlight the question of how far we have removed later additions that had some authority and served to assist the overall legibility of the composition. Leonardo was, after all, painting a narrative, not providing us with a collection of details.

Bringing these considerations to bear on the actual restoration of an object as severely damaged as the *Last Supper* is by no means easy. We were told that the repaints were further threatening the adhesion of Leonardo's shards. Even if this were not a consideration, the painting as I saw it in the mid-1960s was not in a pretty state. There was some overall pictorial coherence, but it was disfigured by dull blotches and discordant colours. My criteria for embarking on any restoration are twofold: the first is when the structural integrity of the work is threatened; the

second is when its appearance is grossly disfigured. The degree at which disfigurement becomes gross is obviously subjective, but it sets the bar quite high. There is a strong case to be made that the *Last Supper* qualified on both counts. But even if this is allowed, the decision of what to do remains fraught. Each age claims that it has reached the right solution, and present assumptions are likely to be superseded. Over the years I have not been convinced that what we are doing is definitively wrong, but I have become less confident that it is right.

Brambilla's restoration has offered spectacular detailed gains in keeping with our quest for minute scrutiny: colourful blossoms in the *mille fleurs* tapestries on the side walls; small hooks and rings that suspend the tapestries; the reflective sheen of pewter tableware portrayed with the suggestive magic of Chardin; a slice of lemon worthy of a Zurbarán still life; the lovely blue embroidery of the linen tablecloth, which still bears the rectangular creases of the laundress's crisp ironing; scattered patches of blue and red draperies finely tuned with interactive precision; glimpses of the disciples' urgently communicative expressions; and one of those elusive Leonardo landscapes that succeed in being both particular and general. There is a vivid parade of these and other delights in the large boxed volume that Marani and Brambilla published in 1999.

But what of overall unity? On first viewing, the hatched and low-key infilling gave the whole mural a sense of having been executed in pastels, certainly when set against the memory of how it was. In many areas, such as Christ's draperies, islands of Leonardo's pigments seemed to float in a misty sea that lacked formal definition. The pale coherence that had been achieved was disconcerting, even to someone who had seen the infilling close up. Published photographs, typically taken under strong spotlights like those in the books of the

Low-key infilling: Christ in the restored *Last Supper*.

65

Sistine Ceiling after cleaning, did not help the image to settle in. However, over the years, as the older recollections and expectations have been superseded, I and many spectators have become used to the *Last Supper* looking like this. We have become reconciled to it. I take qualified pleasure in seeing it. Seeing is a malleable business.

In the final analysis, I feel inclined to retell an old joke. A lost traveller in the Irish Republic stops her car, lowers the window and hails a pedestrian who looks local. 'Can you tell me how to get to Dublin?' 'Ah, well,' comes the thoughtful reply, 'I would not start from here.' No one would choose to start with what now survives of the 500 years of wreckage of Leonardo's majestic composition. On balance, I think that the direction pursued by Brambilla is the least bad of the unfortunate solutions open to us. I hope it is. With the exception of the infilling, it cannot be reversed.

A major problem with the harsh debates about cleaning is that they tend to be a dialogue of the deaf. Professional conservators maintain their line steadfastly, reinforced by criteria that are, to a large extent, shared internationally. They tend (especially in Britain and the USA) to avoid directly taking on the opposition in the public media. The critics, for their part, are prone to produce their 'shocking revelations' in the press and on the internet with an assertive brevity that does not allow recourse to actual evidence. The more polemical of the critics who do argue at greater length cite 'evidence' with highly selective zeal. When detailed evidence is supplied, it often consists of 'before and after' photographs. These, as I have suggested, are very unreliable. Unless the photographs are taken with the same lighting and camera set-up, they cannot be reliably compared. With digital manipulation, it is not hard to persuade the photographs to support whichever argument we favour. As a specialist who has worked with scientific conservators, I think that most of their work stands up to technical scrutiny – given the present state of the technologies – but I remain anxious about how our criteria are very much of the here and now. My preferences are to emphasize remedial conservation, and to do less in a cosmetic sense.

Ernst Gombrich voiced his own anxieties about technologically based cleaning, first in 1950 and subsequently in *Art and Illusion* (1960) and a number of later essays and letters. He warned that:

Even the picture restorer must and will be influenced in
his difficult task by the image he has formed of the original
appearance of the work he hopes to restore. He will be
influenced by his scale of values, his unconscious bias and his
conscious convictions. It is this image which the art historian
has the right to question, and to which, perhaps, he can
make a contribution.

Gombrich presents us with his own image of the artist launching
his or her works into the unknown seas of the future, in full awareness
that their creations will acquire the patina of age and even become
damaged. The artists, like ourselves, are best advised to accept that
there is and always will be a dialogue between physical condition and
modes of seeing. We are perceptually adept at coping with surface
dirt, just as we can filter out the noise in an early recording of a famed
instrumentalist – although digital remastering of early recordings
now seems to be the norm. Remastered performances tend to exhibit
a clinical sheen, but something often seems to have been lost. Or is
this just false romanticism, delighting in a scratchy voice from the
past? At a certain level, dirt and noise become intolerable and prevent
the artist from being adequately seen and heard. I set that level higher
than is now customary.

Underlying the controversies about cleaning is the concept of
the 'original'. Defining what we mean might seem straightforward: the
'original' corresponds to the appearance of the work when the artist last
lifted his or her hand from it. But even this idea has its complications.
Often a Renaissance painting, such as an altarpiece, was created in the
artist's workshop and transported to its intended location. Many an
artist must have groaned as his or her masterpiece disappeared into
a dim chapel. If the work was painted *in situ*, as obviously happened
with the *Last Supper*, the setting would still be subject to variations.
The image of Christ's last meal would look different when the refectory
was peopled with munching monks than when a visiting artist stole
in for a look. A marginally literate monk would be seeing something
different from a theologically sophisticated prior. Everyone sees their

own *Last Supper*, as evidenced by Rubens and Rembrandt over a century later when they worked their variations on Leonardo's composition.

The cutting of a central door at the level of bottom of the tablecloth not only obliterated a section of Leonardo's painting, but also radically affected the experience of anyone entering the refectory through the new door. As the centuries progressed and the function of the refectory changed from a dining hall, so did the look of the mural. As the refectory became 'museumized', so the work of art increasingly became a *Work of Art* and not a functioning narrative of deep relevance in its setting. The copies that for some years stood on easels in the refectory set up the mural as a work for the art academy, to be studied by those who aspired to practise and appreciate 'history painting' at the highest level. Not least, it became 'a Leonardo', with all the baggage that accompanies that appellation.

Even had the *Last Supper* survived with little paint loss, its appearance would have changed radically. Some pigments are stable, others not. Over time, pigments deteriorate in very different ways. White lead is reasonably stable. Mineral or 'earth' pigments, like ochre, are generally durable, though the brilliant and expensive lapis lazuli (or ultramarine), made from a semi-precious blue stone, can be subject to dramatic deterioration. Browns tend to become more transparent and red lake fades, like many other animal and vegetable dyes, while copper greens tend towards brown (a familiar feature in early landscape paintings). The binders – egg or various oils – change over time, both in themselves and in their effect on the pigments they carry. The colour of the underpainting can exercise a radical effect as the overlying pigments become more translucent. The result is that the 'original' will be selectively and irreversibly transformed, with the hues and tones thrown out of kilter. This would have happened to the *Last Supper* even if other deteriorations had not occurred. During a restoration it has become increasingly common for a thin layer of old varnish to be left on, to help harmonize the discords produced by selective changes to the pigments. What we do to ameliorate the changes depends on what we want our 'original' to look like. It is certain that we are not seeing the *original* 'original'.

Even if we indulge in a rather extreme thought experiment (or envisage a brilliant digital reconstruction) that would somehow restore

the *Last Supper* to its actual appearance in 1500, we would be seeing the 'original', but not in the original way. We are spectators from the second millennium. We know to varying degrees about the history of 'Art'. We are likely to have acquired some knowledge of Leonardo – most probably knowing that he was a universal genius. Inevitably we know something, right or wrong, about the *Mona Lisa*. This, and much other baggage, we inevitably bring to our looking.

There is a parallel with listening to music from Leonardo's time. An aficionado of Renaissance music listening to a scrupulously authentic performance of work by Josquin des Prez (whom Leonardo would have known in Milan) cannot wash away more than 500 years of later music-making. We hear the authentic performance as just that – as authentic in relation to something else, say, a less authentic performance from a few decades previously. We are not hearing it as we would have done in 1500. We have different ears. The modern viewer of the *Last Supper* has different eyes from anyone in Leonardo's period. One of the jobs of the art historian – perhaps the key job – is to set up criteria that enrich our modes of looking in terms that are analogous to those of the period itself. Ultimately, to look with a period eye is an impossible quest, but much profit and delight is to be gained from trying.

What of the *Last Supper* in the early 21st century? Having subjected ourselves to the international cultural process of online ticket acquisition, informatics and merchandise, we witness a painting by Leonardo and Brambilla and by those whose decisions lie behind its present appearance. We are in the presence of one of the colossuses of world culture. I have been interviewed for TV programmes in the refectory and the café opposite; I can generally get in without paying. I am part of the Leonardo industry. The obstinate memories won't go away. It is an odd and contrived experience in the refectory. Am I really here?

Trying to look afresh, we see that Clark's 'ghostly stains' have become brighter and paler. We can delight in the lovely details. We are in the presence of a picture that works in a different kind of way from the heaviness of earlier restorations, but neither way is Leonardo's. We have done it our way, and future generations may curse us for it.

CHAPTER 3

LOOKING AT LISA

Meeting Lisa outside her prison is an incredible privilege. I have been fortunate enough to meet her twice – once privately in 1994, and again in company with an international gathering of Leonardisti in 2010.

The venue for the private viewing in 1994 was the famed Salon Carré in the Musée du Louvre. The painting on its panel was emerging for its annual inspection. In charge of this momentous operation was Pierre Rosenberg, Président-directeur of the museum, Officier de la Légion d'Honneur, Chevalier de l'Ordre National du Mérite, Commandeur des Palmes Académiques, Commandeur des Arts et des Lettres, Grand Officer of the Order of Merit of the Italian Republic and Commander of the Order of Merit of the Federal Republic of Germany. Immaculate, urbane and poised, he wore his signature red scarf draped round his neck, reaching to his thighs. Pietro Marani, the major Leonardo scholar from Milan, was also present, accompanied by a photographer to capture fresh images for a monograph he was writing.

The framed picture first has to emerge from its specially constructed, alarmed and air-conditioned closet, with its viewing window of specially toughened glass. The frame is laid face down on a table. The wooden panel is removed with tender care, and lifted clear of the glass. It is carried gingerly to an easel by the staff charged with handling it, and firmly clamped into place.

To observe this is a strange, unreal, disorientating and worrying experience. Can it really be happening? What should I do – stand back in rapt awe? Dive in to look closely? Take out the magnifying glass I normally carry, talk enthusiastically to my companions, take measures to make sure I will remember as much as possible about this 'memorable' event, try not to make a fool of myself, look cool...? The worry

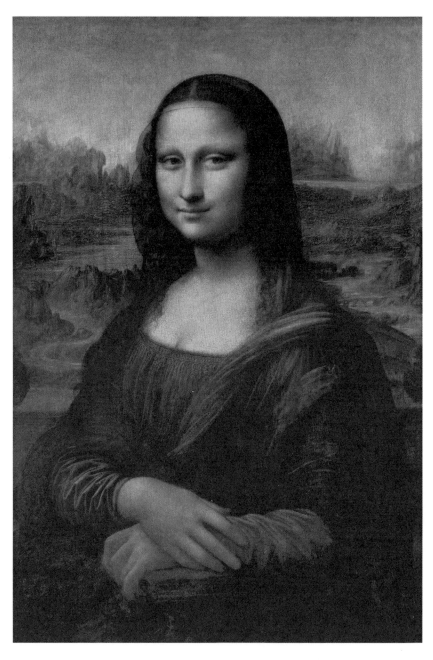

From portrait to 'universal picture':
Mona Lisa, c. 1503–19. Oil on poplar, 77 × 53 cm (30⅜ × 20⅞ in.).

is, of course, that the whole thing might be a let-down in the face of huge expectations.

It could be argued that to see the *Mona Lisa* as she normally appears in the Louvre was, and is, barely to see her at all. Following the sensational 1911 theft of the panel by Italian odd-job man Vincenzo Peruggia, and subsequent physical assaults on this greatest of all pictorial icons, it has been imprisoned within the bulletproof closet that removes it visually from any close encounter. It is impossible for most viewers even to be certain it is not a copy. Having seen the painting come out of the casing, I can testify that it is indeed the real thing; but this hardly makes a difference, other than ethically, for the millions who want to believe they have seen the original.

There is also the problem of the crowds. Such is the customary press of spectators, herded along by a series of signs, that it is an elbowy challenge to manoeuvre into something like a prime position, and it takes strong nerves to remain there for any amount of time while others cluster round. The physical and psychological discomforts of the process invade our act of seeing.

The visual obstacles are only part of the problem. We approach any work of art with some kind of expectation – if we did not, we would not be standing in front of it. With the *Mona Lisa* there are simply too many expectations, some very powerful. The biggest bit of baggage is that it is the world's most famous painting, perhaps even the world's best-known visual image. If we don't get much from it (which is reasonable, given the circumstances of viewing), do we feel guilty? Do we declare that it is overrated – or, as often happens, simply express disappointment that it is much smaller than we expected?* Do we come away disillusioned, believing that the *Mona Lisa* is only famous for being famous? Perhaps we fancy ourselves as iconoclasts, and pronounce that it is definitively not worth a second look.

Whatever our reaction, we come to the picture via a dense haze of popular manifestations: advertisements, parodies, cartoons, souvenir mugs, fridge magnets, T-shirts, bikini bottoms, pornographic

* It measures roughly 31 by 21 inches, which is not small for a Renaissance portrait.

subversions, and millions of reproductions in every kind of printed and electronic medium. I have accumulated, mainly by gift, an unsystematic collection of *Mona Lisa* paraphernalia. My personal assistant, Judd, recently gave me a pair of *Mona Lisa* socks, which seem to go down well at the start of talks.

It is equally difficult to avoid all the stories and myths that surround the picture, even if we take the dafter ones with a pinch of salt. We might well have heard that the sitter was Leonardo in drag, or that his roguish and pretty pupil, Salaì, was playing the transvestite role. We may have heard rumours that she was a high-class 'lady of the night'. There have been many alternative sitters proposed. Even if we believe that we are seeing a portrait of Lisa, the bourgeois wife of Francesco del Giocondo, we can't entirely sweep away the clinging penumbra of the legends. Experiencing the picture, whether in person or second-hand, is a layered cultural experience. It is very difficult to get at the painting in its own right.

For much of my career as a student of Leonardo, my experience of his masterpiece in its setting was the same as everyone else's. My memories of it on my visits to the Louvre are not compelling. I tended to keep clear of it in my writings, daunted by the volume of writing and the arbitrary profusion of contradictory interpretations. I must have spoken of it in lectures, presumably trotting out the standard clichés about its being the first 'psychological' portrait, about Leonardo's famed *sfumato* (the 'smoky' appearance of his veiling shadows) and the innovatory landscape background, inspired by Netherlandish portraits. I certainly could not have done better than Kenneth Clark's beautiful account in his monograph of 1939, founded upon his having seen it out of its frame:

> Anyone who has had the privilege of seeing the Mona Lisa taken down, out of the deep well in which she hangs, and carried to the light will remember the wonderful transformation that takes place. The presence that rises before one, so much larger and more majestical than one had imagined, is no longer the diver in deep seas. In the sunshine something of the warm life that Vasari admired [in his 16th-century *Lives of the artists*] comes back

to her and tinges her cheeks and lips and we can understand
how he saw her as primarily being a masterpiece of naturalism.
He was thinking of that miraculous subtlety of modelling. That
imperceptible melting of tone into tone, plane into plane which
hardly any other painter has achieved without littleness or loss
of texture. The surface has the delicacy of a new-laid egg and yet
it is alive: for this is Pater's 'beauty wrought out from within upon
the flesh little cell by little cell' – a phrase which more than any
other in that famous cadenza expresses Leonardo's real intention.

The phrase 'diver in deep seas' also comes from Walter Pater's
famous, high-flown and intimidating hymn to the *Mona Lisa*, first published in the *Fortnightly Review* in 1869.*

When I had to pay sustained attention to the *Mona Lisa* in my 1981
monograph, I approached the painting via the concept of the microcosm,
through which the geology of the body of the earth and the anatomy of
the human body were brought into conjunction. I began with one of
Leonardo's two key statements of the theme, choosing that in the *Codex
Leicester*, since it dates from the period during which the painting was
in progress. This is what I quoted:

This earth has a spirit of growth, and its flesh is the soil; its
bones are the successive strata of the rocks which form the
mountains; its cartilage is the tufa stone; its blood the springs
of the waters. The lake of the blood that lies within the heart
is its ocean. Its breathing is by the increase of the blood in its
pulses and even so in the earth is the ebb and flow of the sea....
The ramification of the veins of water in the earth are all
joined together as are those of the blood in animals, and they

* I notice that Pater does not feature in the index of my *Marvellous Works...* monograph.
At that time I would have harboured reservations about Pater's extreme belletrism, with its
self-conscious aesthetic flourishes, and been less open to its poetic insights than I am now.
His fantasy that 'she [Lisa] is older than the rocks among which she sits' would then have
seemed clever enough as a poetic paradox, but not as a historical interpretation. Now I regard
Pater's geological allusion as an invaluable personal insight, analogous to those for which
the historian searches.

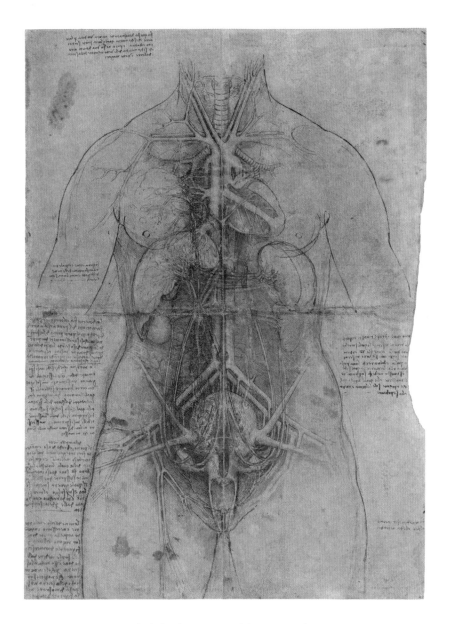

The irrigation systems of the 'Great Lady':
The Vascular, Respiratory, and Urino-Genital Systems of a Woman, c. 1510.
Pen and ink with chalk and wash on paper, 47.6 × 33.2 cm (18¾ × 13⅛ in.).

are all in continual revolution for the vivification of it, always consuming the places in which they move, both within and without the earth.

As we will see, the translation I used at this time, excerpted from a longer passage, proved to not do the job as well as it might have done.

My main anatomical point of reference was Leonardo's 'Great Lady', a demonstration of the irrigation systems of the body, at which I had already looked carefully during my earliest investigations into his anatomical studies. This astonishing drawing, which pushes his innovatory techniques of anatomical draftsmanship to and even beyond their limit, represents a synthesis of what he had discovered in his dissection of the 'centenarian' in 1507–8 – but cast in terms of female anatomy rather than male. The method of demonstration is far removed from a dissection drawing, since Leonardo was synthesizing how ideal systems should look and operate, not least in terms of the geometrical laws of branching and hydrodynamics. It could be described as a demonstration of anatomical functions, deeply informed by dissection and the laws of fluid flow – with a strong dash of traditional ideas. Leonardo himself referred to such drawings as *dimostrazioni*.

I had increasingly come to define the 'Great Lady' as a 'preparatory' drawing for the *Mona Lisa* – not in the literal or normal sense of that term, but as part of the visual and conceptual foundations for the image in a deeper sense:

> There is a profound affinity between the artistic grandeur of her [Lisa's] portrayal and the anatomical magnificence of the 'great lady'. The parallels are both formal and philosophical. In terms of design, they share a similar use of contour, which now consists of sonorous curves rather than the delicate vibrancy of line in his earlier portrayals of women....Underlying these formal affinities is his feeling for microcosmic vitality, for the way in which the two ladies are 'vivified' (to use Leonardo's term) by the ebb and flow of their inner spirits. The background of the portrait insistently underlines this affinity, illustrating the

bodily mechanisms of the earth as clearly as the anatomical drawing demonstrates the passage of fluids in the body.

It was not hard, so attuned, to discern surface manifestations of flow in the person of Lisa – in the cascades of her hair, the twists of her diaphanous shawl and the tiny rivulets of fine silk-muslin that trickle from the gathered neckline of her dress.

Later, I was to draw sustained analogies between the landscape of the *Mona Lisa* and Leonardo's accounts of geological change in the *Codex Leicester*. At this stage, though, I focused more on a passage in the *Treatise on Painting* in which he instructed the artist how to 'show the configuration of the Alpine mountains and hills'. He described how mountains would be eroded at the bases by flowing rivers, eventually causing them to collapse, at least in part. The avalanches shut off the valleys 'as if they wished to be avenged, blocking the course of that river and converting it into a lake, where the water in slow motion seems pacified, until such time as the dam caused by that fallen mountain is newly consumed by the course of the said water'.

I rather lost sight of this handy passage in my later writings on the *Mona Lisa*; but the point is that the landscape behind the sitter speaks of the perpetual dynamism of the body of the earth, the vast changes that it has undergone in ages past and is still undergoing. The two lakes dammed up at different levels, and the more precarious of the mountains, speak of continued flux rather than of the eternal configuration offered by standard interpretations of God's Creation as narrated in Genesis.

Alongside some more conventional art-historical assessments of the position of the *Mona Lisa* in the context of Renaissance portraiture, my other pitch to say something new in 1981 was an alignment of the presentation of the smiling lady with Italian poetry – above all, with that of Dante. Unlike the anatomy, this was not comfortable territory for me. At the time of my move from biology to art history I had been woefully ignorant of literature in other languages, and only patchily aware of it in English. I had always preferred tales of real adventures to fiction; making up a story seemed to me to be 'cheating'.

CHAPTER 3

I also have no gift for languages. At school, I 'did' Latin and French without developing a sense that anything interesting might be written in either of them. In Latin we read Caesar's tedious *De bello gallico* – presumably because it features ancient Gauls and Brits, and boys are meant to be attracted to battles, though all I can recall is that Caesar spent much time exhorting his troops. If we had encountered Catullus's erotic poems, I might have sat up and taken notice. I passed the O-level exam by 'photographing' pages of the translation in my head. For French O-level, we studied a story by Guy de Maupassant set in snowy wastes – perhaps the short story *The Inn*. We progressed ploddingly at not much more than a paragraph a week, which tended to negate any sense that an exciting narrative was under way. The French master, Mr ('Froggy') Croker, called me his 'nameless friend' because he could not remember who I was. I retaliated by invisibly emitting from my lips a high-frequency whistle which seemed to come from no definable location. To his evident irritation, he never traced the source.

Acutely aware of my cultural deficiency when I converted to art history, I began a campaign of self-education, during which the remarkable *Penguin Classics* series came to my rescue. I worked my way through affordable translations of the basic Platos, Aristotles, Ciceros, Ovids, Lucretius and so on. I particularly remember Aristotle's *On the Soul* and, of the medieval texts, Boethius's *Consolations of Philosophy*. More functionally, I read the available texts by Dante, Petrarch and Boccaccio, supplemented by other translations in paperback, to gain a feel of Italian culture of the periods to which I was most drawn. I acquired a Bantam dual-language edition of *Novelle* in which the English and Italian texts were printed side by side. In more immediately art-historical and Renaissance terms, Penguin also provided a useful *Dictionary of Saints*, Machiavelli's cynical *Prince*, *Selected Letters* by the rumbustious Aretino, Titian's friend, and of course Leon Battista Alberti's seminal little book *On Painting*.

The legacy of acquiring some Italian through the *tre coronati* – the three great laurel-crowned poets – is that I did not realize their language was 'early' and difficult (I still find modern Italian challenging, and am sometimes told that words I use are archaic). Nor did I have much of a

literary framework within which to set the texts I was reading; but this had the advantage that I came to Dante's lesser works, such as the *Convivio* (The Banquet) and *La Vita Nuova* (The New Life), without knowing they were 'minor'. In fact, it was Dante's commentary on his own poems in the *Convivio* that provided me with one of the interpretive keys to the imagery of the *Mona Lisa*. Pondering the portrait for my 1981 book, I heard an echo from this greatest of poets. It came from Dante's gloss on his own phrase, 'in her eyes and in her sweet smile':

> The soul operates very largely in two places, because in these two places all the three natures of the soul have jurisdiction, that is to say in the eyes and mouth, which it adorns most fully and directs its whole attention there to beautify them as far as possible. And in these two places I state these pleasures by saying 'in her eyes and in her sweet smile'. These two places, by a beautiful simile, may be called the balconies of the lady who dwells in the architecture of the body, that is to say the soul, because she often shows herself there as if under a veil.

The conjunction of the soul, eyes, lips, balconies, architecture and veil seemed too good to miss, and corresponded precisely to Leonardo's use of analogy as a form of real knowledge. I was not arguing that his smiling portrait of a lady, drawing us deeply into her eyes, was an illustration of Dante's text, but that Leonardo's way of thinking about how to portray a 'beloved lady' was infused with Dantesque motifs. The overall presentation – the lady is present before our eyes, yet for all her apparent reaction to us, she remains elusive – is profoundly consistent with the characterization of idealized devotion in Italian sonnets. Renaissance poets' tormented love was not destined to be requited.

On the vexed question of the identity of the sitter, I was austere to an embarrassing degree. I asserted that anyone who claimed to be able to identify her was 'building bricks without straw' and pointed out that the first time she was accorded a name was in the first edition of Vasari's *Lives* in 1550, over thirty years after Leonardo's death. The caption to my plate 71 read 'Portrait of a Lady in a Balcony (the "Mona

Lisa")'. This position served to sidestep lots of difficult questions, and had some advantage in that it meant the text could focus on what the portrait looked like. It has since, as we will see, been blown out of the water by evidence not available at the time.

During the following years, my accounts of the *Mona Lisa* worked variations on the geological and poetic themes. A published lecture in 1984 on 'Leonardo da Vinci: Science and the Poetic Impulse', delivered at the Royal Society of Arts in London, set his portraiture of women more broadly in the context of Renaissance poetry, including the love poems that were the staple diet of the Sforza court (some of which were actually inspired by Leonardo's portraits). The poets closest to Leonardo do not feature in the standard Renaissance hall of fame, and are now little read. For good measure, most of them have not been translated.

There things might have rested, were it not for an email I received on 29 January 2014. It was from Giuseppe Pallanti, a professor of economics in Florence who had undertaken decades of private research in the Florentine archives. These years of scholarly investigation eventually formed the basis of his first book, *Mona Lisa Revealed: The True Identity of Leonardo's Model*, published in 2006. He indicated that his book had been translated into many foreign languages, and that his research had featured in other studies and filmed documentaries (including Dianne Hales's *Mona Lisa: A Life Discovered*, then forthcoming). He had in the meantime discovered new documents that warranted the revision of his book. He was hoping to find an English publisher and, ideally, an agent. He was also aware that he needed art-historical input. He tentatively suggested that 'we could find a form of collaboration in this matter...of course, if you like!'.

Giuseppe had been endearingly modest about his work, declaring that it was 'not a book of art history: I am not expert in this matter.' I had, in fact, already bought *Mona Lisa Revealed*, which provided a richly textured sense of the real lives of the main players – Lisa del Giocondo (née Gherardini); her merchant husband, Francesco; Leonardo's father, Ser Piero; and other more peripheral participants. I loved what I call the 'whiff of reality' in Giuseppe's detailed documentation, in contrast to the nebulous myths that have swirled with ever-increasing opacity around

the picture. Of course, his researches would only be relevant if the sitter was indeed Lisa, which I had once been reluctant to acknowledge.

The game-changer in identifying the sitter was a chance discovery in the University Library in Heidelberg. In 2005 a senior librarian, Armin Schlechter, published an exhibition catalogue of early printed books in the library. He included an edition of Cicero's *Epistulae ad familiares* (Letters to Friends), printed in Bologna in 1477. The book had been owned by Agostino di Matteo Vespucci, from a minor branch of the famous family, and had been richly annotated over a series of decades by Agostino and others.

Not far into the edition, one of Cicero's letters referred to the great Greek painter Apelles – misprinted as 'Appelles' in the Bolognese edition, and pedantically corrected by Agostino. The Roman author recorded that 'Apelles completed with the most polished art the head and bust of Venus but left the other part of her body *incohatam* [inchoate or incomplete]'. Cicero's reference stimulated Agostino to add a marginal annotation:

> Apelles the painter. That is what Leonardo
> da Vinci does in all his
> pictures, as in the head of Lisa del Giocondo,
> and Anne, the mother of Mary.
> We will see what he will do in the hall
> of the great council, about which he has made an agreement
> with the standard-bearer. 1503. October.

Some background research revealed that Agostino knew Leonardo. There were a number of points of contact; most significantly, the humanist scholar had provided the Italian account of the Battle of Anghiari that Leonardo had been commissioned to paint 'in the hall of the great council, about which he has made an agreement with the standard-bearer'. The 'standard-bearer' (the *Gonfaloniere*) was the Republic's executive head, Piero Soderini, who had the task of dealing with both Leonardo and Michelangelo, both of whom required skilful handling.

At the very least, Armin Schlechter's discovery meant that Leonardo was indeed involved in painting Lisa del Giocondo; at best, it meant that

the picture in the Louvre is definitely of her. I had broached the idea of writing a joint study with the German librarian, but we had not gone ahead with it. In any event, Giuseppe's documents presented a far more wide-ranging picture of the circumstances and people involved.

In early March 2015, Giuseppe and I met at a hotel in Florence. Born in Greve, in the heart of Gherardini country, Giuseppe was then a professor of economics at the Istituto Alberghiero 'Buontalenti' di Firenze, a training institute for all aspects of the tourist industry. As I had imagined from our correspondence, he proved to be extraordinarily dedicated, collaborative, skilled and infallibly modest. His relevant skills were not those deployed in his day job. He spent large swathes of his free time trawling through archives, above all those in Florence. The strange environment of records scrawled by lawyers and semi-legible documents about Florentine organizations, families and individuals had become his natural territory.

Language is a real problem in deciphering these texts, whether they are written in old Italian or idiosyncratic Florentine Latin. There are numerous formal abbreviations, and the handwriting is frequently unreadable for anyone without well-honed palaeographic skills. An example illustrated in our book (not one of the worst) brings together Leonardo's lawyer father and Lisa's husband in his silk merchant's premises. Ser Piero was acting to resolve a dispute. The readers of such documents would typically have been local historians and antiquarians in generations long since passed. For the modern art historian, under institutional and governmental pressure to publish voluminously and with incontinent haste, archival work is profoundly unappealing. It is slow, it requires laboriously acquired skills, and long periods of work often yield nothing of significance. Giuseppe, however, is not accountable to his immediate bosses – he is accountable only to himself, and those close to him.

Along with swathes of documents about Lisa herself, Giuseppe had found plentiful records with which to paint a compelling picture of her family life. We already knew that one of her daughters had entered the convent of San Domenico, where a sister of Lisa had apparently participated in an orgy involving four nuns and four male intruders. Not all of the young women placed in convents by their families – many

for financial reasons – were well suited to the celibate life. Lisa herself was to develop a special relationship with the prestigious convent of Sant'Orsola, where another of her daughters was a nun and where she was to spend the last years of her life. Lisa's husband Francesco, whose core business was silk, a Florentine speciality, emerges as a commercial opportunist, equally willing to import leather from Ireland and to trade in sugar from Madeira. He also appears to have dabbled in the slave trade. Broadly speaking he belonged to the Medicean camp, especially when it was convenient; but he cannot be considered a member of the inner circle of the ruling family.

Through Giuseppe's documents we also encounter Leonardo's ambitious father in action, setting up office immediately outside the Palazzo del Bargello in Florence. He became a prominent notary, and acted in a professional capacity for the Giocondo business. The del Giocondo brothers and Ser Piero were closely involved with the large and commercially active monastery of Santissima Annunziata, where Leonardo himself resided on his return to Florence in 1500. He was supposed to provide paintings for the very grand altarpiece that was planned at the junction of the nave and choir, but we have no record of measurable progress. It was from this set of professional and social links that the commission for the portrait of Lisa emerged. Courtesy of the inventory of Ser Piero's possessions at his death in 1504 – a death recorded with notarial brevity by Leonardo – we gain an impression of a prosperous and sophisticated lifestyle that mirrored, on a smaller scale, the domestic luxuries of leading families such as the Medici and Strozzi. Exceptionally virile, Ser Piero fathered no fewer than seventeen children, beginning with the illegitimate Leonardo and ending with a son when he was in his seventies.

In July 2014, I raised with Giuseppe the subject of the so-called *Casa Natale* (Leonardo's supposed birthplace) at Anchiano, two miles into the hills outside Vinci. There was at that time not one piece of concrete evidence to connect Leonardo, or even his mother Caterina, to the peasants' houses there. As they say, a nod is as good as a wink, and Giuseppe busied himself in the archives in Vinci.

Assiduously tracking the complex and sometimes broken records of properties in the Borgo of Vinci (the small domestic cluster of

The Casa Natale, where Leonardo was not born.

buildings below the castle), he identified the properties of Leonardo's grandfather, Antonio, and those acquired by Ser Piero and his brother Francesco. He also traced the ownership of the humble properties in Anchiano in 1452, the year of Leonardo's birth, without finding the slightest trace of a connection with Ser Piero or any Caterina. Only in 1482 did Ser Piero or his family acquire any property in Anchiano. This was not good news for the *comune* of Vinci, which has poured considerable sums into converting the peasant properties into a bijou place of homage with adjacent car park. We agreed that we were likely to be banished from Vinci, and decided to break the news as diplomatically as we could. We were also concerned about the current owners of the quiet property near the castle occupied by Antonio, where Leonardo spent his childhood and where he was likely to have been born.

By the end of 2014 I was hopeful that it might be possible for Giuseppe to find Caterina herself in the Vinci archives. This was in the face of an idea that had gained some traction: that she might have been a trafficked slave from a Muslim country, or even from China. This is

based on the record of a slave called Caterina owned by one of Ser Piero's friends in Florence; but there is no record of the slave ever being present or actually living in Vinci. Caterina was a common name to give to a Christianized slave – one of the slaves traded by Francesco del Giocondo was called Caterina. There were a number of archival Caterinas in Vinci, but in January 2015 the indefatigable Giuseppe wrote to tell me he had discovered in the tax records for 1451 that 'there was a "Caterina", of 15 years, without parents, who lived in Vinci'.

I had a feeling that this might be the real Caterina. Giuseppe pieced together her story. She was the daughter of the ne'er-do-well Bartolomeo (Meo) Lippi. By 1451, she and her two-year-old brother Papo had been deserted. Nothing is known of their mother or mothers, and they were looked after by relatives. Was it this orphaned and vulnerable girl of fifteen with whom the young lawyer enjoyed productive sex on a visit to Vinci in the summer of 1451? Giuseppe uncovered a set of family link-ages indicating with a high degree of probability that Caterina Lippi was the Caterina rapidly married off after Leonardo's birth to become the wife of Antonio di Piero Buti, known as 'Accattabriga' (a nickname that suggests an irascible temperament). Buti was not rich, but he provided a viable household for Caterina in Mattoni, a hamlet near Vinci, to which she contributed five children.

It became clear, looking at the existing documentation and at the records of the well-attended baptism of Leonardo in the main church on Sunday, 16 April 1452, that Leonardo's birth was not regarded as shameful. It was common enough for illegitimate children to be welcomed into leading Tuscan households. As Antonio's tax returns indicate, Leonardo became one of the *bocche* (mouths) to be fed in his grandfather's Vincian household. Identifying Leonardo's mother is not central to our understanding of the *Mona Lisa*, but since our book was to be about 'The People and the Painting', it enriched our pen portraits of the participants. It also provided a big peg for some prominent publicity. Leonardo's real mother is news, as the extensive press coverage confirmed.

Having Skyped with the authorities in Vinci about our discoveries, we agreed to hold a day of press conferences with a public presentation

in the Biblioteca Leonardiana in Vinci on 13 June 2017. We soft-pedalled the news about the *Casa Natale*, concentrating on what the headline in *The Times* called 'Ma Vinci'. As it turned out, our proposal of Caterina Lippi as Leonardo's mother proved to be inflammatory. Alessandro Vezzosi, founder and director of the Museo Ideale Leonardo da Vinci (a private museum in vaults below the castle in Vinci) is a passionate supporter of Caterina the slave. At the end of our presentation, he seized the lectern and spoke vehemently and tearfully against our idea. The audience joined in noisily, largely on our 'side', as far as I could tell. Rival archival interpretations had become players in a kind of contact sport.

More contention was to follow. It transpired that Elisabetta Ulivi, an accomplished historian of mathematics at the University of Florence, had already looked at the same documents for Caterina, and had published her results in the *Bullettino Storico Pistoiese* (the Pistoia Bulletin of History) in 2009. We had missed this – not good, but something that is always a hazard in the outpouring of Leonardo studies. The *Bullettino* is not widely available, and does not appear to be online. Ulivi's well-researched article on the 'Identity of Leonardo's Mother' eventually ruled out Caterina di Meo Lippi as Ma Vinci because of a tax record stating that one Domenico di Taddeo di Domenico Telli owned 'a piece of land in Mattoni...left by Meo di Orso di Giusto, father of Mona Caterina, mother of that Domenico'. Ulivi assumes that Meo di Orso di Giusto is the same as Meo di Lippo Lippi; but tax records rely upon accurate patronymics (based on the fathers' names), and Meo (Bartolomeo) is a common name. We still much prefer our interpretation.

Giuseppe and I have always taken mutual responsibility for the whole of our book, but it is not hard to tell who drafted what. After the salutary grit of his documented realities, I tracked the history of the painting from its first mention by Agostino Vespucci in 1503. Primary sources were to rule: for instance, we published the full witness testimony from the trial of Vincenzo Peruggia, who had 'liberated' the masterpiece from French hands for two years (1911 to 1913). As always, the real voices from the period speak with a vivid authenticity that later accounts struggle to match.

The story, as we have confirmed it, runs as follows: the painting was begun by 1503; it was seen by other artists in Florence, probably in unfinished condition, most notably by Raphael; it went with Leonardo to Milan and then to Rome, where Giuliano de' Medici encouraged its completion; it was still in Leonardo's hands when he was in France, where it was admired by Antonio de' Beatis; it was acquired by Francis I, probably from the heirs of Salaì. There are other hypotheses that can be drawn out of the documentation, but they all require special pleading and selective emphasis. None of them is *necessary*.

The historical principle at work here was one I have always tried to apply. It is quite 'scientific'. In the conclusion to our book, we outlined its basis:

> We are advocating a form of Ockham's razor, the principle
> enunciated by the 14th-century English philosopher, which
> states that the hypothesis with fewest assumptions and which
> is most consistent with the evidence is to be preferred. This
> is the law of parsimony, the *lex parsimoniae*, which is a very
> rare bird in the flocks of modern theories about the *Mona Lisa*.
> The alternative theories all involve giving selective credence
> to witnesses of uncertain reliability and denying one aspect or
> another of the more straightforward mainstream of evidence.
> Our theory is...straightforward. There is one *Mona Lisa*.
> It was painted by Leonardo. And it is in the Louvre.

This is unlikely to grab many headlines. But at least we have a good idea who Leonardo's mother was.

The later chapters of our book provided interpretative frameworks for this most deeply pondered of masterpieces. They expanded upon my previous efforts to set the portrait in the context of Renaissance love poetry, to relate its visual qualities to the sciences (particularly anatomy, optics and geology) and to show how what began as a commissioned portrait of an individual evolved into what I am calling a 'universal picture' – one into which Leonardo poured his visual knowledge and human understanding, in a way that expressed his own stated brief for the painter:

Of some it may be said that they deceive themselves when
they call that painter a good master who can only do a head
or a figure well....Since we know that painting embraces and
contains within itself all things that are produced by nature or
whatever results from man's passing actions – and ultimately
anything that can be taken in by the eyes – he seems to me
to be a pitiful master who can only do one thing well....He
is not universal who does not love equally all the elements
in painting.

The *Mona Lisa*'s entanglement with the vision of Renaissance poets was
two-way. On one hand was Leonardo, framing the communicative power
of his image in terms of the tropes of literary love; on the other were
poets writing about Leonardo, above all his teasing visions of 'beloved
ladies'. Leonardo's relationship with poetry was both fraught and pro-
ductive. He was obsessed with showing how painting was superior to
poetry in his so-called *paragone*, his comparison of the various arts.
There was an intellectual dimension that challenged the poet to be as
vivid in visual description as the painter; and there was a social one,
in that practitioners of the various arts were in competition for atten-
tion and remuneration in Renaissance courts. That Leonardo went to
such elaborate pains to attack poetry indicated not only that he took
its challenge seriously, but also that he knew a great deal about what
poets were doing. His own library was quite well stocked with what we
might term literary works.

It was Dante who set the tone in his evocation of his beloved Beatrice,
with whom he was barely acquainted. The essence of the perpetually
inaccessible lady was distilled into a divine spirit, emitted from her eyes
and expressed sweetly by her smiling lips. One passage on the beloved's
eyes in poem XIX from *La Vita Nuova* can stand for many:

From out of her eyes, wherever they may move
come spirits that are all aflame with Love;
they pierce the eyes of any one that looks
and pass straight through till each one finds the heart;

upon her face you see depicted Love
there, where none dares to hold his gaze too long.

Not the least of Dante's attractions for Leonardo was that he framed his sensory and psychological experiences in terms of medieval science. In one of the commentaries in the *Convivio* (II, IX), Dante explains:

> Here it should be known that although many things can enter
> the eye at the same time, nevertheless that which enters
> along a straight line into the centre of the pupil is the only one
> that is truly seen and which stamps itself upon the imagination.
> This is because the nerve along which the visual spirit runs
> is pointed in this direction; and therefore one eye cannot really
> look into another eye without being seen by it; for just as the
> one which looks receives the form in the pupil along a straight
> line, so along that same line its own form proceeds into the
> one it looks at; and many times along the extension of this line
> is discharged the bow of him against whom all arms are light.

This concept of the supreme power of the direct visual ray was precisely what Leonardo had gleaned from his readings of medieval optics.

Alongside such poetic imagery, Giuseppe and I looked more generally at poems about paintings, including Petrarch's two famous sonnets on Simone Martini's portrait of the poet's beloved Laura. The spirit, as ever, is one of sublimation: 'For certain my friend Simon was in Heaven / the place from which this gracious lady comes'. It was Petrarch's vision that dominated the aspirations of the poets at the Sforza court, who not only set the immediate tone for the poetic effusions that Leonardo attempted to surpass, but also specifically wrote about the artist and his own works.*

* The two chapters in which we entangled the picture and the poetry are ones that provide me with a good deal of retrospective satisfaction, as no one had attempted anything quite like this before. We were pleased to have the opportunity to work with Maria Pavlova, a post-doctoral expert in Italian Renaissance poetry at Oxford. Maria translated Giuseppe's texts, as well as helping with the translation of some of the far from easy and very allusive poems.

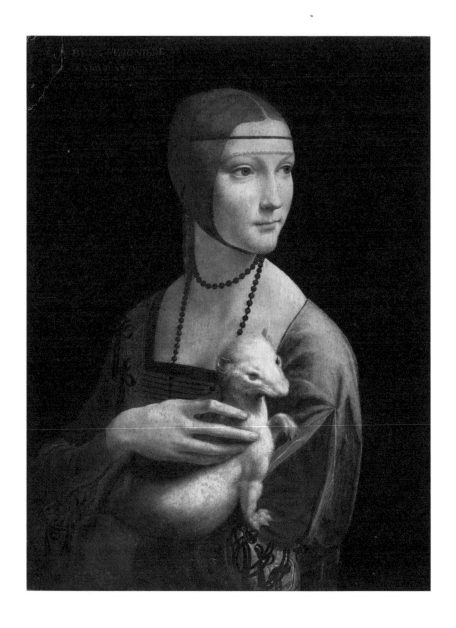

'To understand what is nature and what is art':
Portrait of Cecilia Gallerani, 1489–90. Oil on canvas, 54 × 39 cm (21 × 15 in.).

Here I will present just two of the poems – the first from the then famous, now little-known courtier-poet Niccolò da Correggio:

> If Zeuxis, Lysippus, Pyrgoteles or Apelles
> [the ancient Greek artists]
> had to paint this lady on vellum,
> having to gaze at each of her features
> and at the grace with which they are then infused,
>
> like when one looks at the sun or counts the stars,
> his eyes and his art would fail him,
> because nature does not grant to the eye
> the powers in what nature herself excels.
>
> So, my dear LEONARDO, if you want
> to be true to your name, and conquer [*vince*] and surpass everyone,
> cover her face and begin with her hair,
>
> because if you happen to see all her beauties at once
> you will be the portrait, not her, since
> they are not for the mortal eye, do trust me.

Contemporary readers would have picked up the common poetic *topos* of a vision that is too wonderful for our mortal eyes, and perhaps also the cliché that 'every painter paints himself', which Leonardo was specifically concerned to avoid.

The second poem, which relates to the known portrait of Cecilia Gallerani, was written by Leonardo's fellow Tuscan at the Milanese court, Bernardo Bellincioni, with whom he collaborated on theatrical spectaculars.

> Nature, what provokes you, who makes you envious?
> It is Vinci, who has painted one of your stars!
> Cecilia, today so very beautiful, is the one
> Beside whose beautiful eyes the sun appears as a dark shadow.

The honour is yours, even if in his picture
She seems to listen and not to tell.
Think only, the more alive and beautiful she is,
The greater will be your glory every future era.
Give thanks therefore to Ludovico, or rather
To the supreme genius and hand of Leonardo,
Which allows you to partake in posterity.
Everyone who sees her thus, even later
Seeing her alive, will say, that 'this is enough for us
To understand what is nature and what is art'.

The authenticity of such primary sources stands in sharp contrast to the prodigious range of theories and interpretations that have been imposed on the *Mona Lisa* during the past fifty years or so. Some of the 'secrets' that have been read into the painting are discussed later, but there is space here for just one story: that of the supposed 'Earlier *Mona Lisa*'.

One of the odder claims that tends to recur about the *Mona Lisa* owned by the Louvre is that it is not what it is said to be. These claims are typically promulgated by individuals who claim to own the 'real *Mona Lisa*'. There is no shortage of copies that can be put forward as pretenders to Lisa's crown. One of these, almost certainly copied in the 17th century for the Duke of Buckingham (who had tried in vain to buy the original), was subsequently acquired by Sir Joshua Reynolds, President of the Royal Academy, who was convinced that it was superior to the one in the Louvre.

An even more persistent pretender among the many copies or variants is that known as the 'Isleworth *Mona Lisa*'. Having seemingly faded from the scene during the 1960s, this work has recently been revived as Leonardo's 'earlier version', backed by what seems to be a good deal of financial and legal muscle.

The Isleworth *Mona Lisa* first emerged into the light of day in 1913 after being discovered by Hugh Blaker in an unnamed English country house collection, said to be in Somerset. Blaker was a well-connected painter, connoisseur and collector – a talented amateur of a very English

The young pretender:
The 'Isleworth *Mona Lisa*', date unknown. Oil on canvas, 84.5 × 64.5 cm (33¼ × 25⅜ in.).

kind, credited with what is called 'a good eye'. He lived in Isleworth, west London. In his diary in January 1914 he recorded that he was 'about to publish abroad details of my Mona Lisa picture, picked up [at auction] in Bath, a very delightful thing showing the colours mentioned by Giorgio Vasari; and much larger than the Louvre picture...John Eyre, my stepfather swears that mine is the original and vows to sell it for a fabulous sum.' Blaker became convinced that it was 'NOT A COPY as we understand the term'.

A year later, the painting was published by Eyre in his *Monograph on Leonardo da Vinci's Mona Lisa* (reworked as *The Two Mona Lisas* in 1926). It was Eyre who first formulated the idea that the Isleworth version preceded that in the Louvre, and was in fact the actual portrait described by Vasari. His little book of fifty-one pages is full of careful scholarship, and makes about as good a case as can be made.

After the deaths of Blaker in 1936 and his sister in 1947, the Isleworth version did not resurface until 1962, when it was purchased by the American dealer and publisher Henry Pulitzer in partnership with a Swiss syndicate. To finance its acquisition, Pulitzer 'had to sacrifice a large number of paintings in my own collection and a house with all its contents'. The Pulitzer Press published his 1966 book, entitled *Where is the Mona Lisa?* The answer, apparently, was 'not in the Louvre'. I enjoyed a short correspondence with Pulitzer during the 1970s, by which time the Pulitzer Gallery in London was no longer in business. He sent me a photograph of the painting before his death in 1979. The photograph and the pasted-in colour illustration in his book are in some ways preferable to the digital image issued by the later owners.

Pulitzer carefully cited the main documents for the early history of the painting as then known, and made use of the scientific techniques then available, though he bizarrely asserted that the Louvre picture 'is actually on canvas transferred to a panel'. Like other supporters of the 'young pretender', he needed some way of explaining why it was painted on canvas, when all the accepted Leonardos are on panel. He regarded the Louvre painting as greatly inferior and came up with the idea that it had been reworked by Leonardo to portray Costanza d'Avalos, a widowed Spanish noblewoman who became Duchess of Francavilla and established a notable court on the island of Ischia.

Pulitzer left the painting to his daughter Elizabeth. In 2008 it was purchased by a consortium of investors based in Geneva.* Subsequently – and this is what makes the 'Isleworth *Mona Lisa*' so unusual among the supposed Leonardos – it was brought confidently into the public realm.

The public exposure of the painting and research was assigned to the 'Mona Lisa Foundation', a non-profit organization founded in 2010 and based in a large and handsome villa in a leafy suburb of Zurich. Its six-member board is headed by the lawyer Markus Frey as president, with David Feldman as vice-president. Feldman is a hugely successful Irish stamp auctioneer and author, whose business in Geneva is one of the biggest in the world. He has diversified into other areas of dealing and auctioneering. The Foundation has consistently refused to indicate how the membership of the board relates to the consortium that owns the painting.

It seems that Pulitzer's daughter had arranged in 2005 for Feldman to bring earlier researches into the painting to a conclusion. The Foundation felt confident enough to display the picture in Japan at Shizuoka, Fukuoka and Tokyo in the winter of 2011/12 as part of an exhibition, 'Leonardo and the Idea of Beauty', curated by Alessandro Vezzosi of the Museo Ideale in the town of Leonardo's birth. A grand European launch was then staged, with much pomp and media ceremony, in Geneva on 27 September 2012.

David Feldman had contacted me about the portrait in January 2012. From the outset, I maintained that there was no realistic chance of it being by Leonardo – not least because of the technical evidence that had emerged from recent scientific examination in the Louvre. Our subsequent correspondence was conducted in a courteous manner, and the Foundation was kind enough to send me a copy of its mighty 320-page

* There are quite a number of paintings owned by syndicates of money men and held in free-port stores in Geneva and Zurich. The ruse of the freeport is that owners pay no import taxes or duties while a work of art is in such storage; and if it is sold in the freeport, no transaction tax is payable. Works can accordingly change hands as tax-free investments without ever seeing the public light of day. I have been contacted on a number of occasions about paintings in such stores; I was sent images of one supposed Leonardo, *Portrait of a Lady with a Fur*, at least six times in the space of two years. Each was accompanied by 'expertises' certifying its authenticity (generally provided by well-remunerated 'experts'), but the story of its ownership varied each time. I repeatedly replied that I thought it was a pastiche based on Leonardo, Luini, Raphael and Sebastiano del Piombo; but whether I was right or wrong in my judgment, the whole business is very shady.

book, written largely by Feldman's brother, Stanley. This was sumptuously illustrated, gold-edged, fancily designed and crammed with a rich assembly of material purporting to prove the attribution. In terms of art history, Eyre's little book in 1915 had done a better job – more focused, scholarly and eloquent.

The Foundation invited me to view the picture. I have not done so. As I later explained to the BBC:

> I have not 'refused' to see it. I decided not to. I only go to see works (at my expense and never for remuneration) if the evidence I have – documentation, provenance, digital images and scientific examination – convinces me that it is worth the time, travel and expense....I saw nothing to convince me that seeing it in the flesh is of high priority. I am sent many non-Leonardos – as many as one a week – and have to make choices. If I travelled to see every hopeful 'Leonardo', I would be impoverished. If they want to bring the painting to me, they can.

This position ran foul of a largely unquestioned canard in the art world: that one can only judge something by seeing it in the original. There is no question that the ultimate experience of a work consists of viewing it 'in the flesh'. However, in this age of incredibly high-resolution digital images (the Foundation kindly sent me one of more than 370 MB) and scientific examinations, a secure judgment can be made when there is a very measurable gap between what the item in question reveals under such scrutiny, and what we know about paintings by Leonardo.

A further reason for not viewing the painting on the Foundation's home territory and on their terms was the kind of insistent pressure that tends to come with such visits. The staging of such viewings, typically accompanied by elaborate courtesies and favours – taxis, lavish hospitality, offers of 'expenses' – is corrupting. Afterwards, those whose aspirations have not been met by the courted scholar are in a position to concoct eyewitness denunciations ('he barely looked at it', and so on).

I am not saying that this *would* have happened, but I had been down this path once before, and I now choose to avoid such situations.

Faced with the barrage of publicity and incessant media requests during and after the Geneva launch, I decided to issue a press release, which I also posted on my occasional blog. Some excerpts follow. Reading it again, it appears rather severe, but I stand entirely behind the arguments.

> The book...is as physically impressive as it is historically
> slippery. There is no sense of how to distinguish core evidence,
> evaluate sources and construct arguments methodically.
> The piles of unstable hypotheses, stacked one on another,
> would not be acceptable from an undergraduate....
> The book claims that *none* of the evidence of scientific
> examination indicates that the Isleworth picture is *not*
> by Leonardo. Nor does it show that it is *not* by Raphael.
> Even this ineffectual claim, with its double negative, is not
> justified. The infrared reflectogram and X-ray published
> on p. 253 do not reveal any of the characteristics of Leonardo's
> preparatory methods. Leonardo, as the infrared images
> of the Louvre painting show, was an inveterate fiddler with
> his compositions even once he had begun to work on the
> primed surfaces of his panels. The [IR] images of the
> Isleworth canvas have the dull monotony that would be
> expected of a copy....

> I see lots of dossiers of 'scientific evidence' attached to purported
> Leonardos. It often seems enough to have the texts with plentiful
> data, diagrams and images to 'prove' the authenticity, whether
> or not they actually tell us anything that actively supports
> Leonardo's authorship.

> When we come to look really carefully at the 'Isleworth *Mona
> Lisa*' it is evident that the copyist has failed to understand
> significant details and the suggestive subtlety of Leonardo's
> image. I could give a big list, but here are a few:

1 Lisa's dress, as revealed by the gathered neckline in the Louvre painting, consists of a miraculously thin, translucent overlayer with thicker opaque cloth underneath. The copyist does not understand this structure and renders it lamely;

2 the spiralling veil over her left shoulder, rendered by Leonardo with depth and diaphanous vivacity, is transformed into a series of dull stripes of inert highlight;

3 Lisa's hair has that characteristic rivulet pattern in the Louvre painting, but is rendered in a routine manner in the Isleworth picture;

4 the veil beside Lisa's right eye floats over the sky, rocks, water and her hair with extraordinary delicacy, with its meandering edge marked with a minutely thin, dark border – but not in the Isleworth version;

5 the folds of draperies in the latter are hard, routine and show little sense of the folding processes that are apparent in the Louvre painting;

6 the mid-ground hills/mountains in the Isleworth picture are painted in a thick, heavy-handed and opaque manner, with none of the optical elusiveness of Leonardo, and none of his living sense of the 'body of the earth';

7 the island on the left of the painting is truly bad – a literal blot on the landscape. There is no logic to the reflection and no other sign of the water that is responsible for the reflection;

8 the head in the Isleworth picture has been conventionally prettified in stock direction of the standard Renaissance image of the 'beloved lady'. The idea, in the book, that Renaissance

portraits of mature women can be used as accurate registers of their actual age is misguided.

Everything points to the Isleworth painting being a copy. There is a comparable copy – island and all – in the National Museum in Oslo. Another is illustrated on page 199 of the Foundation's book. There are families of copies of the *Mona Lisa*. This family of three is not the best.

I should have added that the presence of fuller lateral columns in the Isleworth version, about which both Eyre and the Foundation make great play, are typical of what many copyists have done, faced with the strange slivers of columns and truncated bases that Leonardo seems to have added to the edges of his picture quite late in its development.

The roll-call of significant contemporary Leonardo specialists who openly and unequivocally supported the attribution in public was precisely zero. Alessandro Vezzosi, who spoke at the launch in Geneva, and Carlo Pedretti, the great Leonardo specialist, made encouraging but noncommittal statements about the picture being of high quality and worthy of further research. As the one conspicuous head above the parapet (later joined by Luke Syson of the Metropolitan Museum), I was singled out for attack at the exhibition in Singapore during the winter of 2014/15. It transpired that:

> [Martin Kemp's] words are highlighted on entry to the room: 'I always view a painting up close and in person to know things that other people don't know', but later in the room we find that Kemp has ignored his own words and declined personal invitations to view it. The strand of logical implication is obvious.

I do not recall writing any such thing; all I can say is that I would never view a work expecting 'to know things that other people don't know'. When very many millions of pounds are potentially involved, accuracy can suffer.

CHAPTER 3

As it happens, all the tendentious arguments made in favour of the 'Earlier *Mona Lisa*' definitively collapse in the face of the data that has emerged recently from the technical examinations of the painting in the Louvre. Evidence from the under-layers of the real *Mona Lisa* show Leonardo slowly manoeuvring towards the final composition. The costume underwent considerable transformations, and there were a number of details that were adjusted, such as the sitter's hands and hair. It is this *revised* composition that is apparent in the Isleworth picture. There is not the slightest case for saying that Leonardo painted an earlier version, and then undertook another version that began very differently but was then progressively changed to conform to what he had previously done.

A copy, albeit with some variant features in the architecture and background, remains a copy. A lot of expensive fuss about nothing. Presumably the pretender is back in its freeport – and the only *Mona Lisa* by Leonardo himself is on public display in the Louvre.

Let me finish on a happier note by returning to the moment of her emergence during the 1994 inspection in the Salon Carré.

In the event, once she is in the room with us, any anxiety on the observers' part recedes – the picture takes over. Its sense of presence is truly uncanny. It is alive. The sitter seems to respond to us no less than we respond to her. Through the insistent cracks, grimy varnish and splotchy retouching, her teasing glance and inviting smile invade our space with astonishing vibrancy.

What would Pater have made of her out of her frame? No longer a 'diver in deep seas', she is breathing our air as a living entity. Few artists have ever achieved anything comparable – Raphael sometimes, Rembrandt in his self-portraits, Velázquez almost infallibly, Bernini and Houdon in cold marble (yes, Houdon), Vermeer and Chardin on smaller scales. Picasso can do it, at his best. The strange thing about the *Mona Lisa* is that she occupies a unique territory, poised between a portrait of an individual and an ideal fantasy of a beloved woman who cannot really be real. As Peter Cook said to Dudley Moore in their famous 'Art Gallery' sketch, 'she's never been to the lav in her life'. This is as true of Dante's Beatrice as it is of Leonardo's Lisa.

Dante, encountering the visionary Beatrice in *Paradiso*, can fittingly have the last word.

> The image of her when she starts to smile
> breaks out of words, the mind cannot contain it,
> a miracle too rich and strange to hold...

CHAPTER 4

THE STOLEN MADONNA

In the summer of 2003, a Leonardo Madonna and Child was stolen from a Scottish castle. It was one of the two best versions of the *Madonna of the Yarnwinder*, small paintings that show the mother and child engaging actively with each other and a cross-shaped object, recognizable as the distaff onto which wool and other fibres are wound before being twisted into thread on spindles. By seizing the distaff the infant Jesus is prophetically embracing his crucifixion – a tragic message in an apparently innocent subject.

On 27 August, when news of the theft reached me, I was in the hills above Greve in Chianti. The landscape was a beguiling Tuscan cliché: bumpy brown hills, toasted by the sun, were clothed in a quilt of neatly pruned vines and green olive groves, punctuated by regiments of dark cupressus trees. As a breeze stirred the olive branches, they flutteringly displayed their silver undersides – an effect Leonardo described when explaining how to paint different kinds of trees. I was staying at the Villa Vignamaggio, once owned by the Gherardini family and haunted by the shade of Lisa.

Gherardini history is the stuff of novels and stage plays. In the 10th century, Cosimo Gherardini rose to become the first duke of Florence. In later centuries the family was caught up in the deadly disputes between the 'Black' and 'White' factions of the Guelfs. The warlike Gherardini were condemned with other Whites as 'malefactors' and 'bandits' by the Florentine government, and accused of aligning themselves with Siena; the Florentines successfully besieged their properties. In 1302 it was stipulated that the imposing Gherardini Castle of Montagliari should be so thoroughly demolished that there would be 'no hope of its being

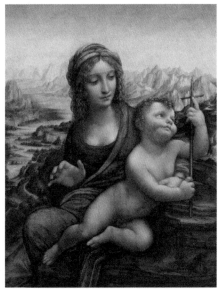

Madonna of the Yarnwinder.
Top: The Buccleuch Madonna, 1501–7, or later.
Oil on walnut panel, 48.9 × 36.8 cm (19¼ × 14½ in.).
Bottom: The Lansdowne Madonna, 1501–7, or later.
Oil on panel, transferred to canvas and re-mounted on panel, 50.2 × 36.4 cm (19¾ × 14⅜ in.).

rebuilt'. Its precise location in the Tuscan hills is no longer evident. Gradually some branches of the Gherardini reinstated themselves as Tuscan landed gentry, with residences in the countryside and in Florence. By Lisa Gherardini's time, their ancient name was of greater moment than their power and wealth.

The stones of the spacious Villa Vignamaggio are manicured and freshly pointed, the walls freshly plastered. Its proprietors over the years have produced robust Tuscan olive oils and Chiantis with personality – including, inevitably, one named after Mona Lisa. In the early 15th century a Gherardini named Amideo wrote of wine that he had 'barrelled' in Vignamaggio, offering one of his customers more 'if you do not have enough'.

I was there because Vignamaggio was participating in the admirable *agriturismo* programme, in which agricultural properties of a substantial and historic kind welcome paying guests – not quite as hotels, nor as standard bed and breakfasts. The large, airy rooms of the villa had been assigned Leonardesque names; I was booked into the 'Mona Lisa', with huge windows opening onto a sweeping vista. Near the pool I encountered Marco, who was labouring to keep the fecund Tuscan garden in order. Marco was not only a gardener; he was also involved in the recreation of medieval street theatre in Tuscan towns, work which did not offer a living wage. Even someone of his sophistication was unable to resist being drawn into the legends.

'That's where she was sitting.' He pointed up at the window of an adjacent room. 'She', of course, was Lisa. Marco assured me that traces had been found locally of the arched bridge in the portrait. That the fertile landscape does not look at all like the bare bones of Leonardo's blue mountains did not serve as a deterrent. To tell Marco that he couldn't be right – that Leonardo was not painting actual landscapes, and that the property was not even in Gherardini hands at the time of the portrait – would have been like an assault with a blunt instrument. I decided to keep quiet.

There is, however, a Leonardesque dimension to the local vistas. The topography of the area, with a wide plain squeezing into low valleys beween verdant ridges of steep hills, is recognizable in Leonardo's earliest

dated drawing. It depicts a plunging vista. Far on the left, a substantial castle stands proudly on a promontory. The distant plain is marked by fields hatched in rough perspective and culminates in a cluster of small-ish mountains. Leonardo has inscribed the drawing, using what for him was an unusually ornamental and legible script, 'the day of S. Maria della Neve [Holy Mary of the Snow] on the 5 August 1483'. The reference is to the miraculous snowfall in Rome that delineated the precise location and plan of Santa Maria Maggiore. The draughtsman was twenty-one years old, and was already flexing the muscles of his independent genius.

My initial assumption, and that of most other students of Leonardo, had been that the drawing was of a real place at a real time. Some years previously, I had driven around the dizzying roads that cling to hillsides in Tuscany; each bend promised to disclose Leonardo's actual vantage point, but none did. If we look at the precocious drawing carefully, tracing its topography on the left and right of the mighty cleft, we eventually realize that it is full of illogicalities of space and scale. I came to see, as Gombrich had argued, that this famous 'Val d'Arno' drawing is a marvellous invention, a *fantasia* on a Tuscan hillscape of the day of Holy Mary of the Snow.

A *fantasia* on a Tuscan landscape:
Mountainous Landscape with a Castle (on 'the day of S. Maria delle Neve on the 5 August 1483'). Pen and ink on paper, 19 × 28.5 cm (7½ × 11¼ in.).

But why the reference to the miraculous day? Across the valley from the Villa Vignamaggio is an oratory dedicated to Santa Maria della Neve, erected by the Gherardini – an unexpected location for the commemoration of a Roman event. Does the drawing have a Gherardini connection? Perhaps the mighty castle deep on the left of the drawing is a re-envisaging of their Castle of Montagliari. Is the landscape a fantasy on a Gherardini theme? I cannot quite make any credible explanation stick, and Leonardo's motive for making the drawing remains an enigma.

At the moment the call came through about the stolen Madonna, I was sitting in the shade of a large umbrella on a stone-paved terrace beside a blue swimming pool. My attention was not on my paradisical Tuscan surroundings, but on a chapter I was writing for a short monograph on Leonardo commissioned by Oxford University Press. I peered at the screen of my laptop, barely legible against the glare of the sun. The last thing I wanted was to be interrupted and when my phone began vibrating insistently on the metal table, I thought about ignoring it. Then I saw that the caller was Thereza Crowe (now Wells), my former research student and collaborator, who would not have been ringing casually.

'Have you heard the news?'

'What news?'

She told me about the theft of the Duke of Buccleuch's beloved *Madonna of the Yarnwinder* from Drumlanrig Castle, his great Renaissance-cum-baronial home in the Scottish Borders near Dumfries. The facts were hazy, but apparently some men driving a VW Golf GTI had snatched it.

Later, I learned the story in more detail. The castle is open to the public, and two casually dressed men had appeared as early morning visitors in the staircase hall, where the painting was hanging in its protective case. A young woman working as a tour guide had attempted to speak to them about the collection, but they seemed uninterested in seeing the other rooms with their many treasures. Then, as the guide subsequently explained in court, one of the thieves 'put his hand over my mouth and told me I had to lie down on the ground or he would kill me if I didn't'. A more experienced guide heard 'a commotion' in the hall – a

male colleague was shouting, 'Please don't do it. Retreat, retreat.' She bravely entered the hall and saw one of the thieves wielding an axe: 'He was standing guard on the picture....After it was done, they disappeared out of the window'.

Even the basic facts Thereza was able to give me over the phone made shocking news. The *Madonna of the Yarnwinder* was a painting I had come to know well over the preceding years. I had already drafted a short account of it for my new book, and had intended to return to it in a later chapter, so there would be some impact on my work in that respect; but I could only begin to imagine the distress of the Duke, with whom I had become acquainted in the course of my research.

The *Madonna of the Yarnwinder* is as well documented as any of Leonardo's paintings. It was commissioned in Milan by Florimond Robertet, Secretary of State to the invading French king, shortly before Leonardo's departure from the city in December 1499. An eyewitness – Fra Pietro Novellara, head of the Carmelites in Florence, reporting to

The Duke's castle: Drumlanrig in the Scottish Borders.

CHAPTER 4

Isabella d'Este, Marchioness of Mantua – described Leonardo as actively working on the picture in Florence in April 1501:*

> During this Holy Week I have learned the intention of Leonardo the painter through Salaì his pupil and some other friends of his who, in order that I might obtain more information, brought him to me on Holy Wednesday. In short, his mathematical experiments have so greatly distracted him from painting that he cannot bear the brush. However, I tactfully made sure he understood Your Excellency's wishes, seeing that he was most eagerly inclined to please Your Excellency by reason of the kindness you showed to him in Mantua, I spoke to him freely about everything. The upshot was that if he could discharge himself without dishonour from his obligations to His Majesty the King of France as he hoped to do within a month at most, then he would rather serve Your Excellency than anyone else in the world. But that in any event, once he had finished a little picture that he is doing for one Robertet, a favourite of the King of France, he will immediately do the portrait and send it to Your Excellency. I leave him well entreated. The little picture he is doing is of a Madonna seated as if she were about to spin yarn. The Child has placed his foot on the basket of yarns and has grasped the yarnwinder and gazes attentively at the four spokes that are in the form of a cross. As if desirous of the cross he smiles and holds it firm, and is unwilling to yield it to his Mother who seems to want to take it away from him. This is as far as I could get with him.

Fra Pietro did not, of course, miss the symbolism of the cross. He would also have been alert to the fact that this was a new kind of Madonna, in which a symbol was being built dynamically into a psychological narrative. It was an innovation that was to affect both Michelangelo and Raphael.

* Leonardo had visited Mantua in 1500, and Isabella was striving to extract a picture from him. She never succeeded.

Leonardo was never quick to complete commissions, and it was not until six years later that the Florentine ambassador to France recorded 'a small picture by his hand which has recently arrived here'. He was writing from Blois, where Robertet had built an ambitious Renaissance townhouse. Such was the impact of the little painting that King Louis XII expressed a desire to have 'certain small pictures of Our Lady or other things according to what I might devise in my imagination'. Leonardo was becoming the first European star artist.

The historical dilemma is that we have two candidates for the painting that Leonardo actually produced for his French patron. Fortunately, the documentation does allow for a second version. A 'Madonna with a Child in her arms' appears in the two inventories of the possessions of Salaì, in company with the *Mona Lisa*. The lists, as we have seen, were drawn up in 1525 so that the assets of Leonardo's pupil could be divided equitably between his heirs. The Madonna seems to have been among the paintings that were still in Milan in 1530, having become pawns in a legal dispute between Salaì's sisters and his wife. One version of the painting had been delivered to Robertet in Blois; the other remained with the artist, taken with him to France and transported back to Milan after his death in 1519.

Many copies and variants of the painting survive, but only two can be associated directly with Leonardo himself. One of these is the painting stolen from Drumlanrig Castle. The other was once in the distinguished collection of the Marquises of Lansdowne, and is now in a very private collection. Neither has a history earlier than the 18th century, and we have no obvious way of telling which was delivered to Robertet and which remained in Leonardo's own hands.

My own association with the Duke's Madonna went back a number of years and closely involved Thereza Wells, who had been undertaking doctoral research on Leonardo's French patrons. At that time few Leonardo specialists had actually seen either painting, and judgments of authorship were chanced on the basis of photographs. At some point in the late 1980s I visited Drumlanrig with a group of students from the University of St Andrews. Seeing the surprisingly small oil painting on its wooden panel convinced me that it would be worth examining

further, using the latest techniques science then had to offer. The Duke and the National Galleries of Scotland, where I had served as a trustee, both proved keen on the idea.

The examination in the Galleries was scheduled for 16 May 1990. At ten o'clock on a brisk morning, John Montagu Douglas Scott KT, the 9th Duke of Buccleuch and 11th Duke of Queensberry, arrived at the National Galleries in Edinburgh. This was where the Scottish National Gallery of Modern Art had recently opened to the public in the elegantly refurbished John Watson's Institution, a classical building with a grand portico worthy of the 'Athens of the North'.

A finely crafted wooden box lay in the back of the Duke's Land Rover. It was carried with studious care through the security doors to the Department of Conservation in the basement. There, in a well-lit studio that looked like a cross between an unusually tidy artist's workshop and a scientific laboratory, Chief Conservation Officer John Dick tenderly slid the picture and its gilded frame from the velvet lining of the case. The small panel, not quite 19 inches high and 14.5 inches wide, was eased from its frame and clamped onto a stout easel.

Scientific examination of paintings had made great strides during the second half of the 20th century. Before that time, the established method for attempting to catch a technological glimpse of what was happening beneath the surface of old master paintings was X-radiography – basically the same technique deployed in medicine. The other *Madonna of the Yarnwinder* had been examined with X-rays in the early 1930s and a number of *pentimenti* (changes by the artist) had been detected, suggesting that Leonardo himself was involved. The Buccleuch version had thus been relegated to the status of a pupil's copy. It too was X-rayed while it was in Milan in 1939 for a major Leonardo exhibition, promoted by Mussolini as a grand exercise in cultural propaganda.* No substantial *pentimenti* emerged from this examination. This is characteristic of Leonardo's paintings – he certainly changed his mind a good deal, but

* Having lent the picture in good faith, the 8th Duke experienced a good deal of difficulty in getting it returned to him. This experience has made successive Dukes nervous about exhibiting the work in Italy.

earlier designs of the panel did not involve the lead-rich pigments that show up well in X-rays.

By the later 20th century the newer and rapidly improving technique of infrared reflectography (IR) was yielding striking results with Renaissance paintings – typically picking up visible underdrawings unseen since the very earliest stages of a painting's evolution, and perhaps only previously seen by the artist himself. In 1990, when we examined the Buccleuch Madonna, cathode ray technology (similar to that formerly used in televisions) was needed to pick up any images that might be captured.

John Dick brought the IR camera to the easel and panned across the surface of the painting. A magical sequence of elusive images flickered onto the viewing screen, each showing only a small portion of the work. We clustered around, watching the tantalizingly indefinite images arise in jerky sequence. As we became increasingly naturalized in the strange topography of streaky greys, we started to pick out key features of the painting as geographical markers. The whole was later reassembled as a photographic mosaic, a collage of abutting parts with visible seams. All this seemed like a thrilling miracle of technology, although looking back on it from nearly three decades later, the equipment and the results seem primitive.

Looking at images produced by scientific examination is an exercise in patient and selective viewing. Key features may be relatively indistinct and need to be teased out from the general 'noise'; a small feature may tell a big story. As with medical X-rays, it can be embarrassing to admit that we do not 'see' what is being pointed out to us, but for the untrained viewer to distinguish what is significant in the unfamiliar landscape of ghostly traces is difficult, if not impossible. To a large extent, we only see what we are actively looking for. This has its dangers – and we all have a tendency to indulge in 'wishful seeing'.

Gradually, as we gazed at John's screen, exciting signs of the Buccleuch Madonna's underdrawing began to emerge. We could see the firm, simple, confident lines with which the artist had mapped out the main contours of heads and bodies. There were some signs of slight manoeuvring in the drawing of the faces. More strikingly, the child's right arm appeared to have been repositioned, and the Virgin's sharply

Four infrared images from the 1990 examination:
a) the alternative contour of the Child's arm;

foreshortened hand – a particularly difficult thing to draw convincingly – had been subject to careful adjustment, particularly its thumb, which had been more tucked in. As we moved into the middle ground and background of the picture, surprises were in store. To the left of the Virgin's head was a recognizable arch, and to the right there were indications of a landscape with higher hills than those in the painting. There were also suggestions of other inchoate shapes within the lower region of the arch. The results suggested that the Duke's picture was not, after all, simply a routine copy. He appeared fascinated and quietly thrilled.

I proposed that we plan a compact, high-quality exhibition at the National Gallery, where Scotland's wonderfully select collection of old master paintings is displayed. The central idea for the show was to juxtapose the two main versions, together with related drawings. This scheme met with an enthusiastic reception from Timothy Clifford, the imaginative, ambitious and irrepressible director of the National Galleries, and from Michael Clarke, the more measured Keeper. Crucially, the Duke also expressed his enthusiasm. His support for the research was unwavering throughout, despite the possibility that his painting might not stand up to the more sustained scrutiny we were proposing.

b) Christ's head; c) the arch in midground;
d) the alternative contour of the Virgin's thumb.

113

Coincidentally, the gallery in Edinburgh held in its storerooms another eccentric version of the *Madonna*. This painting was not up to Leonardo's quality, belonging instead with the many variants inspired by the original composition. What we did not yet know was that the little figure group in its left middle ground would play a key role as our research unfolded. It shows the Virgin and her inquisitive child with another woman (perhaps a midwife), watching Joseph making a frame on wheels. Joseph was a joiner by trade. The frame is recognizable as a baby-walker of the kind both my children enjoyed before they could walk unsupported. A similar wooden baby-walker was later made for me by my joiner, Gordon Brown, and road-tested by my grandson Etienne. It tended to topple over on rough surfaces. Caterina Cornaro, the 15th-century Venetian Queen of Cyprus, is said to have availed herself of an adult version when her legs no longer bore her where she wanted to go.

The next step was for the National Gallery to enquire whether the rival mother and baby might be available. Without it, there would be no show. The great Leonardo scholar Carlo Pedretti acted as intermediary with the owner of the picture, which turned out to be in New York. Its owners asked the gallery to expand on the rationale for the show and how the painting was to be catalogued. I responded on the gallery's behalf: 'I do not expect the juxtaposition to show that there is a simple answer to the question as to which is Leonardo's "original" painting (if either). Indeed, I do not think this is quite the right question with respect to Leonardo's smaller devotional images.' I went on to say (I hoped reassuringly) that 'from the examination of the Buccleuch Madonna, it is my opinion that it is not wholly autograph, but does involve Leonardo's participation.

Etienne testing the Leonardo baby-walker.

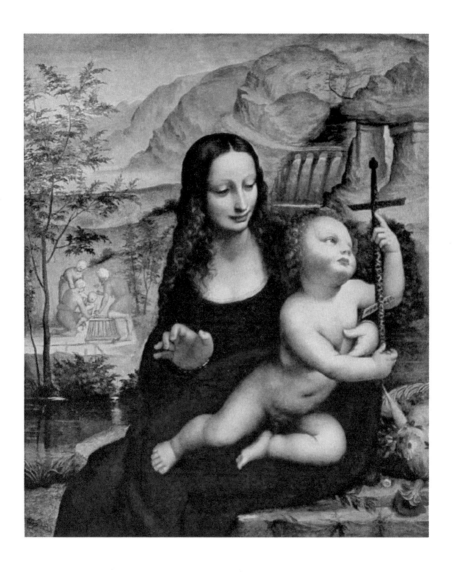

The Madonna and Child with the baby-walker group.
After Leonardo da Vinci, *Madonna of the Yarnwinder*, c. 1520.
Oil on panel, 62 × 48.8 cm (24⅜ × 19¼ in.).

I have no reason at present for regarding the ex-Reford painting less or more favourably.'* This somewhat slippery reassurance seemed to do the trick.

In early December 1991 – at which point the exhibition was still at the planning stage – I was in New York, and was able to arrange to see the *Madonna*. It transpired that it was back in the hands of Wildenstein's, who had reinvested in 1971 at the Christie's sale of the late Robert Reford's collection. At this point, strangely, the painting had been re-attributed to Sodoma. My host at the dealer's sumptuous town house was Joseph Balilio, charming, round, pink, enthusiastic and scholarly – a leading expert on French 18th-century art. He attended patiently as I studied it under different lights with my magnifying glass. It proved to be virtually the same size as the Buccleuch picture, and the figures were on the same scale. I looked at the back of the picture. Whereas the reverse of the Buccleuch version revealed the original panel, the New York version was boxed in so that the rear was not accessible. In any event, the back would have been uninformative. In 1910 the pigment layers had been stripped off the panel (a once fashionable procedure) and mounted on canvas. To make matters worse, the layers had been stripped off the canvas in 1976 and laid down on an inert board. This was not a kind way to treat an elderly picture. The second procedure had been conducted by the Italian restorer Giannino Marchig.

Even though the painting was now mounted onto the flat board, the impress of the earlier canvas was all too apparent. The surface was very different from that in the Scottish painting, even allowing for the latter's yellowed varnish. It looked pale and scrubbed by comparison, and there were areas of missing paint that had been touched in by restorers – for instance, a darkened patch to the immediate left of Christ's lips. Most conspicuously, the area of Christ's genitals was oddly

* The Reford reference was to Robert Reford, a Canadian shipping magnate who had previously owned the painting in Montreal. He had purchased it in 1928 from the leading art dealers Wildenstein & Co., whose stock would form the basis of a very respectable national collection. At that point it was attributed unexcitingly to Sodoma (Giovanni Antonio Bazzi), a colleague of Raphael, but Reford had consulted some leading art historians who encouraged him to think that his painting was by Leonardo.

blurred, for reasons that became all too clear: Thereza later unearthed old photographs showing that a prudish loincloth had once been painted over his penis. The stripping of this loincloth had removed more than it should.

The ravages in the New York picture were clear, but so were its painterly and colouristic delights. The evocative setting of typically Leonardesque mountains surpassed the pedestrian landscape of the Buccleuch version and there were some brilliant passages of painting, not least the eyes of the actors. As I've noted previously, Leonardo characterized eyes as the 'windows of the soul', permitting us to see outwards from our bodily prison and promising access to the inner life of our thoughts. The eyes of the New York Madonna are lowered as she looks anxiously at her son's embracing of the cross, while Christ's right eye is fully visible, portrayed with a moistness and translucent sheen that allows it to perform its pivotal role in the narrative. The child's line of sight is focused on the cross at the point marked by the tip of his index finger, with the short-range engagement typical of a young child who has just learned to recognize objects within reach.

The Lansdowne Madonna: detail of the Child's abdomen and legs.

The Lansdowne Madonna: detail of the heads of the Virgin and Christ.

Many other nice details emerged as I looked at the picture. The way that Jesus' hair curled in vortices like turbulent water was recognizable from Leonardo's water drawings. The painter described a rhythmic interplay between the twisted fabric of the Virgin's headdress and the cascading curls of her hair, at first partly veiled and then emerging in full flow. The diaphanous material of her veil undergoes cleverly characterized optical transitions. Passing across her forehead, it catches the light and appears paler than her skin, while it assumes the guise of a dark filter against the brilliance of the pale mountains. These were just the kind of relative effects of light and dark that Leonardo spent so much time discussing in his notebooks – and they are precisely in keeping with what happens in the *Mona Lisa*.

There was one feature I had not observed previously: a startling series of vivid, blood-red filaments of yarn snaking across the strata of rocks on the right. The reference to Christ's blood was inescapable.

However, the rocks themselves were painted in a routine way, exhibiting none of the geological conviction evident in the strata of the rocks on the right of the Buccleuch picture.

Even without exercising elaborate judgments of connoisseurship, it was becoming apparent that the relationship between the two pictures was complex. Some features in one painting spoke of higher skill and thought than the equivalent passages in the other, and vice versa. The key actors in both were beautifully realized. I explained to Joseph Balilio that the infrared examination of the Buccleuch Madonna had been revealing, and he agreed that the picture owned by Wildenstein's should be subject to comparable tests.

For a time, we heard nothing from New York. The exhibition was getting ever nearer. We eventually learned that the painting was being examined using infrared reflectography in the conservation studios of the very grand Metropolitan Museum, where the equipment was as good as any. The results reported to Michael Clarke on a visit to New York were disappointing. On 31 January 1992 he wrote: '[T]here is apparently little underdrawing visible and what is there is uncharacteristic of Leonardo. There is not a great deal of later restoration/repaint. There is, however, an underdrawing for a small hut in the upper left.' We agreed that this was unsatisfying, and Wildenstein's decided to try again with a good private laboratory. But the date for the opening of the show was fast approaching, and the catalogue was being written.

Then the results of the private examination arrived, and they were remarkable – as surprising as anything I have seen. It transpired that the examination in the Metropolitan had not been as discouraging as first reported. This was very odd, and suggested that someone was playing silly games.

Large portions of underdrawing were visible in the New York painting. Some corresponded to those in the Buccleuch painting, though they were far clearer, given the more advanced equipment. Some features had undergone substantial changes. The upper cross of the yarnwinder was originally planned at a slightly different angle, and a series of yarns hung from it. On the rocks below were a series of curved shapes, which we later realized were spindles (*fusi*) of yarn onto which the thread had

been twisted. To the left of the Virgin some architecture could be discerned, drawn rapidly with a brush. There was an arch in a wall, which we had seen in the Buccleuch underdrawing, and a higher structure like the overhanging roof of a porch. There were also the same curved shapes under the arch.

This startling evidence emerged as the exhibition catalogue was nearing completion. Not all its implications could be fully digested, but there were enough clues to show that the two paintings had been produced alongside each other in the workshop – one to fulfil Robertet's commission, and the other to be sold to a suitable client when the opportunity arose. This meant that there was no lost 'original'.

I was coming increasingly to realize that the whole notion that there must be just one autograph version of a picture, with all others relegated to the status of copies by followers, is deeply flawed. It is a concept that meets the needs of the trade, dealers, auction houses, collectors and curators, all of whom want to believe that they have access to an exclusive 'original'. But it does not fit readily with Renaissance studio practice in the production of small-scale devotional paintings.

The exhibition of the two Madonnas, along with related drawings and other historical material, opened to the public on 15 May 1992 in

Infrared images of the New York version:
a) the arch to the left;

the handsome classical building of the National Gallery on the Mound in Edinburgh. The date was one month after Leonardo's 540th birthday. The Duke ('Johnnie'), in his wheelchair, was the life and soul of the preceding dinner.

After the exhibition closed on 12 July, the National Gallery in London agreed to put the Buccleuch Madonna on show for a few months. The Duke had written to Neil MacGregor, then director of the gallery, suggesting that it might be 'of interest for you to display it until then [April 1993], perhaps in the "grotto" near your Cartoon with which it seemed to me to have an affinity'. This 'grotto' was the small penumbral room that had been specially constructed to house the precious

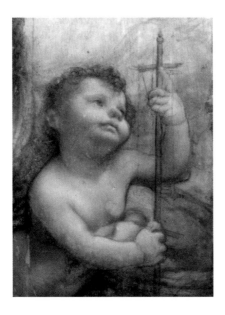

b) *pentimenti* in the yarnwinder.

full-scale drawing for the *Virgin, Child, St Anne and St John the Baptist*. While at the gallery, the painting was to be subjected to deeper analysis with infrared reflectography. The results were no less surprising than those from New York.

Again, very detailed and patient observations were involved. The underdrawing was substantially clarified, as we had hoped. The most startling revelations were in the middle ground on the left. At the level of the Virgin's right hand we could see clear signs of the arched bridge familiar from the New York *Madonna* and the *Mona Lisa*. It was once intended to be present in the Buccleuch picture, but had been eliminated. More significantly, the tangle of brush-drawn contours under the arch suddenly made sense. There, beyond doubt, were the kneeling Virgin, twisting Christ and standing woman of the baby-walker group that we knew from the Edinburgh variant. In the upper right corner of the group there appeared to be the head of a horse, ass or ox. Looking back at the reflectogram of the Wildenstein painting, the presence of the baby-walker group became evident once we knew what we were looking for. In retrospect, it's difficult to see how we missed it.

121

Infrared reveals a) the baby-walker group;
and b) the bridge in the Buccleuch Madonna.

These remarkable disclosures fully supported the idea that the two paintings were commenced more or less together. At some relatively early point Leonardo decided to eliminate the baby-walker group – probably because it was interfering with the impact of the main group in such a small painting. The shared presence of the baby-walker group in the two underdrawings, as well as in a group of variants related to the Edinburgh painting, indicate that the composition of the unfinished pictures leaked out into the work of his pupils and followers.

As it happens (and the story is full of coincidences), the next step came seven or eight years later when Thereza and myself were asked to conduct further research into the New York *Madonna* by its new owner. Wildenstein's had found a buyer. At this point we started referring to it as the Lansdowne Madonna, on the basis that it was first imported to Britain by the Marquis of Lansdowne in the late 18th century. I do not know the price for which it was sold, and never ask about such things.

We had already embarked on an ambitious initiative called 'The Universal Leonardo', supported by the Council of Europe and other generous benefactors.* The brief was to construct a website, initiate a

* This programme was undertaken under the aegis of Artakt, a research and exhibition-making company I founded with Marina Wallace. By the time of the initiative, Artakt had been absorbed into Central St Martin's College of Art, where Marina was Professor. She has over the years been an inspiring collaborator and a close friend.

series of European exhibitions, and stimulate scientific examinations of as many Leonardo paintings as possible. We designated the programme 'the Leonardo Lab'. The Lab centred on the excellent state conservation laboratory in Florence, the Opificio delle Pietre Dure, housed in the former 'Workshop for Hard Stones' in the massive Medicean fortress north of the station in Florence. The Workshop was where renowned pictorial mosaics had been assembled from *pietre dure* in past centuries.

Thereza, back in the UK after a spell in Houston, became a founding member of the Universal Leonardo team. She assumed special responsibility for the Lab, liaising closely with the Opificio and the scientists who were conducting the explorations. The owner of the Lansdowne Madonna generously consented to it serving as the test case for the Laboratory's own research programme, which the Opificio defined as involving eleven separate procedures. Some real courage was required on behalf of the owner. Even in the face of what we already knew, one definitively negative finding could still transform the painting from a Leonardo to an also-ran. He waited with notable patience for a period of seven months in 2002–3 while the small panel took up residence in the Opificio, during which time it was subjected to the most extensive series of tests ever undertaken on any painting. Of the eleven procedures, it was the renewed infrared examination that contributed by far the most to our understanding.

The IR reflectograms produced by the state-of-the-art scanner housed in the Opificio were vivid. We could see, on exactly the same scale as the panel itself, an incredibly high-resolution image of what lay immediately on the surface of the gesso priming – not everything, to be sure, but enough to tell us some very remarkable things. Experienced though they were, Cristina Acidini and her staff at the Opificio (most notably Cecilia Frosinini and Roberto Bellucci) had never seen anything quite like it.

The arch, awning and baby-walker group were brilliantly clarified. The bridge was there on the left, and must have been added after the group was abandoned. The bridge and the group could not have co-existed in any coherent relationship. There was some free brush-drawing around the Virgin's headdress. We could discern the alternative position for her thumb on the Child's chest. The changes in the yarnwinder and its threads were very evident, as were the spindles at its base. The threads

hung vertically between the cross-members, as they should with this kind of distaff. We could also see that the Child's right leg had once been much straighter, and the earlier position of his foot was clarified. We searched in vain for a basket at the Child's foot, as described by Fra Pietro ('The Child has placed his foot on the basket of yarns...'). Thereza thought she could see something, as did the experts in the Opificio. Those later versions which include a basket show that it was the foot of the yarnwinder that was in the basket, not that of a baby. I think Fra Pietro simply remembered or recorded this detail wrongly.*

Leonardo's design processes never fail to surprise. Taking everything into consideration, I can think of no Florentine Renaissance picture that has undergone such remarkable changes during the course of its execution (though Leonardo's unfinished *Adoration of the Magi* exhibits so many fluid and undefined passages that it could only have progressed in a comparably improvised way). The more of Leonardo's paintings we examine, the more it becomes evident that such brainstorming during the actual painting was the rule rather than the exception.

It was towards the end of this 2002–3 sojourn of the Lansdowne picture in Florence that Thereza's phone call arrived at the Villa Vignamaggio announcing the theft of the Buccleuch picture. The press ran with what was a big story. The police announced that they were seeking a white Volkswagen Golf GTI, a five-door saloon car, which contained four men, one of whom was wearing a large white hat. The car had last been seen locally on the Thornhill to Durisdeer Road at about 11:15 hours. Two of the men were described:

1. in his early 40s, 5 feet 10 inches tall, slim build and clean shaven, he was wearing brown shoes, cream trousers with black belt, a cream T-shirt, brown Nubuck leather jacket, a light-coloured brown baseball cap and round framed glasses;

*As always, technologies move on, and these 2003 discoveries were again superseded in 2009 by means of a multi-NIR (near infrared) scanner using fourteen infrared bands. This was deployed by the Opificio to provide even clearer images of Leonardo's many changes of mind – not least those relating to the shaft and threads on the distaff, which looked even more different from the finished painting, and different again from the underdrawing in the Buccleuch version.

2. in his late 40s, 5 feet 10–11 inches tall, slim build and clean
 shaven. He was wearing black trousers, black shoes, cream long-
 sleeved shirt, sleeveless taupe-coloured safari-type jacket with
 lots of pockets and a light cream-coloured wide-brimmed hat.

CCTV pictures and e-fit images were issued; one showed the man in the
flat-brimmed white hat and his partner in crime scuttling into the white
Golf before speeding to the exit of the estate.

Experts were wheeled out by the press to assess the painting and
confirm its authenticity. A series of arbitrary pronouncements were made
by scholars, most of whom had not seen the painting in the original, and
invariably without reference to the technical evidence. They should have
known better. I decided to do just one interview, with Godfrey Barker of
The Sunday Times, not because I particularly like the paper but because
I had dealt with him before and found him to be a clever, serious and
responsible journalist. I explained that there was no lost 'original' – that
both paintings were of high status. He read back my quotes for his piece,
and I confirmed they were OK. There are things I would question about
the story as it subsequently appeared, but I recognize that Godfrey was
bound to report views with which I might not agree. The quoted value
of the painting fluctuated wildly according to whether it was consid-
ered 'autograph' or a studio 'copy' – the upper estimates were in the
£50 million range.

Johnnie was deeply affected by the loss of the *Madonna*, and told
me that he felt he had let Britain down. A serious concern was that the
painting had been stolen by lower-league thieves trying to move into
the big time, who might find that it could not be sold and decide that
it was best destroyed.

The police contacted me to ask if there was anything about the
painting that could reliably identify it as the real thing, should they ever
recover it. Not too difficult, I explained. Two officers from the Dumfries
and Galloway Constabulary visited me at my house in Woodstock,
Oxfordshire, where I took them through unpublished evidence of the
scientific examinations of both versions. They were fascinated, not least
because they recognized similarities with the forensic work used in their

investigations of crimes. But there was no sign of the painting, and the trail seemed to have gone cold.

All we could do was wait. Johnnie followed up a suggestion that the painting was in Milan, but it led nowhere. In September 2003 the BBC programme *Crimewatch* aired a reconstruction in the hope of jogging witnesses' memories. My own best guess was that after a gap of some years the new possessors of the painting would, via intermediaries, contact the loss adjustors who were acting for the insurers, and that they would attempt to strike a lucrative deal for the painting's return. In the meantime, the thieves might well have been using their 'asset' as security in criminal deals, particularly those involving drugs. At least this scenario would mean that the painting was being looked after – it would have been worth less as damaged goods.

Early in October 2007, a little over four years after the theft, a Dumfries and Galloway detective constable telephoned the Department of the History of Art in Oxford, asking if I would contact him. Even before calling back, I felt a rising sense of optimism. The police told me that the painting might have been recovered, and asked about the tests to confirm that what they had was not a clever replacement. I explained that the unpublished IR reflectograms would provide about as good forensic evidence as they might wish for. They asked if I would travel to Edinburgh to look at the picture they had in their hands. I could not go on the first date they suggested – it was agreed that Michael Clarke, by now director of the National Gallery in Edinburgh, would look at it in my stead and I would visit Edinburgh on 24 October, which was my first free day.

Meanwhile, the recovery of the Madonna was announced publicly. On 5 October, the *Guardian* reported:

Police in south-west Scotland said last night that they had
recovered the painting, in an operation also involving detectives
from the Scottish drugs enforcement agency, the Scottish
organized crime agency and Strathclyde police. Chief Inspector
Mickey Dalgleish, who led the investigation, said the force was
'extremely pleased' at its recovery. 'For four years police staff

have worked tirelessly on the theft and with help from the public we have been able to track down the painting.'

Joy at the recovery and the arrests was severely tempered by the fact that Johnnie had died a month earlier, on 4 September 2007, aged eighty-three. He had been informed that there were moves afoot, but did not live to see it confirmed that his beloved Leonardo would be restored to the family.

Arriving in Edinburgh, I was met by a police car to ferry me to the conservation studios of the National Gallery. Entering the same room in which we had inspected the picture seventeen years earlier, I was thrilled to see the small panel lying on a covered table surrounded by delighted conservation staff and two members of the team of detectives. Even from a distance, its radiant intensity declared that the police had indeed got their woman (and baby).

Apart from some scuffing in one corner, the panel appeared to have suffered no damage. The fragile paper labels on the reverse were still

The recovered Buccleuch Madonna,
with National Gallery conservators and two police officers.

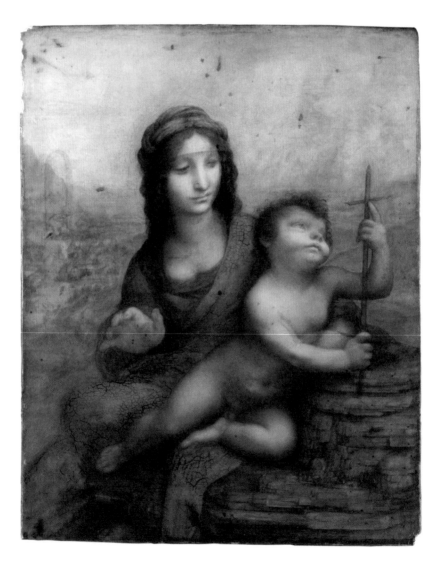

The Buccleuch Madonna under new infrared examination.

intact. It was obviously the real thing, but the police were, as always, interested in hard forensic evidence. The painting was carried into a smaller room, where an up-to-date IR camera was housed. As the camera scanned the surface, it picked up features that the older equipment had missed.[*] We completed the examination for the immediate purposes of identification, but did not at this stage record everything we would need to bring the examination up to the level we had conducted on its sister painting. I left Edinburgh in high spirits.

I composed a report for the police summarizing the results of the analysis; they also requested a formal statement covering everything I knew and could remember from before the theft onwards. Two officers from Dumfries again visited me in Oxford and painstakingly recorded in longhand my replies to a series of questions. These were read back to me with ponderous care before I signed the statement. The idea that I might be a suspect crossed my mind, but the police were simply determined that there should be no loose ends.

It would take more than two years for the case to come to trial. In the meantime, further research on the painting was initiated by Richard, the new Duke of Buccleuch, whose enthusiasm was equal to his father's. In March 2008 he arranged a more detailed examination in the conservation studios of the National Gallery. We renewed the IR examination, this time moving systematically across the picture, taking notes and comparing the underdrawing with the Lansdowne Madonna, which I had as a high-resolution file on my computer. A series of exciting new details emerged.

Most of the changes were comparable but not identical to those in the other *Madonna*. But there were further surprises. The top of the vertical shaft of the yarnwinder was at one point conspicuously further to the left, with threads hanging diagonally and vertically from the left arm of the upper cross. A clearly drawn contour for the child's arm,

*The painting was examined in infrared by Rachel Billinge, Research Associate in the Conservation Department of the National Gallery, London. Infrared reflectography was carried out using a Hamamatsu C2400 camera with an N2606 series infrared vidicon tube. The camera is fitted with a 36mm lens, to which a Kodak 87A Wratten filter has been attached to exclude visible light. The infrared reflectogram mosaic was assembled on a computer using Vips-ip software. This technique was also used to examine the *Virgin of the Rocks* (see p. 216). For further information about the software see the Vips website at www.vips.ecs.soton.ac.uk.

well inside the painted one, confirms that he was once holding the cross closer to his head.

The department also had a newly acquired toy, a very high-quality binocular microscope with which to look at the painting's surface under a variety of magnifications. The microscope disclosed the magical delicacy with which the heads of the Virgin and child, her headdress, her forehead veil, the neckline of her dress, the highlights of his curls and his moist eyes were handled. The edge of the translucent veil above her eyebrows appears to have been painted with a tiny brush and dark pigment as a calligraphic series of broken ripples, brilliantly conveying its delicately scalloped margin. Everyone

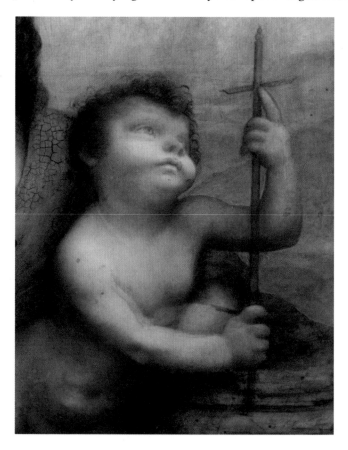

Infrared reflectogram of the Buccleuch Madonna.

present marvelled at the ability of Leonardo to see and operate at such tiny scales, an ability confirmed by the often tiny drawings in his manuscripts.

The quality of key areas of the picture was clearly evident, both in the underdrawing and the final pigment layers. The relationship between the design processes in the two pictures was becoming more complicated every time we looked at them. Clearly, one was not perpetually in advance of the other, with its companion following in the manner of a copy. We had conclusively demonstrated that the two paintings were generated alongside each other in Leonardo's workshop as small-scale pictures of a very marketable kind.

The suspects accused of conspiring to extort £4.25 million for the return of the *Madonna of the Yarnwinder* were tried at the High Court in Edinburgh over eight laborious weeks during the spring of 2010. A motley crew of legal professionals and dubious chancers appeared in the dock. Four men had been arrested, three from Lancashire and one from Glasgow. The Lancashire trio were later named as Robert (Robbie) Graham, John Doyle and a solicitor from Lancashire, Marshall Ronald. Another man from Glasgow, Michael Brown, who ran a private detective agency called Diamond Investigations, was later arrested; as was George Short, luridly described in the press as a 'drugs baron'.

The accounts of the theft and its aftermath that emerged in the trial were riven with inconsistencies. Even now, I doubt whether the full truth is known; but the broad outline of events has become clear. Graham, a publican, and his friend Doyle were sharp small-time operators who had set themselves up as private investigators and established an online business, Stolen Stuff Reunited. They aspired to persuade crooks to return stolen material that turned out to have little easily realized financial value. Graham and Doyle claimed to have been approached in a pub by a man known as 'J', who knew another man called Frank, who knew 'someone'. 'J' told them that the picture had been given to this 'someone' as security on a £700,000 loan for a property deal that had collapsed. The 'someone' wanted his money back.

Graham next involved the solicitor Marshall Ronald, who might best be described as a maverick. Realizing that they needed Scottish expertise,

Ronald contacted the law firm of HBJ Gateley Wareing in Glasgow, with whom he had earlier done business. The next move was to make contact with Mark Dalrymple, the loss adjustor who was acting for the Duke's insurers. The roles of Michael Brown and George Short remain rather unclear, but Short was quoted as saying the painting would be destroyed if the ransom was not paid.

Mark Dalrymple behaved entirely properly, immediately informing the police on the understanding that strict secrecy must be maintained. The police then set up their own sting, with an undercover officer acting as a representative for the insurers and the Duke. This 'representative' agreed to pay £2 million into the law firm's client account, and subsequently another £2.25 million into a Swiss account. He guaranteed that 'he and no other person acting on his behalf...has given any notification or information relating to the terms of the said agreement (nor will do so until after the completion date) to the law enforcement agencies'. To massage the transaction, Ronald apparently used £350,000 of another client's money to secure the release of the painting from the criminals.

It remains uncertain who planned to obtain how much money from the various transactions, but the trio from the North of England were clearly hoping to profit handsomely. There was, of course, also the excitement of being involved with such a big story, and the glamour of association with Leonardo. Even a sober Glasgow solicitor can be forgiven a frisson of excitement at the prospect of a stolen masterpiece being handed over in his office.

After prolonged negotiations a meeting was set up at the solicitors' offices in West Regent Street in Glasgow, with the promise that the painting itself would be present. Undercover police officers posing as loss adjustors were in attendance. They were assured that 'the lady' was close by. The officers were introduced to Ronald, Graham and Doyle in the boardroom, and the painting was then extracted from a black case carried by Doyle. It seemed to be the real thing. Having blocked all routes of escape, the police swooped in, capturing the men in possession of the stolen masterpiece. The Dumfries and Galloway Constabulary were rightly proud of their operation; as one of the officers said to me, 'I normally deal with muggings and slashings.'

I was asked to give evidence about the painting itself and the advice I had given the police. This rather surprised me, since whether the picture was actually a Leonardo or not did not seem to affect the case of extortion. Nevertheless, in March I travelled from Italy, where I had again been staying, to Edinburgh.

The cavernous High Court chamber was filled with serried ranks of lawyers – considerable numbers of them – together with other observers, including the press. It was easy to see why the law is so expensive. The accused sat in a glum row. Under examination from the prosecutor I described the visual evidence of the painting's authorship, explaining how we could be sure that the work which had been recovered was the same as that which had been stolen. I sensed that those in the court were pleased to have a diversion into an artistic realm outside the main legal grind.

During the trial the painting was on show down the hill in the National Gallery, where it remains for the time being. I went to pay my respects. The panel was beautifully framed, mounted and lit. It looked stunning, more than holding its own with Raphael's *Bridgewater Madonna* in the same room. Raphael's composition, in which the infant Christ surges across his mother's lap, is the younger artist's own homage to Leonardo's seminal invention. At one point, the main players in the trial decamped to the gallery to become directly acquainted with the celebrity at the centre of their drama.

I was back in Italy when, in mid-April, the news arrived that majority 'not proven' verdicts had been returned for Ronald, Graham and Doyle. Astonishing! 'Not proven' in Scots law allows a jury to say that the case against the accused has not been demonstrated to their total satisfaction, but it stops short of declaring them not guilty. The two Glasgow solicitors who had been charged were found unanimously not guilty; the charges against Brown and Short were dropped.

Something had gone badly wrong. In my layman's view, the extortion charge was not the right one. A charge of handling stolen goods (or 'reset' in Scots law) might have stuck better.

We might ask whether members of the legal profession and private citizens should be forgiven for not informing the police. All the men

who appeared in court had given what seemed to me rather thin excuses for not doing so. Doyle argued that if they were found guilty, no stolen art would ever come back again. It seems to me that the actions of the English trio were such as to encourage thieves to think that stealing paintings could be a profitable enterprise for all involved, including the intermediaries. In any event, the result confirmed the view I had formed after becoming involved with other cases of art in court: that the law at this level involves elaborate and horribly costly rituals, acted out by lawyers according to arcane internal rules in which common sense and natural justice are all too readily obscured. I feel for the police, who were doing their best.

On 6 July 2010 it was reported that the police had interviewed Marshall Ronald, the solicitor, over allegations he had embezzled £800,000 from a client to fund the recapture of the Buccleuch painting. He has since been struck off the solicitors' register. It must have been galling to the police that Ronald subsequently decided to pursue a claim that he was owed £4.25 million by the Duke and Dumfries Constabulary for his part in safely restoring the painting to its rightful owner – evoking the terms agreed with the undercover officer. On 18 June 2015, his case was decisively rejected. Richard, Duke of Buccleuch, issued a statement to the press.

> I am very pleased that Lord Brailsford has issued an unequivocal judgment in my favour in which he found that the pursuer's case was entirely inconsistent with the evidence that he heard. The theft of the *Madonna of the Yarnwinder* painting was deeply disturbing for my family and it is a matter of regret that court proceedings have continued over so many years. As was made clear in the evidence of three retired police officers as well as my own, my involvement in supporting the 'sting' operation which involved an undercover police officer was entirely at the request of and under the direction of the police. I pay tribute to their patience, persistence and courage in thus recovering the painting. The suggestion that, in doing what I did, I was somehow entering into an arrangement

which could have been illegal has been absurd and I regret
the waste of time and money that it has involved. It is almost
twelve years since the painting was stolen. The *Madonna
of the Yarnwinder* is now on loan to the National Gallery of
Scotland and my family and I are delighted that it can be
enjoyed by the tens of thousands of visitors who visit the Gallery
each year. I hope today's judgment will provide a closure to
a long and heavily scrutinized process and that this supremely
beautiful painting can be thought of for that rather than as a
legal battleground.

Was that really the end of the matter? Experience suggests not.
Many stories connected with Leonardo continue to create ripples for a
long time, and this one has been no different. As recently as 2016, the
Glasgow private detective Michael Brown briefly reappeared in the news
in connection with events in his personal life – hardly noteworthy, except
because of the traces of notoriety left over from his entanglement with
the stolen Madonna. Perhaps there is still hope that the actual thieves
will eventually be brought to justice.

At the time of writing, the *Madonna* still exercises its spiritual magic
among the Renaissance masterpieces in the National Gallery of Scotland.
Without wishing to deprive visitors to the gallery of the chance to appreci-
ate Leonardo's wonderful little picture, it would be nice if it could come
home to Drumlanrig Castle. Do the fraught events of its theft stand in
the way of its safe return to the Duke's castle in the Borders? I hope not.

CHAPTER 5

THE BEAUTIFUL PRINCESS

19 Mar 2008 at 09:35

Dear Dr Kemp

I am writing at the suggestion of our friend Adriano Cera who speaks highly of you as a Leonardo specialist. We have, my wife and I, in our collection an intriguing work on parchment put down on old panel. A number of art historians, many old friends whom I respect, including Nick Turner, Nick Penny, Mina Gregori, Giulio Bora, Adriano Cera etc. have all pointed out that the work is by a left-handed Florentine artist working in the late 15th c. in Lombardy using silver-point (see shading around the face). A Louvre-accredited restorer has confirmed that it is definitely of the period. It seems no one can come up with a name other than Mr. L. As this name is too important to be bandied about I would love to have your thoughts....

The work can be viewed in Paris, where we live. Looking forward to hearing from you,

Yours, Peter and Kathy Silverman

ps I am enclosing also an infrared photo

My heart generally sinks on receiving messages from owners of supposed Leonardos. Pretenders to the august title of 'a Leonardo' surface with tiresome regularity – no wonder, as his work ranks at the summit of cultural possessions. The optimism of these hopeful owners knows no bounds, and encourages wishful thinking and seeing to an extraordinary degree. I was once approached for an opinion on what was clearly a French Rococo engraving of a domestic scene. I pointed out what it was, but to no avail: evidently, Leonardo had invented a painting

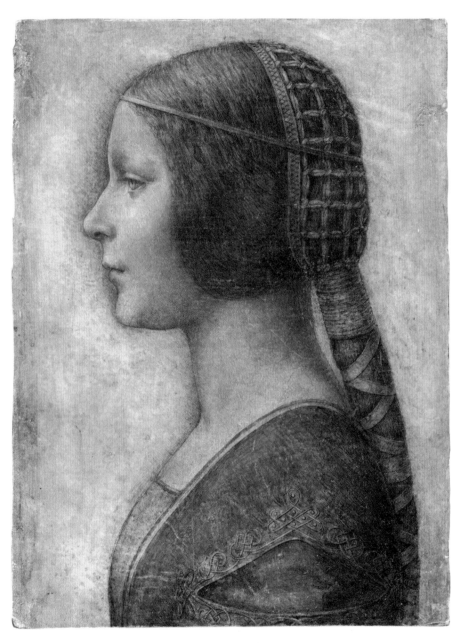

'Almost too good to be true':
Portrait of Bianca Sforza (*La Bella Principessa*), 1495–6. Black, red and white chalk,
heightened with pen and ink on vellum, laid on oak panel, 33 × 23.9 cm (13 × 9⅜ in.).

method that anticipated the most advanced engraving techniques of a period more than two centuries later.

Correspondence in these cases tends to rumble on and the longer it continues, the more likely it is to end unpleasantly. One dealer who owned a freely painted, colourful oil sketch of a young male figure with long curly hair insisted it was a study for St John the Evangelist in the *Last Supper*. He would not take no for an answer. During the course of an increasingly heated correspondence he delivered accusations and eventually threats, apparently composed with the assistance of Google Translate:

> Your false declarations are damaging me ask *ritrattarle* [retract them] or I will be forced to report to the International Court of Justice (ICJ), main judicial body of the United Nations your misrepresentation and make it public on newspapers. Your opinions have been written on previous email where nominal is your mailing address.

One might ask why I respond at all to such correspondents, let alone continue to exchange views. There are two reasons. First, I am conscious that it is a privilege to have become a professor with a profile in the public domain; the position carries with it a responsibility to try to present considered judgments in what are seen as my areas of expertise. Secondly, many of the hopeful owners have gone to considerable lengths in their own research, and the case they wish to advance matters to them a great deal – sometimes to an obsessional degree. Being misguided about a Leonardo attribution does not mean that someone deserves to be treated with disrespect.

As the Silvermans had cited such a roll-call of distinguished art historians, I felt I should probably take notice. For good measure they had attached a digital image of the portrait, and an infrared reflectogram. It was immediately apparent that the drawing deserved to be taken seriously.*

* Technically the portrait is classified as a drawing; it is executed in coloured chalks and ink, with some later painted restorations. In actual appearance it lies somewhere between a drawing and a painting.

It was very pretty, delicate and sophisticated – perhaps too much so. The digital image was of sufficient resolution to allow me to focus on some details. There were clear signs of the intervention of restorers. I responded later the same day. At that point I was interested – whatever it was – but very consciously detached from any initial thoughts about authorship.

> Dear P & K Silverman,
> Many thanks. It certainly looks impressive – almost too good to be true. I'm suspicious of the colour and the costume has obviously been gone over. You do really mean that it is on parchment not paper? This would be odd for Leonardo and his circle. The knotting is just about OK in structure, but I suspect this has also been reworked. This is true of other details.
>
> Recently I've been shown a spate of very clever forgeries, and I assume that something is wrong until proved definitively right. Anyway, it's definitely worth following up. Has Carlo Pedretti seen it?

Peter Silverman's reply amplified the views of those he had cited.

> Thank you for your prompt reply. The restorer who has examined the work certifies it to be of the period and says that apart from some normal old restoration the piece is in rather good state. It is definitely on parchment – which Nick Penny said would not be unique since there are other examples of portraits from late 15th c. on that support....
>
> Now those who have seen it in the flesh so far all agree on the period and the good state of conservation – Nick Turner, the first to suggest the L. idea, Catherine Goguel, who saw it last year and agreed it was definitely late 15th c. and Mina Gregori, who of her own volition insisted on having the honor of being the first to put in writing her conviction that it could only be by L. by

process of deduction – Florentine left-handed artist using silver-point and working in Lombardy. As I already mentioned. As to Giulio Bora, he writes that 'only Boltraffio has this level of quality but he is not left-handed'.

....I must mention that I never set out to establish the work as by Da Vinci but suddenly many important people are saying they know of no other artist who could have done it. So there we have it for the moment.

Nicholas Turner, previously of the Department of Prints and Drawings in the British Museum and Curator of Drawings at the J. Paul Getty Museum in California, is a major authority on old master drawings. Mina Gregori is a senior Italian art historian of international distinction; Giulio Bora is a noted specialist on Lombard art; and Catherine Goguel is a French expert on drawings.

I decided to research the portrait in no different a way than if it were owned by the National Gallery. A work of art is not responsible for who owns it. The job of research is the same, whether it is in public or private hands. I had at that stage no idea whether my investigations would lead anywhere fruitful.

It transpired that the first known public appearance of the portrait had been at an auction of old master drawings at Christie's in New York on 30 January 1998. It was lot 402, the 'property of a lady', catalogued as 'German School, Early 19th Century. The Head of a young girl in Profile to the left in Renaissance Dress, pen and brown ink, bodycolor on vellum'. The estimate was $12,000–16,000 – a goodly price for an Italianate confection by an unknown German artist. It sold to the New York dealer Kate Ganz for the hammer price of $19,000 ($21,850 with the buyer's premium). Peter Silverman had bid up to his predetermined limit of $17,000. Ganz harboured hopes that it was something better than a German pastiche of a Renaissance portrait. She later testified in court proceedings that 'it had a quality about it that made me think of Leonardo Da Vinci, and I thought this looks like it might be something older and better, more important than what it's been catalogued [as]'.

But Ganz's enthusiasm for the Leonardo possibility quickly cooled, and was thoroughly doused when she showed it to Leo Steinberg of the Institute of Fine Arts in New York (who had written a book on *Leonardo's Incessant Last Supper* and was best known as an iconographer). She included it in exhibitions at her gallery in 2000 and 2007, where it would have been seen by a succession of curators from major American museums who knew that she often had items of the highest quality in her stock. As she said, 'My gallery is always visited by the chief old master drawings curator at every major museum in America and other places.' She specifically recalled 'talking about the drawing with the curator of Italian drawings at the National Gallery in Washington, with the curator of Italian drawings at the Getty Museum, with the curator of Italian drawings at the Art Institute of Chicago'. None of them encouraged her initial Leonardo hunch.

It was during Ganz's exhibition in January 2007 that Peter Silverman renewed his acquaintance with the portrait. He had been haunted by memories of the drawing he had missed, and was excited to see it again. During the ensuing conversation Ganz assured Silverman that the drawing, however attractive, could not be by Leonardo. After some haggling and debates about the invoice and payment, they settled on an amount that Kate Ganz says was $21,000 – a modest loss for her on a drawing she had held for nine years without making any progress on determining what it might be. Silverman was thrilled, and took the portrait back to Paris.

He lost little time in showing it to his most respected contacts, most notably Mina Gregori, who became increasingly convinced that it could only be by Leonardo himself. The Leonardo ball began to roll. Silverman was advised to ask Pascal Cotte of Lumière Technology in Paris to undertake technical examinations with his newly built multi-spectral scanner. This not only greatly extended what could be seen with the naked eye, but also provided glimpses of layers beneath the immediate surface.

A decisive turn came when Silverman bumped into Nicholas Turner, who was now working as a self-employed consultant. After inspecting the drawing in the original, Turner composed a carefully researched report,

which he delivered in September 2008.* The report is an exemplary piece of work which reviews all aspects of the portrait and concludes unequivocally that it is a 'remarkable drawing by Leonardo'.

By this point, I too was looking at the possibilities. I wrote to Peter, saying that I had 'been giving some thought to the drawing, not least making some comparisons....I am...mega-cautious about attributions to Leonardo'. After an outline of my main technical and stylistic observations, I chanced my arm.

> My *provisional* judgment is that there is a fair chance that the original drawing is by Leonardo from ca. 1490, and that it has been quite extensively reworked....I confess that, subjectively, what gives me the most uneasy feeling is the sheer prettiness of the drawing. But that is a feeling rather than an objective judgment.

> I should of course like to see it at some point. I have a dilemma here. I have a huge unpaid tax bill and have cut down my expenditure to the bare bones. I never take money for inspecting works, and, following an unpleasant experience some years ago, I do not accept expenses for such things. If the drawing is in Paris, my seeing it will have to wait!

> Since I have not seen the drawing in the original, please do not pass my views on either in full or in summary.

I had not at that stage seen Nicholas's report.

In the meantime, images of the portrait and its story were seeping into the public domain – prematurely, as I thought then, and *very* prematurely, as I now think. Its debut had come in the summer of 2008 in *Leonardo Infinito*, a glossy limited-edition book by Alessandro Vezzosi. He had managed to shoehorn it in just as his monograph was moving

* It is published in full in Peter Silverman's book, *Leonardo's Lost Princess* (2012), written in collaboration with Catherine Whitney.

into production. He speculated, reasonably enough, that it might be a 'nuptial portrait', possibly of Bianca Maria Sforza, the Duke's niece, who married the Emperor Maximilian. Citing Turner, Gregori and Cristina Geddo (an expert on Leonardo's 'school'), Alessandro effectively marshalled some compact arguments in favour of the attribution. His book carried an introduction by Carlo Pedretti, who particularly drew attention to:

> one new previously unpublished item – too important to be skimmed over lightly. I refer to the large drawing on parchment of a *Young Woman Seen in Profile to the Left,* dressed in a lavish Renaissance outfit without jewelry, and presented as a presumed portrait of a 'betrothed bride,' the sort of portrait that one could imagine being sent to a distant prospective groom....The sitter's profile is sublime, and the eye is drawn exactly as it is in so many of Leonardo's drawings of this period. On these grounds, the suggested identification with a 19th-century German artist seems to me unsustainable. Certainly, the insidious possibility of a fake must always be considered, bearing in mind the ability of an artist like Giuseppe Bossi (1777–1815), a noteworthy Leonardo scholar, who assembled a distinguished collection of drawings by the artist, now in the Gallerie dell'Accademia, Venice. Vezzosi concedes the necessity of carrying out further laboratory examinations, which will allow the date of the parchment support, as well as the drawing materials, to be established with certainty.

> Notwithstanding the questions raised by the lack of any known earlier provenance, this work constitutes – at least for the moment – the most important discovery since the early 19th-century re-establishment of the *Lady with the Ermine* in Krakow as a genuine work by Leonardo...

I later learned that Peter had also shown the portrait to Pietro Marani, distinguished head of the Raccolta Vinciana in Milan. It seems that, after

initial enthusiasm and expressing an interest in publishing it, Marani had decided that the portrait was a copy: 'The fact that one is looking at a drawing by a left-handed artist does not carry any weight: there exist copies of drawings by Leonardo made by imitators which present this particular characteristic – by Francesco Melzi, for example, as Kenneth Clark and others have already written.' Pietro has also been quoted as criticizing the 'monotonous' detail, use of coloured pigments in specific areas, firmness of touch and lack of craquelure (fine cracks in the surface). If it is a copy, the question is: a copy of what?

Vezzosi's book, published in an edition of less than 2,000 with a 'hand-numbered seri-lithographic print' of the portrait and costing €1,000, did not initially have a wide impact. However, the story was breaking. On 22 August 2008, *The New York Times* reported that a portrait sold for a modest price at Christie's had now been attributed to Leonardo. The 'Swiss owner' was said to have been offered 'more than $50 million' for it. Peter Silverman was said to be a friend of the owner. Peter explained that he had invented this story of the Swiss owner so as to deflect attention away from the experts who had missed the portrait at auction and in Ganz's gallery. The newspaper cited a series of experts, pro and con, among whom I was rather peripheral. The most serious adverse opinion came from Carmen Bambach, curator of prints and drawings at the Metropolitan Museum and a great scholar of Leonardo drawings, who was quoted as saying that it 'does not seem to resemble the drawings and paintings by the great master.' I had personally shown her a series of digital files of the portrait when I was in New York, and was surprised to learn later that it had *no* apparent resemblance to Leonardo's art in her eyes.

That *New York Times* article definitely comes into my category of premature ejaculations. I am unsure how it was triggered. For a series of experts to be telephoned and asked, 'What do you think of this new work by Leonardo, valued at over $50 million dollars?' when they have only seen poorish photographic images is likely to provoke adverse reactions. The sensationalism of such 'stories' alienates scholars, who are all too familiar with the ridiculous kite-flying in which some avaricious owners indulge. There is also a measure of professional *amour-propre* when one is asked to comment on something that appears without forewarning.

It is not pleasant to feel ignorant about something that one should know about as an expert. Above all, the public debut of a major item should be accompanied or preceded by the full historical and technical evidence being made available in the way scholars regard as proper. For my part, I was quoted as saying that I had not seen the original, but was 'pretty convinced that it is the real thing' – which was stronger than I really intended at that stage.

The opportunity to see the portrait presented itself in an unexpected manner. Jo Ann Caplin, the very able American television producer and academic who founded the Science Television Workshop, approached me about a series of programmes she was developing on art and science. In spring 2008 I did an interview for these programmes. We also discussed the scientific examination of works of art, and I suggested she might shadow the research into the portrait. Her interest had already been tickled by the article in *The New York Times*. It seemed like a good idea because tracking the actual processes of examination as they occur is more vivid than reconstructing them later. Jo Ann raised sufficient funding to cover our travel to Paris, to look at what Pascal Cotte was doing with his fancy equipment at Lumière Technology, and then to Zurich, where the portrait was in store in one of the freeports, the tax-free repositories for artistic treasures. This whistle-stop tour took place in October 2008.

Meeting Pascal in Paris was a delight. Short and stout, with owlish glasses and a perpetual bow tie, he is a one-off – inventively brilliant, sincere, open and (at least in those days) rather innocent of the slippery wiles of the art world. Trained as an optical engineer, he had invented and constructed his own multispectral scanning equipment, which allowed for a work of art to be successively illuminated across thirteen distinct spectral bands and photographed by a camera operating at massive levels of resolution. If a painting or drawing were to be illuminated simultaneously and so powerfully in one go across the full spectral range, it would be fried. Ten of the bands are within the normal visible spectrum, while at either end are two infrared bands and one ultraviolet. The IR bandwidths are particularly penetrative, while the ultraviolet is good at picking up later restorations. A world leader in this type of technology,

Infrared reflectogram of the hatching at the junction of the chin and neck.

Pascal nevertheless tends to be treated rather sniffily by those working in official institutions. He is what they patronizingly call a 'privateer'.

Pascal took us step by step through his images and analyses. What we could see stood up convincingly as a Leonardo. It was possible to draw some reasonably clear conclusions.

What we saw was consistent with the vellum and pigments having experienced quite a tough life. There was extensive and delicate parallel hatching in Leonardo's distinctive left-handed manner, with strokes inclined from upper left to lower right. This was more apparent with the IR images than with the naked eye. The hatching had been reinforced by a less subtle hand. Some more opaque areas of pigment on the cheek and neck had been diplomatically reinforced during an old campaign of restoration, apparently using pastels and liquid pigment applied with a brush to cover areas of damage. Darker ink reinforcements had been added later with a brush, as was evident in the headdress, hair and costume. By looking carefully at greatly magnified images, we could discern that the retouchings were by a right-handed artist.

A handprint in the sitter's neck.

Cleverly, the original artist had left the base colour of the vellum uncovered or little covered in the iris of the eye and some regions of the head, to provide an underlying radiance. The contours of the sitter's facial profile, neck, shoulder and the rear of her headdress revealed some manoeuvring (*pentimenti*) to establish the right outline. There were clear signs in the multispectral images that the outside of the palm of the artist's right hand had been pressed into the pigment layer in the cheek and neck. This is a very characteristic feature of Leonardo's technique.

A small and fragmentary fingerprint was evident, close to the left margin at the level of the woman's hairline. The inky fingertip of whoever held the sheet down was to give us a good deal of trouble.

Looking at the vellum itself, we could see that its left edge had been cut jaggedly and was quite damaged. A crooked vertical incision within the margin at the lower left third of the sheet showed how a knife had slipped when the sheet was being cut.

Somebody's fingerprint.

Where the knife slipped, on the lower left of the vellum.

This clearly indicated that the sheet had once been bound in a manuscript or codex before being excised. Pascal also indicated where he was able to see at least three stitch holes. We could not have predicted where this evidence would eventually take us.

Fuelled by enhanced anticipation, we travelled to Zurich, spic-and-span city of money and bourgeois self-satisfaction, so that Peter could show us his treasure in person. Peter is what is sometimes described as a 'character': lively, personable, enthusiastic, forthright, with darting eyes, a ready smile and a sharp sense of humour. His gracious wife Kathy, trained as an art historian, was the perfect foil, measured, restrained and systematic. We were to be joined by Giammarco Cappuzzo, an art consultant whom Peter trusted and who had arranged for the carbon dating of the vellum. The probable date was determined as between 1440 and 1650 – not precise enough to narrow it down to Leonardo's time, but enough to be encouraging.

The morning after our arrival in Zurich, we drove up to the intimidating entrance of the storage block. Credentials checked, we passed through clanking gates and were directed upstairs to a starkly functional and unwelcoming room. Eventually a small strongbox was brought in, having presumably been retrieved from an ultra-secure bowel. The thin, aged wooden panel emerged with the uneven and creased vellum glued to its surface. It was placed on a sponge wedge on a large covered table.

The actual physical presence of a work of art is always very different from even the best photographic images. Even the small size can be a surprise – in spite of knowing its dimensions. The first moments are always edgy. If a certain 'zing' does not occur, the encounter is going to be hard going. The portrait 'zinged' decisively.

We spent a long time looking, mainly without talking. It is wise to look intensively before using magnifying glasses and comparing with digital images. Looking past the obvious restorations – rather like filtering out the scratchy noises on an old music recording – I could see that the image sang with a refined beauty. It exuded an intimate sense of the sitter's living presence. It was poignant to gaze at the quiet and formalized effigy of a tender young woman, little more than a girl, already locked into her predetermined role – an aristocratic role constrained by social niceties. Likely to be married at the age of thirteen or fourteen, she was destined to be a trophy in a rich man's cabinet. Whoever she was, she might not live long.

Silverman and Kemp: double scrutiny.

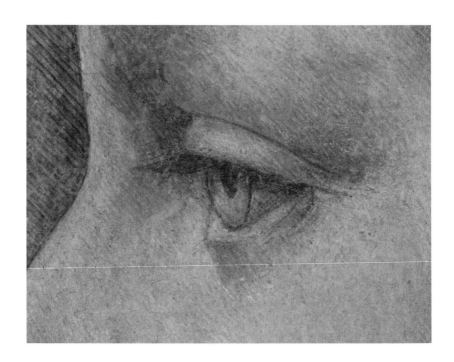

The radiant eye.

A subtle magic emerged, spanning the corrosive years – a magic of the kind unique to really great artists. I began to record in my mind (but not on paper) some of the admiring observations I would later make in print.

A young lady, or a girl on the cusp of maturity, is costumed
for a formal portrait....Her light brown hair, glowing and tightly
bound, is elaborately dressed with a caul of knotted ribbons,
edged by a smaller interlace design. It is held in place by a
thin band located at precisely the right angle on her forehead.
Extruding from the net, her pigtail – the Milanese *coazzone* – is
bound into a neat cylinder by a tightly circled thread. Below this
binding, a flat ribbon disposed in two spirals constrains the
long tresses of her hair, only a little less strictly. The details are
beautifully observed. Her ear plays a subtle game of hide-and-
seek below the gentle waves of her hair. The band pulls the rear
profile of the caul into a slight concavity. Below each band of
the spiralling ribbon, her hair swells slightly before it is
constricted again by the next loop.

The profile of her face is subtle to an inexpressible degree.
No contour, no convexity, no hollow lapses into a steady,
mechanical curvature. The line is incised with stiletto-like
precision, yet retains a living, breathing life. The evenness
of her features nowhere falls into routine generalization.
Those aspects of the faces of beautiful women most extolled
by Renaissance poets – roseate lips and eyes like stars –
are drawn with infinite tenderness. The iris of her pensive
eye retains the translucent radiance of a living person.
Her eyelashes are so fine as to elude a casual glance. The tip
of her upper lip barely touches the pink curve of her lower
lip with extraordinary delicacy....

The beauty of the characterization of the sitter's eye was particularly compelling, and it invariably produces a gasp of pleasure when shown in public lectures.

Such passages of praise were later to be damned as 'advocacy'. Indeed, I am an advocate for Leonardo. Because the newly discovered work was 'in the trade', such appreciation becomes 'advocacy' for the attribution and commercial value of the picture. If I were writing in comparable terms about the *Mona Lisa*, I would not be seen as advocating the attribution of the picture in the Louvre. Whether or not my writing is up to the job, I stand by what I was trying to express about the effect of the image in the original.

I had already written an extended report for Peter Silverman – longer than a standard academic article, shorter than a book. What I had seen and what I was gleaning from my continuing research persuaded me to write a book with Pascal. I would tackle the art-historical dimensions – style, medium, historical circumstance (above all the court context), the costume and hairstyle, the function, possible sitter and its likely origins in a manuscript – while Pascal would look at all aspects of the optical examinations.* We also decided to include a short chapter by fingerprint specialist Paul Biro, who compared the inky fingertip with likely Leonardo prints.

Ideally, nothing more should have appeared before our book was launched. I was very concerned that the piecemeal, erratic and sensationalized release of incomplete stories was proving prejudicial. Early in 2009 I circulated a strategy to Peter and his supporters, proposing that the drawing should be 'exposed in a wholly non-commercial venue at the same time as all the research data and analyses are published in full'. I emphasized that all the material in the planned book should be embargoed before its publication. This placed considerable demands on Peter's uneven reserves of discretion and patience.

My feeling about the need to exhibit the portrait in a non-commercial venue was triggered by having learned from the London dealer Simon Dickinson that he was arranging with Peter to display the portrait at the massive European Fine Art Fair (TEFAF) event in Maastricht in the Netherlands. This annual fair is the biggest and swishiest of all the circuses dealing with historical *objets d'art*. Having attended once and hated it for its stylish pretentiousness and class-ridden arrogance, I was

* I felt it was important that Pascal's analyses should be an equal and integral part of the book rather than tucked away at the end in a technical appendix, as was customary. The prominence given to the science probably did not improve the book's eventual sales.

strongly opposed to the portrait making its public debut in this context. It seemed very likely to cement the view that the attribution was a bit of commercial puffery. Ultimately, to my relief (and perhaps in part because of my objections), the portrait was not exhibited at Maastricht.

Meanwhile, I was seeking a suitable public gallery in which it might make its debut. Finding a major public institution to show a work that is 'in the trade' is hard going. The Albertina in Vienna, with its great collection of drawings, was mooted as an ideal venue and Klaus Albrecht Schröder, its director, was willing to consider the possibility. Peter sent the drawing to Vienna for yet more scientific tests. Klaus wrote in February 2009 that 'we could not share your enthusiasm completely, however it is a very special and exciting drawing. I plan to travel to London in June, on this occasion we could probably discuss our evaluation personally.' I did not hear from him again before seeing him quoted by Milton Esterow in *ARTnews* as saying 'no one is convinced it is a Leonardo'. The findings of the Vienna examination were not disclosed – at least, not to me – and no meeting ever occurred.

The strategy I had outlined fell apart when the fingerprint became the explosive subject of international attention before our book was published. Paul Biro, working from his studio in Montreal, compared Pascal's amplified image of the fingerprint with prints in Leonardo's unfinished *St Jerome* in the Vatican. Paul identified a print in the *St Jerome* which he saw as showing eight points of resemblance with that on the vellum. The most characteristic part of a fingerprint is the complex whorl at the centre of each fleshy pad. This was not apparent in the print on the portrait, which was made by the very tip of a finger. Paul's 'eight characteristics' would not have been enough to secure a criminal conviction, but they were suggestive and supportive. I could more or less see what he was seeing, if I tried hard, and I was happy to accept that he possessed a more expert eye for such things. The fingerprint evidence was a small part of the total fabric of the evidence I was building up.

But a 'Leonardo fingerprint' is news; it has a 'cops and robbers' dimension. The story was broken in the *Antiques Trade Gazette* by Simon Hewitt, a journalist with whom Peter had developed a trusting relationship. On 12 October 2009 the *Gazette* announced:

ATG correspondent SIMON HEWITT gains exclusive access
to the evidence used to unveil what the world's leading scholars
say is the first major Leonardo Da Vinci find for 100 years....
ATG have had exclusive access to that scientific evidence and
can reveal that it literally reveals the hand – and fingerprint –
of the artist in the work. The fingerprint is 'highly comparable'
to one on a Leonardo work in the Vatican.

The article went on to review the other main arguments in favour
of the attribution. But unsurprisingly, the fingerprint became the story,
with what proved to be highly unfavourable consequences.

Some weeks later David Grann of the *New Yorker* contacted me,
explaining that he was 'looking into a story about the new Leonardo
painting'. We spoke at length at least twice on the phone, discussing the
process of attribution. Things then went quiet for a few months. What I
did not know was that Paul Biro was himself becoming the story. Grann's
massive 16,000-word article, entitled 'The Mark of a Masterpiece', even-
tually appeared in July the following year. The first six of its thirty-seven
pages delivered a colourful and largely accurate review of my involvement
and the debates about the attribution. Then the essay metamorphosed
into a demolition job on Paul Biro.

It transpired that Paul had previously achieved some notoriety
in the detection of a purported Jackson Pollock discovered by a truck
driver in a thrift shop. This discovery had been chronicled in a 2006
TV documentary, *Who the #$&% is Jackson Pollock?* Grann went on to
tell a complex tale of Biro's engagements with other Pollock authentica-
tions, in which the artist's fingerprints appeared on paintings that were
subsequently rejected by important Pollock scholars. It was alleged that
Biro had forged the Pollock fingerprints.

David Grann threw a lot of unpleasant mud at Paul Biro. The source
of much of the mud was Theresa Franks, founder of the Fine Art Registry,
who had developed a reputation as an effective and litigious polemicist
about the vagaries of the art world. Franks subsequently claimed that
'I supplied [Grann] with a good number of documents. So, he took that
and ran with it....It was our investigation that really was the catalyst for

that article.' The *New Yorker* piece was hugely damaging for Paul – and for the portrait, because our limited use of his evidence was then used to taint the whole of the case we were making.

Paul was incensed, and his response was to launch a $2-million lawsuit against the publisher, Condé Nast. In this case a central legal issue was whether Biro could be defined as a 'limited purpose public figure'. If so, he would have to prove that both the author and publisher acted with 'actual malice' (whether or not the story was untrue in whole or in part). In time, Paul's case was dismissed. Whatever the rights and wrongs of the court case, Grann's reliance on Franks now looks very shaky, given that her business has since effectively disappeared (as recorded online by Fine Art Investigations). It has apparently been discredited, leaving artists and other clients in the lurch.

Pascal and I had continued to work towards publication during 2009. In the meantime, scholarly articles were being written by Cristina Geddo and Mina Gregori arguing powerfully for Leonardo's authorship of the portrait. A key role in the book's publication was played by Jane Shoaf Turner, wife of Nicholas, the long-term editor of *Master Drawings* and now head of the Print Cabinet at the Rijksmuseum in Amsterdam. Jane was as convinced about the attribution as Nicholas, and threw her energies into the editing and design of the book. For good measure, she translated Pascal's text from the French. The text, illustrations and Jane's elegant design were close to completion by autumn. My agent, Caroline Dawnay, went in search of a publisher, and in November we were signed with Hodder & Stoughton, presenting them with a fully designed, illustrated text.

We set up some advance publicity. I published a piece in the *Independent* in connection with a talk I was to give at the Woodstock Literary Festival. The redoubtable Milton Esterow wrote a characteristically canny and perceptive piece in his journal, *ARTnews*. Again the fingerprint was headlined. The book itself was published in March 2010 as *La Bella Principessa: The Story of the New Masterpiece by Leonardo da Vinci*. Thinking that the portrait needed a catchy name, I had initially favoured *La Bella Milanese*, until Italian friends pointed out that it sounded like a tasty veal cutlet. As a vegetarian, I found this doubly unappealing. The new name has stuck, too firmly.

Reviews of the book were not generally favourable, and not one dealt seriously with Pascal's evidence. The most polemically unfavourable was that in the *Daily Telegraph* on 12 April 2010, written by Richard Dorment, Kate Ganz's former husband. In it, I was characterized pointedly as 'a recognized expert on Leonardo's scientific work' and subjected to heavy denigration. Pascal's chapters were dismissed in a few phrases as 'the complex (and to the layman, barely intelligible) analysis of X-rays, scans, infra-red emission images and so forth'. A museum director, 'who asked not to be named...believes the drawing is not even 19th century, and thinks it is "a screaming 20th-century fake", made up out of a "compilation of obviously Leonardesque elements that is not even close to Leonardo himself"'. Other hostile quotes were duly martialled. I was accused of 'steamrolling the public into accepting [the] attribution'. The aggressive tone struck me as unnecessary, and characteristic of the increasingly personalized nature of such attacks – as if more were at stake than a matter of historical judgment.

One of the adverse factors seized on by Dorment was the exhibition in which *La Bella Principessa* was appearing in Gothenburg: 'And There was Light: Michelangelo, Leonardo, Raphael'. It had been organized by a Swedish company called Excellent Exhibitions and curated by Francesco Buranelli, director of the Vatican Museums, and Alessandro Vezzosi, who had been the first to publish the portrait. The show featured striking multimedia presentations of the great masters, including a full-scale replica of the *Last Supper*, models of Leonardo's mechanical inventions and facsimiles of his manuscripts. The portrait lent by Peter, as one of a limited number of 'originals' in the show, was the star. It was a skilfully mounted and very successful exhibition visited by 250,000 spectators, but as a commercial operation, it did not help the drawing's reputation in the art world. Dorment's reaction was typical:

As part of the promotional drive, the drawing is being shown to the public for the first time – not, as you might expect, in a museum in Paris, New York or London – but in a conference centre in Gothenburg, Sweden. Watching the opening on YouTube is like watching the circus come to town. The picture

arrives in an armoured van under police escort. Flashbulbs pop. A man who is handcuffed to a metal briefcase opens it with a theatrical flourish and then produces the drawing that Silverman (or the 'Swiss collector' he still claims owns the work) is now saying is worth $150 million.

I was not there to witness any of this; nor were any of the major scholars. Peter saw the show as a triumph. I was concerned that it cemented official opinion that the portrait belonged in the commercial rather than the public domain. I was becoming disillusioned with how things were proceeding.

CHAPTER 6

UGLY ARGUMENTS

There, I thought, things stood. The book on *La Bella Principessa* was out, with a strong bank of evidence. Opposition was already entrenched. I was happy to take a back seat, let time pass and allow the personal polemics to fade. Perhaps we would have to wait until an entirely new generation of Leonardo scholars had taken over.

Within a few months, however, the story was radically transformed by two new revelations. Both concerned the provenance of the sheet of vellum. One involved the 'lady' who had consigned the drawing to Christie's; the other, even less expected, concerned the earliest origins of the portrait.

The Christie's 'lady', Jeanne Marchig, was the widow of a noted Italian restorer, Giannino Marchig, who had worked in Florence before moving to Geneva in 1954. He had restored the New York version of the *Madonna of the Yarnwinder*. Madame Marchig was dismayed to find that her 'German' drawing was now 'a Leonardo'. She had told Christie's that it was of Renaissance origin, and that her late husband had attributed it to Leonardo's contemporary Ghirlandaio, who produced some beautiful profile portraits. She testified in the subsequent court case that 'I had inherited the drawing from my late husband, Giannino Marchig (1897–1983), who was an art restorer and artist, and an expert in Italian Renaissance art. At that time the drawing was in an antique ornate Florentine wooden frame, which it had been before I married him in 1955.'

After her husband's death Jeanne had sold some items from his collection via Christie's. Probably the star among these was Piero di Cosimo's *Jason and Queen Hypsipyle with the Women of Lemnos*, which was

Bianca's return: Pascal Cotte and Martin Kemp inserting a facsimile
of the *Portrait of Bianca Sforza* into the Warsaw *Sforziada*.

auctioned in 2007 for £200,000. The portrait we later knew as *La Bella Principessa*, of which she was very fond, was the last of the items to be sold.

In the face of her protestations that the drawing was of Renaissance origin, François Borne, Christie's expert in old master drawings, had insisted that it was a German pastiche from the 19th century. He wrote on 25 July 1997 that 'Your superb German drawing in the taste of the Italian Renaissance fascinates me. I think it is an object of great taste and I would be ready to try our luck with an estimate of $12,000 to 15,000 in New York. As I told you, I would be tempted to change the frame in order to make it seem like an amateur object of the 19th century and not an Italian pastiche.' The Italianate frame was duly removed, despite Jeanne's objections, and was to become a legal bone of contention. She explained that 'as I was in urgent need of funds, I had no choice but to accede to M. Borne's opinions'.

I visited Jeanne Marchig twice in Geneva, in August 2010 and May 2011. Well into her seventies and stoically battling fragile health, she was impressively resolute, articulate and welcoming. She was outraged at Christie's behaviour, both at the time of the sale and when the Leonardo attribution became public. Noël Annesley, then International Head of Old Masters at Christie's, had contacted her at that stage, expressing hope that their differences could be resolved amicably. He and a lawyer had also visited Pascal Cotte in Paris to fortify Christie's against the scientific evidence.

Even though major auction houses trade heavily on the expertise of their staff, which is often considerable, their terms and conditions place limits on the extent to which they can be held liable for their opinions. These provisions are specifically addressed to the buyer who relies on the auction-house description, not to the seller who has consigned the item to the auctioneer. Auction houses are not insulated from any negligent failure to determine the correct attribution of a work, within the limits of the state of knowledge and scholarly opinion or other relevant factors at the time.

Jeanne Marchig, as seller, claimed to have advised Christie's that the drawing was by a 15th-century Italian master, which contradicted their identification of the portrait as originating from the 19th century.

She had the reasonable expectation that the drawing would be properly researched in light of this and not subjected to an instant judgment – particularly one so far removed from the information she had provided.

On 3 May 2010 Jeanne's attorney filed a suit against Christie's, citing the auction house's 'wilful refusal and failure to investigate plaintiff's believed attribution, to comply with its fiduciary obligations to plaintiffs, its negligence, its breach of warranty to attribute the drawing correctly, and its making of false statements in connection with the auction and sale'. The initial court proceedings centred on threshold considerations of law, rather than the substance of the allegations. Christie's argued that the action should be dismissed purely on the grounds that the statute of limitations had run; in other words, the action had not been taken in time. Jeanne argued that she could not have initiated proceedings any earlier, because it was only in 2009 that anyone had proposed Leonardo as the likely author of the drawing.

Christie's rehearsed their arguments. Accurate attribution was impossible because the portrait was coated in a heavy layer of shellac. The new attribution relied on technology not available at the time of the sale. And 'most of the proponents of the new attribution have a significant financial stake in their conclusion'. In the event, in January 2011, the case was dismissed on the grounds that the plaintiff had not 'tolled' the statute of limitations, that is to say, interrupted the running of the statute by commencing an action before her time to do so expired. The auctioneer's due diligence was never tested; the court never heard evidence concerning the question of the drawing's true authorship.

Jeanne and her attorney were not content to let matters rest there. They appealed and, on 12 July 2011, the initial decision of the court was 'affirmed in part and reversed and remanded in part', with respect to the frame that had been removed from the picture while at Christie's and apparently lost. The appellate decision neither considered the question of authorship of the picture nor allowed that question to be pursued in the initial court.

The frame itself has been lost, and is only known through rather poor photographs. It is very odd, and is unlikely to have been of Renaissance origins – it looks like a 19th-century confection based on

Renaissance motifs. Christie's eventually settled out of court, donating an undisclosed sum to Jeanne's animal charity. It has been reported to me that anyone who asks Christie's what they now think is told privately that the portrait is a forgery.

Jeanne died in 2013. Given her insistence that the portrait was owned by her husband before their marriage, the idea that it is 'a screaming 20th-century fake' becomes difficult to sustain – not least because no forger in or before the first half of the century would have known it was necessary to replicate many of the characteristics revealed by Pascal's scanning, or to fortify themselves against carbon dating. This has not stopped accusations that Giannino himself faked the drawing. When I told Jeanne that ArtWatch was implying he had forged the portrait, she

Giovanni Pietro Birago, illuminated title page of the *Sforziada*.

answered, 'As you can imagine, I am outraged by these innuendos.' If her husband was a forger, Jeanne, who was integrally involved in all his business, must have lied in court. It also seems very unlikely that Giannino or anyone else would have gone to the considerable trouble of creating a fake Leonardo without ever promoting it as such. The first person to associate the portrait with Leonardo's name had been Kate Ganz.

The second revelation arrived totally unexpectedly from Professor D.R. Edward Wright of the University of South Florida, whom I had never met, but whose levels of erudition as a scholar of the Renaissance I much admired. David, as he preferred to be called, wrote out of the blue suggesting that the page might have been cut from a vellum book in the National Library in Warsaw. This was one of four presentation versions of the *Sforziada*, a eulogistic book written by Giovanni Simonetta in praise of Ludovico's marital father, Francesco. They were specially printed on vellum. Duke Francesco was to have been the subject of Leonardo's unrealized equestrian memorial. The frontispiece, by the quirky illuminator Giovanni Pietro Birago, indicates clearly that this particular presentation volume was made to mark the union in 1496 of Bianca Sforza, Ludovico's illegitimate daughter, who had been legitimized to make her a fit bride for Galeazzo Sanseverino, aristocratic and knightly commander of the duke's forces. In the bottom panel Birago cheekily portrays Ludovico Il Moro as a dusky infant 'moor', seated on a stone dais and receiving homage from very grown-up babies. On the left a moorish Bianca (with blond hair) arrives on the arm of her future husband. David provided a rich analysis of the iconography of the title page, and explored routes by which the *Sforziada* might have reached Poland.

We already knew that the vellum sheet had been excised from a volume, and we had found some stitch holes. I had thought that finding the book or manuscript from which the portrait had been cut was a distant prospect. Was the Warsaw book the source of the portrait?

Peter Silverman was immediately keen to see if David's insight would prove productive. He went to Warsaw in December 2010 and worked carefully through the book. He detected that there was some kind of stub visible in the binding after page 161. He declared with great excitement that this must be where the portrait had come from. Simon

Hewitt was set to break the story, but I objected. Deciding if there was a page missing from the book would require full examination of the binding and pagination. Placing the portrait where Peter believed it to have been, in the middle of the text about Francesco Sforza's military and political conquests, seemed to make no sense.

Peter had been accompanied by producer David Murdock and a film crew from *National Geographic*. David was planning a programme on *La Bella* as a study in scientific authentication. Meanwhile, Pascal and I were planning our own visit to Warsaw, financed by a National Geographic Expeditions Grant. Negotiations with the National Library had been tricky, but David and his camera crew were given permission to film Pascal and myself examining the precious *Sforziada*, which was deemed a national treasure. We were greatly assisted by the young Polish scholar Kasia Wosniak, whom I had met when she had invited me to lecture in Gdańsk. Kasia's language skills and knowledge of Polish mores served us well. She has subsequently conducted sustained and selfless research into the history of the *Sforziada*, in part financed by Peter. We booked in to see the *Sforziada* at the National Library on Monday, 31 January 2011.

Again we found ourselves in an upper room, awaiting a strongbox. Among those watching was Tomasz Ososiński, a young keeper of early printed books, who was unfailingly helpful. He seemed far more open-minded than his senior colleagues, who appeared to resent us trespassing on their intellectual and curatorial territory, and were visibly uncomfortable with the filming. Pascal had brought with him a camera equipped with a macro lens to take images at minutely graded depths of 0.1 mm, which could be combined digitally to assemble a hugely magnified image of the way the sheets in the book have been bound. He also had with him a micrometer to measure the thickness of the vellum pages, and a spectrometer to record the spectral composition of the light reflected from the surface of the vellum.

The match between the vellum sheets in the book and the portrait proved to be close. We observed definitively that the pages had been severely disturbed in the first quire, or gathering, of the stitched book. All the other quires were composed from four double sheets folded inside each other, comprising eight folios and sixteen pages. In the first

RECTO	BLANK	Missing
VERSO	TEXT	Folio 2
	TEXT AI	Folio 3
	TEXT AII TEXT	Folio 4
	TEXT	Folio 5
	TEXT TEXT	Folio 6
	TEXT TEXT	
	BLANK	Missing
LA BELLA PRINCIPESSA	BLANK	Missing
	BLANK	
COLOUR ILLUMINATION	TEXT	Folio 9
	TEXT B II	Folio 10
	TEXT B III TEXT	Folio 11
	TEXT B IIII TEXT	Folio 12
	TEXT	Folio 13
	TEXT TEXT	Folio 14
	TEXT TEXT	Folio 15
	TEXT TEXT	Folio 16

Diagrammatic reconstruction of the first two quires
of folded sheets in the Warsaw *Sforziada*.

quire there were only five folios, where there should have been eight. The Warsaw book was missing one complete folded sheet and half of another. Did one of the missing pages carry the portrait?

When we reconstructed the original form of the first quire, we were able to identify where the portrait might have been, faced with a blank sheet to stop the transfer of pigment from its surface to one of the printed pages. Peter's stub was a red herring.

This was exciting. We then carefully inserted a very accurate facsimile of the portrait into the place from which we supposed it to have been removed. The fit was very snug.

The stitching in the book was also matched against the holes in the vellum of the portrait. The book is now stitched at five intervals. Three of the stitching points, spaced irregularly, corresponded well to those in the portrait. There was a strong feeling of rightness as we matched the portrait and the book physically, in a way that was quite different from working

with even good reproductions and accurate measurements. It would have been nice to have all five of the stitch holes, but traces of the two intermediate holes in the portrait could well have been lost when the page was sliced from the book. The left margin of the vellum of the portrait is in a rough state and the book has been rebound on more than one occasion, with a paper folio and endpaper inserted at the beginning and end of the volume. Given the changes in the binding and trimming of the sheets, the evidence of missing pages and the physical fit was more significant than the precise number of holes and the dimensions of the sheets.

Nevertheless, the senior staff of the library seemed reluctant to countenance that a Leonardo might have come from their prized book. Did they think it was somehow shameful that the portrait had been excised? This was common enough practice in the 19th century and still happens today in the commercial world. Or did they resent outsiders telling them something that generations of able Polish researchers had not discovered? Or was it more broadly that the stony and insular mores of the old communist regime were hard to shake off? In any event, there was no general sense of pleasure or excitement within the library, and a proposal to publish something by Professor David Wright, Kasia Wosniak and myself in the library's *Bulletin* died a slow death. The researches of David and Kasia still await full publication.

How had a book made in Milan in 1496 come to be in Warsaw? As David Wright had demonstrated, there were a number of possibilities, given dynastic and other contacts between the Milanese court and the Polish nobility. What is certain is that the book was at one stage in the Polish library of the learned Zamoyski (or Zamojski) family. It was owned by Jan, the founder of the library in the late 16th century, as recorded in pen and ink on an inserted paper sheet at the start of the book.

When was the portrait incised from its safe haven? Kasia's research suggests it was removed as a 'work of art' in the earlier years of the 19th century, as happened to many manuscript illuminations. There was a key link between the Zamoyski and Czartoryski families, the latter of which had acquired the wonderful Leonardo painting of the *Lady with an Ermine* (which they identified as *La Belle Ferronière*). Izabela Czartoryska, perhaps the greatest Polish collector, was establishing a notable museum

in Pulawy, the 'Polish Athens'. In 1798 Stanisław Zamoyski married Zofia Czartoryska, daughter of Izabela. Was this the occasion for releasing the portrait from the privacy of its bindings to join the other Polish Leonardo? It would be nice to associate the image of Bianca with a second wedding. I suspect that the peculiar frame was produced in Poland to provide a 'Renaissance-style' setting for the profile. I hope that Kasia's researches will disclose what really happened.

Pascal and I wrote up our findings in time to be fully incorporated in an Italian edition of our book, to be published in 2012. Entitled *La Bella Principessa di Leonardo da Vinci: Ritratto di Bianca Sforza*, it reflected our new confidence about the identity of the sitter. It carried a preface by Claudio Strinati, the former superintendent of museums in Rome. Prestige endorsements are particularly important in Italy, where the public profile of scholars often seems to carry a weight in excess of the actual evidence. The edition was produced, designed and printed with characteristic Italian flair.

For the benefit of the National Geographic television programme I suggested that we attempt a reconstruction of how the portrait was created, working out how ink and chalk on vellum might be a viable medium for an image in a book. We enlisted Sarah Simblet of the Ruskin School of Art at the University of Oxford. I had first encountered Sarah as a graduate student when she was executing huge drawings of the human figure with consummate verve, skill and anatomical understanding. She researched the media, even creating her own iron gall ink from the 'oak apples' that result from wasp infestation. We journeyed to the Buckinghamshire town of Newport Pagnell to visit the firm of William Cowley, which uses entirely traditional methods to make parchment of many types and of the highest quality. The sustained labour and manual dexterity required are of the highest order. Cowley's business has benefited from the continued archiving of all British parliamentary acts on vellum – still the most robust material for enduring records. Cowley's recently reported that 'following a lengthy debate in the House of Commons, MP's have voted overwhelmingly to continue to record acts on vellum'. It is tough stuff, compared to paper and digital records.

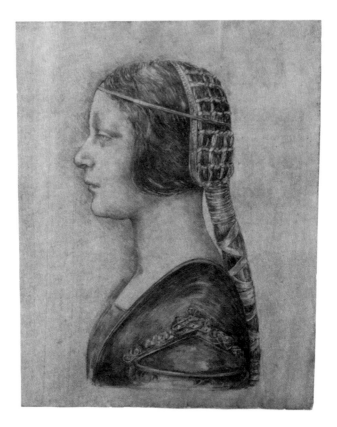

Sarah Simblet, reconstruction of the technique of the *Portrait of Bianca Sforza*.

There is a memo by Leonardo in the *Codex Atlanticus* that reminds him to ask Jean Perréal, a French master of drawing in ink and coloured chalks, about the use of vellum:

> Get from Jean de Paris the method of dry colouring and the method of white salt, and how to make coated sheets; single and many doubles; and his box of colours; learn the tempera of flesh tones, learn to dissolve gum lake...

The very best quality skins of young goats, sheep or calves were hard to come by, and it made sense to extract as many sheets as possible from each stretched and scraped skin. Leonardo's note also encouraged

us to investigate gum arabic for the priming of the vellum and fixing of the chalks. The cameras watched as Sarah experimented. The result was not intended to be a replica of the portrait, but to demonstrate the likely means of its execution. Sarah confirmed that the technique was unusual and difficult, but entirely feasible. It also confirmed that there was no more difficult assignment than emulating Leonardo, even for someone of Sarah's exemplary skill.

David Murdock's excellent programme, *Mystery of a Masterpiece*, aired in the USA on 25 January 2012, and an accompanying print feature appeared in the February issue of *National Geographic*. French and German editions of the programme were broadcast later in the year, and there is also a version with Portuguese subtitles; but it has never been seen in the UK. A Japanese TV company, Documentary Japan, had also produced a programme on the portrait and its authentication following the Japanese publication of our book – this programme, *A Fingerprint of Da Vinci*, had been transmitted in early December 2010. Interviews and on-location filming were accompanied by the kind of picturesque reconstructions that Japanese viewers much enjoy. They also filmed Sarah's reconstruction. The Japanese public shows a particular passion for Leonardo's art and his 'universality'.

Despite the widespread public interest in and appreciation of these programmes and of the portrait more generally, many in the art world remained suspicious of its authenticity. Without a showing in a major public gallery, 'Bianca' was perceived as lurking in the commercial shadows. The route towards an appropriate public debut was via the production of a facsimile of the *Sforziada*. The Italian publisher Scripta Maneant decided that a facsimile of the volume in Warsaw, accompanied by a facsimile of the portrait, would be a striking addition to their list of fine books for collectors. The initial idea was that the portrait of Bianca would be bound into what we believed to be its original position, but this was roundly rejected by the National Library during what proved to be very bumpy negotiations. Instead, Scripta adopted my suggestion that the portrait could be presented separately within a replica of the covers of the version of the *Sforziada* in the British Library (the only copy that retains its lavish binding).

The silver decorations on its velvet covers brandish Sforza emblems and the moor's head of 'Il Moro'.

Scripta Maneant embarked on a quest for suitable venues for the portrait's exhibition. The first venue was the Galleria Nazionale delle Marche, housed in the wonderful castle-palace in Urbino built by Federico da Montefeltro, patron of Piero della Francesca. The presentation was spectacular, with large illuminated panels presenting the evidence in visually compelling ways, not least Pascal's scans and reconstructions. The catalogue contained translations into French, Spanish, Polish, Russian and Japanese. For the press preview in early December 2014 a young model played the role of Bianca, *coazzone* and all. Unfortunately I missed all the fun, having picked up a chest infection at a literary festival in Gibraltar.

The media attention was huge, and I was sent pictures of impatient queues. The catalogue, with a text adapted from the précis I wrote for the facsimile, was introduced by Vittorio Sgarbi, historian, critic, journalist, prolific author, politician and TV personality. He provided noisy and insistent support for Leonardo's authorship, lambasting those public institutions that were reluctant to show the portrait and lacerating critics of the attribution. He was still on the warpath when the exhibition was shown at the Villa Reale in Monza during the huge Expo Milan 2015.

The Monza catalogue also included contributions by Cristina Geddo and Mina Gregori, both now seasoned campaigners in the Bella battles. Elisabetta Gnignera, historian of costume and hairstyles, also contributed a highly informative essay. Her evidence about the authenticity of the hairstyle and its superb portrayal had already appeared in her 2010 book on hairstyles and headdresses in the Renaissance. Her full analysis of Bianca's style has now been published (in 2016, by Scripta Maneant) as *La Bella Svelata* (Beauty Unveiled). Supporting evidence from another area of expertise is very important. Elisabetta has successfully refuted arbitrary declarations about 'faults' in the sitter's costume.

But still there was no showing in Florence or Rome...and stances were becoming even more polarized, opinions hardening. There is a strong tendency in such circumstances for believers and disbelievers to aggregate

into groups. A 'circle' of sorts has formed around Peter Silverman. There are geographical clusters. The auctioneers, dealers and museum curators in New York and more widely in the USA are unlikely to acknowledge a work that escaped from under their noses. In their circumstances, I, too, would probably welcome any evidence that spoke against the attribution. There is also a recognizable 'Polish camp'. Geography plays a larger role in the formation of opinions in art history than is generally recognized.

A good deal of abuse has come in my direction, scattered across the internet and via the machine-gun fusillades of email. Some of it is creative and funny – for example, one from a dealer in the USA (not the same one I quoted previously). Defending Christie's identification, the dealer specifically attributed the drawing to Julius Schnorr von Carolsfeld, a German painter associated with the Nazarene movement who worked in Rome in the early 19th century. I can only give some excerpts from a sustained diatribe.

> The points of connoisseurship you offer as proofs of authenticity are no better than reasons given to a child; they are unconvincing, fallible and inconsequential, proving nothing more than pedantic erudition. As a German 19th-century drawing, a category widely accepted as such by specialists and scholars with no vested interest or hidden agenda, the 'Principessa' can only seem as the height of dishonesty and conceit to claim it as a late 15th- or early 16th-century work by Leonardo da Vinci.... Your keeping the 'Principessa' cloistered and preventing it from being actually examined by the most eminent conservators, Leonardo scholars, and 19th-century scholars has, in spite of this fact, not prevented its widespread rejection as a work by Leonardo....

> No one in your group of experts can be credited with a history of peer-reviewed and successful art discoveries nor have any effectively displayed connoisseurship by discovering the authorship of any comparative works of art, much less Leonardo. The science you cite is nothing more than pompous and

confusing and unverifiable rubbish, signifying nothing but your skill at manipulating digital images to support your case and further proof of pathological liars and sociopaths at work....

Now that you can clearly see that your defense of Leonardo's authorship cannot withstand the evidence against it, I would advise the best course of action to save what is left of your reputations and to save yourselves from being prosecuted for fraud by your publisher and a number of State governments is to admit publicly that you were mistaken and accept Schnorr as the true creator of the 'Principessa'. You have lost the game.

I subsequently received comic notification that I was the proud winner of the '2010 LFS IGNOBLE PRIZE', addressed to 'Dr. Prof. Rev. Martin Kemp, Cardinal of the Unauthorized Church of Leonardo da Vinci Orthodoxy'.

Your Eminence,

As you are the current President and Editor-in-Chief of The Crazy Leonardo Club – Principessa Division, please accept the sincere congratulations of the Lear's Fool Society (LFS) on your club's winning the 2010 LFS IgNoble Prize for Leonardo da Vinci Theory, a newly established category for gold-plated gobbledygook.

Along with a limited edition tin-plated lead medallion depicting Leonardo's Parachute for each of the members including the shadowy Mr. Peter Silverman, you and your fellow alchemists – especially citing the contributions of Mr. Pascal Cotte and Mr. Peter Paul Biro – will receive a year's supply of gift-boxed Leonardo's Meatballs made entirely of organic bullshit, which as Leonardo instructed in his Notebooks, the meatballs can be burned as fuel, used as cannon balls, or boiled and eaten during cold winters of discontent.

Martin Kemp [together with 'the impeccably imperious and pompous couple Nicholas and (faux-book designer) Jane Turner'] was again cited as author and editor of *The Story of the New Masterpiece By Leonardo da Vinci: La Bella Principessa*, an unctuous and slippery-tongued tome with proofy illustrations and pseudo-scientology. The LFS says three cheers for your well-done hoax!

The dealer's name rang a bell. In 2009 he had sent me a purported Leonardo drawing, which I had rejected. I had been offered a 'princely fee' for being involved in its publication. No Leonardo specialist has endorsed the drawing, as far as I know.

At the other extreme was a lengthy rebuttal of the attribution published in a respected academic journal. 'La Bella Principessa: Arguments against the Attribution to Leonardo' was written by Katarzyna Krzyżagórska-Pisarek and published in *Artibus et Historiae* in 2015. The journal is based in Kraków and its editor-in-chef, Józef Grabski, is an experienced and distinguished editor. Pisarek's article appeared systematic and scholarly, but on reading it I identified a number of 'errors, misconceptions and allegations of forgery'.*

Pisarek attempted to reinstate the findings of a distinguished Polish librarian, Horodyski, from the 1950s, in order to deny that folios had been removed from the first quire of the *Sforziada*. However, she failed to realize that there had been a later insertion of a sheet of paper at the beginning of the text – and, assuming that the inserted paper was vellum, she then compared it to the actual vellum of the portrait to declare that there was no match. I wondered how her article had navigated its way through the editorial processes.

Our proposal that the portrait came from the book in Warsaw relies upon a notable set of conjunctions. The book was made for the wedding of Bianca, whom I had already suggested as the sitter. There are demonstrably

* This was the title of a piece I wrote in response and submitted to *Artibus et Historiae*. It was rejected on the grounds that it was 'an errata list' and therefore unsuitable for the journal. Not obviously belonging in any other journal, it was eventually published on the website of Authentication in Art, an organization based in The Hague.

ArtWatch's demonstration of the eye in the *Portrait of Bianca Sforza*:
a) An eye in profile, *c.* 1490, by Leonardo, in reverse; b) ArtWatch's transcription
of the eye in the portrait; c) the eye in the portrait.

pages missing from the first quire, at exactly the point where the portrait
would have made best sense; the match between the vellum of the portrait
and adjacent pages is good; the 'fit' of the portrait into the book is good,
allowing for the rebindings and trimming of the pages of the book; and
what can be reconstructed of the stitching from the damaged left margin
of the portrait is consistent with what we can see in the present binding.
For all these conjunctions to be coincidental is an implausibly long shot.

The underlying implication throughout Pisarek's article was that
the portrait was a forgery. She implied that the late Giannino, as 'a
Leonardesque painter', was the prime suspect. That Giannino owned
the portrait, formerly worked as a painter and became a skilled restorer
is true; that he restored it is virtually certain. But there is not a shred of
positive evidence to suggest that he was a forger.

Pisarek had first come to public notice about a decade earlier with her dismissal of the early painting by Rubens of Samson and Delilah in the National Gallery in London, calling into question the willingness of the director, Neil MacGregor, to pursue the truth. I wondered why she was now so concerned to address this portrait, when she had no record as a Leonardo scholar. I assumed it resulted from a kind of Polish solidarity. I subsequently learned that she was an active member of ArtWatch, which had already undertaken a series of sustained assaults on the Leonardo attribution. I am not imputing a 'conspiracy', but it is undeniable that there exists a clustering of opinions by dint of geography, national and/ or personal proximities and shared interests. We all do it. The best we can do is to be openly aware of the biases that ensue.

ArtWatch and its director Michael Daley are, as discussed in Chapter 2, vigorous campaigners against restoration and highly effective at inveigling unwary scholars into increasingly personalized exchanges. They have exhibited a remarkable keenness to destroy the attribution of the portrait to Leonardo. An example of their mode of visual argument is the detection of 'anatomical errors' in the eye. Alongside a detail of the eye, they place a reversed-image fragmentary drawing from Windsor (which I think is nicely comparable), and Daley's own re-drawing of what he takes to be the way that the draftsman has constructed the eye. Looking at a very high-resolution image of the eye in the portrait, we can see –

allowing for the damaged surface – the incredibly delicate, curving strokes of the upper and lower eyelashes. These are either traduced or omitted in ArtWatch's reconstruction. The stiff lines imposed on the eyelids in the reconstruction also badly traduce the complexities and subtleties of the original draftsmanship. If we want to talk of 'anatomical errors', we may note the difficulties Leonardo had with the lower part of the profile of the front of the upper

LAM image of the underdrawing of the eye in the *Portrait of Bianca Sforza*.

lid in the Windsor eye. Leonardo is drawing an eye, not making an ana-
tomical demonstration.

We now know from Pascal's later analyses that the full iris of the
'principessa's' eye was originally laid in before it was partly covered by
the upper lid. This is characteristic of Leonardo's desire to understand
underlying structures, rather than just imitating surface appearance.

At the heart of ArtWatch's campaign is the allegation that Giannino
Marchig forged the drawing. Again, some excerpts will give a flavour.

> As the only known owner of a work with a five-centuries-long
> provenance lacuna, Giannino Marchig must be considered
> as a potential Leonardo forger....Nothing material here might
> refute a suggestion that Marchig was the drawing's author,
> working on old vellum that was at some point attached to an
> old, previously repaired and labelled panel, thereby conferring
> a spurious antiquity and concealing the back of the vellum....

> In delayed response to our January 2014 suggestion that the
> disputed drawing's author might have been the painter/restorer
> Giannino Marchig...Kemp now alleges on his blog that we
> are making 'scurrilous and unsupported' attempts to 'divert
> the argument into claiming that Jeanne Marchig lied profusely'.
> This is not the first such slur against us from that quarter.
> When Professor Kemp reviewed the...book *Art Restoration: The
> Culture, the Business and the Scandal* in 1994 he made similarly
> unfounded charges which we rebutted immediately. In recent
> years Kemp has cast his denunciations more widely and
> generally against his fellow scholars....

> In Kemp, everything is dunked in pseudo-philosophical
> terminology...some are cowed by Professor Kemp's trademark
> abusive critical put-downs....

> What Kemp sees as a peripheral issue that lacks 'non-arbitrary'
> evidential value, I take to be of the essence in the evaluation

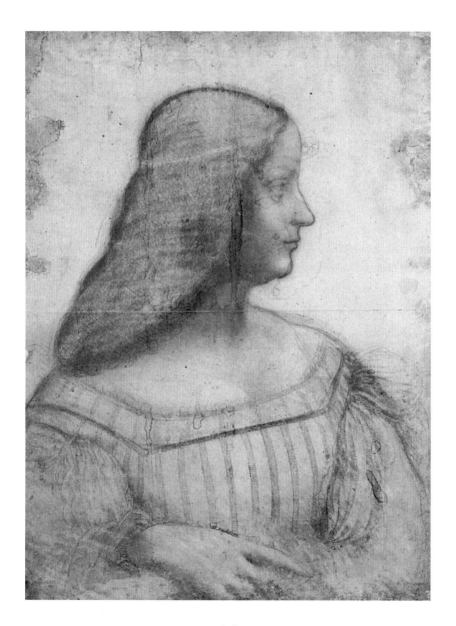

'Anatomical errors':
Cartoon for the Portrait of Isabella d'Este, 1499–1500.
Black and red chalk, yellow pastel chalk on paper, 63 × 46 cm (24⅝ × 18⅛ in.).

Top: The shoulder in the *Portrait of Bianca Sforza* viewed in raking light.
Bottom: Pascal Cotte, reconstruction of the shoulder in the *Portrait of Bianca Sforza*.

and critical appraisal of (visual) works of art...traditional connoisseurship – an area which Kemp frequently disparages on quasi-scientific professional and leftist political grounds....

As mentioned, two decades earlier we had experienced Kemp's invective and sneering distaste for traditional connoisseurs.

Far from denying that 'connoisseurship' has a key role to play, I suggested that it might be reframed as 'judgment by eye' in order to put it on a more systematic and less tainted basis. More on this later. The danger of responding to this kind of polemic is being drawn into the wholly unnecessary personalization of judgments made according to the best of one's ability. Readers can judge for themselves.

The criterion of 'anatomical errors' has been a recurrent feature of criticisms of the portrait. This has applied particularly to the sitter's shoulder. Again, the first thing to say is that Leonardo was not making an anatomical demonstration. He was making a functional image. His drawn portrait of Isabella d'Este is full of 'anatomical errors', above all the absence of any space for much of her right arm to exist. The setting of a detailed and refined image of a woman's head above a relatively schematic shoulder and upper torso is a standard feature of profile portraits of women in both Florence and Milan. It reflects the formula of sculpted portrait busts. Looking at the portrait in its present condition, we may well feel that the shoulder and bust are unduly schematic; in reality, the costume is an area that has been heavily damaged and reworked. A reconstruction by Pascal that clarifies the foreshortening of the interlace pattern indicates that there was once adequate if restrained three-dimensional conviction in this area.

The forgery theory again reared its head from an entirely expected quarter when the notorious forger Sean Greenhalgh claimed responsibility for it. Greenhalgh is a prolific forger of great dexterity and ingenuity, particularly adept at forging sculptural objects from old and exotic civilizations. Born in Bolton in 1961, he was self-taught as an 'artist' and operated a worldwide business out of his modest family home – until he was sentenced in 2007 to four years and eight months in prison.

In Greenhalgh's rather rambling memoir, *A Forger's Tale*, he tells the story of how he forged *La Bella Principessa*. His picturesque account, added at the very end of the book as a kind of afterthought, gained a good deal of media attention on its first appearance in 2015, as it was no doubt intended to do.

Greenhalgh described how in 1978, when he was seventeen years old, he decided to 'try my hand at an "Old Master" drawing....Not particularly a "Leonardo"' on an old vellum document. He rotated the vellum so that he could shade it in an apparently left-handed manner, in order that it appeared to be 'a bit Leonardo-like'. He chose as his model 'Bossy Sally from the Co-op...a glazed and bored girl at the supermarket checkout', presenting her in a 'typical Milanese court dress of the late 15th century'. He then mounted the drawing on a 'Victorian school desk lid' using

'cabinet maker's pearl glue'. The result was sold (without an attribution) to a dealer in Harrogate in Yorkshire in late 1978.

The story is high on entertainment value, not least because it satisfies the public taste for 'experts' and the 'art world elite' being made to look ridiculous, but it is low on credibility. Greenhalgh's detailed account of the drawing's making is an embroidered version of the technical examinations published in the English edition of the book by Pascal and myself. It requires us to accept that a self-taught seventeen-year-old knew more than even specialists in Leonardo and Milan at that time. Awareness of the specifics of the 'typical Milanese court dress of the late 15th century', including the elaborate hairstyle, is the product of comparatively recent scholarship. In a highly amusing way, Greenhalgh the forger has forged his story of his forgery. Initially his claims were entertaining, but after some days dealing with media enquiries from around the world, the joke ran a bit thin. It proved that the silly season for Leonardo never closes.

Greenhalgh's claims triggered a piece in the *Guardian* by the art critic Jonathan Jones, whose writings I generally admire. Jones wrote that

> I have no idea whether or not Greenhalgh – jailed in 2007 for other art forgeries – really created this ugly pastiche. But I am absolutely certain that it has nothing to do with Leonardo da Vinci....

> The real giveaway is the total absence of an emotional dynamic between this young woman and Leonardo da Vinci. She just sits there, waiting, as if she was posing in a passport photobooth. There is no chemistry and no sense of personality....The most damning comparison is Leonardo's most superficially similar work, a profile drawing of Isabella d'Este, Renaissance woman and ruler of Mantua, that is in the Louvre. This may be the inspiration for whoever did La Bella Principessa, but the gulf is so vast between the real thing and the fake. Leonardo makes Isabella warm and passionate and full of energy and intelligence – even uncoloured, she glows. La Bella Principessa is just flat and dead and dull....

Leonardo da Vinci loved women and he worked hard to give them portraits they deserved. La Bella Principessa is a lifeless fake that has none of his vision or delicacy. Personally it looks to me like a Victorian knock-up. The artists may even have based it on a photograph.

For Jones, the whole episode serves as 'a warning of the dangers of scientific analysis replacing the good old human eye'.

It is common for critics of the attribution either to make no reference to the evidence of the technical examinations, or to assert that the science is without value in reaching a judgment. Science is unlikely in most cases to 'prove' an attribution, but it can decisively narrow down and in some instances eliminate possibilities. We have scientific evidence that acts decisively against any of the forgery claims.

The most important finding proved to be in a report I had earlier overlooked. In 2011, the Department of Chemistry at the University of Pavia analysed the white lead pigment using gamma-ray spectroscopy. This technique relies upon the decay over time of one of the radioactive isotopes of lead (lead-210), which undergoes a decay over the course of twelve half-lives, each of 20.4 years. The lead isotope in a sample of the white lead of the portrait had completed its decay, and was therefore at least 244.8 years old. I suppose it could be argued that Marchig or Greenhalgh had somehow obtained unused white pigment that was centuries old; but neither would have known that they had to do so, even were it to be possible.

The science of attribution tends to be regarded as particularly suspicious when the examinations are conducted by a 'privateer'. Before its exhibition at the Gallerie Nazionale in Urbino, the portrait was required to undergo an official examination. This was conducted by the Centro di Conservazione e Restauro in Turin. The centre was founded in 2005 under the aegis of the Ministry of Culture to undertake advanced training in conservation and restoration, and its imaging facilities are of the very highest standard. The results were reported on 19 June 2014, confirming and extending Pascal's findings. The examination disclosed additional *pentimenti*, clear indications of the extent of successive restorations and

other technical evidence that testified to the age of the vellum and its backing board.

What more is needed? Nothing will ever be enough for those determined to find ways of rejecting Leonardo's authorship, who will continue to batter away. The rejections of the attribution have tended to assume an obsessional character. I am happy to rest my case on what we have published rather than getting drawn into unproductive, unedifying and endless tit-for-tat exchanges.

For his part, Peter Silverman has been dismayed at how the worlds of academia and galleries have behaved. He has openly denounced 'the treacherous backbiting, the egos and jealousies' of what he refers to as 'book-smart but object-dumb curators and scholars defending their little bit of territory'. The polarities have become stark, to such effect that judgment and emotions have become inseparable.

Looking back over the controversy, which has become unnecessarily ugly, I am struck by the exaggerated importance attached to being right about authorship. Connoisseurship is regarded as an intensely personal matter, deeply embedded in our artistic being. An act of false attribution is held to impugn the whole of the attributer's professional competence, and even their ethical standing. If I am wrong about the portrait of Bianca, no one has died. Over seventy publications on Leonardo do not suddenly become invalid. I do sometimes wonder if I should have left others to stick their necks out. However, the portrait adds a crucial dimension to Leonardo's service at the Sforza court, and needs to be taken on board.

Following the consuming unpleasantness of some of the debates about the 'Beautiful Princess', I added a statement to my website.

> After 40+ years of responding carefully to every message
> about attribution and other enquiries, including many
> concerning supposed 'secrets' hidden in Leonardo's works,
> I am stepping aside from this aspect of my activity. I have
> been committed to the notion of public service, and have not
> taken any money for opinions, but the quantity of material
> I receive and the abuse to which I am subsequently subject on

the internet means that in the IT age this ideal is no longer sustainable. There is also too much dubious practice in the world of attributions and in the conduct of sales. I am sorry. This is a pity, but my work as a historian in public is being seriously distorted, not least by the unnecessary personalization of arguments about matters of judgment. I will continue to engage selectively with a few major items/issues and with important developments in the academic and public domains. I refer those interested in issues of attribution to http://authenticationinart.org.

This may not make much difference in practice, but at least it gives me the option of not getting involved in some of the personal nastiness that ensues from legitimate divergences of opinion.

There are rumours that one or more buyers are interested in purchasing the *Portrait of Bianca Sforza*. I would be pleased to see it emerge from the limbo that it currently inhabits.

CHAPTER 7

THE SAVIOUR

On 5 March 2008, my birthday, an email arrived announcing the appearance of a new Leonardo – a painting rather than a drawing. I am of an age when one birthday seems much like any other and is best overlooked, but this time the message granted the day a special significance. It came from a well-known source: Nicholas Penny, then director of the National Gallery in London.

> I would like to invite you to examine a damaged old painting
> of Christ as Salvator Mundi which is in private hands in New
> York. Now it has been cleaned, Luke Syson and I, together
> with our colleagues in both painting and drawings in the Met,
> are convinced that it is Leonardo's original version, although
> some of us consider that there may be [parts?] which are
> by the workshop. We hope to have the painting in the National
> Gallery sometime later in March or in April so that it can be
> examined next to our version of the Virgin of the Rocks.
> The best-preserved passages in the Salvator Mundi panel are
> very similar to parts of the latter painting. Would you be free
> to come to London at any time in this period? We are only
> inviting two or three scholars.

To put things in perspective, a demonstrably authentic Leonardo painting had not emerged 'from nowhere' for over a hundred years. The last one had been the so-called *Benois Madonna*, which made its public debut in 1909 and entered the Hermitage in St Petersburg in 1914. We agreed on a date of Monday 19 May for me to travel to London.

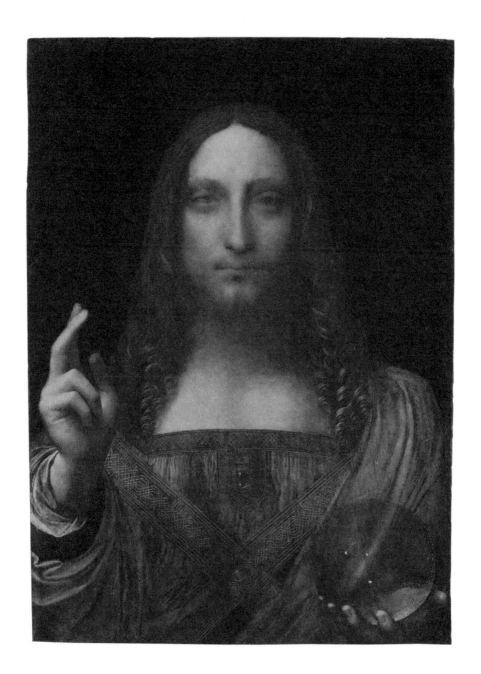

The true Saviour:
The *Salvator Mundi*, *c*. 1490. Oil on walnut, 45.4 × 65.6 cm (17⅞ × 25⅞ in.).

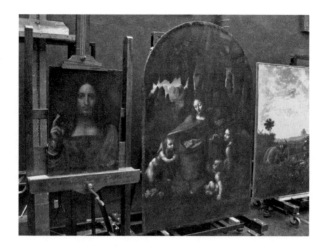

Distinguished company in the conservation studio:
The *Salvator Mundi* and *Virgin of the Rocks* in the National Gallery.

I entered the gallery by the staff entrance and was taken to the conservation studio, where I had been once or twice before. It is a kind of infirmary for paintings with various maladies, and it typically contains an array of pictures in various stages of treatment – all of them known to the public, some of them mega-famous. It is always a thrill to see masterworks close up, without glass and sometimes stripped of previous restorations. In 2007, when the gallery was considering whether to tackle the cleaning of the *Virgin of the Rocks* (which was bound to attract some hostile attention), I had been involved in discussing the pros and cons in front of the painting in the studio.

Today there were more people in the room than normal, including the conservation staff, led by Larry Keith. Two paintings were propped up and clamped to easels. One was the *Virgin of the Rocks*, again out of its frame and naked; the other was the painting mentioned by Nick. Which to greet first – the people, or the new picture? It was a confusing moment. With one eye on the picture I said cursory hellos to Pietro Marani and Maria Teresa Fiorio from Milan, and Carmen Bambach from New York. I was introduced to the art historian and dealer Robert Simon, also based in New York. They had already made the acquaintance of the *Salvator Mundi*.

The painting was asserting its presence in the studio even before I approached it, the image confronting me before I could confront it. It seemed much bigger than it was – actually a little over two feet by one-and-a-half feet. It gave off 'a vibration', to quote its former owner, Dmitry Rybolovlev. In a sense, that was enough. I had seen copies and variants. This was something different. However, not wishing to be seen by my peers as rushing intemperately to judgment, I examined it carefully from different ranges and with my rather battered magnifying glass. I also looked at the back, as any serious art historian should. This showed that the panel, seemingly of walnut, had suffered severe cracking along its curving grain and that a sizeable knot towards the bottom was causing problems. The cracks had recently been stabilized. I later learned that during conservation the cracked panel had been dismantled into separate sections before being reunited.

Signs of Leonardo's magic asserted themselves: the soft skin over the bony joints of the fingers of Christ's right hand, implying but not describing anatomical structure; the illuminated tips of the fingers

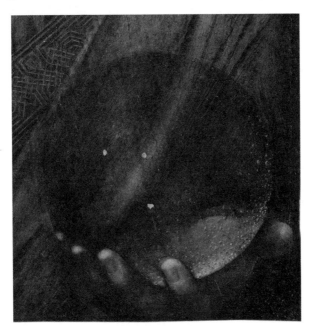

The crystalline sphere.

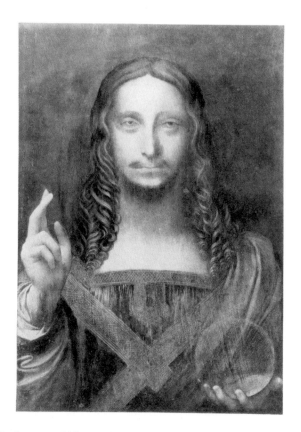

The drug-crazed hippy: *Salvator Mundi* before cleaning and restoration.

of his left hand; the glistening filaments of vortex hair, above all on the right as we look at the picture; the teasing ambiguity of his facial features, the gaze assertively direct but removed from explicitness; the intricately secure geometry of the angular interlace in the neckline and cross-bands of his costume; the gleaming crystal ellipse on the pendant plaque below his neckline; the fine rivulets of gathered cloth on his chest. *Mona Lisa*-ish echoes were sounding loudly.

I stared hard at the sphere cradled in Christ's left hand. Damage was very evident, as elsewhere across the surface, but I could see that it was absolutely not one of the standard kinds of orb, and did not seem to be a hollow sphere of glass speckled with bubbles. It looked like rock crystal with 'inclusions' – small gaps of varied configurations, laid down

as the crystalline substance was generated as a liquid under intense heat. I just about recalled something I had seen when ineffectually studying a half-subject in geology at Cambridge. I had been visually fascinated by the specimens of crystalline minerals in the museum, but not much engaged with proper geology. I said now, to the others gathered in the conservation studio, 'That's a rock crystal sphere' – probably with more confidence than was supportable at that stage. If it was crystal, it signi-fied the crystalline sphere of the heavens. But there was much to do to make this stick.

No one in the assembly was openly expressing doubt that Leonardo was responsible for the painting, although the possibility of participation by an assistant or two was generally acknowledged. I sensed that Carmen was the most reserved about the painting's overall quality. A general discussion followed. Robert Simon, the custodian of the picture (whom I later learned was its co-owner), outlined something of its history and its restoration. He seemed sincere, straightforward and judiciously restrained, as proved to be the case in all our subsequent contacts. We looked, we talked and we looked again. It was a remarkable occasion. By the time I left, I was determined to research every aspect of the *Salvator Mundi*. It seemed at first sight to resonate deeply with key aspects of Leonardo's science of art and his views of the role of God in the cosmos.

I remained in touch with Robert Simon, who is strongly committed to scholarly research. I learned that the eloquent painting we had viewed was in fact one of the known versions of the *Salvator Mundi*, formerly in the Cook Collection – previously heavily overpainted, it had now been cleaned and retouched. It had never before attracted serious attention; we had paid only passing attention to the black-and-white photograph (left) of it that had occasionally been used as an illustration. I had in fact once described it as looking like 'a drug-crazed hippy', and dismissed it as one of the nastier copies. We should have looked more carefully.

The collection of paintings owned by Sir Francis Cook, built up from the late 1860s onwards, ran to well over six hundred items and was one of the finest in private hands. His Italian Renaissance holdings were a particular strength, and many of them now adorn major galleries around the world. Cook acquired a good number of the best items from the

Telling *pentimento*: alternative thumbs.

art historian and collector Sir Charles Robinson, who was also responsible for many of the founding acquisitions of the Victoria and Albert Museum. It was via Robinson that the *Salvator Mundi* came into Cook's hands in 1900. We do not know where Robinson found it. Cook did not rank it as one of his more prestigious holdings – it was posthumously listed in his collection as number 106: 'Boltraffio, Giovanni Antonio, after'. Although Boltraffio was a highly rated pupil of Leonardo, to be 'after Boltraffio' is definitely not a high rank. The painting had been marginally upgraded to Boltraffio himself when the Cook collection was sold at Sotheby's in London in 1958. It was then 'knocked down' to 'Kunz' for the small sum of £45. The identity of 'Kunz' is unknown – perhaps a bidder's pseudonym adopted as a pun on *kunst*, the German word for art.

At some point the painting entered an American collection. It crossed Robert's path in 2005 when it came up for sale at a regional auction house in Louisiana. Robert and his fellow New York dealer Alexander Parrish, who had also noticed it, thought it might be a bit better than it superficially looked – without imagining that it might be the original. They decided to bid by proxy, and met with success, apparently acquiring it for less than $10,000, which at the time would have seemed like quite a high price. Examining the painting after its arrival in New York, they noticed glimpses of revelatory light shining through the gloom of heavy overpainting. Some of the details looked extraordinary. Whatever the painting was, it was undeniably old and interesting.

The next step was to have it examined by an expert conservator. Wrapping it unceremoniously in a bin liner, Robert took it by taxi to the noted conservator and connoisseur Mario Modestini (then not far short of a hundred years old) and his wife Dianne Dwyer Modestini, who

taught at the Conservation Centre at New York University's Institute of Fine Arts. They shared his view that the painting had 'expectations', if not necessarily 'great' at this stage. A small test clean was encouraging to a startling degree, and Dianne stripped off further areas of disfiguring grime and overpaint. The presence and quality of the image, not least some of its scintillating paint handling, were beginning to assert themselves. Particularly telling was a clear *pentimento*: Christ's right thumb had been painted in two different positions, and had originally been straighter. All other copies of the work showed the somewhat more bent position of the thumb. This, while not conclusive, was a good pointer that they were indeed dealing with the original.[*]

The walnut panel was in an extremely fragile state; it needed urgent and radical treatment. Monica Griesbach, a specialist in such matters, was enlisted. She carefully detached what had in effect become two separate boards, together with five small fragments – radical indeed. By means of careful reassembling, with some added fillets of old walnut, the structural integrity of the wood and paint layers was secured. Dianne's work on the painting could continue in 2006, culminating in her painstaking and diplomatic filling in of lost areas with readily soluble paint.

Robert pursued his own fundamental research with intensity. He assembled a large bank of reference images, including a growing number of copies or variants which testified to the hold that Leonardo's inventions exercised on other artists and patrons. He also arranged for the panel's scientific examination with the latest technologies (more about this below). Such was the state of play when he showed the *Saviour* to Nicholas Penny, who recognized it as very special – as exhibiting the 'weirdness' that Nick described as typical of Leonardo. It was at this stage that Nick set up the National Gallery viewing I attended.

All of the witnesses in the gallery's conservation studio were sworn to confidentiality, and the painting travelled back to New York with Robert. It was becoming 'a Leonardo'. No more bin liners! Robert recounted that he felt 'like Fredo Corleone in *The Godfather* taking a million dollars in a suitcase to Cuba'. As he passed through customs with what was declared

[*] The first version of the thumb has now been painted over again, which I think is a pity.

as 'One painting by Leonardo da Vinci', a customs officer insisted that the sealed case should be opened. The motive was not exactly official: the officer wanted to see it because, as he said, 'I'm an Italian-American, and I have to tell my grandchildren.'

Robert and I corresponded during the course of that summer and autumn. I was pushing on with research on several fronts: the iconographical type of the *Salvator Mundi* as a distinct subject; the two related drapery drawings at Windsor; the relationships between the painting and the best of the copies; the optical qualities of Leonardo's depiction; the description of the sphere in Christ's left hand; and the earlier ownership of the painting. I visited Windsor to look at the drapery studies and all Leonardo's related drawings of folded cloth, endeavouring to arrive at a chronology of his drawn and painted draperies. I also looked in Windsor at an engraving of the *Salvator*, inscribed 'Leonardo painted it/Wenceslaus Hollar made it in etching, from the original, in the year 1650'. Since Hollar engraved items in English collections, most notably that of Charles I, an English provenance seemed likely.

By a happy coincidence, Margaret Dalivalle, a Scottish graduate student whom I had taught in Oxford, was acquiring great expertise in the inventories of British collections of the 17th century. She set to work on published and unpublished inventories, and reported to Robert in October that she had 'tracked the picture' to its inclusion in the 1649 Commonwealth Sale inventory, compiled after the beheading of Charles I. The king's many creditors were being reimbursed with items from his world-class collections. Margaret found that Charles's *Saviour* had been sold to Captain John Stone (son of the royal mason Nicholas Stone) and that it featured in Stone's declaration of what remained of his 'dividend' at the Restoration of Charles II in 1660. She also reported that she had found the *Saviour* – 'to my great (and muffled) joy' – in the numbered list of the 'King's Closet' in Whitehall. It featured as number 311: 'Leonard De Vince O.r Savio.r w.th a gloabe in one hand & holding up y.e other'.

We could not be absolutely sure that Charles's Leonardo was the same as 'Robert's' Leonardo, rather than one of the copies, but it seemed highly likely. Margaret was subsequently able to trace the picture back to the beautiful Queen's House in Greenwich, where it was in one of the

'closets' of Queen Henrietta Maria, Charles I's Catholic wife. She was also able to track its later history, though not as yet as far as the Cook collection.

The most satisfying facet of my own research concerned my hunch that the globe was made of rock crystal. I needed to top up my thin geological knowledge. Two of the advantages of working in Oxford are the range of expertise at hand and the richness of the university's collections. I turned to Monica Price of the University Museum of Natural History for a hands-on briefing about rock crystal. She explained about the formation of the quartz rock crystal and the presence of inclusions. We looked at specimens. I had toyed with the idea that the double image of the heel of Christ's right hand visible through the sphere might be the result of the double refraction characteristic of rock crystal; but the optics would not work. The apparent doubling is almost certainly another *pentimento*.

It became evident that substantial pieces of rock crystal were likely to exhibit both inclusions and jagged cleavage planes, compromising the 'purity' for which the best crystal is prized. I began to understand why flawless pieces were so highly valued in aristocratic collections. They were also considered appropriate for small windows in expensively designed reliquaries, through which we peer at the fragmentary remains of long-dead saints – a finger-bone of John the Baptist, or a splinter from Christ's cross. Large, unblemished pieces of crystal are very rare, and are often endowed with spiritual properties in their own right.

Leonardo himself was considered something of a connoisseur of such precious and semi-precious materials. In 1502 Isabella d'Este, writing from Mantua, sought Leonardo's opinion about vases of crystal, agate, jasper and amethyst previously in the hands of the exiled Medici family. She learned that Leonardo 'greatly praised them all, but particularly the one of crystal, which is all of one integral piece and very clear'.

Rock crystal sphere
owned by John Tradescant.

Oxford also delivered an actual sphere – a notable example in the possession of the Museum of the History of Science. At a little under two inches in diameter, it is quite large, as spheres go. It was owned in the 17th century by John Tradescant, an avid collector of curious things, who placed it proudly in what he called his 'Ark' – a museum worthy of Noah. The contents were to be presented to the university by Elias Ashmole, who had wheedled his way into inheriting Tradescant's treasures. We inspected Tradescant's sphere and strove to photograph it in lighting conditions that brought out its similarities to Leonardo's painted example. By eye the resemblances were close, not least the refracted glow at the base of the sphere and the glimmer of inclusions. Photographing it was a very different matter, and we never quite managed to capture what our own flexible visual systems could see.

I also scrambled in the trays of small crystal pebbles one sometimes sees sold in shops for their supposed magical properties, and found a few that resembled Leonardo's sphere – albeit on much smaller scales. The lighting set-ups used to photograph the Tradescant orb and the smaller pebbles confirmed that a sphere illuminated as in Leonardo's painting would have had a shiny highlight towards the upper left. He is unlikely to have left this out, and it seemed likely that the raised area of white pigment had been abraded off at some point in the painting's chequered history.

We should remember that Leonardo was drawing on his knowledge of rock crystal to devise a large sphere for Christ to hold – he was not making a 'portrait' of an actual sphere, nor was he following all its optical consequences to their logical conclusions. I have been asked on more than one occasion why the drapery behind the sphere is so little affected by what is, in effect, a large magnifying lens. The answer, in a word, is *decorum*; that is to say, pictorial good manners. Leonardo observed many visual effects in the real world, such as the blur of very fast-moving objects, that he would never have incorporated into paintings. He believed that such extreme effects belonged to the world of 'speculators' on natural phenomena rather than to the art of painting. He knew about refraction in water, but he certainly would not have portrayed Christ's legs as optically bent in a *Baptism*. Leonardo's paintings remake nature – not only in accordance with natural law, but also in obedience to the rules that

Raphael's *Astronomy* with her crystalline sphere. Detail of ceiling fresco.

govern functioning images. He would not have disrupted the efficacy of the painting as a devotional image.

Leonardo's endowing of Christ with a rock crystal sphere was not just a case of optical and geological cleverness for the sake of it. The finite cosmos of Ptolemy comprised a series of orbital spheres around the central earth. The ninth was the *crystallinum*, outside the sphere of the fixed stars that comprised the zodiac. The tenth sphere was the 'prime mover' – what Leonardo called the *primo mobile* – which was the unmoved mover of the whole system. Nothing stood beyond this except for God and his heaven.

On the ceiling of the Stanza della Segnatura in the Vatican, Raphael depicted the allegorical figure of *Astronomy* as an awed witness of the

cosmic orb adorned with the figures of the zodiac. Leonardo's Christ, cradling the crystalline sphere in his firm hand, was in the same external position, acting in effect as the prime mover, beyond the finite spheres of the material cosmos and therefore beyond the reach of our human senses. As God's son incarnate he had become visible in fleshly form on earth, as in Leonardo's picture, but he brought with him an aura of ineffability – of something unfathomable to our dull understanding. It is this aura that Leonardo evokes though the elusiveness with which he describes Christ's features. We seem to see them, but they elude us. As always with Leonardo, form and content are one – and novel.

I checked in the photographic library of the Warburg Institute to see what other artists had made of the orb in images of the *Salvator*. There was quite a variety. Brass globes were common, sometimes with a cross on top. Some took the form of terrestrial globes with indications of land and seas. Others were made of glass, and a few contained little landscape vistas. In two Venetian examples Christ placed his hand on an ample glass orb – appropriately enough, given Venice's pre-eminence in glass manufacture. But none seemed to show a crystal sphere.

I wondered why Christ's soft-focus features contrasted so strongly with the precise definition of his right hand. Was it simply a question of condition? It was true that the face was quite abraded; but even the best-preserved parts, such as his left eye, seemed blurred. Or was it what photographers call a depth of field problem? If a camera lens is physically or digitally focused on a form at a certain depth in a scene, objects closer or further away will be out of sharp focus – increasingly so as they are more distant from the focused zone.

Depth of field in photography is an anachronistic concept when looking at a Renaissance painting. However, in the little manuscript that Leonardo produced entitled 'On the Eye' around 1507, he explored the reasons why vision worked less than perfectly under different circumstances. He stated that something would not be seen well if much too close, and it would lose clarity as it moved further away (though he did not have any sense that the 'lens' of the eye focuses our vision). He realized that there was an optimum distance at which something would be seen most sharply. Christ's hands are at this distance. The softening of

Christ's more distant facial features works to define depth in an image that is otherwise very shallow, and serves brilliantly to evoke the otherness of Christ's gaze. If this interpretation is right, it is a nice example of Leonardo's science serving spiritual magic.

Contemporary science also played its role. Robert Simon sent me images of the scientific examinations undertaken by Nica Gutman Rieppi, who was a colleague of Dianne Dwyer Modestini at the Institute of Fine Arts. As is generally the case with Leonardo, infrared rays delivered the most striking results. It was good to be able to see that the painter had pressed the edge of his hand into the tacky paint above Christ's left eye – which we have seen to be characteristic of Leonardo's technique. We could also observe more clear evidence of details being designed as the painter went along. Most conspicuously, there were plentiful signs of fiddling with the golden interlace patterns on the bands across Christ's costume. The gold thread was originally interlaced in a more curvy mode than the angular geometry that we now see. The curvy knots are like those Leonardo designed when in Milan. I remembered that he had been in the great trading city of Venice in 1500, where he would have seen Islamic pattern designs based upon intersecting criss-crosses at 45 and 90 degrees. This implied that the panel was being painted after 1500.

The white lead of the final layer of priming was lightly tinted with yellow. Ground particles of glass were found in the various layers – an odd technique, even for Leonardo. Was he aiming to endow the paint with special luminosity?

By early November 2008 I had a substantial essay of more than 8,000 words in draft, albeit with further research to conduct. The draft expanded as months went by. At one point it was entitled 'New Wine in an Old Bottle', to acknowledge that Leonardo had endowed a very traditional format with radically new features. On a trip to New York during a few brutally cold days before Christmas, I visited Robert and the painting again to check my observations and to see Dianne's most recent conservation work.

What to do with the developing essay? Its destiny became caught up in plans that had long been brewing at the National Gallery. As early as 2007 Luke Syson, the energetic, cheery and ambitious curator

responsible for the Italian Renaissance paintings, had been discussing with me the possibility of a major Leonardo show in autumn 2011. The plans, focused on Leonardo's years at the Milanese court of Ludovico Sforza, were about as ambitious as they could be. The idea was to borrow as many of Leonardo's paintings from this period as were obtainable, including the Paris version of the *Virgin of the Rocks*, which would join its London counterpart, probably for the first time ever.

At that stage it seemed likely that I would have some curatorial input, but it was later decided that all the curation should be conducted in-house. The *Salvator Mundi*, unsurprisingly, was on the loan list to make its public debut. The Buccleuch version of the *Madonna of the Yarnwinder* was also to be requested; but not the *Bella Principessa*. Peter Silverman considered that this omission was a dereliction of duty by the gallery, in the persons of the Director and the trustees. He unwisely enlisted a lawyer to write sternly to Nick Penny emphasizing that the gallery had a public duty to show the Milanese portrait of Bianca Sforza. Having learned that the *Salvator* was to be shown, Peter's lawyer demanded 'consistent and non-discriminatory treatment for *La Bella Principessa* and *Salvator Mundi* and their respective owners'.

I explained to Peter that were I a trustee of the National Gallery, I would have supported the Director on the grounds that the portrait was apparently 'in the trade'. By this point I had served as a trustee of the National Galleries of Scotland, the Victoria and Albert Museum and the British Museum, so knew my way around this issue. Nick's letter of response emphasized that the content of the exhibition was a matter for the curators' judgment, free of pressure from owners who thought their works should be included. This implied, but did not state, that neither he nor Luke Syson believed in *La Bella Principessa*.

This episode highlighted the rationale for the inclusion of the *Salvator Mundi*. Was it on the market? Would exhibiting it mean that the National Gallery was tacitly involved in a huge act of commercial promotion? It seemed highly likely that it was also 'in the trade'. All I knew at this stage was that it was being represented by Robert Simon. He told me that it was in the hands of a 'good owner' who intended to do the right thing by it, and I did not enquire further. I was keen to consider

the painting in its own right, not in relation to its ownership. I speculated, of course, that Robert might have a financial interest, perhaps a share in its ownership; and I assumed that he was gaining some kind of legitimate income from his work on the picture's behalf. But the gallery was assured that the painting was not actively on the market. Understandably keen to exhibit it, they were happy to accept this assurance.

That the *Salvator* was to be exhibited in what would be a block-buster show altered everything, including the publication schedule for my study of the painting. Robert thought it was a good idea to publish a book of essays by various authors, including Margaret Dalivalle and myself. Yale University Press, which does not normally publish monographs on single paintings, was signed up as publisher. I was happy to go along with this, while expressing reservations about a volume with multiple authors being completed on time. Academics are notably adept at missing deadlines, and I was unconvinced that all the authors actually had anything new to say. My rule of thumb is that having two authors to write a book increases by 20 per cent the likelihood of non-delivery on the deadline. By the time five authors are involved, the likelihood has effectively increased to something like 100 per cent. In the event the complete book was not delivered and, deprived of the rationale of selling a good number of books at the time of the show, Yale withdrew.

I turned to outlets that would deliver in time for the opening of the exhibition – not for the full research, but to get across some key points. The outlet over which I had most control was the regular column I was then writing in the science magazine *Nature*. There was enough science in the topic to justify the inclusion: not only the fruits of the scientific examination, but also Leonardo's optical ingenuities and the cosmology of the crystalline sphere. The essay appeared on 10 November, one day after the opening of the show.

The Sunday Times, presumably primed by the publicity people in the National Gallery, expressed interest in a substantial piece for its colour magazine. The accomplished journalist Kathy Brewis was assigned to the project, gathering information and speaking to the main protagonists, including Robert Simon and Luke Syson. She interviewed me at length in the café that occupies the roofed-in courtyard of the Wallace Collection

in London. I ran through the evidence I had: drawings, iconography, chronology and above all the scientific dimensions. Kathy was the first to publish the idea that the sphere was of rock crystal. With Margaret's approval, I summarized the results of her archival sleuthing – though she only featured in the final piece under the guise of 'my team'. Kathy's lengthy and substantially accurate article was published on 8 October, with a powerful image of the *Salvator* on the cover of the magazine accompanied by the apposite headline 'Fingers Crossed'.

The National Gallery were certainly not keeping their fingers crossed that enough people would attend 'Leonardo da Vinci: Painter at the Court of Milan' – their problem would be excessive demand. I went to one of the preview openings, which was well populated by figures from the art world. It was close to impossible to navigate through the show with any fluency. I also attended two of the early-morning special views, which were even more mobbed. It was embarrassing to stand in front of the smaller items long enough to look at them properly. Only when I was interviewed for a gallery podcast did I see the individual items with the kind of rhythm that felt unflustered.

My discomfort was nothing compared to that of the general public. Advance tickets went on sale in May, and by the first week they had all gone. Under siege, the warders were instructed to limit admission to 180 people per half hour, though they had no control over how long the visitors stayed. Opening hours were extended until 7.00 p.m. on Sundays and 10.00 p.m. on Fridays and Saturdays (and to 10.00 p.m. on every day for the last two weeks). What to do for those who had not been quick off the mark? The first option was to queue on the chilly pavements outside the doors to the Sainsbury Wing for one of the 500 on-the-day tickets. Dedicated visitors did so in remarkable numbers over inclement hours in very early mornings. Some hardy souls settled in for the long haul regardless of the vagaries of the London weather. The other option was to go on the black market. Tickets, at the already expensive price of £16, were selling on eBay and the 'hot ticket' websites for up to £400, competing with tickets for a Bruce Springsteen concert and other spectaculars.

Officially, the gallery did not approve of the ticket touting. A 'spokeswoman' insisted that 'the resale of tickets for the Leonardo da Vinci

exhibition is against the terms and conditions of their sale and this information is printed on the tickets. Our website clearly states: "Tickets that have been resold will be cancelled without refund and admission will be refused to the bearer".' The gallery was contacting those selling black-market tickets to tell them to stop immediately – though in reality they were powerless to do so. Never had an art exhibition stimulated such demand. Leonardo at the Court of Milan was up there with the most popular of pop events. Unofficially, the gallery was gratified.

Engaging with art is still categorized as a minority pursuit, but this is not the case. It is just that anything that typically attracts working-class people is conventionally seen as 'mass entertainment', while those leisure activities that are viewed as attracting only the middle classes are labelled 'minority pursuits'. The numbers game does not bear out these class-based assumptions, and it is clear that many of the visitors to the gallery did not come from the usual art crowd.

The exhibition was a personal triumph for Luke Syson. Curatorial success is measured not least by the ability to extract improbably good loans from international sources. Obviously the two *in situ* murals of the Sala delle Asse and the *Last Supper* could not be borrowed, and the latter was represented by the full-scale copy owned by the Royal

A chilly queue for Leonardo at the National Gallery.

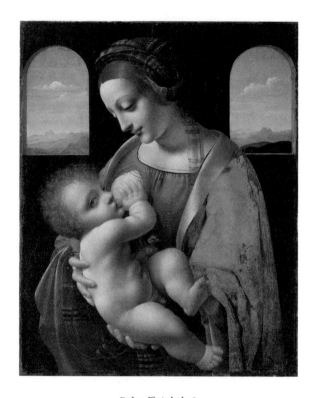

Boltraffio's baby?
Giovanni Antonio Boltraffio, *Madonna and Child* (the *Madonna Litta*), 1490.
Oil on canvas, 42 × 33 cm (17 × 13 in.).

Academy. Luke had obtained *eight* of the *six* or so paintings that have survived from Leonardo's years in Milan from 1482 to 1499. This is not a mathematical error. Two of the paintings he commandeered for the Milanese years were not executed during this period. The *Madonna of the Yarnwinder* is recorded as under way in 1501, and not delivered to Florimond Robertet until 1507. The fact that Leonardo met Robertet in 1499, when the French ousted the Duke and before Leonardo left Milan, seemed thin as an argument for inclusion. It was odd that the other version, which is of a status equal to that owned by the Duke of Buccleuch, was not asked for – and that the catalogue entry (not written by Luke) spuriously downgraded it, partly by writing off its experimental underdrawing as not by Leonardo. Its anonymous owner was not pleased. The other opportunistic 'Milanese' picture was the *Salvator*

itself. It is very hard to push the picture back to before 1500, and the Islamic echoes in the interlace more or less preclude the possibility of its execution before that date. At best, it might have been begun just before Leonardo left Milan.

There were other art-historical niggles. A comparable inclusion by agile re-dating was the gallery's own cartoon for the *Virgin, Child, St Anne and St John the Baptist*. A convincing consensus has built up over the years that this wonderful full-scale drawing was made around 1507. The hydraulic engineering studies on the preparatory drawing in the British Museum belong with those in the *Codex Leicester*, and are therefore consistent with the date of *c.* 1507. No doubt the presence of the cartoon in the gallery had been part of Luke's pitch internally and externally to stage the exhibition, and I think he had genuinely convinced himself of the earlier date. It was, however, naughty not to acknowledge on the label that the date of 1499 was far from definite – a problem that has persisted into the present label for the cartoon. The evidence for the later date still seems to me to be decisive.

Another oddity, unlikely to be picked up by most visitors, concerned the so-called *Madonna Litta*, once owned by the Litta family in Milan and now in the Hermitage in St Petersburg. As we have seen, territorial factors come into play with attributions. It is widely accepted that the composition of the Madonna suckling her son is a Leonardo invention, if one of his weirder ones, and that the making of the final picture is down to Giovanni Antonio Boltraffio, the most polished of Leonardo's Milanese assistants. The very accomplished drapery studies for the Virgin, both in the London show, bear every sign of Boltraffio's characteristic refinement. However, the painting itself was credited to Leonardo. If we look in the catalogue, the drapery studies are indeed catalogued by the gallery staff as Boltraffio – but the catalogue entry for the painting, written by Tatiana Custodieva of the Hermitage, uncompromisingly claims that everything is by Leonardo. This is the only entry in the catalogue not written within the gallery. I can imagine what happened: the condition for the loan, imposed by the Hermitage, was that the *Madonna* would be attributed firmly to Leonardo and that the catalogue entry would be written by their own curator. I am familiar with such expedients. There is

an echo here of the kind of national obstinacy we encountered in Poland about the profile portrait.

None of this nitpicking alters the fact that it was a truly remarkable show – one of the most memorable ever for specialists and non-specialists alike. I was enthralled by it, not least by the juxtaposition of the two versions of the *Virgin of the Rocks*.

How did the *Salvator Mundi* fare on its public debut? It seemed to me to settle in naturally, exerting its 'vibratory' presence among the works in the smallish room in which it was shown. The main problem was that its best comparators dated from after 1500 and were not there, most notably the *Mona Lisa* and *St John the Baptist*. The direct gaze rendered ambiguously elusive was not a feature of Leonardo's art in Milan. The *Salvator* and the *Mona Lisa* are counterparts, one evoking the natural magic of the human and terrestrial worlds, the other suggesting spiritual realms beyond the earthly.

Not all observers were so impressed. The German art historian Frank Zöllner, who had produced the most recent full catalogue of Leonardo paintings, was undecided. He recognized that the blessing hand was painted with 'extraordinary accuracy', but considered that Christ's facial features were too elongated to be by Leonardo. He is far more favourably inclined in the 2017 edition of his catalogue. Stronger doubts were expressed by Charles Hope. Writing in the *New York Review of Books*, the recently retired director of the Warburg Institute cast shared doubt on the *Salvator* and the *Portrait of a Musician*, the latter of which is widely accepted.

> The unfinished portrait of a man holding a sheet of music, from the Pinacoteca Ambrosiana in Milan, seems static, pedantic, and slightly lacking in character. This is the only male portrait regularly attributed to Leonardo, and I share the reservations that have often been expressed about it. Much more suspect, however, is a recently cleaned painting of Christ as Salvator Mundi from a private collection. This was recorded in a print of the mid-17th century, and the composition is known in other versions. But even making allowances for its extremely poor state of preservation, it is a curiously unimpressive composition and

it is hard to believe that Leonardo himself was responsible for anything so dull.

It is always surprising that the same work can be seen in such different ways.

The most unfortunate of the rejections had earlier come from Carlo Pedretti in August, before he had seen an image of the restored picture. He had to rely on the 'hippy' photograph. Writing in the Vatican newspaper *L'Osservatore Romano*, he declared that

> The recent announcement of the discovery of a new version purported to be an original Leonardo, has been launched in a sophisticated marketing operation with the endorsement of specialists who have recommended that the work be placed among the original signed works which are due to be exhibited next Fall at the National Gallery of London. The only way to justify such distinguished recognition would have to come from an eventual spectrograph and other laboratory tests which would reveal the presence of an entirely different underlying image. But there has been no discussion of such tests and proponents instead are relying on a phantom provenance of the work which is said to have been part of the collection of the English royals, passed to the Cook Collection in Richmond at the end of the 1800s with an attribution to Boltraffio – one of Leonardo's best students – and then disappeared into private hands with subsequent sales of indefinite dates....

> A...better version, and closer to an eventual prototype of Leonardo (the existence of which is legitimately dubious), is that which was part of the collection of the Marquis de Ganay in Paris, sold by his descendants a few years ago at auction in New York for a few hundred dollars and now in private ownership. It is this version which at the beginning of the 1980s had the honor of being attributed to Leonardo in a monograph by Joanne Snow-Smith, during an exhibit which

I organized in 1982 in Vinci, and was then transferred to ten museums in the United States....There is...much in circulation in the art market and it would be wise not to chase chimeras, like the case of the 'rediscovered' Salvator Mundi, which in the end explains itself. Just look at it.

I wished that Carlo had waited until he had seen the restored panel. It was not his finest hour. The Ganay picture, which is one of the more accomplished copies, had been sold at Sotheby's in 1999 for $332,500. It seems that Carlo is still heavily invested in his opinion that it is the original, undertaken at least in part by Leonardo. I hope he might change his mind, but he shows no sign of doing so.

The National Gallery's declaration that the *Salvator* was not for imminent sale was tested late in 2012 when it was dispatched to the Dallas Museum of Art in Texas, where it was being considered for purchase. I had speculated that the National Gallery itself might be in the market for it. There was talk of $200 million. Maxwell Anderson, the new and ambitious director of the Dallas Museum, was hoping that major local benefactors would bankroll the purchase. His hopes were not realized.

During the course of the following year, the *Salvator* was indeed sold. The purchaser was Dmitry Rybolovlev, an extraordinarily rich Russian who was quietly building up a great collection – as well as acquiring AS Monaco Football Club, which is benefiting from its owner's purchasing power. The pictorial roll-call of Rybolovlev's expensive masterpieces is impressive: Toulouse-Lautrec, Gauguin, Klimt, Picasso, Modigliani, Magritte, Rothko...

The broker for purchases on behalf of Rybolovlev's family trusts was Yves Bouvier, the Swiss 'king of the freeports', who was making large sums of money from a string of tax-efficient storage facilities around the world. His freeport in Geneva alone was said to contain works worth $100 billion. He was using his contacts and position to sniff out what might be for sale privately or levered out of owners' hands – in effect he was acting as a dealer. In what was probably Rybolovlev's most expensive acquisition, he paid Bouvier $127.5 million for Leonardo's masterpiece. Sotheby's had acted as the agent for the sale to Bouvier.

The *Salvator* was a painting to which the Russian was intensely attracted. He had earlier collected Eastern Orthodox icons, and it is not difficult to see how the typically hieratic, frontal presentation of holy figures in Russian devotional images would have resonated powerfully with the traditional composition and spiritual power of the *Salvator Mundi*.

However, things were not quite as the collector believed. He had previously paid Bouvier $118 million for a classic nude by Modigliani, *Nu Couché au Coussin Bleu*. He had then learned by chance that Bouvier had obtained the picture for a mere $93 million – making a nice profit of $25 million. It transpired that the mark-up on the Leonardo was something approaching $50 million. Although Bouvier and Rybolovlev did not have a formal contract in place, the sums of money being siphoned off by Bouvier seemed exceptional and unacceptable. Bouvier was to claim that he was simply acting as a buyer and seller, setting his price according to what the market would bear. Rybolovlev filed a criminal complaint in Monaco, and arranged a meeting with Bouvier. The scheduled encounter turned out to be with eight police officers, who arrested the 'king of the freeports' for fraud and money laundering. Bouvier's bail was set at $10 million. Along the way, it transpired that Bouvier was also being investigated for Picassos he had sold to Rybolovlev; Picasso's stepdaughter alleged that two paintings and some fifty-eight drawings had been in effect stolen from a trust belonging to her. The story had far from run its messy course.

The art market is an unregulated jungle – even more anarchic than the transfer market for mega-expensive footballers. The sums of money are not so different. Dubious dealers resemble footballers' agents. There are differences, though. Not a few leading players in the art market exploit their status as 'gentlemen', sometimes boasting real backgrounds in aristocratic families and invariably cultivating a gloss of class. Auctioneers are particularly prone to this. It is difficult from the outside to tell which are the honest brokers and which the manipulators. Robert Simon and Yves Bouvier could hardly have been more different in their modes of operation. I imagine that Robert did well out of the sale of the painting to Bouvier – and he deserved to do so.

Looking back over the different fortunes of the attribution of the *Salvator Mundi* and the portrait of Bianca Sforza, there are some clear

lessons to be drawn. The first concerns how a work of art enters the scholarly and public domains. Robert quietly introduced the *Salvator Mundi* to a judicious selection of experts, who – remarkably, given the usual leakiness of the art world – kept their counsel for three years. By the time the painting emerged in public, there was a critical mass of influential voices who would speak in the painting's favour. By contrast, a series of incontinent leaks to the press, as happened with the *Bianca*, prejudices a work in the eyes of specialist commentators. I regret that I did not have more influence on when and how *La Bella Principessa* emerged.

Where a work makes its debut is also crucial – being shown in the National Gallery in London or debuting at a flashy commercial show in Sweden will radically colour how it is regarded. Once a painting enters a circuit of commercial or semi-commercial exhibitions, typically in secondary venues, it is increasingly unlikely to be welcomed by major public museums. It will be stigmatized as 'in the trade'.

Ownership also plays its role. The owners of the *Salvator* played their hand cleverly, fostering the idea that they wanted to do right by Leonardo's masterpiece and were interested in it entering a public collection. Peter Silverman, on the other hand, has become a conspicuous presence in the art world, having made a series of speculative acquisitions of high-quality artworks that have previously escaped identification. Among his finds is a possible Michelangelo *Crucifix* that he has generously donated to the Louvre. He has what is conventionally called 'a good eye'. I believe that his intuition about the portrait of Bianca Sforza will be vindicated in the longer term, but unfortunately his variable declarations about its ownership, even if well-intentioned, did not induce trust and made him vulnerable to media criticism.

The other significant factor was that Leonardo was already known to have generated a *Salvator Mundi* (if not necessarily a fully autograph painting). We had the drawings, the Hollar engraving and the copies. The profile portrait, on the other hand, went straight into a book for private presentation, seen by few, and resided for centuries in Polish libraries. In fact, we know much more about the circumstances that gave birth to the portrait than the *Salvator* – but no one was prepared for what a profile portrait by Leonardo in inks and chalks would look

like. By contrast, we had clear expectations of how a Leonardo *Salvator* should look.

Might the *Salvator* have been less well regarded if its messy sale to Bouvier and its resale had been apparent before its public debut? It has turned out to be a substantial mess. In November 2016, an article in *The New York Times* reported the latest developments: three 'art traders' (Robert Simon, Warren Adelson and Alexander Parrish) were disconcerted to find that the painting was 'flipped' by Bouvier for $47.5 million more than their selling price. Was Sotheby's a knowing party to the resale? The auction house claimed that it was not, taking pre-emptive legal action to block any lawsuit by the 'traders'. It was, however, revealed that Sotheby's had taken a handy $3 million for arranging the initial sale to Bouvier.

Had the ownership of the painting stabilized? This proved not to be the case. It was known that Rybolovlev had been off-loading – at a loss – some of the very expensive pictures he had acquired through Bouvier. It was, however, a great surprise to find that the *Salvator* was to be sold at Christie's in New York on 15 November 2017 in a mega-auction of celebrity works of art from the modern era. The auctioneers sent the painting on a glamorous marketing tour of Hong Kong, San Francisco and London. I was approached by the auctioneers to confirm my research and agreed to record a video interview to combat the misinformation appearing in the press – providing I was not drawn into the actual sale process.

The price inched upwards from less than $100 million to $450 million, shattering the world record for a work of art. The result was cheered to the rafters. I was besieged by media requests for comment. Three weeks later reports that it had been purchased by one of two Saudi princes began to circulate, prompting Christie's to announce that it had been acquired by Abu Dhabi's Department of Culture and Tourism for the Louvre Abu Dhabi, the remarkable new 'world museum', where it will join Leonardo's *La belle ferronnière*. A public home at last, I hope.

In the meantime, Robert Simon, Margaret Dalivalle and myself are publishing a book on the *Salvator*, which opens with Robert's detailed and picturesque account of its discovery, conservation and research. Whatever the extraordinary vagaries of its ownership, it is a huge privilege to have been involved with the advent of a new Leonardo painting.

CHAPTER 8

SCIENCE AND SEEING

The earliest X-rays of paintings took place not long after the accidental discovery of X-ray technology by Wilhelm Röntgen in 1895. Some pioneering art historians were quick to realize that they could use it to see 'secrets' hidden by the old masters – changes of mind, abandoned ideas. The Italian word for such changes, *pentimenti*, means 'regrets'. Would the artists have been pleased? Scholars and the public certainly were.

Having trained as a scientist, I have always been sympathetic to the scientific examination of works of art. However, this sympathy is not universally shared in the art world. In my view, in the controversies about authenticity with which I have been engaged, scientific evidence has rarely been addressed adequately by commentators and has often been wholly bypassed. Such evidence is, like all evidence, in need of critical interpretation, but it does not deserve to be dismissed or ignored. Its status in art history still needs clarification.

My own first involvement with the X-raying of paintings was during my time as a young lecturer in Glasgow. The teaching post I occupied from 1966 to 1981 also included curatorial responsibilities as an Honorary Assistant Keeper of the Hunterian Art Gallery, the notable collection of paintings, prints and drawings established by Dr William Hunter, midwife to George III's queen and first professor of anatomy at the newly founded Royal Academy of Arts. Having studied a little and published briefly on 18th-century French art, I was encouraged by the then Richmond Professor and Keeper of the University Art Collections, Andrew McLaren Young, to pay special attention to the wonderful Chardins that Hunter had purchased.

Andrew was a character. Ample, rumbustious and decisively untidy, his presence was suffused with a pungent aura of Schimmelpenninck

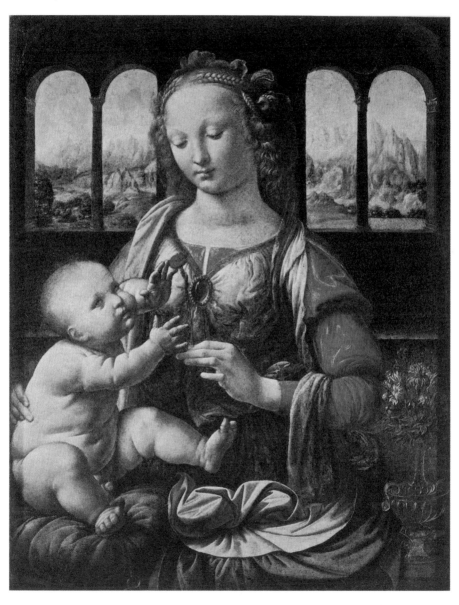

Young Leonardo's ambitious oddness:
Madonna and Child with a Carnation, c. 1470. Oil on panel, 62 × 47.5 cm (24⅜ × 18⅝ in.).

cigarillos, with, as they might say in wine tasting, an underlying hint of good whisky when in party mode. He declared his mission was 'to inspire the young'. His vehicle for inspiration was a series of chaotic lectures delivered from battered notes. They oozed warm insights, and he was loved by the students. He was genuinely learned, again in a disorderly manner. He recruited staff of considerable ability. He published very little that could be assessed in modern research reviews, and his great catalogue of the paintings of James McNeill Whistler was published posthumously. He was given a consolation MA by Glasgow because he had missed out on a degree during the Second World War. These days there is no room for such eccentric mavericks in academia, and someone like Andrew would not get within miles of a university post. He died prematurely in 1975 of a heart attack while attending a huge Turner show at the Royal Academy – an art-historical exit of the highest order.

The three paintings by Jean-Baptiste-Siméon Chardin were two little pictures of servants – the *Cellar Boy* and the *Scullery Maid* – and the larger bourgeois image of a *Lady Taking Tea*. I don't remember why, but we decided to X-ray the paintings using the medical equipment at the Western Infirmary, down the hill from the main university build-ing. A patient left, and the paintings moved in. The *Cellar Boy* yielded some *pentimenti* in his body and head – the young servant performing his duties was initially conceived as holding a glass of wine at his eye level to inspect it for colour and clarity. A small finding, but it gave me a disproportionate amount of pleasure.

The *Lady Taking Tea* was subsequently subjected to conservation. It was entrusted to Harry Woolford and his apprentice John Dick at the National Galleries of Scotland in Edinburgh. They came to Glasgow to inspect and collect the painting. Harry came from the old school. Large, tweedy and warm in a wry manner, he had trained and practised as a painter. He was a hands-on restorer of a sensitive and judicious kind. He did not like to look at X-rays before ministering to his patients. He did not want to find what he was actively looking for, preferring instead to let a picture tell him what was needed. The much younger John – who was later to play a significant role in the story of the *Madonna of the*

Yarnwinder – provided a vivid contrast. Small, slim, dark and reserved, he hovered in Harry's substantial shadow.

The *Lady* had been relined – that is to say, a second canvas had been applied from behind to support the one on which Chardin had originally painted. Harry and John surgically removed the relining canvas and found that Chardin had brushed an inscription on the back of the original canvas: '*ce tableau a este fait en fevrier 1735* [this picture was made in February 1735]'. This was nice, because it dated the painting earlier than previously assumed. Again a small finding, but enough to encourage me to work further with the conservation staff in museums and art galleries. We later arranged to hold seminars for senior students in the National Galleries, during which John and the curators gave insights into their research and technical findings. They were among the best classes in which I have participated.

The first Leonardo painting to be X-rayed seems to have been the portrait of Ginevra de' Benci, then in the collection of the Prince of Lichtenstein in Vienna, where the German art historian Emile Möller arranged for it to be looked at with medical X-ray equipment in 1921. Möller was the first to note the presence of a fingerprint. The *Ginevra* was subsequently subjected to serial examinations by X-ray and other methods, before and after its acquisition by the National Gallery in Washington, DC in 1967. Leonardo's unusual techniques have repaid repeated attention with each generation of new equipment.

The accumulated results for the *Ginevra* have been notable, including many more finger- and hand-prints, vigorous underpainting and the dotted *spolvero* marks left when Leonardo's cartoon was transferred to the panel. The transfer was effected through the dusting (*spolverando*) of black charcoal powder through small holes pricked or 'pounced' along the main outlines of the full-scale drawing. I was in the conservation studio in Washington when agents from the FBI (the best experts available) re-examined the painting for fingerprints. Two square, intimidating men with crew cuts and dark suits picked up a number of fugitive prints that we had not detected. Leonardo had delicately deployed his hands almost as much as his brushes in softening the transitions of light and shade in Ginevra's pale skin. The FBI operatives

were subsequently scolded by their masters for wasting their valuable forensic time on arty matters.

The Lansdowne *Madonna of the Yarnwinder* was not too far behind. First came the controversial transfer of the paint layers, with some priming, from panel to canvas in 1911; this was when Wildenstein's was seeking to make the painting more saleable. Möller reported that the effect was 'pleasant but overtrim, so that this important copy had largely been deprived of its original value'. He had decided that the Buccleuch version was the original. After purchasing the Lansdowne picture from Wildenstein's in 1928, the Montreal shipping magnate Robert Reford sent it to Wilhelm Suida in Vienna to be studied with X-rays and ultraviolet in the hope of enhancing its status. He had bought it as by Sodoma, a one-time colleague of Raphael who was much influenced by Leonardo. Reford's hopes were realized to a degree, since the X-radiograph presented the first elusive signs of *pentimenti*; Suida published the results in 1931. Arguing, rightly, that Leonardo had been involved in the making of the Lansdowne version, Suida downgraded the Buccleuch picture to the work of a pupil.

We have already told the story of the successive examinations of the two Madonnas before and after the Edinburgh exhibition in 1992. The examination of one picture using one set of equipment was followed by the examination of the other using more advanced technology, and so on, in a game of leapfrog. This highlights one of the problems that bedevils the scientific examination of paintings: it is impossible to compare two sets of results reliably when the technologies deployed are significantly different. Even similar equipment can be set up differently, and the results processed and presented in different ways. In the world of mainstream science, this lack of matching technology and protocols would be regarded as deeply unsatisfactory.

It was as an attempt to overcome this inconsistency that Marina Wallace and myself devised the 'Leonardo Lab' within our Universal Leonardo project. The idea of the Lab, co-ordinated by Thereza Wells, was to promote the examination of as many of Leonardo's paintings as possible, using the same or similar equipment in comparable ways and with a core of shared experts. With Council of Europe funding we held

a workshop in London, followed by one in Paris in December 2003. Our aspiration was ambitious, but not unrealistic given the relatively small number of Leonardo's paintings (examining all the world's Raphaels, for instance, would not have been a practical proposition).

The original idea was that individual institutions would willingly support the initiative in a spirit of international collaboration; but the reality was not that simple. For the most part, the scientists in the relevant departments of the museums and galleries were keen on the project, while the curators were guarded about sharing information within the programme – they seemed to be wary of losing control of their cherished territories. We were advised to move the agreement onto a more formal basis with a series of obligations and safeguards, so the London Institute of Higher Education Corporation (under whose legal regime the Universal Leonardo functioned) drafted a tediously complicated 'Consortium Agreement' running to some fifteen pages. Its implementation was to be overseen by a 'Great Committee' comprising representatives of each of the participating organizations. Under this committee were to be an Art Historians Sub-Group and a Scientists Sub-Group. There were detailed specifications for 'project deliverables', and the only obvious carrot was a promise to refund 'reasonable' expenses.

Perhaps unsurprisingly, of the components in the Universal Leonardo project, the Lab was the one that seemed to fall most conspicuously short of its original aim. Viewed in the longer term, though, it met with more success than was initially apparent.

The immediate fruits of the Lab were the groundbreaking examinations of the Lansdowne *Madonna of the Yarnwinder* by the Opificio, and an exhibition in Munich centred on the technological analyses of the *Madonna with the Carnation* in the Alte Pinakothek. The gallery in Munich, one of the world's greatest, collaborated with the nearby Doerner Institute to look at Leonardo's earliest and somewhat crabby *Madonna* using a range of up-to-date methods including X-rays, infrared reflectography, microscopy and varied analyses of two paint cross-sections. The results, published in the exhibition catalogue, showed that Leonardo's questing originality and technical experimentation had been there from the first. We observed him pushing new media to their limits, creating

layers of thinly dispersed pigments bound together with egg tempera and various oils in a way that caused some serious wrinkling of the paint surface. There were many traces of constructional geometry, including some complex compass drawings in the roundels above the windows that played no role in the final design. This experimentation was placed in the service of the passages of insistent description – of space, plasticity and natural form – in which a young artist was striving almost too hard to give reality to the parts at the expense of the whole. At various times this *Madonna* has been attributed to the German artist Cranach the Elder or listed as 'school of Verrocchio', but its ambitious oddness speaks loudly of the young Leonardo.

On the face of it, the *Madonna of the Yarnwinder* and the Munich *Madonna* were the only works examined under the aegis of the Lab. A significant obstacle was that most of the museums and galleries felt they had no need of external agencies, nor of imported equipment. The National Gallery in London stated that they had all the equipment and expertise they required. Then, around 2007, I received a call to say that the scanner owned by INOA (Istituto Nazionale di Ottica Applicata in Florence) had arrived in their London studio and was being used to look

Infrared reflectogram of the head of the Virgin in the *Virgin of the Rocks*.

at the *Virgin of the Rocks* in the run-up to the big Leonardo show. This was the device that had been used to such good effect by the Opificio. It provided a very high-resolution infrared reflectogram on the scale of the actual picture, without the need to collage separate images. The results were remarkable.

We know a good deal about Leonardo's troubled commission in 1483 to provide the painted decorations for a large altarpiece in Milan. It seems that the painting intended for the centre of the ensemble (the version in the Louvre) was sequestered by Ludovico Sforza as a wedding present in 1494 for Bianca

Maria Sforza and Maximilian, the Holy Roman Emperor. This left the tardy Leonardo to meet his obligations to the commissioners. We know that the London version was the one eventually delivered to occupy the centre of the altarpiece. It is relatively little modified from the first painting; however, the scanner revealed an underdrawing that was notably different. We could see a large left hand with its fingers in the region of the Virgin's nose, chin, neck and shoulder. Above and to the right of the Virgin's halo there was a readily identifiable eye, with some discernible outlines of facial features. Piecing together these signs and other indications of underdrawing, the staff of the gallery were able to sketch the incomplete outlines of a kneeling Virgin a good deal larger than in the painted picture. Her pose was identifiable as belonging to a composition

Finally delivered, the second version:
Virgin of the Rocks, *c.* 1491/2–9 and 1506–8.
Oil on poplar, thinned and cradled, 189.5 × 120 cm (74⅝ × 47¼ in.).

known in more than one of Leonardo's drawings, in which children are playing on the ground in front of her. The eye, face and gestures of the Virgin in the underdrawing are very similar to those deployed for St Philip in the *Last Supper* around 1497.

Faced with making a replica, the creatively restless Leonardo considered providing a radically revised composition. Then, in what was an unusual episode of pragmatic good sense, he decided to work with at least one of his assistants to provide the commissioners with something close to the first version. Even this was slow in arriving: the London picture did not take its due place until 1508, a quarter of a century after Leonardo had signed the original contract.

What may have been a delayed response to the aspirations of the Leonardo Lab also occurred at the Louvre. Successive directors had steered clear of cleaning their Leonardos, largely because the public aggravations would simply have been too much. The *Virgin, Child and St Anne with a Lamb* was the best candidate for restoration, given its patchy and discoloured varnish and darkened retouchings. On a visit in the 1990s, I had seen a test clean on an area of the sky. The vivid blueness that was emerging dissuaded the curators from proceeding further, and the cleaned area was touched in.

Gradually the climate changed, largely in response to a campaign of scientific examinations of the Louvre's Leonardos. On a visit to the Centre de Recherche et de Restauration des Musées de France (C2RMF) when they were embarking on this campaign, one of the staff admitted privately to Thereza Wells that 'none of this would have happened without you [the Leonardo Lab]' – although what they were doing did not fall, even unofficially, within the embrace of our programme.

Subsequently the scheme to restore the *St Anne* was revived, and the Louvre set up a weekend of discussion and consultation in the spring of 2010. On the Saturday they arranged a seminar attended by international *Leonardisti* to look at the results of the examinations so far conducted. All the Leonardos were on parade in the Salon Carré, on easels and out of their frames. Remarkably for an event in France, speakers were invited to discuss the issues in their native languages. The resulting multilingual debates were complex, with the experts

sharing their experiences of the scientific examination of paintings by Leonardo and his followers.

A public event was then held on the Sunday in the Louvre's very large lecture room. A panel of speakers was set up on the grand stage to provide an overview of what we had discussed. It was evident that this was a softening-up exercise to prepare for the restoration of the *St Anne*, and that the Louvre wanted to be seen to undertake wide-ranging consultation.

There were, unsurprisingly, objections to any attempt to clean any Leonardo. One of the most persistent objectors was Jacques Franck, who has ingeniously advocated that Leonardo achieved his fabled *sfumato* effects through his application of paint in a series of dots so minuscule as to escape detection – what he calls '*micro-divisionisme*'. He has stated that the surfaces of Leonardo paintings are so uniquely vulnerable that they are in effect 'unrestorable'. Although it is certain that Leonardo must have used small, delicate touches to create his blended flesh tones, scans of very high resolution have failed to disclose the kind of minute stippling that Jacques envisages. He has been billed as 'the man who paints like Leonardo'; but his own attempts to use micro-divisionism to recreate the elusive softness of Leonardo's flesh tones have resulted in images that resemble dusty soft-focus photographs of cinema starlets from the 1930s and 1940s.

We might note in passing that Leonardo's much-discussed *sfumato* has assumed an inflated significance. It has come to be regarded as his own key term for the 'softened' or 'smoky' effects that are the signal feature of his painting technique. However, it is in fact a later designation. In a number of places Leonardo talks of softened effects – *sfumose*, *sfumate* and *sfumato* – and recommends more generally that 'light and shade should blend without lines or borders in the manner of smoke'. But Leonardo nowhere advocates *sfumato* as some kind of secret of his art, or even as a special term. His usage is not essentially different from Cennino Cennini's twice recommending, in his *Il Libro dell'Arte* around 1400, that shadows should be blended like 'a nebulous smoke' ('*un fummo bene sfumate*'). *Sfumato* is handy enough as a shorthand term to describe Leonardo's melting effects of light and shade, but it has no authentic status.

The *St Anne* was indeed restored, and made its sparkling debut in 2012 in the splendid exhibition 'St Anne: Leonardo da Vinci's Ultimate Masterpiece', curated by the excellent Vincent Delieuvin. The Louvre declared that

> Leonardo da Vinci's masterwork *The Virgin and Child with St Anne*, restored with the aid of the C2RMF (Centre for Research and Restoration of the Museums of France), is the centrepiece of an exceptional exhibition that reunites all surviving related works for the first time....Compositional sketches, preparatory drawings, landscape studies and the National Gallery of London's magnificent cartoon are brought together for the first time since the artist's death to illustrate his lengthy meditation and expose the succession of solutions he had envisioned.

The report of the restoration indicated that the removal of dirt, discoloured varnishes and blotchy retouchings was conservative and did not involve the total stripping of the paint surfaces back to the 'original'. The most problematic area was the Virgin's blue skirt, in which the brilliant lapis lazuli had characteristically 'bleached' the shadows that originally modelled the folds. A thin layer of old varnish was apparently left to soften the bright and flattened starkness of the blue, but it is disconcerting nonetheless. The gains are considerable, but any conservation of a painting that has suffered substantial changes over time involves difficult choices and compromises that are inevitably conditioned by our ideas of what this particular painting should look like. The differences, before and after, are striking (see overleaf).

Not everyone was happy. Two senior members of the advisory committee had already resigned. Predictably, the most antagonistic review came from ArtWatch UK. The posting on their website began:

> The penny dropped last week in Paris: museum picture restoration is becoming a money-making machine in which the artistic sums may not necessarily add up. The Louvre's restored Leonardo *Virgin and Child with St Anne* re-appeared

in a series of openings for a swish exhibition-of-celebration, 'La Sainte Anne, l'ultime chef-d'oeuvre de Léonard de Vinci', sponsored by the Italian fashion house Salvatore Ferragamo (whose 2012 fashion show is to be held within the Louvre).

Using 'before and after' photographs – which are highly unreliable evidence on which to base close comparisons, given the vagaries of colour and tone in reproduced images – ArtWatch argued that the Louvre's restorers had removed essential modelling. On their website, they denounced how 'the restoration-weakened *St Anne*, with its now arbitrarily floating, obtrusively abstract and glitzy lapis lazuli blue drapery, has departed from its formerly-realized self'. The restored *St Anne* is indeed something of a shock, as is the cleaned *Last Supper*; but much if not all of the shock comes from our being accustomed to Leonardo's shadows operating in a sooty penumbral manner rather than with bright softness. Leonardo's own notes on the colouristic properties of shadows favour the latter rather than the former. But I remain nervous about what future generations will define as the right thing to do.

In the meantime, a major European initiative was accomplishing more or less exactly what the Leonardo Lab had hoped to do. A consortium of conservators and experts in scientific examination had come together to secure a hefty tranche of European Union funding under the aegis of a programme called CHARISMA: Cultural Heritage Advanced Research Infrastructures: Synergy for a Multidisciplinary Approach to Conservation/Restoration. Despite its cumbersome name, this proved to be an outstanding initiative.

One of the CHARISMA workshops was devoted to Leonardo. It was held at the National Gallery in London on 13–14 January 2012. Richly peopled with most of the significant curators and conservators who were directly involved with work on Leonardo, it was one of the best events I have attended. The quotient of new material and the collaborative spirit were outstanding. Thereza spoke effectively about the picturesque conservation history and the scientific examinations of the *Madonna of the Yarnwinder*. Dianne Dwyer Modestini gave the first public airing

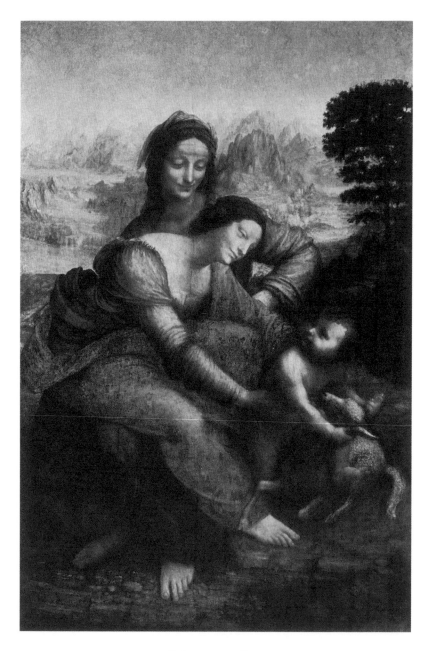

Before conservation:
Virgin, Child and St Anne with a Lamb, c. 1503. Oil on wood, 168 × 112 cm (66 × 44 in.).

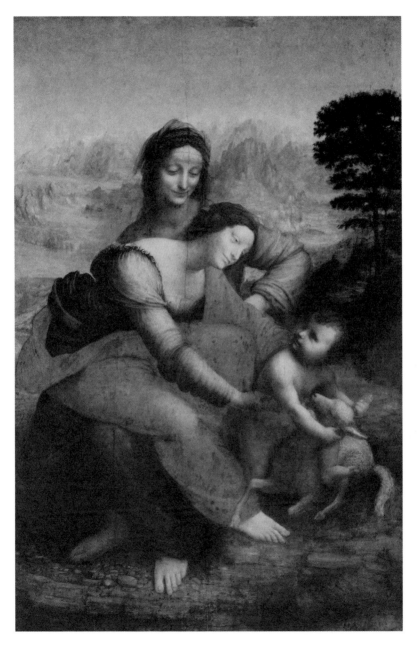

After conservation:
Virgin, Child and St Anne with a Lamb.

of her study of the *Salvator Mundi*. Vincent and his colleagues spoke of the Louvre *Virgin of the Rocks*, pointing out among other things that the angel's conspicuously pointing right hand was a late addition to Leonardo's composition. There were many other good things.*

I was invited to take part in the final CHARISMA event, on 5–6 March 2014 in Sant'Apollonia in Florence – famed as the setting for Andrea del Castagno's compelling *Last Supper*, at which Leonardo had looked very carefully. The 'lecture hall' was the main body of the decommissioned church. High at the far end was the private gallery from which the cloistered nuns would have watched pious services; our piety was that of science applied to art. My contribution was an expanded version of a lecture I had given at Princeton as a visiting professor the previous year. It was my first systematic attempt to define the *status* of different kinds of evidence in tackling a series of art-historical questions, above all attribution; and my prime case studies involved the scientific examination of Leonardo paintings.

I had been increasingly concerned with what I saw as chaos in the attribution of works of art, and the role of scientific evidence. There was little or no sense of the status and efficacy of different kinds of evidence in the demonstration of who made what and when. There were no accepted methods for arriving at sound judgments. Should connoisseurship rule? Was science decisive? Did documentation trump all other kinds of evidence? Was provenance the key? Different sectors in the art world operated, and still operate, with quite different criteria and priorities.

With paintings from past eras, it is rare for the various strands of evidence to add up consistently with no gaps, uncertainties or contradictions. Only the *Last Supper* among Leonardo's paintings has a continuous history, and even in that case, as we have seen, there are problems in knowing what we are really looking at. The arguments about the identity of the *Mona Lisa* show that the most heavily scrutinized bodies of evidence are perpetually open to reinterpretation – there is just enough of a gap in 'her' provenance after Leonardo's death to allow speculators to have a field day. No newly emergent candidate for Leonardo's authorship will have a continuous history, and no single piece of evidence will be wholly

* The papers were published in 2014 as *Leonardo da Vinci's Technical Practice*, edited by Michel Menu of the C2RMF in Paris.

decisive in a positive manner – though there can be negative evidence that decisively scuppers the candidate's chances. My intention was to evaluate the types of evidence for their particular roles in relation to each other, and within the whole process of arriving at a reasoned historical judgment.

The talk was later published online on the website of Authentication in Art, the international initiative set up by Milko den Leeuw in The Hague to bring much-needed public order into the private chaos of authentication. I also presented a compressed version of the arguments in the *Art Newspaper* in May 2014, suggesting that we might use the term 'judgment by eye' rather than connoisseurship.

Techniques of attribution have arisen in an *ad hoc* manner. First there was connoisseurship, as defined by Jonathan Richardson in the early 18th century. Then in the later 19th century came Morelli's valiant attempt to place visual comparisons on a diagnostic basis, in which the art historian investigates the forensic signs of the artist's 'hand' like a detective at a crime scene. Scientific examination entered with X-rays in the later 19th century and gained increasing utility from the mid-1920s. Then came various kinds of material analysis, optical and chemical, infrared reflectography and other kinds of scanning, all offering ever-increasing precision. You might expect that we would by now have some way of evaluating the status of the various kinds of evidence, in relation to each other and in the context of other kinds of art-historical analyses. We do not. It seems that we have the irrefutable data of 'hard' science on one side; on the other the ineffable arrogance of connoisseurship. This is a false dichotomy. If for 'connoisseurship' we substitute the less loaded term 'judgment by eye', we can see why. Faced with the often elusive visual information of an X-ray or infrared reflectogram a great deal of judgment by eye comes into play, judgment that is informed by the expertise of those interpreting the slippery images. Typically, we are shown a less than lucid X-radiograph or reflectogram and are told, 'as you can see...'. We are likely to

assent, even when we cannot really 'see'. This is what my dentist does when he shows me a patch of decay in an X-ray of my teeth.

Looking at computer-generated images of a distant galaxy or X-rays of a breast tumour involves judgment by eye to no less a degree than scrutinizing visual evidence about a work of art. Judgment by eye embraces all those factors, physiological, psychological, cognitive, personal and contextual, that are involved in and direct our acts of seeing.

What we conceive to be the most relevant and powerful methods of judgment by eye rely upon a series of assumptions about what is significant in the making and viewing of works of art. This is by no means a simple and consensual matter. The implicit causal explanations that lie behind what we regard as significant in art are very complex – even more so than explaining a car crash, an example I have used on a number of occasions.

Let's imagine that a car has skidded off a wet road at a bend and damaged itself by striking a tree. A series of experts seek an explanation. The most important, at least financially, is the representative of the insurance company, who is interested in finding reasons not to pay out. He or she notices that a tread on one of the tyres is below the legal limit. This is therefore the 'cause' of the crash, and the driver's insurance claim is invalidated. A local authority road engineer notes that the camber of the road at the bend is sloping in the wrong direction, and that the tree could not be in a worse position for anyone coming off the road at that bend. A meteorologist explains that there was a very light shower a few minutes earlier and that there had been no rain for the previous fortnight, making the road slippery. A psychiatrist characterizes the driver as a risk-taker who tends to drive dangerously fast. The driver claims that a cat ran out in front of him, causing him to brake suddenly. And so on. There are also a series of more general causes, such as the fact that wheels are round and can roll fast, and that petrol and air combine to make an explosive mixture.* None of the causal explanations in the case

* The conference at The Hague was sponsored by Mercedes. It was a happy accident that the slide of a crashed car I used in my presentation, attended by senior Mercedes executives, was a BMW. I pointed out that a Mercedes would not have gone off the road like that.

of the crashed car is demonstrably wrong, but not one of them alone is sufficient. It is possible that *all* of them were necessary for the accident to happen. Each observer will select and prioritize different kinds of evidence, depending on their standpoint.

If we take this notion of the standpoint of the observer into works of art, we can see that a comparable variability of seeing applies. Someone concerned with the sociology of art will be interested in such aspects as the economic transaction that brought it about and the social 'message' of the work; Leonardo's lost mural of the *Battle of Anghiari* is very responsive to such analyses. A feminist may concentrate on the way gender is handled in a painting, as when a female nude is presented for a male voyeur's gaze – we may think of Leonardo's lost *Leda and the Swan*. The iconographer undertakes a close analysis of a painting's symbolic and allegorical content in the context of relevant texts. We saw something of this with the *Salvator Mundi*. The style historian characterizes a work within a broad procession of stylistic developments; the late date for the Louvre *St Anne* is largely dependent on stylistic considerations. The monograph writer sees each work as a manifestation of the artist's individual production and creative personality. The connoisseur delights in the aesthetic qualities of the painting. The owner, or even the museum curator, takes a pride in possession that grants a special aura to the picture in her or his eyes (Peter Silverman is unlikely to be immune from this when he looks at the profile portrait he purchased). The auctioneer or dealer will seize upon those characteristics that will be most efficacious in the act of selling. The conservator will focus on the condition, looking closely at nasty repaints. The scientist who has disclosed 'secrets' lurking beneath the surface can claim to have demonstrated how the painting came into existence. Someone who discovers a painting, and the first person to publish a substantial study of it, will search out those things that best support the attribution; someone who rejects the attribution will seek out any small vulnerability in the evidence. The press will look for whatever creates a 'story'.

This is not to say that each observer is necessarily blind to the visual qualities that the others highlight; one person may practise a number of modes of looking. One mode is not necessarily more right than another.

Each observer will see in a way coloured by their own assumptions, interests and observational skills.

In short, seeing, as I have observed before, is not arbitrary – in the car crash example, everyone who saw the crushed front of the car would have known that an accident had occurred. However, the way that we interpret what we see is powerfully shaped by what we are looking for. When it comes to attribution, the causal or explanatory model in which we believe will affect what arguments we regard as most significant.

In coming to terms with different kinds of evidence – art historical and scientific – I have endeavoured to apply two kinds of test. The first involves what in the philosophy of science is called 'falsifiability'. This means that for a theory to stand any chance of acceptability, it should be formulated in such a way that it can be shown to be wrong. A clearly developed and expressed idea is available for scrutiny in such a way that it can be shown definitively to be erroneous. Showing that it is *right* is more provisional. To take an example from attribution: a painting purporting to come from the Renaissance that uses cadmium yellow cannot be from the period, because cadmium yellow only came into use in the 19th century. If we find that the pigment is lead tin yellow, this allows us to say that it is consistent with a Renaissance date – but it does not *prove* such a date. A knowledgeable forger could have used lead tin yellow. There are many arguments deployed in the study of Leonardo (and in the humanities more broadly) that are not systematically testable, such as the theory that the *Mona Lisa* depicts a courtesan from Urbino. If the 'evidence' cannot be shown to be wrong on its own terms, the theory is not necessarily right or wrong, but it only has the status of a plausible or implausible fiction.

The second test involves my version of Ockham's razor as discussed in Chapter 3, in the context of the *Mona Lisa*: the 'law of parsimony', which states that the hypothesis with fewest assumptions and which is most consistent with the evidence – i.e., the most economical – is to be preferred. When too many qualifying and untestable theories need to be aggregated to save a hypothesis, the hypothesis itself should be questioned. A good example is when Copernicus challenged the increasingly elaborate mechanisms invented to save the Ptolemaic cosmological

system, in which all the heavenly bodies rotated around the central earth. Copernicus's explanation, which heretically placed the sun at the centre, was far more economical. The most parsimonious explanation might not be right, but it is the only systematic way to proceed.

The kinds of arguments we deploy can be grouped under two headings: 'constructive' and 'permissive'. A constructive argument adds positively to the case being made for a specific attribution, while a permissive argument simply presents no obstacle to the attribution being made. These two types of argument are regularly confused and even conflated in processes of attribution.

Looking first at the characteristics of a painting that are subject to scientific analysis, it is apparent that the evidence is for the most part permissive. Factors such as the condition (overpainting, etc.), the support on which the picture is painted, and the pigments and binders used allow us to assess whether a picture could *not* be what it is supposed to be; but they fall far short of proving it *is* by a specific artist.

In Leonardo's case, his unusual methods of priming have provided useful if not definitive pointers. His method of painting over his first underdrawing with a light wash of white lead (sometimes tinted) was not widely shared, and his laying of a white lead priming directly onto some of his panels without an intervening layer of gesso was idiosyncratic. Similarly, if we can pick up his characteristically radical changes of mind in the lower layers of the underdrawing and pigments, this provides good support for a Leonardo attribution. His technique of using his hand to blend the modelling of his flesh tones was also individualistic, if not exclusively so.

When we look at scientific techniques in their own right, those that are most potently informative with respect to attribution are also those requiring the most judgment by eye. Multispectral scanning produces huge bodies of data, not least about what lies beneath the surface. There are two main problems with it. First, we do not know exactly how the lights of different wavelengths interact physically with the pigments and binders, which makes it very difficult to understand the resulting images. Secondly, data from different strata within the pigment layers is mingled, making them difficult to disentangle. X-rays are somewhat

less complex, but they too suffer from the problem of mingling data from different layers.

When it comes to the various optical and physical methods of analysing pigments and binders, these are permissive rather than positively constructive in identifying whether Leonardo undertook the work in question. Carbon dating of organic materials, typically of a wooden panel, has been hailed as a game-changer – but it only produces probabilities for the dating, not in narrow enough bands to lend more than general support. It may be that more specific and decisive forensic techniques will come along, such as DNA analysis. Perhaps fingerprints will help more than they have done so far.

Turning back to traditional art history, we encounter three types of evidence. The type that makes the most specific claims about attribution is judgment by eye – ranging from our overall impression of a work to its detailed characteristics, such as brushstrokes and individual ways of painting eyes. The persistence of long-term consensus about what judgment by eye tells us is important, but we have to be careful that we are not just seeing what we have been led to expect. We accept 'strange' works like the portrait of Ginevra de' Benci because they are long established as Leonardos.

There are also bodies of evidence that relate to the context for a work, both within the artist's own career and more broadly. I call these 'orbital factors'. We are fortunate in Leonardo's case to have all the notebooks, not least those dealing with the science of seeing. The attributed work should not only fit in the orbital contexts, but should enrich our sense of the artist's accomplishments. There are also 'outside factors': those dealing with evidence that is not internal to standard art history. An example is the history of costume, which has played such an important role in determining the date, the sitter and the authorship of the profile portrait.

We can also, of course, look to the panoply of primary documentary evidence such as contracts, letters and memoranda. The subsequent history of a work, its provenance, is crucial. Inventories are useful in tracing this history, but the people who made the inventories were only doing enough to render the objects identifiable – they were not aiming

to present historians with comprehensive information. The ideal situation for a historian is one in which primary documentation is linked to a continuous provenance; but such a situation is rare with free-standing paintings by old masters. Any slight gap in the provenance opens up the possibility of doubt.

I eventually came to the following conclusions in my paper: attribution is, by its nature, a hybrid process utilizing arguments that are incommensurable in method;* judgment by eye is malleable in the light of multiple interests, and is falsifiable only by factors outside itself; and the visual techniques, both 'art-historical' and 'scientific', that are most specific in the process of identification are those that are the most malleable. Finally, I stressed that we should strive to recognize the effective *status* of different kinds of evidence and argument, not over-claiming or granting a monopoly to any one type of argument. We should remain perpetually alert to the malleability of our own seeing, and to the varied personal and contextual factors that operate selectively in what we claim to see. Above all, we should be modest and prudent in our personal investments in our acts of seeing.

The technical examination of the *Mona Lisa* is a good example of how these issues of method operate; Pascal Cotte's recent work serves to illustrate both the excitement and the difficulty of seeing with science. His LAM (Layer Amplification Method) is the most advanced technique for the analysis of multispectral scans. The holy grail of scanning is to be able to isolate separate data from each of the very thin layers of pigments and underdrawing; Pascal's method strives heroically towards this end.

His camera gathers data within thirteen distinct spectral bands, across the visible spectrum and extending into the infrared and ultraviolet at either end. When he was granted permission to examine the *Mona Lisa* he gathered a massive 3.2 billion bits of data. These involve both the surface and deeper paint layers. The longer the wavelength of the light, the greater the penetration. Waves in the infrared bands are

* By 'incommensurable', I mean that they lack common qualities or 'measures' which would allow us to effect direct comparisons and coordinations of methods.

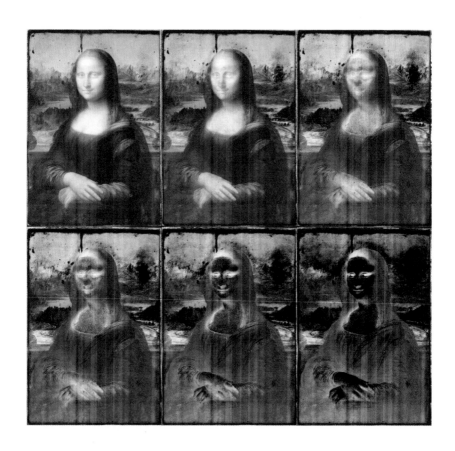

Pascal Cotte: Six LAM images of the *Mona Lisa*.

more penetrative than those in our visible spectrum. Ultraviolet light picks up surface features, particularly retouchings. Different pigments and binders are penetrated to varying degrees.

To untangle the data Pascal has used modern methods of signal processing, akin to those applied to fuzzy CCTV images to extract data that might help identify a bank robber. These techniques use algorithms to discern fugitive configurations that might be suppressed by dominant features of the image.

In Pascal's view, what we are seeing is 'real'. This is true in so far as the images result from physical processes; but we cannot say that we are seeing 'real' images of what Leonardo's painting once looked like before it was finished. What seems to be picked up are paint layers of varied thickness, pigment density and type, perhaps mingled with the effects of different degrees of damage, cracking and layers of restoration. Some of the LAM images of Lisa's head exaggerate the contrast between the lit areas, which are rich in white lead, and the shaded portions at the side of her face, in which brown was prominently used to shade the flesh. The outer contours of her face are effectively suppressed and seem to move inside the present outlines.

Pascal has produced convincing images that show how Leonardo manoeuvred the composition as he painted. The sitter's costume underwent particularly notable changes. But whatever we are seeing, we are not witnessing a series of quasi-finished versions of the *Mona Lisa* under the present surface. We are being presented with new evidence of Leonardo's very fluid processes of creation, on the ground-plan of an initial cartoon. Different motifs come and go, often fleetingly. This improvisation, typical of Leonardo, permeates every phase of his experimental work on the underdrawing, underpainting and painting.

That Pascal and I can see rather different things in the remarkable images he has produced emphasizes the principle that any evidence, scientific or otherwise, only assumes significance through a process of shaped interpretation. However much we assign 'seeing' to technology, judgment by eye still plays a decisive role at the end of the day. Science tells us nothing outside the framework of our specific questions, and these questions rely upon definite notions of what we are looking for.

In the art world, reactions to the deployment of science occupy a spectrum from uncritical acceptance ('it's science, so it must be right') to outright disparagement of scientific seeing in favour of 'the good old human eye'. This range of stances maps closely onto the professions of the commentators. Those most in favour are the specialists employed to conduct scientific examinations in institutional and private settings; increasingly they come from backgrounds in science and technology, rather than the practice of art. However, their specialized expertise may lead them to prioritize their findings over other kinds of historical evidence to an excessive degree. Curators responsible for works in major institutions that support conservation departments have, over the years, largely come to regard scientific examinations as enthusiastically as their technical counterparts, though they are likely to be very conscious of the tensions that arise when science produces results that sit unhappily with other forms of evidence.

Auctioneers and dealers have increasingly embraced scientific examination as a tool in proving that what they are selling is authentic. Such evidence comes in very handy when it reveals that a meagre 'copy' is actually a pricey 'original'; conversely, when scientific results are less than favourable, they are sometimes suppressed. Private companies offering scientific tests may be subject to confidentiality agreements that prevent undesirable results emerging. In the commercial world, connoisseurship is accorded a high priority and the percentage of paintings examined scientifically is far smaller than in museums and galleries. The overall style of operation for auctioneers and dealers is founded upon the glamour of the connoisseur's sensibility – science has not traditionally been central to their practice. Lately, though, after a number of bruising cases about the expensive sale of forgeries, a distinct shift of emphasis is in the air.*

Overt hostility to scientific examination thrives in the world of art journalism and online, where snap judgments, 'stories' and sensations are the name of the game. Within museums and galleries scientific analysis

* This change is signalled by Sotheby's recent announcement that it is establishing a Scientific Research Department.

is strongly associated with the cleaning of pictures, so those opposed to modern campaigns of conservation see the science as actively distorting the methods used to recover the 'original'. I have some qualified sympathy with this view, as was apparent when we looked at the *Last Supper*. I would prefer it if there were always a clear distinction between scientific examinations intended purely to discover how a work of art was made or how it has changed, and actual decisions to restore.

Where do modern academics stand on this spectrum? They often don't. If their priority is to demonstrate the social context, meaning and reception of art – which is the predominant tone of recent art history – scientific examination seems very marginal. I happen to think this is misguided; to take one example, the history of the two prime versions of the *Madonna of the Yarnwinder*, disclosed above all by IR reflectography, tells us a great deal about the studio production of small-scale devotional images in the context of patronage. But the reality is that it would be easy to attend a year's worth of research seminars in a substantial department of art history without seeing a single X-ray or infrared reflectogram, or encountering the data of pigment analysis.

Looking at this spectrum of reactions, we find – as we have repeatedly done – that what is regarded as 'valid' knowledge is heavily conditioned by the sources of that knowledge, and the professional positions of those promulgating and judging it. Across this spectrum, there are many more than 'two cultures' within the modern world of art history.

CHAPTER 9

CODICES AND COMPUTERS

Opposite the Seattle Art Museum on First Avenue was a notorious strip joint called The Lusty Lady (now a boutique hotel). Keen not to miss a trick, the striptease artistes were advertising two special programmes on their marquee: 'LEONARDO-O-O-O-O' (I forget how many Os), and 'CODEX-X-X-X' (ditto).

The occasion, in the winter of 1997–8, was the exhibition across the road of the *Codex Leicester*, owned by Bill Gates; its full title was 'Leonardo Lives: The Codex Leicester and Leonardo da Vinci's Legacy of Art and Science'. The codex itself was ingeniously displayed among a wide selection of artistic homages to Leonardo by his immediate followers, later old masters and contemporary artists. The director of the museum was Mimi Gates, a notable specialist in Asian art and the wife of William Henry Gates, Bill's father. One of Microsoft's major sites of operation was in Bellevue, across the lake from Seattle; so this exhibition was both a local and a family event, involving two of the biggest figures in the history of artistic and digital culture.

Bellevue is the site of what was Bill Gates's 'other' company, Corbis, which was accumulating a huge archive of visual images for licensing. Corbis had recently produced a high-spec CD-ROM, *Leonardo da Vinci*, for which I was consultant and part-author. It was one of several projects I have worked on involving the 'computerizing' of Leonardo. The intention has not so much been to create databases of his writings and images (useful though these might be), but to scratch visual itches that Leonardo himself could not reach, given the limitations of the media available to him. I feel strongly that something of the non-linear quality of his thought and presentation – in which he moved

Studies of the Illumination of the Moon, from *Codex Leicester, c.* 1506–8.

with astonishing lateral fluidity across the kind of mental and visual boundaries we take for granted – can most effectively be explored in a digital context. My aim has been to accomplish a matching fluidity on the screen of a computer.

It has always seemed to me that Leonardo would have liked his drawings to move. You can see this by looking at them. He had pioneered a 'brainstorming' mode of drawing, in which rapid and intense scribbling suggested a range of alternative positions for bodies in motion. He was insistent that the painter should rival the poet in fluency of invention:

> Have you ever reflected on the poets who in composing their verses...think nothing of erasing some of the verses in order to improve upon them? Therefore, painter, decide broadly upon the positions of the limbs of your figures and attend first to the mental attitudes of the creatures in the narrative rather than to the beauty and quality of the limbs. You should understand that if such a rough composition turns out to be right for your intention, it will all the more satisfy in subsequently being adorned with the perfection suitable to all its parts. I have in the past seen in clouds and on walls stains that have inspired me to beautiful inventions in many things.

Looking at his drawings of animated forms in motion, we cannot help seeing the forms as a blur of dynamic action. No one had previously drawn like this. But are we looking with eyes conditioned by later conventions? We obviously cannot look with Renaissance eyes; but I think it was, and is, impossible on perceptual grounds not to be caught up in seeing motion, rather than just a series of alternative positions for the horse's legs and head. I find the sense of movement irresistible. Leonardo was also alert to how we can project powerful images onto scribbled and inchoate patterns that were not wholly under the artist's conscious control – a form of serendipitous seeing-in.

I had come to see that his notion of 'continuous quantity' was the key to Leonardo's ideas of motion in space. He insisted that 'motion by action is infinite'. This was because there are no separate points in

space, since a geometrical point in itself has no dimensions. We need to depict a frozen moment when we capture something in motion, but this is artificial, because 'motion occurs across space and that space will be a continuous quantity, and every continuous quality is infinitely divisible'. A 'continuous quantity' is something like a line or plane (or space itself) that is not broken into discrete sections. This seductive continuity belonged to geometry, whereas arithmetic dealt ploddingly with separate numbers. Accordingly, Leonardo saw geometry as the supreme branch of mathematics.

To this 'continuous quantity' of motion he added the continuity of locations from which the same thing can be seen. He stressed that 'the same action will show itself as infinitely varied, because it may be seen from an infinite number of locations. These locations have continuous quantity....Hence from varied viewpoints each human action is displayed as infinite in itself.' In his drawings, particularly those related to sculpture, he often portrays each form from a number of viewpoints, sometimes in an overtly sequential manner. His vision of the infinite positions of a moving body and the infinite positions from which to view it is fully cinematographic. He well realized that his beloved painting had to freeze

Set in motion: *Study for a Rearing Horse, c.* 1503.
Pen, ink and chalk on paper, 15.3 × 14.2 cm (6 × 5⅝ in.).

both action and viewpoint. It was to overcome this double limitation that I proposed we animate Leonardo's drawings and concepts.

Leonardo was dedicated to the *re-making* of nature on the basis of the principles governing how it worked and how it looked to us. We may think of him as aiming at a 'photographic' vision of nature; but this is wrong. Photography records the effects of nature; Leonardo aimed to create effects from underlying causes.

Computer-aided design (CAD) programs build images from the bottom up, starting with the three axes of space in essentially the same way as Renaissance perspective. Bodies are constructed in space as 'wire' frames, and the surfaces are rendered with colour and texture and bathed in light and shade from one or more predetermined sources of light. The bodies are seen from a specific viewpoint, with the computer screen acting as the front plane of the picture. This synthetic process is analogous to what Renaissance artists were doing. The difference is that the modern CAD image can be rotated at will in space, corresponding to Leonardo's infinite viewing points, and components in the image (such as an arm or leg on a human figure) can be set in a series of sequential positions and viewed in time in such a way as to provide an illusion of motion across Leonardo's 'continuous quantity'.

Not that it has ever been my intention to demonstrate that Leonardo 'anticipated' cinematography or CAD. Rather I have sought to place his legacy in a creative dialogue with modern technology, in order to demonstrate his particular ways of exploring and recording motion in space.

My first effort to set up such a dialogue was for an exhibition entitled 'Leonardo da Vinci: Artist, Scientist, Inventor' at London's Hayward Gallery in 1989. In this instance there was a happy collaboration between the sponsor of the show, computer giant IBM, and an innovatory dimension of its content. I imagine the computerizing of Leonardo was part of the gallery's pitch to IBM. It is generally good if an exhibition sponsor can play an active role in the show.

My idea was twofold: first, to use computer animation to capture the fluidity of Leonardo's processes of invention and visualization; and secondly, to program his rules for physical processes – such as the flow of water, or the branching of systems for the transmission of fluids – and let

them run, to see how the results compared to Leonardo's. We explained to the staff at the IBM Research Centre that we wanted to render some of Leonardo's ideas as computer animations. At first they seemed to expect that this would take up only a small amount of their time and resources. In the event, realizing our planned sequences pushed the team at IBM very hard, but their efforts resulted in what were then state-of-the-art computer graphics.

With my collaborator Philip Steadman,* I outlined five areas of Leonardo's thought to be demonstrated by computer modelling for the Hayward show. The first involved his brilliant plastic sculpture of the five uniquely regular (or 'Platonic') solids, the faces of which are the same regular polygons. The second gave the simplest rendering of the perspective of the *Last Supper*, such that we could see how the 'upper' room extended the real space of the refectory. The third showed Leonardo's meticulously systematic expositions of light and shade. The fourth – which, for various reasons, ultimately had to be made with graphic animations rather than computer modelling – dealt with his innovatory law of branching; and in the final demonstration we looked at his designs for centralized churches in the 1490s, which are miracles of geometrical permutation. At the time, this work was at the edge of what technology allowed. We felt afterwards that we had accomplished something new and significant – and that Leonardo would have been pleased.

This first run at computerizing Leonardo left me keen to do more work in a similar vein. I was delighted when, some time later, Corbis approached me about the possibility of developing a CD-ROM based on the *Codex Leicester*.

The *Codex* is so-called because in 1719 it was imported from Italy by Thomas Coke, first Earl of Leicester, who purchased it on his Grand Tour. While still in Italy, he had a more legible copy made. Later he was to build Holkham Hall in Norfolk as his magnificent country house. The original codex consists of eighteen double sheets (thirty-six folios, seventy-two pages) folded one inside the other, and was bound in a

* Philip had originally trained as an architect, and his 1979 book *The Evolution of Designs: Biological Analogy in Architecture and the Applied Arts* was notably Leonardesque in spirit.

cardboard cover at some unknown date. Its main subject – the role of water in the body of the earth – seems to have given it a special interest to hydraulic engineers and pioneering geologists, and it was accurately transcribed on a number of occasions.

In the 1970s the trustees of the Holkham Estate, needing to raise money, chose to sell the codex. In December 1980 it was auctioned by Christie's and sold for $5.12 million. The purchaser, advised by Carlo Pedretti, was US businessman and art collector Armand Hammer, president and chairman of Occidental Petroleum. After studying to become a doctor in the early decades of the 20th century, Hammer had cultivated very profitable trading links with Lenin's Russia, earning the sobriquet 'the Soviet Union's favourite capitalist'. The picturesque and devious dramas of his commercial and political relationships with the rulers of the USSR seem to have become enhanced in the telling.

In the 1930s Hammer opened an art gallery in New York with his brother Victor, who had studied art history at Princeton. He also purchased the long-established international art dealership Knoedler & Co. in 1971. In his own right he collected on a substantial scale, concentrating on Impressionist and post-Impressionist paintings, Russian art of uneven quality and dubious provenance, and the kind of old masters that you would expect in a rich man's collection. Rembrandt inevitably features – two rather good ones – as does a substantial collection of Daumier's satires. Bequeathing a major art collection, and ownership of anything by Leonardo, promises a certain kind of immortality.

Having purchased the codex, Hammer and Pedretti arranged for its dismemberment on the grounds that it was essentially a series of separate pages. In this form it could be displayed as a series of individually mounted double-sided sheets, each of four pages, like sixteen butterflies pinned to a board by an insect collector. It was grandly renamed the *Codex Hammer*.*

The folios were confusingly renumbered for a catalogue by Carlo accompanying a new facsimile edition. Leonardo's own assembly of the

* I met Hammer once in California and gained the impression that he was, as this suggests, an egotistical monster, expecting everyone to pay homage and to dance to his tune. Those he was employing to administer his collection seemed scared to voice their own judgment.

Not an old master drawing:
A double sheet from the *Codex Leicester*, fols 6v and 31r.

double sheets – laying one inside the other before folding – did not obey conventional logic, and he certainly did not systematically begin on the first folio (1r) of sheet one and work his way through to the last page – or vice versa. Even so, the violation of his own preferred order is not to be sanctioned on grounds of either authenticity or content. The advantage to Hammer was that his trophy could be readily exhibited, though it does not comprise an appealing set of old master drawings. The pages of the codex are densely written in almost impenetrable mirror-writing with as many as a thousand words per side, typically accompanied by small marginal illustrations of a technical kind. It attracted good visitor numbers on its exhibition tours, as works by Leonardo always do; but I wonder how much of it was really understood.

Hammer's collection was eventually acquired by the University of California, mired in legal disputes with Hammer's family. To raise money, the university committed the codex to auction at Christie's. Bill Gates purchased it for $30.8 million – almost six times what Hammer had paid – and was quoted as saying he would have been prepared to pay more. His decision to revert to the historic name of the *Codex Leicester* was a happy portent. There is no doubting his profound admiration for Leonardo, nor his willingness to share widely the treasury of thought and visualization locked within the puzzling pages of the codex. He could not present himself more differently from Hammer. To say I know him would be an exaggeration, but on slight acquaintance he gives the impression of striving to live as normal a life as possible considering the extraordinary position in which he finds himself. He has a restless and expansive intellect, engaging intensely with anything that captures his attention – which many varied things tend to do, over comparatively short spans of time. Is there a Leonardesque dimension here?

It was Curtis Wong of Corbis Productions who contacted me about the codex CD-ROM project. Curtis, who is remarkably skilled at data visualization and the communication of difficult things in lucid ways, had first seen the codex in 1980, and he now hoped that a CD-ROM would make it widely accessible. Corbis had already issued a number of comparable products; there was no doubt that it was setting the industry standard. The possibilities were exciting. We met in London to discuss

them, and formed a plan to use the codex as the central focus for a dynamic exploration of Leonardo's universality.

The central goal of the project was to make the pages of the codex accessible. This was accomplished through the 'Codescope', a clever invention typical of Curtis's communicative brilliance. A rectangular window could be moved over an image of each page to perform three tasks: flip Leonardo's mirror-writing, making it a little easier to read; transcribe it in legible form; and translate it. Fitting the three texts into the same space required considerable ingenuity. The Codescope worked well, potentially serving as a training tool for anyone who wanted to master Leonardo's handwriting. It was also fun. The screen devoted to each page in the codex was linked to a commentary on the various notes and diagrams on this page. The text of the commentary on the first folio explains why the moon has an uneven brightness: rather than being a smooth, mirrored ball, the moon consists of land portions that are rough and hilly, and wavy seas. Therefore, some of the light reflected from the sun is dispersed and weakened by shadows, which explains the relative faintness of the moon's glow.

To open up the contents of the codex, we used animations to enhance our understanding of what Leonardo was trying to demonstrate. These were simpler and more diagrammatic than the ones from the Hayward Gallery show. Particularly effective was one in which the earth rotated around the sun and the moon around the earth, tracing the direct passage and rebounds of sunlight and the resulting shadows (see p. 236). Where Leonardo was grappling with the extreme complexity of water in turbulent motion, however, animations simply could not cope. Instead Corbis commissioned the Harris Hydraulics Lab at the University of Washington to replicate Leonardo's observations and experiments, which were filmed for the CD. It was remarkable how well his observations of almost five hundred years earlier stood up to modern experimental verification. For me, this was a return to the topic that had provided my initial entry into Leonardo studies.

The CD-ROM went on sale in 1996; but although it was well reviewed, it was unfortunately timed. It was already becoming clear that such high-production-value CD-ROMs were not commercial propositions.

Top: The *Leonardo da Vinci* CD-ROM box showing the Codescope and 'temple gallery'.
Bottom: Making a splash!

The overall trend was towards educational content being provided online, rather than on a shiny disc injected into the side of a laptop. Production and marketing of the Corbis CD soon slowed to a halt, and it more or less disappeared from the public market. However, our work had a useful afterlife in exhibitions such as the one in Seattle; Bill lent codex sheets to selected venues worldwide and each venue developed its own programme around the material, with appropriate displays of art, science and technology – for instance, the New York Museum of Natural History did some clever hydraulic demonstrations with actual water. The Codescope performed very effectively in these displays.

More than a decade later, the project was unexpectedly revived. The new idea (driven once again by Curtis) was to create a website extending and updating the work we had already done. The foundation of the site would be a completely new transcription and translation of the codex, with a new interpretative apparatus, which was much needed – Carlo Pedretti's version undertaken for Hammer was only available as an expensive facsimile edition, and still left a lot of fundamental work to do. I suggested that we recruit Domenico Laurenza, whom I had met many years earlier when he was researching Leonardo's anatomical drawings. He had translated the text of all the Leonardo and Leonardo 'school' drawings in the United Kingdom (with the exception of those at Windsor).*

Roped together with our contracts, Domenico and I began to climb the Leonardesque mountain, exploring its rocky crags, obscure nooks and crannies, layers deposited over time, onrushing currents, transformations of form, bursts of illumination, precipitous ascents and astonishing perspectives – in both the metaphorical and literal senses. When we began, I thought I knew the codex reasonably well. This proved not to be the case.

Intense attention to how the sheets were compiled – particularly to the order of text and illustrations on each sheet, and the way they were combined into what became the interleaved codex – took us into

* This was authored jointly with my excellent former research student Juliana Barone and published in 2010 as *Leonardo da Vinci. I disegni di Leonardo da Vinci e della sua cerchia. Collezione in Gran Bretagna.*

the heart of how Leonardo worked. Domenico proposed that the outer set of seven sheets, concerned with the passage of light between the sun, moon and earth and with more general cosmological and terrestrial matters, were of effectively different origin from the discussions of water that dominate the main body of the codex – though they were thematically connected by a radical vision of the moon as an earthlike planet, with continents and wavy oceans. Close attention to Leonardo's original language provided a deeper insight into what he actually meant: he was discussing geological questions that were only partly addressed in Latin texts, and very little in Italian. His relationship to ancient and medieval authors was greatly clarified by Domenico, almost always to Leonardo's credit. These are detailed and technical matters of scholarship, but they provided an essential foundation for the bigger conclusions we were drawing.

The genius of Leonardo's arguments in favour of the vast age of the body of the earth emerged in all their polemical brilliance. His evidence was drawn most directly from his observations of the strata of fossils, which provided unequivocal evidence that the shelled creatures buried within the strata had thrived in living colonies at different levels over the course of long and successive eras. The short-lived biblical deluge could not have been responsible. Leonardo decided that the changes were not just the result of local changes in water levels, but would have required huge upheavals and collapses in the earth's crust. This meant that the relative centres of gravity of the irregular earth and of its sphere of partially encircling waters continually shifted on a global scale. He even speculated that the Straits of Gibraltar would eventually widen to such an extent that the Mediterranean would drain and become an extension of the Nile. I had read the various texts before, but it was only on detailed examination of the codex in the context of the whole that the full grandeur of Leonardo's vision took shape in my mind.

It was this vision that I took to the viewing of the *Mona Lisa* in various publications over the years. Having looked in far more detail at the important statement of the microcosm theme in the codex that I had quoted in excerpt in my earlier work (see p. 74), I realized that the earlier translation missed important dimensions of its meaning; the full passage

gave a rather different understanding of what Leonardo was saying. It is salutary, and not a little shaming, to compare the earlier extract with the full translation by Domenico and myself:

> Nothing can be generated in a place where there is neither sensitive, vegetative nor rational life. Feathers are generated on birds and change every year; hair is generated on animals and changes every year, except some parts, like the hair of the whiskers of lions and cats and similar; grasses are generated on the meadows and leaves upon the trees and are renewed in great part every year. So that we might say that the earth has a vegetative soul and that its flesh is the soil, its bones are the arrangements of the connections of the rocks of which the mountains are composed, its cartilage is the tufa [a porous limestone], its blood is the veins of waters; the lake of the blood, which is throughout the heart is the oceanic sea; its breathing and the increase and decrease of the blood through the pulses in the earth is thus: it is the flow and ebb of the sea; and the heat of the soul of the world is the fire which is infused throughout the earth; the seat of the vegetative soul is the fires, which breathe in various parts of earth through baths and mines of sulphur, and in Vulcano and Mount Aetna in Sicily and in many other places.

The detail given by Leonardo is not just detail – it paints a vivid, dynamic and unified picture of what he calls the 'vivification' of all things, great and small. All things on earth are endowed with life-giving spirits and souls (vegetative, animal and rational), but the whole has a destructive potential far beyond man's coping. Death and disaster are always present in the life of the body of the earth.

Looking again at the landscape behind Lisa, the issues of life and death, birth and decay – discussed in enigmatic fashion in the notes on the 'Great Lady' sheet – become deeper and more urgent, far beyond the philosophical niceties of the microcosm. The looming instability of the mountains and the threatening height of the lake on the right express

the perpetual instability of the water-girt earth. Again we can say that the 'portrait' has become so much more than a portrait.

By summer 2011, Domenico and I had the transcriptions and translations in complete draft. Then came a bombshell: in December the whole project was put on hold. Bill Gates had reviewed his priorities and decided that he needed to focus on more pressing issues. It is difficult to argue that a Leonardo website should have assumed priority in the face of Bill and Melinda's charitable activities in health and education; nevertheless, this was a blow. It was agreed, however, that our work on the new edition should be completed, and that we would explore other ways of bringing it into the public domain.*

We forged on with the commentary. Going back over the translation, which we had made as literal as possible, it occurred to me that a full paraphrase in more modern language would help the reader greatly. I began work on this task, having greatly underestimated how difficult and time-consuming it would be; but I am convinced of its utility, and that it will be a valuable component of what should be the most complete edition of any historic manuscript of its kind. Bill Gates's support over the years to advance public understanding of the codex has allowed us to devote the kind of long-term effort that is all too rarely possible for scholars in modern academic posts.

During the course of our work, Domenico was also looking at what the Italians call the *fortuna* of the codex. Received wisdom is that the amazing innovations in Leonardo's scientific and technological manuscripts remained largely unknown until their rediscovery centuries later. This gives historians of science an excuse to write off Leonardo as of no consequence in the great march of knowledge as it is conventionally defined. However, Domenico was able to track the ownership of the codex through the hands of engineers and geologists, and his indefatigable sleuthing identified a series of at least five complete and three abridged copies. On an exciting visit to Holkham Hall we had viewed a very nice copy with elegant illustrations – this was the one produced in Italy for

* One possibility was that we might produce a multi-volume printed edition with Oxford University Press, which is what we are doing, alongside a digital edition.

Thomas Coke, before his return home with the original. Domenico was able to show that the original and a series of legible copies were available over the course of the 17th, 18th and 19th centuries, in just the right places to play a positive role in the radical reform of the geological sciences. The codex was accessible at key points to readers in Florence, Paris, Rome, Naples, London and Weimar. Along the way, Domenico found a good deal of evidence that Leonardo's science as a whole was much better known than anyone thought.*

Now the best for last – at least in terms of bringing Leonardo's actual drawings to life, in both form and content. I had always hesitated to corral computer graphics into the same spaces as Leonardo's drawings, imagining that the disparity would be too evident. However, the talents of animator and director Steve Maher, then of Cosgrove Hall Productions, persuaded me otherwise.

The occasion was the show 'Leonardo da Vinci: Experience, Experiment and Design' at the Victoria and Albert Museum in 2006, and the aim was to animate some of the key drawings in the exhibition. Upon meeting, Steve and I immediately tuned in to the same wavelength. He was happy to take on the challenge of animating the drawings in terms of their actual graphic qualities – the particular characteristics of Leonardo's lines, his use of hatching for shadows and the way his demonstrations are set on the page.

We settled on eight animated sequences, but here I will look at just one. Its jumping-off point was the way Leonardo illustrated his discussions of the human figure in motion with quick little pen-men, dynamically sketched with an unerring economy of line. They were intended to feature prominently in his *Treatise on Painting*. The pen-men stand, sit, walk, run, stop, climb, lift, carry, push, pull, dig, hammer, throw...sometimes in flickering sets across a single page.

* Another notable digital initiative – one of the goals of the 'Universal Leonardo' project discussed in Chapter 4 – was the creation of what was intended to be *the* Leonardo website, a comprehensive and reliable web resource that would balance out the quantities of inaccurate rubbish already online. The work was undertaken by an independent company, Artakt, set up by myself and Marina Wallace of Central St Martin's College of Art. We began in 2000 and the site eventually launched in 2006. At the time of writing it is still largely functional, and although in need of updating, I believe it remains the best educational site for Leonardo as a whole.

We chose one of my favourite studies: a sequence of five tiny figures nestled in a double page of optical investigations at Windsor. A thumbnail man is hammering or chopping. At point 'a' he suspends the heavy head of his implement behind his back. He takes a powerful stride forward, stretching himself as high as he can on tiptoe, before crashing a sudden and mighty blow onto the ground. His elastic stretch violently condenses into a compressed crouch at point 'b' (remember that Leonardo used mirror-writing). Steve found, remarkably, that Leonardo had infallibly identified key stages for the animation in a way that invited the creation of intermediate drawings that would smooth out the motion across time and across space – Leonardo's 'continuous quantity'. The resulting animation, reversed and amplified by some imagined puffing and panting on the part of the hammerer, was supplemented by secondary animations of a figure climbing onto a knee-high block, a walker who runs, and men digging with spades and pick-axes. That Leonardo could arrive at the key stages for animating the hammering man is a total wonder.

Animation by Leonardo:
Notes on optics (detail of a man hammering), *c.* 1508.
Pen and ink with red and black chalk on paper, 43.8 × 32 cm (17¼ × 12⅝ in.).

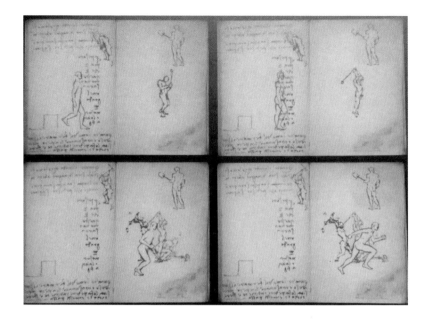

Stills for Steve Maher's animation of the hammering man.

Throughout all my work on various digital interpretations of Leonardo, I have tried to identify where his modes of operation interact most creatively with the possibilities offered by computers. I have concentrated on visual means. Much of humanities computing is involved with the assembly of databases and large-scale data analysis; but I feel that in subjects where crucial amounts of the core evidence are visual – most notably, the histories of art and science – there has still been far too little creative use of digital images. As technology moves on, sometimes at breathtaking speed, it inspires ever more exciting ideas for work in this area.

CHAPTER 10

EXHIBITIONS

Curating exhibitions is exciting and demanding, and it involves interacting with numerous facets of the 'real world' outside academia. As a keen player of sport, mainly hockey, I have always enjoyed teamwork with a range of people from diverse backgrounds whose skills and outlooks are different from those we obsessively measure in academic life. Exhibitions are potentially major vehicles for communication to wide audiences.

Most of the elaborate preparation and administration involved in mounting an exhibition are not apparent to visitors, who simply see a fine array of items that have been assembled, hung and located in cases. Much in the way of complex diplomacy, fundraising, wheeler-dealering, currying favour and 'massaging' lies behind what seems on the surface to be a fine manifestation of international collaboration.

In the beginning is the outline. Even if a curator has been invited to pitch for a show, a detailed outline is vital, and considerable effort goes into making it persuasive. It has to explain why the exhibition is right for that particular venue at that particular time; its main selling point; why it deserves high priority; how it relates to previous shows; its intended audience; its content, overall message and sub-themes; the number, sizes and display needs of the items; the loans that will be needed; and the publications and other media that will be involved.

To whom is the exhibition being sold? Initially, to the exhibiting organization itself – not just the staff but the director, and the board to whom the director is responsible. Often there is an exhibitions committee to be won over. Presentations are likely to be needed, to whip up enthusiasm. What may seem obvious or compelling to the curator might

Beautiful rightness:
Wooden model of Leonardo's ring bearing, based on *Codex Madrid I* fol. 20v,
in the Hayward Gallery's 1989 exhibition 'Leonardo da Vinci: Artist, Scientist, Inventor'.

be less so to a sceptical member of staff or a board member. One outline I prepared was criticized for being 'vaporous like the air'. It helps a good deal if the proposal addresses the issues of finance and sponsorship. At least in the case of Leonardo, we do not at any stage have to answer the questions 'Who?' and 'Is anyone likely to be interested?'

If the venue is enthusiastic, there are issues of timing. A really big or difficult show is likely to need more than a three-year lead time, and different exhibitions work best at different times of year. The venue has to commit financially long in advance of any thrust for sponsorship. A contract is needed – in my case via my agent, Caroline. Even with her firm representation, curatorial fees are never high (I have suggested that it might make sense to pay the curator a smaller initial fee plus a percentage of the take at the door, but to no avail). The main publication generally requires a separate contract. Designers and other firms employed by the venue are typically much better remunerated than curators. As always, it is assumed that academics can be underpaid because they are committed and easily flattered.

I have always believed it is important to involve a designer at the earliest possible stage. An exhibition is a visual event, a kind of theatre of items; its form and content should be totally integrated in the dimensions of space, time and motion that operate within the rooms in which it is shown. Despite this, the inevitable concerns about budget mean that some venues tend to appoint designers quite late in the process, expecting them to make the best of a developed curatorial concept.

A vital stage in the conception is what I call a *sala degli xeroxi* – a very large room full of photocopies. Reproductions (formerly 'xeroxes', now scanned images) are obtained for all the possible exhibits and are spread out across a wide area of floor. We are finding which items speak to each other in what way. They are clustered in conversational groups. They are moved around, keeping new company, seeing what happens. Each item works in a different way in each different place – sometimes brilliantly, sometimes less well. The results are both planned and unexpected. We have to remember scale, of course, but the result of much walking, lifting, placing and debating is a precocious 'hang'. The spatial aspects and physicality of this process cannot really be aped on a computer.

If the conversations are well conceived, essential features of the *sala* will remain discernible in the final show some years later.

Along the way, we need to arrive at a title for the show. I don't recall any title surviving from the very beginning, although the curators will have early ideas which, even if abandoned, will tend to live on in their minds. The official title needs to be both accurate and catchy. This is not easy, as so many people from different parts of the organization have an input.

The loan list begins to take shape. Key lenders have already been approached informally, to gauge reactions and to draw them into the conspiracy if at all possible. Visits to lenders are coupled with research and the tracing of new items – new to the curator, perhaps even new to everyone. Personal relations are crucial, in this as in all other matters. The informal discussions crystallize into formal loan requests incorporating a statement of the purpose of the show and enthusiastic justifications for each loan, written by the curator: 'Your Leonardo is perfect for the show – we can't do without it...'.

The professional staff at the venue deal with all the complex nuts and bolts of transport, insurance, security, environmental conditions (not least air conditioning and lighting), photography and reproduction rights, merchandise, media coverage, emergencies, timing, and payments to the lenders for various things, such as framing, mounting and exhibition fees. In each of the venues for the Leonardo shows we have benefited from the British Government Indemnity Scheme, which effectively guarantees each exhibit against loss or damage without the need for pricey commercial insurance. The budget is likely to have to allow for the cost of 'couriers' who accompany each major item 'from nail to nail', as the professional saying goes. The couriers are typically curatorial staff from the lending institutions. Ideally, each exhibit should arrive in the gallery for its supervised unpacking and installation according to a schedule, with decent intervals between the arrival of all the separate items. In reality, given the vagaries of transport, there are inevitable pile-ups of objects arriving at the same time, leading to frayed tempers. Sometimes exceptional measures are necessary. I once witnessed a set of drawings arrive with a police escort.

Special handling teams will be involved in unpacking and hanging or placing the items under the fretful eyes of the couriers. Detailed condition reports will be taken and agreed, so that any new scratch or previously unnoted blemish is duly recorded. The curators and in-house staff (and sometimes the couriers) will debate the best location for each item. A carefully hung painting will suddenly be seen to be in the wrong place once other items are positioned. Where something is hung, and the company it keeps, can radically affect what it looks like. The handling teams need patience as the curators change their minds. There is nervousness that someone more senior, perhaps the director, might arrive and say that everything is in the wrong place. Somehow, almost indiscernibly, things come together with a sense of rightness. The lighting engineers are key players in this process.

In the meantime, there is the small matter of sponsorship. Development officers identify 'prospects'. The potential sponsors may previously have supported the museum or gallery, or a particular company may be considered as especially appropriate for a particular show. It always requires at least one very senior person in the sponsoring company who is motivated to push the idea to his or her colleagues. We cannot assume that all sponsors look for the same things. They may be interested in the media splash and the number of visitors; they may prioritize the holding of events at the exhibition for their existing clients. They may be focusing on a few major new clients whom they hope to attract. The curator might well be expected to deliver a seductive presentation to the potential sponsor.

Also in the meantime, the curator will have been writing exhibition labels and composing more discursive wall panels. There will also be the generation of a 'catalogue'; these days, this is more likely to be a glossy 'book of the exhibition' than a detailed scholarly account of each individual item. We also need to draft a small brochure to be given to each visitor as an aid to navigating the show. Then there are the press releases, as well as articles written for media outlets – perhaps including an appointed media partner. The curator as author needs to be patient when his or her cherished prose is adjusted for use in these diverse contexts. Never use the phrase 'dumbing down' within earshot.

In addition to all of this there are the texts and images for posters and invitations. Are the sponsor's logos the right size? Is the wording of the invitations right? Will anybody's nose be put out of joint? Have all the right people been invited, representing all the necessary groups and constituencies?

In the past, an ivory-tower scholar might just about have tolerated the commercial and promotional aspects of the whole process as a tiresome necessity, especially given the inadequate funding of our public galleries. These days we are, as a profession, more attuned to fundraising. In essence, Leonardo would have recognized the need for commercial courtship: he was a hired hand, and readily accepted his role as a *stipendiato* of the Italian and French courts in which he worked. By the end of his career he had become a kind of tourist attraction for high-level visitors to Francis I's court in Amboise. He was interested in widespread fame.

At last we come to the opening, or rather openings. The extraordinary and apparently endless chaos of unfinished cases, unpainted partitions, trailing wires, non-functioning lights, recalcitrant IT displays and missing labels has suddenly been transformed into order. The grumpy men with paintbrushes and boxes of rattling tools have finished and gone home.

The press are the first to be accommodated. The director and curators address the assembly of journalists. There will be the regular reviewers, and if you are lucky some feature writers, who need 'stories' strong enough to find a place outside the ghetto of the arts pages. Ideally a weekend colour supplement will have been signed up well in advance. The reviewers are part of a regular circus, often familiar to each other and to the curators. Most do a good job and feel a responsibility in guiding their readers. One or two are constitutionally negative – if a show received a positive review from one particular prominent and posh-sounding critic, I would be worried that I really was doing something wrong. We move with the journalists into the show itself. Saying the same thing many times and trying to make it sound fresh is an art form. Some journalists ask really difficult and well-founded questions, which is salutary if disconcerting. Interviews for radio and TV are booked into designated time slots. It is good to remember that what is needed for a brief news story is very different from an item for an arts programme

(media training helps with this). The prime message is to remain positive rather than defensive.

At one time there would have been one 'big bang' public opening event with the grand, the good and the hangers-on. Glasses of average wine would have been served, and there would have been speeches (ignored by a proportion of attendees – we typically spoke over a buzzing undercurrent of murmured conversation). Private view attendees rarely looked at the show in any concerted manner. Being seen, rather than seeing, was the priority. Wine and waffling were the name of the game.

Nowadays there are likely to be two or more targeted openings over successive days for big shows. There are the gallery's regular ranks of patrons and friends, and there are the 'art world' people (including academics like me). There are those to whom the gallery will be looking for financial and political support, most notably the CEOs and chairs of major companies. They may already have been offered privileged events in the museum or gallery before and after the opening. Above all the direct sponsors of the show need servicing, and are likely to be invited to a dinner within or close to the exhibition. The speeches tend to be too numerous – brevity and a dash of lubricated wit are recommended. Leonardo himself invented various diverting things for smart dinners, such as a trick that turned white wine into red, involving crab apples and 'vitriol', a sulphite of some kind. (He did not say that the results were drinkable.)

Then the reviews. One great advantage of working with Leonardo is that his supreme qualities shine through, whatever the curators may have done (although one critic more or less wrote off Leonardo as presented in the V&A exhibition as an unrealistic dreamer who did not finish much). I find reading reviews an oddly detached process, as if they are about something unrelated to my own work. For the most part I can't complain, and never do – at least, not in public.

I have curated three exhibitions specifically on Leonardo. The first, 'Leonardo da Vinci: Artist, Scientist, Inventor', was a collaboration with Jane Roberts in 1989 at the Hayward Gallery in London; the second was the highly focused show at the National Gallery in Edinburgh in 1992, 'Leonardo da Vinci: The Mystery of the *Madonna of the Yarnwinder*'; and the third was 'Leonardo da Vinci: Experience, Experiment and Design' at

the Victoria and Albert Museum in 2006. I was also responsible for the Italian Renaissance paintings, sculpture, graphic and applied arts in the huge and expensive exhibition, 'Circa 1492: Art in the Age of Exploration', staged at the National Gallery of Art in Washington, DC, during the winter of 1991/2 as part of the celebrations of the 500th anniversary of Columbus's 'discovery' of America.

At the time of the Hayward Gallery show in 1989 everything was simpler than now, and, looking back, more innocent. The opportunity for a Leonardo exhibition came early in the life of the gallery as an independent entity (it had originally been run directly by the Arts Council). Sir Roy Strong, then chairman of the Art Department of the Arts Council, wrote that 'the newly devolved centre called for a blockbuster – and who better than Leonardo?' The gallery's director, Joanna Drew, made an exploratory approach to myself and Jane ('Janie') Roberts, curator of the Print Room in the Royal Library at Windsor, who was looking after the great collection of Leonardo drawings.

The core of the exhibition was to be a wide-ranging selection of drawings. But should we try to obtain paintings? The gallery had no collection of its own. It was what the Germans call a *Kunsthalle* – an 'art hall'. This meant that it could not potentially offer reciprocal loans to those museums and galleries who might be asked to lend. There was a sense that we might just about obtain one or two paintings. We put out exploratory feelers to the National Gallery about borrowing the *Virgin of the Rocks*. It was not far away. Our plea was for 'one great painting...which represents a summation of Leonardo's creative vision'. The request was not rejected out of hand, and a conservator's report was commissioned, but the gallery's final decision was not to lend. I was not altogether sorry. Just one painting would have tended to look apologetic.

The drawings, as well as being compelling individually, offered a vivid insight into how Leonardo thought on paper. The organization of the show was to be thematic rather than chronological, although the first section was devised by Janie to present an outline of Leonardo's life. The idea was that a sense of the unity of his vision would emerge from his apparent diversity if we managed the juxtapositions and resonances well enough. After sustained manoeuvring, much of it in the *sala degli*

xeroxi, the sections crystallized. The first thematic section, 'The Ages of Man', was a natural for someone who possessed such a keen sense of the passage of time in human life as Leonardo. It also included two drawings of seeding plants to complement his image of a gravid uterus. This led into 'The Natural World' of plants and animals, followed by 'The Body of Earth and Body of Man', the latter improvised around Leonardo's core concepts of the microcosm and macrocosm. 'The Vortex' seemed a natural next step, involving the motion of blood within the heart, spiralling draperies, whorls of leaves in spiral phyllotaxis, an intricately plaited wig for Leda, perpetual motion machines, and tangled turbulence in water. The late *Deluge Drawings* linked into the next section, devoted to 'The Forces of Destruction' (human and natural). 'Art and Imagination' was placed deep into the show, so that Leonardo's visions of paintings and sculpture would be seen to emerge from the context of his universal thinking. The last two sections looked at 'The Measuring Eye', as he brought the geometry of optics into his scrutiny of God's orderly universe. Finally, 'Structure and Mechanism' dealt with the mechanics of the human body and the machines invented by Leonardo as a 'second nature' in his emulation and extension of God's creations.

We were keen that we should use all the available means to open up the small drawings for visitors. Models are an established way of doing so. We managed to obtain loans of fourteen models of Leonardo's inventions, including eight of the very handsome, large reconstructions of his 'elements [or components] of machines' made for Paolo Galluzzi to be shown in the 1987 exhibition 'Leonardo da Vinci: Ingénieur et architecte' at Montreal's Museum of Fine Arts. Modern commercial exhibitions of Leonardo's machines that have proliferated recently often present travesties of his inventions. The illustrated ring bearing of independently moving balls and concave reels from Montreal exemplifies that sense of beautiful rightness that characterizes all truly great designs (see p. 255). We also included two of Paolo's models of Leonardo's architectural designs, one of a centralized church and one of a portico.

We were to conceive one model of our own as the climax to the show: Leonardo's 'great bird', his human-powered flying machine. We decided not to try to make something that would actually fly, flapping its wings

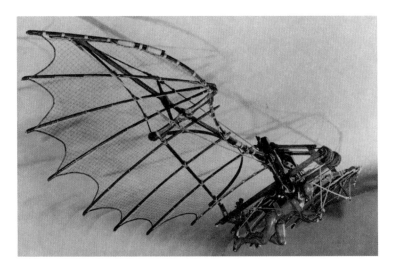

The Flying Machine built by James Wink, in the exhibition 'Leonardo da Vinci: Artist, Scientist, Inventor' at the Hayward Gallery, London.

(which would be remote from Leonardo's actual drawings), but to use his various sketches, mainly from the 1490s, to realize his vision on his own terms. Nothing was included that was not designed by Leonardo. The result was a kind of organic machine. It actually flapped, pivoting at its shoulders and halfway along the wing, at the point that Leonardo designated as the 'thumb'. This wonderfully sinuous motion was filmed and projected onto a blue Italian sky. It exceeded expectations, and seemed fully in keeping with Leonardo's expressed ambitions:

> A bird is an instrument working according to a mathematical law. It lies within the power of man to make this instrument with all its motions, but without the full scope of all its powers; but this limitation only applies with respect to balancing itself. Accordingly we may say that such an instrument fabricated by man lacks nothing but the soul of man.

After the close of the show, the flying machine was sold to Clos Lucé, the manor house in Amboise granted to Leonardo by Francis I, where it joined a growing collection of models.

The really innovative aspect of the opening up of the drawings was the use of computer graphics to realize Leonardo's ambitions in terms of the dynamics of his thought and the dynamics of the objects he was conceiving. That we could involve the sponsor, IBM, in the content of the show was ideal.

Our exhibition designer was Paul Williams, suggested by the gallery at an early stage. His thinking was integral to every facet of the exhibition, and he could not have been a better partner. The gallery staff, too, were creatively supportive. Looking recently at the eleven substantial archival boxes packed with administrative files, I gained some idea of the enormous quantity of work they undertook – not least in dealing with lending institutions and their curators, often eccentric in procedure and personality. Going in at the right level and striking the right tone was vital. In one case, our exhibition organizer Julia Peyton-Jones had to explain patiently that the Southbank Centre was not in the banking business.

What we finally obtained – a gratifyingly rich spectrum of loans – became Paul's design responsibility. The meticulously designed cases, with their rails on which to lean, were constructed with the crystalline precision on which he has always insisted. Where it seemed right to lower the ceiling – given the small dimensions of the drawings and manuscripts – he deployed stretched parachute silk, so that the exhibition space was suffused with a pale silken light. The standard low illumination (50 lux) for the works on paper became radiant, rather than testingly obscure. The illustrated examples show the sectioned 'temple' with some exhibits from the section on the 'Measuring Eye', and one of the beautiful cases with profile heads from the 'Ages of Man'.

The circulation was anti-clockwise so that the deepest single space, which contained a ramp linking the lower and upper galleries, came last and could be devoted to the *coup de grâce* of the suspended flying machine, accompanied by the fictional film of its airborne majesty. This seemed fitting. Leonardo envisaged that the launch of his 'great bird' would fill 'the universe with stupor, filling all writings with its renown and bringing glory to the nest in which it was born'.

Leonardo was a success. He attracted not just the normal art crowd, but also doctors, engineers, scientists and the many fans of his 'universal

View of the sectioned temple, geometrical bodies, jack and optics in 'Leonardo da Vinci: Artist, Scientist, Inventor', designed by Paul Williams of Stanton Williams Architects.

genius'. During its less than three-month run, the exhibition attracted some 262,000 visitors. A serpentine awning was erected on the terrace outside the entrance doors to shelter the shivering queues. The catalogue sold heavily, and a lorry was hired after three weeks to bring emergency supplies from the printers in Italy. It eventually sold over 30,000 copies, which was an unexpectedly high level of take-up.

Two years later, the wide-ranging Washington, DC, exhibition 'Circa 1492' on which I worked as a guest curator included a notable selection of Leonardo drawings, as well as the gallery's own painted portrait of Ginevra de' Benci. We also obtained the portrait of Cecilia Gallerani from Kraków – a loan negotiated by George Schultz, the American Secretary of State, while he was arranging to lend a very large tranche of dollars to Lech Wałęsa's Poland. The most famous painting in Poland served as a bargaining chip in the negotiations.

When international imperatives become involved, some unexpected things can happen with loan requests. For the section on the human figure in 'Circa 1492', we hoped to borrow Michelangelo's early marble relief of the *Battle of the Centaurs* from the Casa Buonarroti, which had been Michelangelo's own house in Florence. The *Battle* was intended to be placed next to the bronze relief of an equestrian combat by Bertoldo, Michelangelo's teacher. The marble relief was a difficult loan, and the

entrepreneurial and buoyant director of the National Gallery of Art, Carter Brown, was deployed. Coming from the wealthy family who had endowed Brown University, he boasted a range of impeccable international connections. On visiting the Casa he was told that the *Battle* was not in a condition to be loaned, but that we could borrow the sculptor's *Madonna of the Stairs*. Pleased with his coup, an ebullient Carter broke the news and asked me if this was OK. I could hardly say no, but my resulting catalogue entry needed to perform some acrobatics to justify its presence. As far as I know, no visitors or critics questioned the relevance of Michelangelo's youthful masterpiece. Curators tend to be more concerned than viewers about the conceptual coherence of an exhibition. Indeed, the *Madonna* proved to be a star item.

My second full exhibition on Leonardo came soon afterwards, and was a very different type of project: the 1992 National Galleries of Scotland exhibition built around the two versions of the *Madonna of the Yarnwinder*. This was not only about Leonardo's art, but very specifically about how he produced small-scale devotional images. As discussed in Chapter Four, the exhibition opened on 15 May, one month after Leonardo's birthday. Well in advance of that date, the gallery's publicity department had swung into action.

Unsurprisingly, the Scottish press focused on how the picture owned by a Scottish duke would fare; the *Daily Record* in Glasgow announced a 'Testing time for the duke'.

> The richest man in Scotland is at the centre of a £50-million art wrangle. For one of the Duke of Buccleuch's treasured paintings is to have rigorous scientific testing. An American collector claims he owns the REAL Leonardo da Vinci masterpiece.

Martin Bailey in the *Observer* reported (prematurely) that 'The Duke of Buccleuch has just been told that he is the lucky owner of the original version of Leonardo da Vinci's most popular painting.' This story cited my 'opinion' that 'evidence suggests that the Duke of Buccleuch owns the original version' (I am sure I would not have said this, because of course

in my opinion there was not a single original). Richard Cork in *The Times* opened his piece with the dramatic idea of a mortal combat between the pictures, anticipating a 'clear winner'; but he, at least, went on to review the complex evidence in a balanced way. Even the National Galleries of Scotland's own brochure for the months of April and May announced that 'Visitors to the National Gallery will be able to consider one of the most intriguing Leonardo mysteries: which is the real *Madonna of the Yarnwinder?*' The brochure for June and July declared that 'Experts are increasingly confident that a portrait of the *Madonna of the Yarnwinder*, owned by the Duke of Buccleuch, is the work of Leonardo da Vinci.' The New York picture was assigned a bit role.

The days leading up to the opening were full of frenetic activity, crises, stress and strained tempers. Most items did not arrive early, and late arrivals triggered anxiety. Temporary shops were erected at the entrance to the two exhibition rooms. Exhibits were hung on the walls and locked into cases. Less than thirty-six hours before everything was due to be complete, the debris of installation was everywhere. As it was finally being spirited away, press photographers and some specially invited reporters arrived.

Exhibitions tend to bring out the arty instincts of press photographers. They spent a long time on their set-ups, positioning lights on tall stands. Finally, one of the gallery staff irritably pulled the plugs on the lights – and the photographer Ian Rutherford suddenly saw his picture. I was silhouetted in the darkened gallery by the spots that were still on

the two paintings. Ian's image made the front page of the *Scotsman*, as did a similar image captured by a photographer from *The Times*.

The exhibition occupied two octagonal rooms on the ground floor of the gallery, a gracious classical building designed by William Henry Playfair in 1822. The room on the left was devoted to Robertet, Leonardo's patron,

The two Madonnas with the curator.

together with items that evoked the French context, while the Leonardo paintings and drawings were on the right. It looked good, after all the panic.

The national and international coverage was far greater than a modestly sized show in Edinburgh might usually expect. Most of the papers were looking for a story about the discovery of an unknown or largely overlooked Leonardo. The Buccleuch and Lansdowne paintings were to fight it out on the walls of the gallery, and I – 'the expert' – was expected to pronounce definitively which was the real Leonardo. I continued to reiterate that neither was a 'lost original'; but academic subtleties do not make good press stories, and the pieces that appeared on the feature pages played to stock expectations, like the stereotype of the Rembrandt found in the attic of a council house (Drumlanrig is hardly a humble attic, but the principle remains the same). Of course, I know that reporters have to do their jobs. I always ask them to read back any direct quotes they might be using, and I console myself with the thought that a story with a misplaced emphasis is better than none.

Scottish art critics were naturally hopeful that the exhibition would provide the apotheosis of the Buccleuch contender as Scotland's genuine Leonardo. The *Scotsman* critic Edward Gage came down clearly in favour of the Duke's picture: 'moved by a gut reaction plus a singularly convincing presence of *sfumato* – Leonardo's most subtle handling of tone – I would place my bet on the Buccleuch version'. Martin Gayford in the *Telegraph* reviewed the arguments with typical care and came to a similar conclusion. An important factor was that the restored brightness of the Lansdowne Madonna seemed unsettling beside the old-masterly mellowness of its rival.

Inevitably, questions were asked about the private collection from which the Lansdowne Madonna had been borrowed. Geraldine Norman, an indefatigable art market sleuth then writing for the *Independent on Sunday*, identified the owner as Wildenstein & Co.: 'my inquiries in New York suggest it is owned by Wildenstein's, the art dealers whose secret stock of masterpieces is legendary'. As Joseph Balilio of Wildenstein's resignedly wrote to the gallery, 'there was obviously no way to prevent Geraldine Norman from asking questions on this side of the Atlantic'.

Cecil Gould, senior Leonardo scholar and former curator at the National Gallery in London, acknowledged in an important review for the art magazine *Apollo* that 'scientific material which became available at the eleventh hour demolished once and for all the theory of "either/ or", and showed that the situation was far more complicated'. In his earlier monograph on Leonardo, Gould had recognized the qualities of the Buccleuch picture, arguing that:

> it has long seemed to me to be demonstrably of Leonardo's execution in the main. The reason why it is not universally acknowledged as such may be that the image of an autograph Leonardo painting of his maturity has been so greatly elevated that hardly any existing picture could live up to it.

This seemed right.

A visit was arranged for Prince Charles a few days after the official opening. It was shoehorned into his schedule, orchestrated by clock-watching courtiers. He was genuinely interested, having some talent as a watercolourist and a known appreciation for historical art. He had been briefed, of course, and knew that no less than nine of the exhibits were owned by his mother. He spoke keenly about the items on display in an engaged manner. When hurried away by his minders he showed some reluctance to leave, but a schedule is a schedule and that is that. I speculated that he was in the wrong job; he would be well suited to running a classy art and antiques shop in Chelsea. Being heir to the throne must be trying.

By the time the exhibition closed on 12 July it had attracted more than 66,000 recorded visitors – a good number for a small exhibition outside London. There was an unexpected legal aftermath. One of the drawings we exhibited was owned privately. It showed the *Virgin, Child and St Anne with a Lamb*, and corresponded quite closely to a description of the lost cartoon exhibited in Florence in 1501. In the catalogue I had outlined three main options: that it was fully autograph; that it was by a pupil; or that it was a forgery. On balance, I was then inclined to think of it as an autograph drawing reworked by another hand.

It was certainly worth exhibiting, but once it was hanging alongside the manifestly autograph drawings from Windsor and the British Museum, it struggled. Although I was less favourably inclined, I was still not prepared to write it off completely.

The next I heard was that an enterprising international dealer named Daniella Luxembourg had been commissioned to handle the sale of the drawing. I looked at it again in Daniella's premises in London in the company of Juliana Barone, who was subsequently to write a report. Her thorough analysis and apposite stylistic comparisons left the issue of its authorship up in the air. It was still genuinely puzzling. I tried to make it fit later in Leonardo's career, as a kind of reprise of his earlier composition. I almost managed to convince myself, but I remained uncertain to a degree that was distinctly uncomfortable.

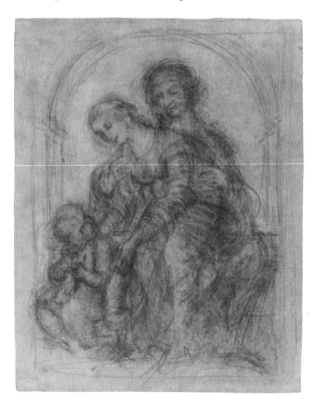

By or after Leonardo? *Study of the Madonna, Child and St Anne with a Lamb.*

Then, wholly out of the blue, I learned that the drawing had become the subject of an acrimonious court case. It appeared that Daniella and another dealer, Simon Dickinson, had negotiated the sale to an American buyer, and that Dickinson's company had taken an unlawful commission of $1 million without the knowledge of the seller (the Accidia Foundation in Liechtenstein). The buyer had subsequently returned the painting, owing to concerns over the attribution. It seems that the drawing has now entered a kind of limbo. If I were invited to investigate it further, I would begin by asking what definitive evidence can be found to rule out its being a forgery.

My third time curating a Leonardo exhibition was in 2006. The bid for a Leonardo show at the Victoria and Albert Museum was generated as part of the Council of Europe's Universal Leonardo project. A design museum seemed a natural site for Leonardo, a supreme operator of *disegno* across all his range of activities.*

There was a local peg on which to hang the project, too: the V&A owned the three Forster Codices, donated by John Forster, Victorian literary man, journalist, editor and biographer of Dickens. These three fat little volumes, closed tight by toggles, contained five of Leonardo's original manuscripts and dealt with a typically wide-ranging series of topics from geometry to costume design. One of the pleasures of planning the show was working though them in order to decide which pages should be open on display. They induced a particular sense of closeness to the master himself. Seated, under the scrutinizing gaze of a supervisor, in the museum's historic reading room – old wooden bookcases, leather-topped tables, cast-iron balconies and that musty scent of old books – I grappled to turn over the stiff pages in their tight bindings. Ill-fitting white gloves with fingers at least half an inch longer than mine

* I was appointed a trustee of the Victoria and Albert Museum in 1986, but my service there came to end rather sooner than anticipated. In 1989, under the Thatcher government, the UK's national museums were called to account by the National Audit Committee for the management of their collections – not least the fact that they held so many items in store. The auditors were apparently blind to the value of reference collections and their report was crass, but it was nevertheless picked up by the House of Commons Public Accounts Committee, who subsequently called in various museum directors for grilling. The consequent sacking of no fewer than eight senior V&A keepers, a plan hatched behind the backs of most of the trustees (including myself), left me feeling I had no choice but to resign.

threatened to do more damage to the precious pages than if I had turned them with well-washed hands.

We submitted our exhibition proposal to the Director of the V&A Mark Jones, whose measured response to us contrasted with the enthusiasm he expressed to his museum colleagues. The original proposal was for a larger show than was eventually realized, with more models distributed in a trail along the route from the entrance of the museum. The basic conception was familiar enough from my work on Leonardo, but the emphasis on design was specially tuned for the museum.

> The exhibition is about how Leonardo thought on paper.
> It contains some of his most complex and challenging
> designs. Although many other artists, inventors and scientists
> have brainstormed on paper, none of his predecessors,
> contemporaries or successors used paper quite like he did.
> The intensity, variety and unpredictability of what happens
> on a single sheet is unparalleled.
>
> However, behind the apparently erratic diversity are a series of
> unifying themes in his vision of how the world works....Drawing

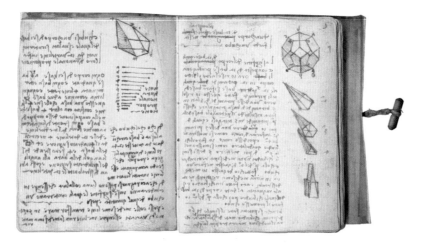

A fat little Forster Codex: *Studies of the Volume of Geometrical Bodies,*
Codex Forster, I 16v–17r.

served as the primary tool of analysis and the most potent way to demonstrate the essential unity of all things designed by nature. The human designer, whether working as painter, sculptor, architect or engineer, acts as a 'second nature' in the world, creating inventions in harmony with natural law.

Looking through the archive of the show recently in preparation for writing this book gave me a belated understanding of how the V&A staff at the time regarded my idiosyncratic demands. In one email a colleague is asked 'Are you sitting down?' before being informed of my suggestion that no fewer than three flying machines be suspended from the dome of the foyer. (We managed to show two of them.)

We decided to open with a portrait of Leonardo – but not the stock image of the bearded and grumpy old man from Turin, which is not a self-portrait or even an image of Leonardo. We chose instead a refined red-chalk drawing by a pupil in the collection at Windsor, which depicts him in profile with delicate features, flowing locks and a manicured beard (see frontispiece). Then came four sections: 'The Mind's Eye', which dealt with geometry; the now-familiar 'The Lesser and Greater Worlds'; 'Force', beginning with motions of the human figure and ending with destruction; then finally 'Making Things', which looked at architecture, ingenious devices and stage designs. As the title of the exhibition indicated, it was about 'Experience, Experiment and Design', not about Leonardo as artist. The core was again provided by Windsor, supplemented by thirteen important pages from the *Codex Arundel*, which had only recently been disbound by the British Library and mounted as separate sheets. In all there were only sixty-two Leonardo exhibits, but given the magnitude of his vision, the show felt much larger.

Paul Williams was involved from the first as designer and devised a way of including the wonderful animations conceived for the show, bringing them into telling conjunction with the relevant drawings without intruding upon them. The engineering of the large, hinged panels of glass on his exhibition cases was worthy of Leonardo himself. As the visitor stepped back, the resonant animations were seen to be working their magic above and behind the cases. Watching Leonardo's ideas

unfolding in time and space added a dimension that static exhibits with brief labels could not have accomplished.

The logistics of looking at small items in a crowded show are problematic. Paul decided to do away with rails on which the spectators could lean, since this would lessen fluidity of movement in the relatively constricted space. The warders were briefed to tell visitors that there was no fixed sequence, to avoid the standard log-jam at the beginning of the exhibition.

In the case of the flying machine that hung dramatically in the dome over the grand foyer of the V&A, our intention was to place Leonardo's designs in the service of something we hoped might fly. The V&A machine had been constructed for one of two television programmes – *Leonardo's Dream Machines*, directed by Paul Sapin for ITN in 2003. We worked with Skysport, a firm specializing in the skilful restoration of vintage planes. The strategy was to use Leonardo's wing designs in a hang-glider; this was something Leonardo himself had considered. We fed Skysport various options and they seized on an early bat-like design in the *Codex Atlanticus*. What, they asked, was the line that passed from the rear of the upper surface of the wing, over the front edge and to the midpoint of the lower surface? It was labelled '*panno*' ('cloth') in typically reversed microwriting. I replied

View of the exhibition and entrance to 'Leonardo da Vinci: Experience, Experiment and Design' at the Victoria and Albert Museum, designed by Paul Williams of Stanton Williams Architects.

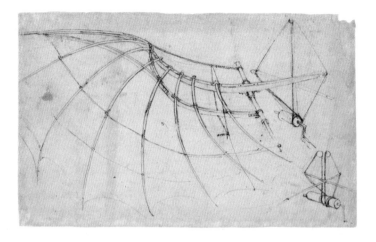

The wing that flew: *Drawing for a wing of a flying machine* (detail),
from *Codex Atlanticus*, fol. 858r.

that Leonardo had intended to cover the wing with a skin of cloth. This previously overlooked detail proved to be crucial, since it provided a profile for the leading edge that would produce lift.

Models were tested promisingly, and finally a full-scale glider was constructed using only materials that would have been available to Leonardo. The result was undeniably beautiful – but would it work? On a cold clear morning in October 2002, the full-scale *uccello* was transported to a long hillside on the Sussex Downs, facing the brisk breeze off the sea....The aviator was Judy Leden, women's world champion in hang-gliding. The risks were considerable. The machine might rise high only to stall, crashing backwards to earth. It might pitch precipitately on its nose. It might roll catastrophically, all lift lost. A few short and limited trial runs were made, the wings tightly tethered by ropes held by running attendants. The lift was more than enough to get the craft well and truly airborne. The problem was that it required modes of control different from a modern hang-glider. Judy needed to learn how to tame it through subtle but definite and controlled motions of her body. Gradually the mind and body of the human pilot and the wings of the 'great bird' began to act in concert. The climactic flight, reaching some 30 feet above the ground, exceeded in length the Wright brothers' epoch-making journey in 1903.

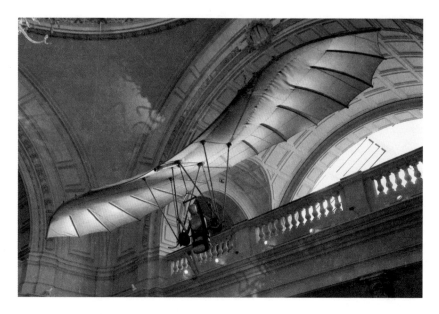

The Flying Machine built by Skysport in the foyer of the Victoria and Albert Museum.

As a form of experimental history, model-making makes unusual demands on the historian. The questions that researchers and constructors must answer are of a rigour that is rare in orthodox historical research. The precise demands of modern engineers are of a nature that brooks none of the ifs, buts or probablys that are part of the historian's stock in trade. The requirements are comparable to the demands Leonardo was making on himself, if the intended flyer of his machine was not to perish in the attempt.

The glider was joined in the airy space of the V&A foyer by Leonardo's pyramidal parachute, constructed and tested in the summer of 2000 by Adrian Nicholas, an intrepid aviator of perilous flying devices. Adrian had been inspired by sketches Leonardo made when he was discussing how an eagle's wings worked. Leonardo's note explains that:

> If a man has a tent of linen of which all the apertures have been blocked, and it is 12 *braccia* [arm-lengths] across and 12 in depth, he will be able to throw himself down from any great height without sustaining any injury.

Adrian's parachute, constructed from materials available to Leonardo, weighed 187 lbs. Launching himself from a balloon at 10,000 feet above the Mpumalanga province in South Africa, he demonstrated that the cloth pyramid with its square frame worked better than the earliest known parachutes of the late 18th century. He triumphantly declared that 'it took one of the greatest minds who ever lived to design it, but it took 500 years to find a man with a brain small enough to actually go and fly it'.*

The third major model displayed at the V&A was very different, and much smaller. It was a reconstruction of Leonardo's own proposed glass model of the neck of an aorta – intended to help him understand how the three-cusp valves operate in the heart. Leonardo realized that the valves did not open by muscular action, but were operated by the vortices of the blood as it was pumped into the constricted neck of the aorta. Using his knowledge of water in motion, he reasoned that the blood expelled from the ventricle spiralled back into the cusps to fill them, closing the neck of the aorta before the next pump. The model was created by Morteza (Mory) Gharib, Professor of Aeronautics and Bioengineering at the California Institute of Technology, whom I had first met in 2001, at a point when he had built the glass model but not yet made the valves. Using modern techniques of imaging, he was able to see the vortices that Leonardo had supposed to exist. This was thrilling – even more so when the membranes of the valves were introduced. As I wrote in the V&A book:

> To see the little Leonardo valve living as it were, pulsing shut and open, fragile yet perfect in its operation is very moving – surrounded as it is by high-tech paraphernalia of a 21st-century lab. Courtesy of the imaging techniques now available to those studying fluid dynamics, we are able to witness in reality what Leonardo could only see in his mind's eye.

My ultimate concern in all this was less with proving that Leonardo was right (although that was nice to know) than with seeing how his

* Adrian, sadly, was killed in a skydive in 2005. He was a man of extraordinary charisma, spirit and bravery.

technique of knowledge transfer from hydraulics to cardiology was operating as a powerful tool. His heart-valve model was what I have called a 'theory machine'. He was completing the circle of proof: God's creation ▸ natural form ▸ human observation ▸ analysis ▸ theoretical synthesis ▸ God-like recreation through modelling. It is a circle that stands at the heart of his art as much as it does at the heart of his science.

The V&A opening in the grand foyer of the museum was heavily attended, with Leonardo's 'great bird' and the parachute surveying the crowd impassively from the lofty dome. There was a separate special

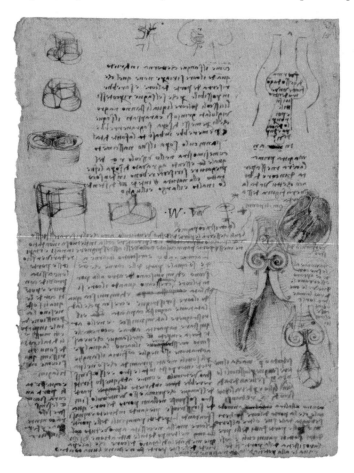

Studies of the structure and geometry of an Aortic Valve, with a scheme for a glass model,
c. 1512–13. Pen and ink on blue paper, 28.3 × 20.4 cm (11⅛ × 8 in.).

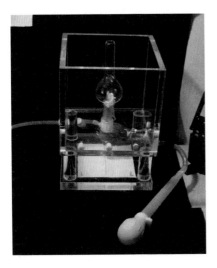

Left: Mory Gharib's model of the neck of the aorta.
Right: Imaging of the motion of the blood in the neck of the aorta.

reception for the sponsor (Deloitte) and their invitees, along with other guests deemed particularly important. Each person there was presented with a copy of the exhibition book, wrapped in white paper with a blue satin ribbon tied in a bow. The exhibition went on to record a figure of 122,418 visitors over the course of 113 days – which is about as many viewers with timed tickets as could comfortably be accommodated in a compact exhibition of drawings. The handsome book has achieved an independent life of its own.

CHAPTER 11

CODES AND CODSWALLOP

Any mention of codes in the same sentence as Leonardo can only signal one thing: the stupendously successful book *The Da Vinci Code* by Dan Brown. Two years after its publication in 2003, it had sold 40 million copies worldwide. On some lists it features as the ninth bestselling book of all time. The last sales figure I could find recorded total sales of 80 million. The film of the book in 2006 took $224 million at the box office on its opening weekend, and earned the second highest revenues of any film in that year.

Both book and film have been dismissed by academics, and by those who profess to have literary good taste. However, the universal reach of the *Code* phenomenon is difficult to ignore, and unquestionably has featured prominently in my living with Leonardo during the last decade and a half.

The effect has been direct, in that I have frequently been asked if I have read the book or seen the film. The answer in both cases is yes. I have seen the film twice: once with a predominantly academic audience in Oxford, where it elicited as many laughs as Mel Brooks's *The Producers*, and once with a 'lay' audience, who seemed willing to grapple with its tortuous plot in an engaged manner. Have I met Dan Brown? The answer is no. There was talk of a TV company arranging a debate, but it never happened. Around the time the film appeared, I did some TV and radio interviews from my home in Woodstock. Asked what I thought of the *Code*, I answered that it helped sell my books – although to have only a fraction of Dan Brown's sales would be nice.

The effect has also been indirect, in that the *Code* has given currency to the idea that 500-year-old works of art might contain secret

Spot the pentagon?
Nicolas Poussin, *The Arcadian Shepherds* (*Et in Arcadia ego*), 1637–8.
Oil on canvas, 87 × 120 cm (34¼ × 47¼ in.).

messages, disguised words, concealed images, mystic geometries and esoteric numbers, all waiting to be read by a smart modern-day sleuth. A whole genre of what we might call 'secretology' has grown up around Leonardo and the *Mona Lisa* in particular; there is much speculation about the artist's allegiance to secret sects and his belief in arcane heresies. The resulting surge of people searching for obscure codes to which they can apply their ingenuity has led to more problems for me than the immediate existence of the book or film.

The history purveyed in Brown's thriller has a considerable back story – to the extent that he was charged in court with plagiarism. I encountered some of this back story in 1996, when I was invited to participate in a BBC *Timewatch* programme entitled 'The History of a Mystery'. It centred on one of a number of sensational and bestselling works of pseudo-history published during the 1990s. They all told of conspiracies on a vast and shadowy scale, involving the authorities of the Catholic Church and secret sects of massive power.

The source of all the stories was Bérenger Saunière, priest at the parish church of Rennes-le-Château, a small French village at the foot of the eastern Pyrenees. In 1897, Saunière claimed to have discovered some ancient and secret documents hidden in the church. It later emerged that he had been illicitly excavating graves in the surrounding burial ground. He subsequently came into money on an improbably large scale; legend had it that he had either stumbled across the lost treasure of the Knights Templar in one of the graves, or come into possession of documents of such an explosive nature that he was paid by the church authorities to keep quiet. Saunière died in 1917. Eventually, an enquiry by the Bishop of Carcassonne concluded that his wealth had in fact come from 'trafficking' in masses – he was pocketing money from benefactors for many thousands of masses which, for the most part, remained unsaid.

This evident truth did not stop French draughtsman Pierre Plantard (b. 1920), an extreme nationalist and anti-Semitic fantasist, from building a great tower of conspiracies around the documents Saunière had supposedly discovered. Plantard, later known as Plantard de Saint-Clair, claimed that the only legitimate kings of France were the Merovingians, who had been ousted in 751 by the Carolingians. The true heir to the

French throne was therefore a living descendant of the Merovingians – who happened to be Plantard himself. This Merovingian 'secret' was zealously guarded by a shadowy organization called the Priory of Sion, based loosely on the Abbey of Our Lady of Mount Zion, which had been founded in the Holy Land in 1099 and destroyed by Muslims in 1291. The Knights Templar were seen as the military arm of the Priory.

Plantard enlisted an impoverished French aristocrat called Philippe de Chérisey to help manufacture the necessary documentation, which they deposited in the 1960s as 'secret dossiers' in the Bibliothèque Nationale. Plantard also collaborated with Gérard de Sède, an aristocratic surrealist who wrote *The Gold of Rennes, or The Strange Life of Bérenger Saunière, Priest of Rennes-le-Château* (1967; published in paperback as *The Accursed Treasure of Rennes-le-Château*).

Among the dubious papers were 'two parchments' with coded texts purporting to have been discovered by Saunière in his church. There was also a list of the 'Masters of the Priory of Sion', which contains some hilariously improbable names:

Jean de Gisors (1188–1220)
Marie de Saint-Clair (1220–1266)
Guillaume de Gisors (1266–1307)
Edouard de Bar (1307–1336)
Jeanne de Bar (1336–1351)
Jean de Saint-Clair (1351–1366)
Blanche d'Évreux (1366–1398)
Nicolas Flamel (1398–1418)
René d'Anjou (1418–1480)
Iolande de Bar (1480–1483)
Sandro Filipepi (1483–1510)
Léonard de Vinci (1510–1519)
Connétable de Bourbon (1519–1527)
Ferdinand de Gonzague (1527–1575)
Louis de Nevers (1575–1595)
Robert Fludd (1595–1637)

J. Valentin Andrea (1637–1654)

Robert Boyle (1654–1691)

Isaac Newton (1691–1727)

Charles Radclyffe (1727–1746)

Charles de Lorraine (1746–1780)

Maximilian de Lorraine (1780–1801)

Charles Nodier (1801–1844)

Victor Hugo (1844–1885)

Claude Debussy (1885–1918)

Jean Cocteau (1918–1963)

Leonardo was named as the twelfth master, succeeding Sandro Filipepi (better known as Botticelli). Why is there no evidence of the Priory in the documentation of the lives of any of the 'masters'? The answer, of course, is that it was all kept secret. 'Secretology' triumphs over evidence.

A further pseudo-historical component that fed into Dan Brown's fictional network of conspiracies was the devastating 'secret' that Jesus was married to Mary Magdalene, and that their resulting issue founded the bloodline of the Merovingian kings (meaning that Plantard became a direct descendant of Christ). The concept of the fruitful union of Jesus and Mary, which had supposedly been aggressively suppressed by the Catholic Church, was promulgated by actor and writer Henry Lincoln in his very successful book *The Holy Blood and the Holy Grail*, co-authored in 1982 with Michael Baigent and Richard Leigh. According to them, the Grail was simultaneously the womb of Mary Magdalene and the bloodline of the French kings – not, as recounted in Arthurian legend, the lost chalice of the wine from the Last Supper, nor the vessel that collected Christ's blood at the Crucifixion. Lincoln went on to write and present three documentaries on the mysteries of Rennes for the BBC's *Chronicle* series.

In his 1991 follow-up book *The Holy Place: Saunière and the Decoding of the Mystery of Rennes-le-Château*, Lincoln tried to extract occult geometry from Saunière's 'two parchments' by drawing straight lines on them until some of the lines appeared meaningful. The resulting 'decoded'

texts appeared to indicate that two works of art – the *Arcadian Shepherds* by Poussin (see p. 281), and a painting by David Teniers – would 'hold the key'. Geometry comparable to that in the parchments (this time, a concealed pentagon overlaying the figures and tomb) was duly extracted from the Poussin painting in the Louvre. This was the starting point for yet another book, Richard Andrews and Paul Schellenberger's 1996 *The Tomb of God*, in which they revised Lincoln's arbitrary geometry with equally fanciful alternatives which they then superimposed on maps of the countryside around Rennes. The 'clues' they identified pointed to Mount Cardou. This was therefore the location, claimed Andrews and Schellenberger, of the actual tomb of Christ. The Templars had apparently been responsible for the transportation of Christ's body to France.

The BBC programme in which I became involved, 'The History of a Mystery', examined the claims of Andrews and Schellenberger. It was written and directed for the BBC by Bill Cran, an accomplished maker of investigative programmes. In the first half, the authors were given their head; then, after twenty-seven of the programme's forty-eight minutes, Bill began to unpick their historical knitting. Key threads had not been secured by even the most basic research, and the whole colourful garment unravelled.

For my part, I pointed out that there was no evidence in the many drawings by Poussin, nor in the technical examination of his paintings, of his deploying *surface* geometry of the kind imagined by Lincoln and the authors of *The Tomb of God*. Nor was there any such evidence in paintings and drawings by Poussin's contemporaries, or his Renaissance predecessors. There is plenty of perspective, and an interest in the mathematics of human proportions; but absolutely no occult geometry inscribed invisibly on the surfaces of their panels and canvases.

At the end of the programme I spoke more generally about the kind of books written by Lincoln and company.

There are certain historical problems, of which the Turin Shroud is one, in which there is...a historical vacuum – a lack of solid evidence. And where there's a vacuum – nature abhors a vacuum

and historical speculation abhors a vacuum – it all floods in....
But what you end up with is almost nothing tangible or solid.
You start from a hypothesis, and then that is deemed to be
demonstrated more-or-less by stating the speculation. You then
put another speculation on top of that, and you end up with
this great tower of hypotheses and speculations – and if you say
'where are the rocks underneath this?', they are not there. It's
like the house on sand; it washes away as soon as you ask really
hard questions of it.

The bestselling books published in the 1990s that depended on
Saunière's story fail to distinguish between imaginative reconstructions
and facts that are solidly documented in primary sources. They rely
incestuously on 'truths' extracted selectively from like-minded titles.
It is not, of course, practical for historians to check every document they
cite; however, it is a rule of historical research that those primary sources
which are absolutely central to a historian's argument should be checked
in the original wherever possible, or drawn from reputable publications
in which the sources have been carefully transcribed and referenced.
The historian is under an obligation to cut back to the bedrock of verifi-
able facts. In building analyses and explanations on this bedrock, we
are inevitably involved in various kinds of imaginative reconstructions.
But it should be fully apparent when this is happening. Fact and factoid
speculations should not be knitted together indecipherably.

Faced with proof that key documents were forged, the advocates of
the conspiracy theories later asserted that the forgers themselves were
'initiates' and provided genuine clues – albeit in a forged manner. It's
impossible to win....

The kind of history perpetrated by Lincoln and others has been
called pseudo-history; however, this term could be applied to any work of
fiction based on history. Just as we have 'historical fiction', we have what
may be called 'fictional history'. *The Da Vinci Code* manages to be both
of these simultaneously, as well as using the resources of normal fiction.

Let's look at how the *Code* begins. After the title page comes the
normal stack of technical information about the publication, copyright

and so on. The publisher, Bantam Press, added a standard disclaimer: 'In this work of fiction, the characters, places and events are either the product of the author's imagination or they are used entirely fictitiously.' This seems right, as does the description on the original cover, 'A Novel'. Brown's dedication to his wife Blythe follows. In the acknowledgments she is described as 'art historian, painter' and is credited with feeding Leonardo 'facts' to her husband. The novel is prefaced by a page headed 'Fact':

> The Priory of Zion – a European secret society founded in
> 1099 – is a real organization. In 1975 Paris's Bibliothèque
> Nationale discovered parchments known as Les Dossiers Secrets,
> identifying numerous members of the Priory of Zion, including
> Sir Isaac Newton, Sandro Botticelli, Victor Hugo and Leonardo
> da Vinci.

> The Vatican prelature known as Opus Dei is a deeply devout
> Catholic sect that has been the topic of recent controversy due
> to reports of brain-washing, coercion and a dangerous practice
> known as 'corporal mortification'. Opus Dei has just completed
> construction of a $47-million National Headquarters at
> 243 Lexington Avenue in New York City.

> All descriptions of artwork, architecture, documents and secret
> rituals in this novel are accurate.

This is naughty. Is the reader to assume that this page is part of the fiction, or an honest preliminary assertion of historical facts? The majority of readers seem to have assumed that Brown is stating the documented truth. If he believes what he is asserting, his research has been negligent. If he does not believe it, he is deceiving his readers.

On the next page we immediately encounter the 'renowned' Louvre curator Jacques Saunière, who happens to share the same surname as the disreputable priest of Rennes. He is dying a violent, messy and drawn-out death. Somehow the mortally wounded curator strips off his clothes,

disposes himself on the wooden floor in the pose of the Vitruvian Man and writes cryptic clues with his own blood on his naked flesh.

Echoes of *The Holy Blood and the Holy Grail* by Lincoln, Leigh and Baigent are pronounced. We later encounter the crazed and conspiratorial English aristocrat Sir Leigh Teabing, whose name combines Leigh with an anagram of Baigent. Brown's key themes, the Priory of Zion and the bloodline of Christ and Mary Magdalene, are shared with the earlier book. Such are the common features that in 2006 Baigent and Leigh sued Random House UK (who own Bantam Press) for copyright infringement. Lincoln did not take part in the action. The judge ruled that

> even if the central themes were copied, they are too general or of too low a level of abstraction to be capable of protection by copyright law....Accordingly there is no copyright infringement either by textual copying or non-textual copying of a substantial part of *The Holy Blood and The Holy Grail* by means of copying the central themes.

Brown's narrative proceeds at a breakneck pace in a sequence of jerky sprints over the course of its 600 pages, divided into staccato chapterettes. It is an effectively packaged popular thriller – a page-turner – and a masterly achievement on its own terms. The plot is all, ceaselessly cutting between the actions of the main participants and other intricate threads in the story. The two central characters – Harvard 'symbologist' Robert Langdon, and French policewoman and 'cryptologist' Sophie Neveu, known sexistly throughout as 'Langdon' and 'Sophie' – are agents for the story, but are largely devoid of inner lives. This gave Tom Hanks and Audrey Tautou in the film a lot of trouble, having to flesh out characters who lack character. Faced with the same problem, Sir Ian McKellen as Sir Leigh Teabing decided to overact spectacularly and to have fun.

How does Leonardo himself come across in the *Code*? Brown's Leonardo is characterized on his website:

> A prankster and genius, Leonardo da Vinci is widely believed to have hidden secret messages within much of his artwork.

Most scholars agree that even da Vinci's most famous pieces
– works like The Mona Lisa, The Last Supper, and Madonna
of the Rocks – contain startling anomalies that all seem to be
whispering the same cryptic message...a message that hints at a
shocking historical secret that allegedly has been guarded since
1099 by a European secret society known as the Priory of Sion....
[Former] French president François Mitterrand [is] rumored to
have been a member, although there exists no proof of this.

Langdon has once explained to an audience of convicts who were
subject to a Harvard outreach programme that 'the *Mona Lisa* was, in fact,
one of the world's most documented inside jokes'. The joke is that of gay
androgyny – what one of the inmates calls 'chicks with dicks'. The symbolo-
gist responds that 'Da Vinci was a prankster, and a computerized analysis
of the *Mona Lisa* and Da Vinci's self-portraits confirm some startling con-
gruities in their faces.' He goes on to reveal that the sitter's name is a fusion
of the Egyptian male god Amon and the goddess Isis – AMON L'ISA: 'And
that, my friends, is Da Vinci's little secret, and the reason for Mona Lisa's
knowing smile.' This act of covert androgyny conveys Leonardo's message
as one of the Masters of the Priory – to the effect that the beloved Mary
Magdalene, as the 'sacred feminine', bore Jesus' child and was accordingly
due greater reverence than the gang of male Disciples.

The message is conveyed even more directly in the *Last Supper*.
Escaping the clutches of pursuing police and murderous factions, Neveu
and Langdon take refuge in Teabing's Château Villette (this is a real château,
not far from Paris), where the metaphorical veils of ignorance are torn
from their eyes by their garrulous host. His centrepiece is an exposition
of the true meaning of Leonardo's mural. 'You will be shocked to learn
what anomalies Da Vinci included here that most scholars either do not
see or simply chose to ignore. This fresco is in fact the entire key to the
Holy Grail Mystery.' The presence of the Grail is signalled above all by the
'V' shape between Christ and the companion to his left: 'This is called the
chalice...it resembles the shape of a woman's womb'. Teabing draws Neveu
on. 'Sophie examined the figure to Jesus' immediate right...[a] wave of
astonishment rose within her. The individual had flowing red hair, delicate

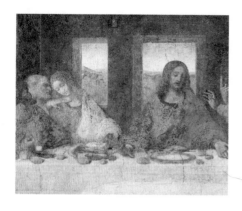

Cherchez la femme: the 'V' of the chalice, and the 'M' of the Magdalene. St John and Jesus from the *Last Supper*.

folded hands, and the hint of a bosom. It was, without doubt...female.' The Magdalene, of course, whose womb is the Grail.

Teabing also insists that there is an 'M' shape at the heart of the composition – for Mary Magdalene? This habit of characterizing compositional motifs as geometrical arrays recalls the mode of formal analysis that was popular when I was a student. Sydney Freedberg of Harvard was notorious for detecting geometrical configurations in High Renaissance paintings. Raphael's Madonna groups, for instance, were infallibly pyramidal. I was always concerned that there was no hint of such modern formalism in Renaissance writings on the visual arts.

To identify Christ's companion as the Magdalene is a nonsense. The Apostle John, especially 'beloved of Christ', was traditionally depicted as a beautiful, beardless young man. His long hair was often lighter in colour than that of the other disciples. He was typically shown as having fallen asleep. This is the case in Castagno's *Last Supper* in Florence, at which Leonardo had looked very carefully. With a characteristic sense of the fluidity of narrative time, Leonardo's St John is rousing just in time to hear Peter's exclamation.

The *Virgin of the Rocks* in the Louvre has also been dragged into the conspiracy. As Brown's website explains,

Da Vinci's original commission for his famous Madonna of the Rocks came from an organization [known] as the Confraternity of the Immaculate Conception, which needed a painting for the centerpiece of an altar triptych in their church of San Francesco Grand [*sic*] in Milan. The nuns gave a Leonardo specific dimensions and a desired theme – the Virgin Mary, baby John the Baptist, Uriel, and Baby Jesus sheltering in a cave. Although

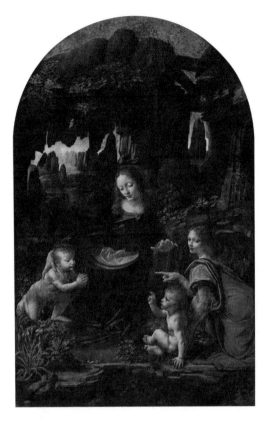

Claw-like hands and cutting gestures, or a holy conversation?
Virgin of the Rocks, 1483–5. Oil on panel (transferred to canvas), 199 × 122 cm (78¾ × 48 in.).

Da Vinci did as they requested, when he delivered the work, the group reacted with horror. The painting contained several disturbing 'un-Christian' anomalies, that seemed to convey a hidden message and alternative meaning. Da Vinci eventually mollified the confraternity by painting a second version of Madonna of the Rocks, which now hangs in London's National Gallery under the name Virgin of the Rocks. Da Vinci's original hangs at the Louvre in Paris.

This is riddled with errors. The carved altarpiece frame contained many panels to be painted and was not a triptych. The Con*frater*nity

composed a group of lay*men*, not nuns. The commission did not mention the Baptist, the Angel Uriel or a cave. There is no hint in the copious documentation of the dispute between the artists and the confraternity that it involved the rejection of the Louvre picture, on doctrinal or other grounds.

The supposedly hidden message concerned the 'Johannite heresy', according to which John the Baptist was the Priest Messiah, one rung above Jesus, the incarnated King Messiah. Brown accords a false priority to the infant St John by incorrectly recognizing him as the child on the right blessing his companion, whom the author identified as the baby Jesus sheltering below Mary's cloak. Moreover, 'Mary was... making a decidedly threatening gesture – her fingers looking like eagle's talons, gripping an invisible head [said to be that of Mary Magdalene]. Finally, the most obvious and frightening image: Just below Mary's curled fingers, Uriel was making a cutting gesture with his hand – as if slicing the neck of the invisible head gripped by Mary's claw-like hand.' It seems that Leonardo is showing how the Church had ganged up on Mary Magdalene.

For a serious historian, this fictional farrago would not be worth mentioning were it not for its widespread impact. There is now a conviction abroad, not least among students, that the Louvre version of the *Virgin of the Rocks* was rejected by the commissioners because of its heretical content – even if only for its omission of halos. Factoids, oft-repeated, tend to become facts once separated from their dodgy origins.

Brown's book is comically bad when considered specifically as history. It has attracted one particularly accomplished parody, *The Va Dinci Cod* by A.R.R.R. (Adam) Roberts, professor in the Department of English at Royal Holloway College in London. The novel begins with the death of the curator Jacques Sauna-Lurker, who expires unpleasantly because a 'three-foot-long codfish had been inserted forcefully into his gullet'. Was he murdered because he was custodian of a dark secret? It transpires that Leonardo was one of twins. His sister was Eda, 'a better painter, arguably, than Leonardo', whose existence had been suppressed violently by sectarian and patriarchal forces. She was of course the real subject of Leonardo's *Mona Lisa*, copied from the original self-portrait by

Eda, but omitting the secret cod that she cradled. The deeply meaningful cod would have given the game away.

> '*All* the conspiracies of the world are masks deliberately worn by the C.O.D. [*Conspiritus Opi Dei*] to hide their very existence. Whilst people are busy chasing after the Illuminati, or the Masons, or the Mafia, they are distracted from the *real* secret power of this world.'
> 'The Mafia?' said Robert. 'Are they part of it too?'[....]
> 'Mafia,' said Sophie, 'means *my faith* – mia-fia. It's a spiritual designation, associated from its earliest days with the Papacy and Catholic Church. But that's only to say that it is a manifestation of a deeper secret organization. They have tentacles everywhere – in Hollywood, where the *Godfather* films were made. In N.A.S.A., where the moon landings were faked. Here in Britain, where the Royal Family are run as a complex scam.'

Alongside the conspiratorial codswallop of Brown's thriller, so neatly mocked by Roberts, how does the overall character of his Leonardo shape up? Brown's Leonardo, the heretical prankster, purveyor of dark theological secrets, alchemical forger of gold from lead and concocter of an elixir to cheat death, is totally at odds with the Leonardo of the notebooks. He shares much with the overtly fictional Leonardo of the video game *Assassin's Creed II*, in which the painter and inventor is deeply engaged with magic powers and mystic numbers.

The real Leonardo had little truck with mystical practices such as alchemy, astrology and chiromancy. He believed absolutely in the supreme creator of the wondrous world system, a system governed by the logic of mathematics. Science and art were the servants of God's order in the world. This conviction did not place him, as Brown claims, 'in a perpetual state of sin against God'. In his dealing with religious patrons there is no hint in the documentation of doctrinal conflict. Where are the 'hundreds of lucrative Vatican commissions' that funded his 'lavish lifestyle' and into which 'he incorporated...hidden symbolism that was

anything but Christian'? At the end of Leonardo's life, his will is cast in entirely orthodox terms, with its provision for 'three high masses' and '30 Gregorian low masses' to be said in three churches in Amboise.

Again, none of this would matter much if the quest for 'codes' had not exercised such an impact on the public image of how to approach Leonardo. Even the Louvre has been ready to exploit Brownian notions. It has introduced a visitor trail – 'The Da Vinci Code, Between Fiction and Fact' – in which we are invited to 'Visit the Louvre in the footsteps of the heroes of the novel and the movie *The Da Vinci Code*, exploring the places, works and themes at the heart of the story.'

A torrent of weird theories has appeared online in the wake of Brown's fiction. Elaborate websites, heavy with graphics and video, retail clever discoveries by uniquely perceptive sleuths. The tone of the sites is generally anti-establishment. The standard literature and academic experts are accused of having missed the real and often 'obvious' truth. All of this appeals to non-specialists who enjoy seeing stuffy experts made to look silly. Not a few of the sleuths have published books, given that printed volumes still carry a special air of legitimacy.

Academics generally do not consider this kind of rogue history worthy of attention. However, it is an integral part of the remarkable phenomenon of the legendary Leonardo da Vinci in world culture, and is of considerable interest in its own right. The media are invariably receptive to Leonardo or *Mona Lisa* stories. The general rule is that the more curious and less well-founded the theory, the more media coverage it will gain. There is a whole world of Leonardo out there that bears little resemblance to the official one of museums and academics. From a personal standpoint, I am far from insulated from this other world. More than enough freelance detectives have contacted me directly in the expectation that I will be bowled over by the finality of their discoveries, and I have come to expect regular calls from the media for comment on often bizarre conjectures.

I have tried to respond politely to the sleuths, while being firm in my opinions about the various ideas. No one likes being told that they are wrong, and the responses to my criticism have ranged from implicit acquiescence to overt abuse. Threats are not unknown.

I'm not sure you realize how disconcerting it is to have been
in such open communication with you for the past week,
yet after I send you proofs of what is the Art Discovery of the
Millenia, I haven't received any replies to my inquiries for over
2 days now. I understand that you would not want to make
any hasty judgments, but I am feeling a bit uneasy about the
silence. As I haven't had any confirmation one way or another
about representation, I have begun my own inquiries into
legal counsel.

Sometimes correspondence with one person has lumbered on for
years, becoming a kind of dialogue of the deaf. One courteous attributer
of a 17th-century landscape to Leonardo bombarded me with 'proofs'
in 2008–9. There were, apparently, secret images hidden in the land-
scape by Leonardo. The same correspondent resurfaced insistently in
2012, and again in 2017. I don't want to resort to being rude. I suppose
that such things go with the privilege of having a public profile as a
Leonardo expert.

An incredibly wide spectrum of specifically visual 'codes' have appar-
ently been lying undetected in Leonardo's paintings. Hidden images have
also been used to attribute improbable paintings to him. Perhaps the
most prominent among those who have detected secret numbers and
letters in the *Mona Lisa* has been Silvano Vinceti, self-proclaimed head of
the Comitato Nazionale per la Valorizzazione dei Beni Storici, Culturali e
Ambientali (otherwise known as CONVAB). This sounds very official, as
if it is an arm of the Ministero per i Beni Culturali e Ambientali, based in
Rome. However, the ministry has confirmed that CONVAB has no official
status. Vinceti, 'bestselling writer and broadcaster', has quite a track record
of well-publicized revelations about Lisa and her portrait. He portrays
himself on his website as 'a lone ranger who belongs to no one, a Sherlock
Holmes armed with the latest technologies', in marked contrast to 'these
snooty old art historians [who] are bound to their universities and their
disciplines, with stale thinking that hasn't moved on in 25 years'.

In December 2010, Vinceti detected secret letters in Mona Lisa's
eyes. In her right eye are the letters 'L' and 'V', telling us who painted

the picture. The letters in the left eye are 'B' or 'S' or 'C' and 'E'. This is what the *New York Post* headlined as 'Mona Lisa's eye-popping "Da Vinci Code"'. Vinceti also claimed to have seen the date '149[?]' on the back of the poplar panel, which would effectively eliminate Lisa as the model. A year or so later he decided that the 'S' stood for Salaì, the pretty, gay youth who thus became the 'real' subject of the portrait. When the curators at the Louvre pointed out that no such letters or numbers were detectable in the scarred surface, even examined with very high magnification, or on the rear of the painting, Vinceti accused them of blindness.

In the meantime, the head of CONVAB was hoping to obtain permission to excavate Leonardo's supposed remains in Amboise to demonstrate that the *Mona Lisa* was a covert self-portrait. He was not the first to suggest this. This ambition then seems to have been replaced by his quest to obtain Lisa's skull from the disrupted burial zone in the former convent of Sant'Orsola in Florence. The identity of the skull would be certified by DNA from the remains of her ancestors in the Giocondo vault in Santissima Annunziata. Where was Salaì in all this? Ah: the portrait began as an image of Lisa, but was converted into a portrayal of Salaì in drag. Again, this would not matter or deserve to be taken seriously were it not for the extensive and sensationalized media coverage – and

Spot the vulture: Oskar Pfister, diagram of the 'vulture' in the *Virgin, Child and St Anne with a Lamb*.

Vinceti's obtaining permissions to excavate graves. In the unlikely event that Lisa's actual skull is recovered, what then? If a forensic reconstruction of her face proved to resemble that in the portrait, it would tell us what we already know – or should know. However, this is unlikely to happen. High levels of idealization were standard for portraits of women in the Renaissance.

My second example of 'reading-in' involves the surprisingly frequent detection of visual images of creatures in the *Mona Lisa*. The forerunner of such diverting fantasies was Sigmund Freud's projection of a rather unconvincing vulture into the draperies of

St Anne in the Louvre. In his famous short book in 1910, *Leonardo da Vinci and a Memory of His Childhood*, Freud credited the observation to one of his followers, Oskar Pfister. Freud identified Pfister's vulture as that mentioned by Leonardo in his account of a dream in which a bird (actually a kite) introduced its tail between Leonardo's lips. Regardless of other problems with Freud's interpretation, the 'vulture' is only discernible (however tentatively) because of the bleaching of the ultramarine pigment in St Anne's draperies.

In a similar vein, Ron Piccirillo on his website The Hidden Horse Head asserts that there are 'images hidden for 500 years' as 'optical illusions' in many famous Renaissance paintings. Piccirillo's most notable reading-in involves the heads of a lion, ape and buffalo in the landscape behind Lisa, when the painting is viewed on its side. Moreover, the head, neck and breast of the sitter reconfigure themselves into a mule's head when similarly viewed. He then proceeds to interpret the sitter as a personification of 'Envy' (notwithstanding that Leonardo drew Envy as a scrawny old woman with sagging breasts). Again, this 'discovery' was widely reported by journalists who should have known better, but who realized that the story would gain them some column inches.

A subset of the reading-in fantasies is the use of a mirror or mirrored image to create bisymmetrical forms. If a mirror is placed vertically along a central axis running from the top to the bottom of the portrait, suggestive configurations emerge. This technique has been used to reconfigure the landscape to make it resemble a known location, or to claim that Leonardo is attempting to replicate binocular vision. The most bizarre of the mirroring claims is propagated by a website called The Paranormal Crucible. If the figure of Lisa is mirrored back-to-back, the resulting formation 'reveals' an alien priest with an extravagant headdress.

I was once involved in a television programme about claims that Leonardo was one of a number of individuals who had been super-charged by invading aliens from outer space. The Paranormal Crucible tells us:

> *Many* theologians believe that Leonardo da Vinci deliberately
> concealed secret codes and subliminal messages in most of
> his work. If this is true, then it's reasonable to assume that the

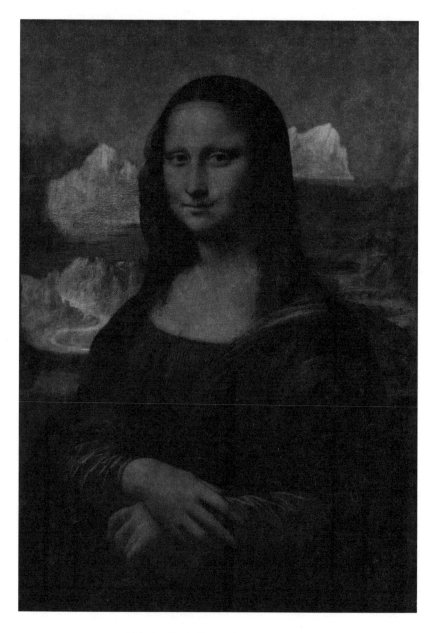

Ron Piccirillo, heads of a lion and monkey in the *Mona Lisa*
from the website The Hidden Horse Head.

Mona Lisa was in fact painted in order to conceal important historical and religious facts possibly regarding the extraterrestrial presence and its surreptitious involvement within the Roman Catholic Church.

The loose use of 'many' – whether theologians, art historians, experts or whoever – is characteristic of the crackpot theorists who simultaneously present themselves as the scourge of established experts and yet crave some majority support.

For his part, Leonardo was fully alert to the imaginative projection of accidental images into arrays of lines, forms and colours.

If you look at walls soiled with a variety of stains or at stones with variegated patterns when you have to invent some location, you will therein be able to see a resemblance to various landscapes graced with mountains, rivers, rocks, trees, plains, great valleys and hills in many combinations. Or again you will be able to see various battles and figures darting about, strange-looking faces and costumes, and an endless number of things which you can distill into finely-rendered forms.

However, he was certainly not recommending this practice as a way of exploring secret messages in his own 'finely-rendered' pictures.

A related kind of 'reading-in' relies upon a combination of skewed iconography with imaginative projection. William Varvel, variously billed as 'a former mathematics professor', a 'historian' and a 'Leonardo buff' has claimed that 'Leonardo constructed and placed a total of 40 separate symbols taken from chapter 14 [of the Book of Zechariah] into the background, middle ground and foreground of the composition of the Mona Lisa.' The chapter in question prophesizes the coming of the Day of the Lord and the establishing of the New Jerusalem. As examples, 'the Curtain of Solomon's Porch' is represented by the twisted veil over Lisa's left shoulder, the veil on Lisa's forehead is the 'rent veil before the Holy of Holies', and the 'gold chains before the veil' correspond to the golden knots at the neckline of her dress. Looking at the landscape, we can see

that 'Calvary rises from behind the Mona Lisa's right shoulder, while the Mount of Olives is on the other side. And folds on the arms of her robe suggest a yoke – a reference to Biblical texts and women's oppression'. The raft of citations from Zechariah are designed to conceal Leonardo's 'blasphemous' message that 'women's rights to the priesthood are to be recognized' in the New Jerusalem. Since the painting of Lisa embodies Zechariah's prophecy, she becomes the vehicle for a radical assertion of the 'sacred feminine'. Again, widely noticed in the press.

Alongside the detection of numbers, letters and hidden images, there have been numerous attempts to demonstrate the presence of the 'golden section' in the design of Leonardo's paintings, above all in the *Mona Lisa*. The golden or 'divine' section (or ratio or proportion) or 'mean ratio' is formed when a line is divided in such a way that the ratio of the longer portion to the shorter is the same as that of the whole line to the larger portion. The proportion cannot be expressed precisely in numbers, but (to 7 decimal points) is 1.6180339. This ratio was then found to be mysteriously related to the Fibonacci series, named after the medieval Pisan mathematician Leonardo Fibonacci. Each number is added to the preceding one, giving the sequence 1, 1, 2, 3, 5, 8, 13, 21, 34, 55, 89 and so on. The ratio of successive numbers converges on that of the golden section. When we reach 55 and 89, giving a ratio of 1.6181818, we are close to the golden mean. Moreover, if we look at a logarithmic or equiangular spiral in which the interval between each successive whorl progressively increases without altering its overall shape, the spiral expands outwards by the golden ratio for every 90 degrees of rotation.

The seductive correlation of the golden section with the Fibonacci series and logarithmic spiral has been hailed as holding the metaphysical or psychological key to beauty in nature and art. How could it not be present in the world's most famous painting? One substantial problem is that the correlation was only made in the 19th century. However, Leonardo did know specifically about the golden section, since in 1498 he illustrated Luca Pacioli's book *De divina proportione* (On Divine Proportion). He also knew and assigned at least as much value to the square root of 2, which is the length of the diagonal of a

right-angled triangle with its two shorter sides equal to one unit, and which equals approximately 1.414.

The lack of early correlation between the golden section, Fibonacci series and logarithmic spiral has not deterred the diagrammatic super-imposition of golden sections and spirals on works of art and architecture as ancient as the pyramids of Egypt. There are websites that obsessively contrive to discover golden sections everywhere, from cosmic geometry to portraits. Renaissance paintings regularly fall victim to this kind of wishful thinking. Looking at the diagrams (characteristically drawn on small reproductions), the correspondences between the surface geom-etry and forms set back in the space of a painting are always arbitrary to a lesser or greater degree – like the supposed pentagon in Poussin's painting. More decisively, as we noted when looking at the *Arcadian Shepherds*, there is no sign among the huge numbers of known drawings and underdrawings of such surface geometry actually being deployed in the composition of Renaissance and Baroque paintings – nor in sculpture or architecture, for that matter. But, of course, it is a secret.

Among the large number of examples of golden sectioning, some of extreme elaboration, it is surprising to find Wolfram Math World, a respected and responsible site, falling into the historical trap of detecting the magic ratio in works of historic art. Wolfram's ingenious animated demonstrator allows us to play with the golden section in the *Mona Lisa*, and it is pointed out that 'Mona Lisa's face can be neatly enclosed by a golden rectangle'. The relationship of the rectangle to the face, which is not square-on to the surface, is approximate at best. We are also told that the shape of the painting 'conforms to the divine proportion'. But the proportion of the height to the width is actually 1.49, not 1.618. The image used in the demonstration is cropped at both its left and right margins. In reality, the ratio of the painting's dimensions is closer to the square root of 2 (1.414). Leonardo was rather good at geometry, and he could have made his dimensions accurate if he so wished. The sloppiness of the Wolfram site is unfortunately typical of what happens when scientists venture imperialistically into the fine arts. They all too often seem to abandon the rigour they take as axiomatic in their own research.

Some of the 'scientific' theories have been cleverly formulated on their own terms, while conspicuously running foul of historical realities. Modern techniques (especially digital) may be applied that are remote from those available to the artist. There is a danger that he is seen to be accomplishing something that he had no way of achieving. One of the most ingenious applications of anachronistic criteria to the *Mona Lisa* comes with the attempt by Claus-Christian Carbon and Vera Hesslinger to adduce some kind of binocular set-up for the Louvre painting and the copy in the Prado. The Prado copy shows some signs that its artist was aware of some details in the Louvre picture before it was finished. This would mean that it was a copy by someone who had inside knowledge of the development of the composition. Carbon and Hesslinger, writing in the journal *Perception* in 2013, use small divergences in the overall size of the two figures and in smaller details to posit different viewing positions for Leonardo and his assistant. This implies that the two paintings constituted a stereo pair. Consciously or inadvertently, they suggest, Leonardo was inventing the stereoscopic image, previously unknown before the 19th century.

The slight variations between the two pictures are entirely consistent with Renaissance practices of studio copying for portraiture, which rely upon copying the original picture, not on a set-up with two artists working simultaneously from the same sitter. The idea that Lisa sat for many patient hours at intervals over many months (if not years) while the two artists laboured on their slow-drying works is a non-starter. Even if the Louvre and Prado versions had been intended together to present a stereo image, Leonardo did not possess a mechanism for viewing them as such.

In a subsequent article in the art-science journal *Leonardo*, Carbon and Hesslinger turned their attention to the background, arguing that the two painters inserted it using 'a plane canvas that hung in Leonardo's studio behind the sitter' – just as in a 19th-century photographer's studio. If this were the case, the relative positions of the sitter and background would be conspicuously different in the two works, in accordance with the laws of parallax. Applying modern techniques of analysis to historic art can potentially yield notable results, but we should not make the

Claus-Christian Carbon and Vera Hesslinger's model of the painting of the two versions of the *Mona Lisa*, from 'Da Vinci's *Mona Lisa* entering the next dimension', *Perception* XLII (2013): 887–93.

mistake of confusing the resources we have and our methods of analysis with the techniques actually available to the artist.

There is also a danger of retrospective diagnoses. Vito Franco, Professor of Pathological Anatomy at the University of Palermo, is known for 'diagnosing' the diseases from which the protagonists in old master paintings suffer. For example, the pregnant Virgin in Piero della Francesca's *Madonna del Parto* is said to display signs of an incipient goitre on her neck, characteristic of people in rural areas who drank water from one well. The idea that the immaculate Virgin – free of *maculae* or stains – would be portrayed with a disease characteristic of country folk is not historically credible. For her part, Lisa apparently suffers from xanthelasma, a symptom of high cholesterol. This is signalled by a yellowish accumulation of fatty acids under the skin, and typically causes subcutaneous lipomas. These are discernible on her hands and in the hollow of her left eye. But viewed under magnification, the lighter patch of paint beside her eye cannot be read as the deliberate description of some kind of swollen accumulation under the skin. It has resulted from disruption to the thin layers of darker pigment used to model her face. Even if Lisa did suffer from such a blemish

or blemishes, Leonardo is most unlikely to have 'photographed' them in his idealized portrait. Professor Franco's ideas have gained a good deal of coverage. It is easy to imagine that the media attention is attractive as an alternative to the normal run of scientific articles in specialist journals.

A conspicuous level of activity in the 'secretology' surrounding the *Mona Lisa* concerns the identity of the landscape. If lakes and mountains behind Lisa comprise a portrait of a particular location, this would potentially exercise a profound effect on how we interpret the picture. One of the more substantial and sustained attempts to forge a specific identity for Lisa's landscape has been that by Sandro Albini, a health professional in Brescia with whom I enjoyed an extended and collegial correspondence. In his studies, including *Gioconda allo specchio: terre bresciane e bergamasche nei dipinti e disegni di Leonardo* (Brescian and Bergamesque Lands in the Paintings and Drawings of Leonardo) and his wider discussion, *Gioconda, chi era costei?* (Gioconda: Who Was She?), co-authored with Elfriede Knauer, he matches her landscape with that around Lake Iseo and the River Oglio (a tributary of the Po) in the provinces of Bergamo and Brescia. This was territory known to Leonardo; a map at Windsor traces the course of the river. To achieve

The Corna Trentapassi from Lake Iseo.

his matches, Sandro has used mirroring, reversing either the landscape or the sitter. Lisa, reversed, is at one point collaged into a view of the pre-Alpine mountains, Corna Trentapassi (sometimes Tentapassi) and Punta dei Dossi. The bridge to the right of Lisa is identified as the Ponte Azzone Visconti, which actually has at least ten arches. The matches are at best suggestive. We know that when Leonardo drew a specific location he was remarkably precise. There is also the question of why Leonardo should have used reversal. Saying that he wrote in mirror script won't work, because in his paintings and drawings everything we can check is shown the right way round.

It is characteristic that the identifiers of the landscape often look proudly to their own localities. Sandro does this, as did the late Carlo Starnazzi, noted expert on Leonardo's maps, who claimed Leonardo for Arezzo. For Carlo the bridge was the ancient Ponte Buriano, which boasts seven arches. Leonardo's arithmetic was sometimes rather wobbly, but he could count to seven, or even to ten. There is no indication that there are more arches behind Lisa's back. The identifications continue to proliferate. The art historian Carla Glori locates the bridge at Bobbio in the province of Piacenza. The bridge was badly damaged in 1472, which conveniently correlates with the number 72 that Vinceti once saw under an arch of the bridge in the *Mona Lisa*.

Perhaps the most intricate and opportunist identification of the landscape has been made by a photographer working out of Urbino, that most delightful of Renaissance towns, haunted by the shades of Federico da Montefeltro, Piero della Francesca and the young Raphael. Rosetta Borchia, assisted by geomorphologist Olivia Nesci, has striven to identify actual landscapes in the background of Piero's paired portraits of Federigo and Battista Sforza. They have achieved some degree of generic success and some potential matches of specific mountains, lakes and buildings. They organize tourist itineraries to strategic viewpoints from which to match the various locations with features in Piero's landscapes. When Borchia and Nesci pull Leonardo into their net, things go badly awry. The landscape behind Lisa does not resemble the topography near Urbino. However, we are told that Leonardo has used an unknown technique for the 'compression' or 'compacting' of the whole wide territory around

Urbino into the single view in the painting. Why has Leonardo done this? Because the sitter is actually the Urbino courtesan Pacifica Brandano, not Lisa del Giocondo. A very unconvincing identification of the sitter is married to a bizarrely contrived identification of the landscape.

For Scott Lund, one of my correspondents who has been responsible for one of the most bizarre of all the code websites (MonaLisaCode. com) and a number of YouTube videos saturated in showbiz glitz, the landscape centres on the Bramante's Tempietto in Rome:

> The Mona Lisa's landscape is not a fantasy, but a precise survey map of Rome and its vicinity. The survey cleverly defines the two extremes of religion, marking the centre of Christianity on the right side, and the centre of paganism on the left. The dome of St Peter's Basilica at the Vatican is one end of the survey, and the site of the cult practices of the goddess Diana at Lake Nemi is the other. A line between the two endpoints, 29.5 km apart, intersects the Tempietto of Bramante....

> Lake Nemi was the cradle of European witchcraft, and its location on the Mona Lisa was dangerously heretical during the Renaissance period. Using the pagan god Janus as the theme for the painting also implied Leonardo's heretical conviction that the sun was the centre of the Universe....The Mona Lisa is a single soul shared between an expectant mother and her unborn male child. The dualistic theme of Janus is symbolized by the partial pillars on either side of the painting, and the god is also identified by the code words ANIMA SOL, which is a secret anagram for the name Mona Lisa, meaning 'Soul/Sun god' in Latin.

No matter that the name 'Mona Lisa' was not attached to the painting in Leonardo's lifetime.

Lund goes on to identify heavenly constellations lurking secretly within Leonardo's paintings, demonstrating how the heavenly bodies moved in 'beatific harmony with the Christian marking of sacred time'.

Leonardo was apparently able to 'dial back' the stars to the Dawn of Creation – established by ancient convention to have occurred at the spring equinox of 5500 BC – exactly 7,000 years before the Grand Jubilee. He discovered that the constellation Perseus would have been directly above the supposed first appearance of the Sun as represented by his painting *Virgin, Child, St Anne and St John the Baptist*, which signals the spring and autumn equinoxes of AD 1500. And so on. That this mighty and fantastical engine of interpretation ignores Leonardo's extreme distaste for astrology and pseudo-scientific mysticism seems not to trouble Lund in the slightest.

I have yet to mention the central argument I have used when approached by the 'secretologists' of the landscapes. There is no reason for thinking that Leonardo ever portrayed specific locations in his paintings. He was concerned in all aspects of his art (and his science) to 're-make' nature on the basis of his understanding of how it works. The landscape behind Lisa, designed to provide a resonant echo of the microcosm (lesser world) of her body, is deeply informed by his understanding of geological flux. The high lake and low lake, the tilting mountains and the meandering river beds are all made on the basis of his hard-won understanding of geological processes – not copied from particular views. Art for Leonardo was as much a 'demonstration' (*dimostrazione*) as his scientific illustrations and diagrams. It is this act of forging an archetypal mountainscape that allows the background to be aligned generically with various specific views, without being identical to any of them. Thus the sharply tilted strata and jagged peaks of the Corna Trentapassi are precisely the kind of formations that fascinated Leonardo, but he was not aiming to make a precise transcription of this or any other specific location.

There is another broader point that should be made about *all* searches for codes and secrets. I have responded to more emails than I care to count with variations on the following statement.

There are no codes (visual, numeric or other) in Renaissance paintings awaiting de-coding some 500 years later. There are allegories and symbols, to be sure, but no hidden codes. A code

is designed to conceal the hidden message or meaning with the maximum level of obscurity, while symbols and allegories are part of continuity of meaning that would have been accessible to well-informed observers at the time. A symbol is when one thing stands for another, as when the bread and wine in the *Last Supper* stand for Christ's body and blood. An allegory is when a series of symbols are brought together to convey a broader message, such as the redemptive power of Christ's incarnation and sacrifice, which is signalled by the sacrament of the Eucharist.

Leonardo openly despised occult secrets, mystic systems and magic. Look at E.H. Gombrich's essay on 'Leonardo and the Magicians' in *New Light on Old Masters*.

An important question to ask is *why* Leonardo supposedly inserted almost indecipherable 'codes' into his paintings. To whom was he communicating, and what was he hoping to accomplish? A novelist can suppose that Leonardo was party to a grand conspiracy set up to convey concealed truths to posterity. As a historian, I can only deal with the reality of Leonardo undertaking his paintings as functional acts of communication in conceivable contexts for their viewing.

The fantastical Leonardo who haunts the forests of falsehood on the internet and the wilder shores of fictional history stands in sharp contrast to the pedantry of detailed historical scholarship. Between these poles stands a rich spectrum of fiction, legends, speculative biographies, popular histories, the public media, and the official Leonardo of mainstream culture. Wherever we are located across this spectrum, the other bandwidths remain insistently apparent. We cannot hope to obliterate the presence of 'Da Vinci' across world culture. Faced with this bewildering diversity, what advice can I give to someone who does not have the time or professional skills to check the validity of what they see and hear? I say, without hesitation, read Leonardo himself. In contrast to all our later clamour, his is the only authentic voice. And look, look at the paintings and drawings. There is nothing quite like them.

NOTE ON SOURCES

Since this is not a reference work on Leonardo, I have not included endnotes. The following list provides guidance to some valuable sources among the vast amount of literature on Leonardo, and includes publications by myself that are cited in the text.

A good point of reference for Leonardo's paintings is Frank Zöllner, with Johannes Nathan, *Leonardo da Vinci* (Cologne, available in a number of editions, most recently in 2017).

Clark's monograph remains a fine introduction: Kenneth Clark, *Leonardo da Vinci*, ed. M. Kemp (Harmondsworth, [1939] 1988).

For the great stock of drawings in the Royal Collection, see Kenneth Clark, *The Drawings of Leonardo da Vinci in the Collection of Her Majesty the Queen at Windsor Castle*, 2nd edition with Carlo Pedretti, 3 vols (London and New York, 1968); and more generally, A.E. Popham, *The Drawings of Leonardo da Vinci*, ed. M. Kemp (London, 1994).

For Leonardo's own writings, the anthology by J.P. Richter is still fundamental: *The Literary Works of Leonardo da Vinci*, 2 vols (Oxford, 1970); and the accompanying *Commentary* by Carlo Pedretti, 2 vols (Oxford, 1977).

A selection of Leonardo's writings on painting is *Leonardo on Painting: An Anthology of Writings by Leonardo da Vinci with a Selection of Documents Relating to his Career as an Artist*, ed. M. Kemp, trans. M. Kemp and M. Walker (New Haven and London, 2001).

The website of the Biblioteca Leonardiana contains valuable resources, including images of Leonardo's manuscripts: www.bibliotecaleonardiana.it/ – see also www.universalleonardo.org.

For the 'earlier version' of the *Mona Lisa*, see the Mona Lisa Foundation's *Mona Lisa: Leonardo's Earlier Version* (Zurich, 2012).

MY OWN WRITINGS INCLUDE:
'Il concetto dell'anima in Leonardo's Early Skull Studies', *Journal of the Warburg and Courtauld Institutes* XXXIV (1971): 115–34.

'Dissection and Divinity in Leonardo's Late Anatomies', *Journal of the Warburg and Courtauld Institutes* XXXV (1972): 200–25.

'Leonardo and the Visual Pyramid', *Journal of the Warburg and Courtauld Institutes* XL (1977): 128–49.

Leonardo da Vinci: The Marvellous Works of Nature and Man (Oxford, [1981] 2006).

with Thereza Wells:
Leonardo da Vinci's Madonna of the Yarnwinder. A Historical and Scientific Detective Story (London, 2011).

with Pascal Cotte:
La Bella Principessa: The Story of the New Masterpiece by Leonardo da Vinci (London, 2010).

La Bella Principessa di Leonardo da Vinci: Ritratto di Bianca Sforza (Florence, 2012).

'Science and Judgement by Eye in the Historical Identification of Works of Art', paper given at the Authentication in Art Congress, The Hague, 7 May 2014, http://authenticationinart.org/pdf/papers/Science-and-judgment-by-eye-in-the-historical-identification-of-works-of-Art-Martin-Kemp3.pdf [last accessed 30 November 2017]

with Giuseppe Pallanti:
Mona Lisa: The People and the Painting (Oxford, 2017).

with Margaret Dalivalle and Robert Simon:
Leonardo's Salvator Mundi and the

Collecting of Leonardo da Vinci in the Stuart Courts (Oxford, forthcoming).

THE LEONARDO EXHIBITION PUBLICATIONS ARE:
Leonardo da Vinci: Artist, Scientist, Inventor, Hayward Gallery (London, 1989).
Leonardo da Vinci: The Mystery of the Madonna of the Yarnwinder, National Galleries of Scotland, Edinburgh, 1992.
Leonardo da Vinci: Experience, Experiment and Design, Victoria and Albert Museum (London and Princeton, 2006–7).

OTHER MATERIALS REFERENCED INCLUDE:
'The Last Supper: restoration reveals Leonardo's masterpiece', *National Geographic* 164:5 (November 1983).
'The perpetual restoration of Leonardo's Last Supper, Part 2', ArtWatch (14 March 2012), http://artwatch.org.uk/the-perpetual-restoration-of-leonardos-last-supper-part-2-a-traumatic-production-of-a-different-leonardo-3/ [last accessed 30 November 2017].
Martin Bailey, 'Leonardo commission case exposes back-room deals', *The Art Newspaper*, January 2011.
Dan Brown, *The Da Vinci Code* (New York, 2003).
Severin Carrell, 'Stolen work by Leonardo recovered after four-year hunt', *Guardian*, 5 October 2007, https://www.theguardian.com/uk/2007/oct/05/ukcrime.artnews [last accessed 30 November 2017].
Pascal Cotte, 'L.A.M. Technique (Layer Amplification Method) – Principe', extract from *Lumière on the Lady with an Ermine* (2014), http://www.academia.edu/8611306/L.A.M._Technique_Layer_Amplification_Method_-_Principe [last accessed 30 November 2017].

Milton Esterow, 'The Real Thing?', *ARTnews*, 1 January 2010, http://www.artnews.com/2010/01/01/the-real-thing/ [last accessed 30 November 2017].
E.H. Gombrich, 'Controversial methods and methods of controversy', *The Burlington Magazine* 105:720 (March 1963): 90–3.
E.H. Gombrich, 'The Form of Movement in Water and Air', in *Leonardo's Legacy: An International Symposium, 2–8 May 1966*, ed. C.D. O'Malley (Berkeley and Los Angeles, 1969), pp. 171–204.
Cecil Gould, *Leonardo: The Artist and the Non-artist* (London, 1975).
David Grann, 'The Mark of a Masterpiece', *The New Yorker*, 12 July 2010, http://www.newyorker.com/magazine/2010/07/12-the-mark-of-a-masterpiece [last accessed 30 November 2017].
Simon Hewitt, 'Fingerprint points to $19,000 portrait being revalued as £100m work by Leonardo da Vinci', *Antiques Trade Gazette*, 12 October 2009, https://www.antiquestradegazette.com/news/2009/fingerprint-points-to-19-000-portrait-being-revalued-as-100m-work-by-leonardo-da-vinci/ [last accessed 30 November 2017].
Vincent Noce, 'La Bella Principessa: Still an Enigma', *The Art Newspaper*, May 2016.
Henry Pulitzer, *Where Is the Mona Lisa?* (London, 1966).
A.R.R.R. Roberts, *The Va Dinci Cod* (London, 2005).
Ken Shulman, 'The *Last Supper*: worth the wait', *ARTnews* (March 1995): 112–13.
Peter Silverman and Catherine Whitney, *Leonardo's Lost Princess* (Hoboken, 2012).
Alastair Sooke, 'The Isleworth Mona Lisa: a second Leonardo masterpiece?', BBC, 17 February 2015, http://www.bbc.co.uk/culture/

story/20150216-a-second-mona-lisa
[last accessed 30 November 2017].
Ellen Thomas, 'Duke delighted
after "absurd" £4m art heist claim
rejected', *The Herald*, 19 June 2015,

http://www.pressreader.com/uk/
the-herald/20150619/textview [last
accessed 30 November 2017].
Alessandro Vezzosi, *Leonardo Infinito*
(Bologna, 2008).

PICTURE CREDITS

2 Royal Collection Trust © Her Majesty
Queen Elizabeth II, 2018/Bridgeman
Images 25 Santa Maria delle Grazie,
Milan 29 San Giovanni in Bragora,
Venice. akg-images/Cameraphoto 30
© 2006 Alinari/TopFoto 31 DeAgostini
Picture Library/Scala, Florence 33
National Gallery, London 35 © Martin
Kemp 36 Alinari/Brogi/Diomedia 39–45
Royal Collection Trust © Her Majesty
Queen Elizabeth II, 2018/Bridgeman
Images 51 Photo Antonio Quattrone/
Electa/Mondadori Portfolio via Getty
Images 52 © Martin Kemp 55 Alinari/
Toscani, Fedele/Diomedia 57 Photo
Claudio Emmer/Alinari via Getty Images
58 Photo O. Louis Mazzatenta/National
Geographic/Getty Images 61 Photo by
Art Media/Print Collector/Getty Images
65 Alinari/Ranzani Mauro/Diomedia
71 Louvre, Paris 75 Royal Collection
Trust © Her Majesty Queen Elizabeth II,
2018/Bridgeman Images 84 © Martin
Kemp 90 Czartoryski Collection, Krakow
93 Private Collection, Switzerland
103 above National Galleries of Scotland.
Long loan in The Buccleuch Living
Heritage Trust, 2008. By kind permission
of the Duke of Buccleuch & Queensberry
KBE 103 below Private Collection 105
Uffizi Gallery, Florence 107 © Martin
Kemp 112–13 National Galleries of
Scotland. Long loan in The Buccleuch
Living Heritage Trust, 2008. By kind
permission of the Duke of Buccleuch &
Queensberry KBE 114 © Martin Kemp
115 National Galleries of Scotland 121

Opificio Delle Pietre Dure, Florence 122
National Galleries of Scotland. Long loan
in The Buccleuch Living Heritage Trust,
2008. By kind permission of the Duke
of Buccleuch & Queensberry KBE 127 ©
Martin Kemp 128–30 National Galleries
of Scotland. Long loan in The Buccleuch
Living Heritage Trust, 2008. By kind
permission of the Duke of Buccleuch &
Queensberry KBE 137 Private Collection
146–8 © Lumière Technology/Pascal
Cotte 149 © Martin Kemp 159 Photo
Grzegorz Mazurowski 162 National
Library of Poland, Warsaw 165 Pascal
Cotte 168 Courtesy Sarah Simblet 174
left Royal Collection Trust © Her Majesty
Queen Elizabeth II, 2018/Bridgeman
Images 174 above right Michael Daley,
*"Problems with 'La Bella Principessa' –
Part II: Authentication Crisis"*, ArtWatch
UK – News and Notices, 3 May 2016
175 © Lumière Technology/Pascal
Cotte 177 Louvre, Paris 178 © Lumière
Technology/Pascal Cotte 185 Private
Collection. Photo 2018, Robert Simon
via Fine Art Images/Heritage Images/
Scala, Florence 186–90 Robert Simon
193 Museum of the History of Science,
Oxford University. Photo Victoria Brown
195 Stanza della Segnature, Vatican 201
Andy Rain/EPA/REX/Shutterstock 202
Hermitage Museum, St Petersburg 211
Alte Pinakothek, Munich 216 National
Gallery, London 217 National Gallery,
London. Heritage images/Fine Art
Images/Diomedia 222–3 Louvre, Paris
232 Sipa Press 237 Private Collection.

Boltin Picture Library/Bridgeman Images 239 Royal Collection Trust © Her Majesty Queen Elizabeth II, 2018/ Bridgeman Images 243 Courtesy Bill Gates 246 Source material courtesy Bill Gates, photographs courtesy Curtis Wong 252 Royal Collection Trust © Her Majesty Queen Elizabeth II, 2018/ Bridgeman Images 253 Courtesy Steve Maher 255 Museo Galileo, Florence 263–5 Courtesy Paul Stanton, © Peter Cook 267 Ian Rutherford for the *Scotsman* 270 Private Collection 272 Victoria and Albert Museum, London 274 Courtesy Paul Stanton, © Morley von Sternberg 275 Biblioteca Ambrosiana, Milan 276 Courtesy Paul Stanton, © Morley von Sternberg 278 Royal Collection Trust © Her Majesty Queen Elizabeth II, 2018/Bridgeman Images 279 Mory Gharib 281 Louvre, Paris 290 Santa Maria delle Grazie, Milan 291 Louvre, Paris/Bridgeman Images 296 Oskar Pfister, diagram of the "vulture" in the *Madonna, Child and St Anne with a Lamb* from Sigmund Freud, *Eine Kindheitserinnerung des Leonardo da Vinci (Leonardo da Vinci and a Memory of His Childhood)*, 1910 298 From *Solving Mona Lisa: The Discovery of My Life* by Ron Piccirillo 303 C.-C. Carbon & V.M. Hesslinger (2013). *Da Vinci's Mona Lisa entering the next dimension.* Perception, 42(8), *887–93.* doi:10.1068/p7524 304 © Drimi/Dreamstime

ACKNOWLEDGMENTS

Many of the projects with which I have been involved have been directly collaborative or involved the crucial assistance of friends and acquaintances. The following list of thanks (complementing the Author's Note and no doubt also incomplete) indicates the nature of the support I have received. I should also say that the mounting of an exhibition or other public manifestation of Leonardo's work is essentially a collaborative act in company with those who view and participate.

Juliana Barone, a former doctoral student of mine, has contributed at a high level of scholarship to various projects, not least on the large catalogue of Leonardo and Leonardesque drawings in the UK (other than Windsor).

Pascal Cotte, of Lumière Technology, has generously shared with me the results of his remarkable multispectral scans and LAM analyses of Leonardo's paintings.

Margaret Dalivalle has undertaken key research into the provenance of the *Salvator Mundi* and shared much valuable thinking about collecting and copying.

John Dick, as senior conservator at the National Galleries of Scotland, not only shared his technical findings but also helped educate me in reading X-rays and infrared images.

Elisabetta Gnignera, historian of hairstyles and costumes, played a key role in refining my interpretation of Leonardo's portrayals of women.

Domenico Laurenza, meticulous and indefatigable scholar of Leonardo's manuscripts, has been an ideal partner in the project for a comprehensive edition of the *Codex Leicester*.

Linda Lloyd Jones, in charge of exhibitions at the Victoria and Albert Museum, worked with high professionalism and calm determination to realize our Leonardo show.

Steve Maher has proved to be a magician in setting Leonardo's drawings in motion.

Pietro Marani, the leading Italian

Leonardo scholar of his generation and Director of the Raccolta Vinciana in Milan, has been a friend and facilitator over many years.

The late **Jeanne Marchig**, wife of Giannino, remained stoically resolute in the face of multiple reverses and was warmly supportive of our research into the portrait on vellum.

Giuseppe Pallanti, co-author of our book on the *Mona Lisa*, displayed extraordinary dedication and modesty in researching the Italian archives.

Maria Pavlova, of St Hugh's College in Oxford, not only undertook vital translations of Italian texts but also provided effective guidance on Italian poetry in the Renaissance.

Julia Peyton-Jones, later Director of the Serpentine Gallery, undertook her first curatorial duties on the Hayward Gallery show to great effect.

Dame Jane Roberts, long responsible for the Leonardo drawings at Windsor Castle, has offered support throughout my studies of Leonardo's graphic work and has played wholly essential roles in the Hayward Gallery and Victoria and Albert exhibitions.

Steve Roberts and Martin Kimm, of Skysports Engineers, devoted their expert knowledge and inventiveness to the recreation of Leonardo's hang glider.

Kathy and Peter Silverman, owners of the portrait on vellum, have been spirited companions on the often bumpy journey to establish its credentials.

Sarah Simblet, who draws like an angel, researched and skilfully recreated the portrait on vellum to establish how it was made.

Robert Simon, one of the discoverers of the *Salvator Mundi*, furthered my research and openly shared his considerable expertise.

Philip Steadman, Professor at University College London, inventively directed the computer-graphic animations undertaken by IBM for the Hayward Gallery show.

Nicholas and Jane Turner contributed crucially to the identification of the portrait on vellum, and Jane played a central role in the production of the resulting book.

Thereza Wells (née Crowe), who undertook her postgraduate research with me, has contributed at a high level to a number of projects, including the Universal Leonardo project and our monograph on the *Madonna of the Yarnwinder*.

Paul Williams, of Stanton Williams Architects, has brilliantly designed all the exhibitions I have curated, contributing integrally to how they worked for the public. His unrivalled insight, visual refinement and technical expertise have been crucial to the success of the shows.

James Wink, of Tetra Associates, worked beyond the call of duty in realizing Leonardo's flying machine for the Hayward Gallery show.

Curtis Wong has served as the creative mastermind behind the projects to render Bill Gates's Leonardo codex accessible via new technologies.

Kasia Wosniak has worked tirelessly in the cause of the portrait on vellum, assiduously researching Polish sources for its provenance.

David Wright (Professor D.R. Edward Wright) provided the breakthrough in identifying the original source of the portrait on vellum and shared many insights into the iconography of the *Sforziada*.

Many others have assisted in diverse ways. I recall with gratitude the support and assistance of Cristina Accidini, Sandro Albini, Giorgio Amaroli, Robert Anderson, Mark Arend, Charles Avery, Martin Baillie, Joseph Balilio, Carmen Bambach, Roberta Barsanti, Reinhold Baumstark, Godfrey Barker, Tetiana Bersheda, Roberto Belluci, Cristiano Bianchi, Paul Biro, Susan Boster, Marie Boyle, Susan Ferleger Brades, Bruno Brunetti, the Dukes of Buccleuch, Martin

Caiger-Smith, Gianmarco Cappuzo, Sergey Chernitisyn, Michael Clark, the late Dennis Clarke, Martin Clayton, Timothy Clifford, Matthew Cotton, Bill Cran, Michael Daley, Nanne Dekking, Vincent Delieuvin, Bryan Deschamp, Joanna Drew, Rowan Drury, Milton Esterow, Clare Farago, David Feldman, Maria Teresa Fiorio, Jacques Franck, Cecilia Frosinini, Paolo Galluzzi, Bill Gates, Cristina Geddo, Malcolm Gerratt, Mortezza Gharib, Melanie Goldstein, the late Ernst Gombrich, David Grann, Mina Gregori, Simon Hewitt, Julie Hill, Sonia Hope, the late Michel Jaffé, Waldermar Januszczak, Samantha Jessel, Mark Jones, Cecil Juanarena, Eric Kauffman, Larry Keith, Martin Kimm, Milko den Leeuw, Daniela Luxembourg, Dianne Dwyer Modestini, Jean-Pierre Mohen, David Murdock, the late John Nichol, the late Adrian Nicholas, Luciana O'Flaherty, Tomasz Ososinski, Carlo Pedretti, Jean Penicaut, Nicholas Penny, Juliette Phillips, Peter Quarendon, Jacqueline Ridge, Steve Roberts, Manuela Roosevelt, Pierre Rosenberg, Ashok Roy, David Rutherford, Ian Rutherford, Dmitry Rybolovlev, Gheri Sackler, Paul Sapin, Jan Schmidt, Fred Schroeder, John Sharp, the late John Shearman, Lesley Stevenson, Heike Stege, Cornelia Syre, Luke Syson, Monica Taddei, Paul Taylor, Elisabetta Ulivi, Alessandro Vezzosi, Francis Wells, Catherine Whistler, the late Andrew McLaren Young and Frank Zöllner. There must be more. To those whom I have inadvertently overlooked, I sincerely apologize.

INDEX

All works of art are Leonardo's unless it is stated otherwise.
References to illustrations are in *italics*.

Accidia Foundation, Liechtenstein 271
Acidini, Cristina 123
Adelson, Warren 209
Adoration of the Magi 14, 124
Alberti, Leon Battista: *On Painting* 78
Albini, Sandro 304–5
Alexander VI, Pope 18
Amboise, France; Clos Lucé 21, 263; Saint-Florentin 23
anatomical drawings 10, 17, 19, 20, 21, 22, 42–3, *44*, *45*, 46–8, 49, 187, 247, 277–8, *278*; see also 'Great Lady'
'anatomical errors' 175–6, *177*, 179
Anchiano 83, 84; *Casa Natale* 83, *84*
Anderson, Maxwell 206
Andrews, Richard and

Schellenberger, Paul: *The Tomb of God* 285
Annesley, Noël 160
Annunciation 14
Antiques Trade Gazette 153–4
Aortic Valve, Studies of... 277–8, *278*
Apelles 81
Apollo (magazine) 269
Aretino, Pietro: *Selected Letters* 78
Art Newspaper 225
Artibus et Historiae (journal) 173
ARTnews 61–2, 153, 155
ArtWatch UK 62–3, 64, 162, 220–21; demonstration of eye *174*, 175–6
Assassin's Creed II (video game) 293
Authentication in Art (website) 173, 225
Avalos, Costanza d' 94

Avery, Charles 26, 27–30, 48
Avery, Mary 27–30

Baigent, Michael *see* Lincoln, Henry
Bailey, Martin 266
Balilio, Joseph 116, 119, 268
Bambach, Carmen 144, 186, 189
Bantam Press 287, 288
Baptism (Verrocchio and Leonardo) 13
Barker, Godfrey 125
Barone, Juliana 270
Battle of Anghiari 19, 58, 81, 227
BBC 38, 96; *Chronicle* series 284; *Crimewatch* 126; *Timewatch* 282, 285–6
Beatis, Antonio de' 21–2, 87

Beck, James 62
Bella Principessa, La
(portrait of Bianca
Sforza) 16, 136, *137*,
138–45, 148–9, *150*,
151–4, 155–7, 158, *159*,
160–66, 170–76, *178*,
178–83, 198, 207–8; the
eye *174*, *175*, 175–6;
finger/handprints 147,
147, 152, 153–4, 155;
infrared reflectogram
146, 146–7; vellum 146,
147–8, 158, 163, 164–6,
167–9, 173, 174
Belle Ferronière, La 166
Bellincioni, Bernardo 91;
poem 91–2
Bellini, Giovanni 28
Bellucci, Roberto 123
Benci, Ginevra de': por-
trait 14, 213, 230, 265
Benois Madonna 14, 184
Bernini, Gian Lorenzo
100
Bertelli, Carlo 60
Birago, Giovanni Pietro
162, 163
Biro, Paul 152, 153,
154–5, 172
Blaker, Hugh 92, 94
Blunt, Sir Anthony 26,
37–8, 40
Boltraffio, Giovanni
Antonio 140, 190, 205;
Madonna and Child
(*Madonna Litta*) *202*,
203
Bora, Giulio 136, 140
Borchia, Rosetta 305
Borgia, Cesare 18
Borne, François 160
Bossi, Giuseppe 143
Botticelli, Sandro 284
Bouvier, Yves 206, 207, 209
Bramante, Donato: Santa
Maria delle Grazie,
Milan 35, *35*, 54;
Tempietto, Rome 306
Brambilla Barcilon, Dr
Pinin 57, 58, 59–60,
61–2, 65, 66
Brando, Pacifica 306
Brewis, Kathy 199–200

British Government
Indemnity Scheme 257
British Museum 198,
203, 270
Brown, Carter 266
Brown, Dan: *The Da Vinci
Code* 280, 282, 284,
286–92, 293, 294
Brown, Michael 131, 132,
133, 135
Buccleuch and
Queensberry, John
Douglas Scott, 9th Duke
of 106, 110, 112, 120,
125, 126, 127, 266, 267,
268
Buccleuch and
Queensberry, Richard
Douglas Scott, 10th
Duke of 129, 132, 134–5
Buckingham, George
Villiers, 1st Duke of 92
Bullettino Storico Pistoiese
86
Buranelli, Francesco 156
Burgess, Guy 37
'Burlington House
Cartoon' *see Virgin,
Child, St Anne and St
John the Baptist*
Buti, Antonio di Piero 85

CAD *see* computer-aided
design programs
Caplin, Jo Ann 145
Capuzzo, Gianmarco 148
Carbon, Claus-Christian
302, *303*
carbon dating 148, 162,
230
Castagno, Andrea del: *Last
Supper* 224, 290
Caterina (Leonardo's
mother) 83, 84–5, 86, 87
Cennini, Cennino: *Il Libro
dell'Arte* 219
Centre de Recherche et
de Restauration des
Musées de France 218,
220
Cera, Adriano 136
Chardin, Jean-Baptiste
Siméon 65, 100, 210;
Cellar Boy 212; *Lady

Taking Tea* 212, 213;
Scullery Maid 212
CHARISMA 221, 224
Charles I 192
Charles, Prince of Wales
269
Chérisey, Philippe de 283
Christie's auction house
116, 140, 144, 158,
160–62, 171, 209, 242,
244
Cicero: *Letters to Friends*
81
Cima da Conegliano 28;
Baptism of Christ 28, *29*
Clark, Dennis 40
Clark, Kenneth 34, 39, 42,
56, 69, 144; *Leonardo da
Vinci* (1939) 734
Clarke, Michael 112, 119,
126
Clifford, Timothy 112
'Codescope' 245, *246*, 247
Codex Arundel 273
Codex Atlanticus 49–50,
168, 274–5, *275*
Codex Leicester 19, 74,
77, 203, 236, *237*,
241–2, *243*, 244, 250–51;
CD-ROM project 244–5,
246, 247; website
translation 247–50
Codex Madrid 255
computer-aided design
(CAD) programs 240
Condé Nast 155
Cook, Sir Francis:
Collection 189–90,
205
Copernicus, Nicolaus
228–9
Corbis Productions 236,
241, 244, 245, *246*, 247
Cork, Richard 267
Corna Trentapassi *304*,
305, 307
Cornaro, Caterina, Queen
of Cyprus 115
Correggio, Niccolò da 91
Cotte, Pascal 141, 145–8,
152, 153, 155, 156, *159*,
160, 170, 172, 176, 179,
181; *La Bella Principessa*
(with Kemp) 155–6, 148,

167; LAM scan of *Mona Lisa* 231, *232*, 233
Council of Europe *see* Universal Leonardo project
Courtauld Institute, London 26, 27, 37, 40–41
Cowley, William (firm) 167
Cran, Bill 285
Cranach, Lucas, the Elder 216
Croker, Mr 'Froggy' 78
Czartoryska, Izabela 166–7
Czartoryska, Zofia 167
Czartoryski family 166

Daily Record (Glasgow) 266
Daily Telegraph 156, 268
Daley, Michael 62, 175
Dalgleish, Chief Inspector Mickey 126–7
Dalhousie University, Nova Scotia 38
Dalivalle, Margaret 192–3, 199, 200, 209
Dallas Museum of Art, Texas 206
Dalrymple, Mark 132
Dante Alighieri 77, 78, 88; *Convivio* 79, 89; *Paradiso* (*Divina Commedia*) 101; *La Vita Nuova* 79, 88–9
Daumier, Honoré 242
Dawnay, Caroline 48, 155, 256
Delieuvin, Vincent 220, 224
Dick, John 110, 111, 212–13
Dickinson, Simon 152, 271
Dorment, Richard 156–7
Downing College, Cambridge 24, 41
Doyle, John 131, 132, 133, 134
Drew, Joanna 261
Drumlanrig Castle 106–7, *107*, 109, 268

Este, Isabella d' 17, 108, 193; portrait *177*, 179, 180
Esterow, Milton 153, 155
European Fine Art Fair, Maastricht 152–3
Eyre, John 94; *Monograph on Leonardo da Vinci's Mona Lisa* 94, 96

FBI 213–14
Feldman, David 95
Feldman, Stanley 96
Fibonacci series 300, 301
Fiesole: Convent of San Domenico 82–3
Fiorio, Maria Theresa 186
Flogdell, Judd 7, 73
Florence 14, 17, 18–19, 28, 102; Archivio di Stato 50; Cathedral Dome 14; Company of St Luke 13, 18; Istituto Alberghiero 'Buontalenti' 82; Opificio delle Pietre Dure 123, 215, 216; Sant'Apollonia 224; Santa Maria Novella 18; Santissima Annunziata 83, 296
Forster, John 271
Forster Codices 271–2, *272*
Fortnightly Review 74
Francis I, of France 21, 22, 87, 259, 263
Franck, Jacques 219
Franco, Vito 303–4
Franks, Theresa 154–5
Freud, Sigmund: *Leonardo da Vinci and a memory of His Childhood* 296–7
Frey, Markus 95, 99
Frosinini, Cecilia 123

Gage, Edward 268
Gallerani, Cecilia: portrait (*The Lady with an Ermine*) 15, *90*, 91, 166, 265
Galluzzi, Paolo 262
gamma-ray spectroscopy 181
Ganay, Marquis

Jean-Louis de 205, 206
Ganz, Kate 140–41, 144, 156, 163
Gates, Bill 19, 236, 244, 247, 250
Gates, Mimi 236
Gates, William Henry 236
Gayford, Martin 268
Geddo, Cristina 143, 155, 170
Gerratt, Malcolm 48
Gharib, Morteza (Mory) 277; model of aorta 277, *279*
Gherardini, Amideo 104
Gherardini, Cosimo, Duke of Florence 102
Gherardini, Lisa *see* Giocondo, Lisa del; *Mona Lisa*
Gherardini family 102, 104, 106
Ghirlandaio, Domenico 158
Giocondo, Francesco del 73, 80, 82, 83, 85
Giocondo, Lisa del (*née* Gherardini) 19, 73, 80–83, 104; *see Mona Lisa*
Glasgow, University of 38–9, 49, 210, 212
Glori, Carla 305
Gnignera, Elisabetta 170; *La Bella Svelata* 170
Goguel, Catherine 139, 140
'golden section' 53, 300–1
Gombrich, Sir Ernst 38–9, 40–41, 47, 48, 49, 51, 66–7, 105; *Art and Illusion* 40, 47, 66; 'The Form of Movement in Water and Air' 39–40, 412; *The Heritage of Apelles* 39; 'Leonardo and the Magicians' 308
Gould, Cecil 269
Grabski, Jósef 173
Graham, Robert 131, 132, 133
Grann, David 154, 155
'Great Lady' *75*, 76–7, 249
Greenhalgh, Sean 179,

181; *A Forger's Tale* 179–80
Gregori, Mina 136, 139, 140, 141, 143, 155, 170
Griesbach, Monica 191
Guardian (newspaper) 126–7, 180
Guelfs 102
Gutman, Nica 197

Hales, Dianne: *Mona Lisa: A Life Discovered* 80
Hammer, Armand 242, 244, 247
Harris Hydraulics Lab, University of Washington 245
Hayward Gallery, London: Leonardo exhibition (1989) 240–41, 245, *255*, 260, 261–3, *263*, 264–5
Hermitage, St Petersburg 184, 203
Hesslinger, Vera 302, *303*
Hewitt, Simon 153–4, 163–4
Holkham Hall, Norfolk 241, 242, 250
Hollar, Wenceslaus: engraving of *Salvator Mundi* 192, 208
Hope, Charles 204–5
horses 16, 19, 121, 238, *239*
Houdon, Jean-Antoine 100
Hunter, Dr William: Collection 210

IBM 240, 241, 264
Independent (newspaper) 155
Independent on Sunday 268
infrared reflectography (IR) 111, 119, 121, *122*, 123, 126, *128*, 129, *130*, 145, 146, *146*, 197, 216, *216*, 225, 235
Institute of Fine Arts, New York 141, 191, 197

Jaffé, Michael 26
Jones, Jonathan 180–81
Jones, Mark 272

Josquin des Prez 69
Julius II, Pope 19

Keith, Larry 186
Kemp, Jill 7, 27–30
Kemp, Martin 149, 159; *La Bella Principessa* (with Cotte) 155–6, 158, 180; Leonardo da Vinci: The Marvellous Works of Nature and Man 10, 50–53, 74, 76–7
Knauer, Elfriede 304
Knoedler & Co. 242
Krzyżagórska-Pisarek, Katarzyna 175; 'La Bella Principessa...' 173, 174

Lady with an Ermine, The see Gallerani, Cecelia
LAM (Layer Amplification Method) scans *175*, 231, *232*, 233
Last Supper, The 9, 12, 16, 24, *25*, 34–7, *36*, 43, 46, *46*, 48, 51–2, *52*, 53, 67–8, 69, 156, 201, 218, 224, 289–90, *290*; computer modelling 241; restoration 54, *55*, 56–63, *58*, *61*, 64–9
Laurenza, Domenico 247–8, 249, 250–52
Leda and the Swan 19, 20, 23, 227
Ledden, Judy 275
Leeuw, Milko den 225
Leicester, Thomas Coke, 1st Earl of 241, 251
Leigh, Richard see Lincoln, Henry
Leo X, Pope (Giovanni de' Medici) 20, 21
Leonardo (journal) 302; Leonardo Lab 123, 214–15, 216, 218, 221
Lincoln, Henry *285, 286*; *The Holy Blood and the Holy Grail* (with Baigent and Leigh) 284, 288; *The Holy Place: Saunière...* 284–5
Lippi, Bartolomeo (Meo) 85

Louis XII, of France 17, 19, 107, 108, 109
Louvre Abu Dhabi 209
Louvre, Paris 70, 95, 136, 208, 218, 285, 287, 294; *Isabella d'Este* 180; *Mona Lisa* 72, 73, 82, 87, 92, 94, 97, 98, 100, 296, 302; *Virgin, Child and St Anne with a Lamb* 218–19, 220–21, 227, 297; *Virgin of the Rocks* 15, 216, 224, 290–92
Lumière Technology, Paris 141, 145
Lund, Scott 306–7
Luxembourg, Daniella 270, 271

MacGregor, Neil 120, 175
Machiavelli, Niccolò 18
Mackworth-Young, Sir Robin 47
Maclean, Donald 37; *Madonna and Child (Madonna Litta)* see Boltraffio, Giovanni; *Madonna and Child with a Carnation* 211, 215–16; *Madonna and St Anne* 19, 20, 23; *Madonna of the Yarnwinder* 171–8; Buccleuch version 9–10, 58, 102, *103*, 106–12, *112*, *113*, 114, 116, 117, 119, 120–22, 124–7, *127*, *128*, 129–35, 198, 202, 212–13, 214, 216, 221, 235, 266–7, *267*, 268, 269; Lansdowne version 58, *103*, 109, 110, 116–20, *117*, *118*, *120*, 121, *121*, 122–5, 129, 158, 202, 214, 235, 266, 267, *267*, 268; *Madonna of the Yarnwinder* (after Leonardo) 114, *115*, 121
Maher, Steve 251, 252
Marani, Pietro 64, 65, 70, 143–4, 186
Marchig, Giannino 116, 158, 162–3, 174, 176, 181
Marchig, Jeanne 158,

160–63, 176
Martini, Simone: *Laura* 89
Mary Magdalene 284,
288, 289, 290, 292
Maupassant, Guy de: *The
Inn* 78
Maximilian, Emperor 15,
143, 217
Medici, Giuliano de' 20,
21, 87
Medici, Lorenzo de' 15, 22
Melzi, Francesco 223, 144
Metropolitan Museum,
New York 99, 119, 144,
184
Michelangelo Buonarroti
8, 18, 19, 81, 108; *Battle
of the Centaurs* 265–6;
Creation of Adam 24;
Crucifix 208; *Madonna
of the Stairs* 266; Sistine
Ceiling 24, 59, 60, 66
Milan 29–30, 49, 54;
Archivio di Stato 50;
Biblioteca Ambrosiana
49–50; Castello
Sforzesco 30, *30*;
Raccolta Vinciana 143;
Sala delle Asse 16,
30–32, *31*, 201; Santa
Maria delle Grazie 35,
35, 54, 56, *57*, *see also
Last Supper, The*
Modestini, Dianne Dwyer
190–91, 197, 221, 224
Modestini, Mario 190–91
Modigliani, Amedeo 206;
*Nu Couché au Coussin
Bleu* 207
Möller, Emile 213, 214
Mona Lisa 9, 11, 12, 19,
20, 22, 23, 34, 48, 70,
71, 72–4, 76–7, 79–80,
83, 85, 87–8, 100, 109,
118, 204, 248; codes,
images and 'secretology'
53, 92, 282, 289, 295–6,
297, *298*, 299–300,
301, 302, *303*, 304–6;
identity of sitter 224,
228, *see* Giocondo, Lisa
del; 'Isleworth *Mona
Lisa*' 92, *93*, 94–100;
LAM scan 231, *232*, 233;

landscape background
73, 77, 121, 249–50,
302–3, 304–6, 307; Prado
copy 302; *sfumato* 73;
'Mona Lisa Foundation'
95, 99
Montefeltro, Federico da
170, 305
Montorfano, Giovanni
Donato da: *Crucifixion*
56
Montreal: Museum of
Fine Arts exhibition
(1987) 262
Morelli, Giovanni 225;
*Mountainous Landscape
with a Castle* 105, 105–6
Munich: Alte Pinakothek
215
Munich *Madonna* 14,
215–16
Murdock, David: *Mystery
of a Masterpiece* 164, 169
Mussolini, Benito 110

National Galleries of
Scotland 110, 126,
127, 133, 135, 198, 212;
Leonardo exhibition
(1992) 112, 114, 116,
119, 120, 260, 266–71
National Gallery, London
64, 129, 184, 206, 208,
269; CHARISMA work-
shop (2012) 221, 224;
Leonardo exhibitions
120–21 (1992), 197–204,
216 (2011–12); *see also
Virgin of the Rocks*
National Geographic
(magazine) 60–61, 164,
169
Nazarene movement 171
Nesci, Olivia 305
New York Post 296
New York Review of Books
204
New York Times 144, 145,
209
New Yorker 154, 155
Nicholas, Adrian 276, 277
Norman, Geraldine 268
Notes on optics: hammer-
ing man 252, *252*, *253*

Novellara, Fra Pietro
107–8, 124

'On the Eye' (manuscript)
196
Ososinski, Tomasz 164
Osservatore Romano, L'
(newspaper) 205–6

Pacioli, Luca: *On Divine
Proportion* 17, 50, 300
Pallanti, Giuseppe 80,
82–7, 89; *Mona Lisa
Revealed...* 80–81
Parrish, Alexander 190,
209
Pater, Walter 74, 101
Pavia, University of 181
Pedretti, Carlo 42, 99,
114, 143, 205–6, 242,
247; *Leonardo & io* 8
Pellicioli, Mauro 56, 57
Penny, Nicholas (Nick)
136, 139, 184, 191, 198
pentimenti 110, *121*, 147,
181, *190*, 191, 193, 210,
212, 214
Perréal, Jean 168
Peruggia, Vincenzo 72, 86
Petrarch (Francesco
Petrarca): sonnets 89
Peyton-Jones, Julia 264
Pfister, Oskar *296*, 297
Picasso, Pablo 100, 206,
207
Piccirillo, Ron: The
Hidden Horse Head
(website) 297, *298*
Piero, Ser (Leonardo's
father) 80, 82, 83, 84, 85
Piero della Francesca
170, 305; *Madonna del
Parto* 303; portraits of
Federigo and Battista
Sforza 305
Piero di Cosimo: *Jason
and Queen Hypsipyle with
the Women of Lemnos*
158, 160
Plantard, Pierre 282–3,
284
Playfair, William Henry
267
Pollock, Jackson 154

Popper, Karl 40
Portrait of a Musician 204
Poussin, Nicolas 38; *The Arcadian Shepherds (Et in Arcadia Ego)* *281*, 285, 301
Price, Monica 193
Priory of Sion 283, 287, 288, 289; 'Masters of' 283–4
Pulitzer, Elizabeth 95
Pulitzer, Henry 94–5; *Where is the Mona Lisa?* 94

Raccolta Vinciana (journal) 64
Raphael 26, 32, 87, 97, 100, 108, 156, 214, 290, 305; *Astronomy* (Stanza della Segnatura ceiling fresco) *195*, 195–6; *Bridgewater Madonna* 133
Reford, Robert 116, 214
Rembrandt van Rijn 100, 242; Self-portrait (Kenwood House) 64
Reynolds, Sir Joshua 92
Richardson, Jonathan 225
Richter, Jean Paul: *The Literary Works of Leonardo da Vinci* 42
ring bearing (model) *255*
Robertet, Florimond 107, 109, 120, 202, 267
Roberts, Adam R.R.R. 292; *The Va Dinci Cod* 292–3
Roberts, Dame Jane (Janie) 260, 261
Robinson, Sir Charles 190
rock crystal *193*, 193–5
Ronald, Marshall 131–2, 133, 134
Röntgen, Wilhelm 210
Rosenberg, Pierre 70
Rubens, Peter Paul: Samson and Delilah 175
Rutherford, Ian 267, *267*
Rybolovlev, Dmitry 187, 206–7, 209

St Andrews, University of 50, 109
St Jerome 153
St John the Baptist 20, 23, 204
Sala delle Asse 16, 30–32, 31, 201
Salaì (Gian Giacomo Caprotti da Oreno) 11, 22, 23, 73, 87, 109, 296
Salvator Mundi 19, 184, *185*, *186*, 186–8, *188*, 189, 190–93, 196–7, 198–200, 202–3, 204–9, 224, 227; crystalline sphere *187*, 188–9, 192, 193–6, 200
Sanseverino, Galeazzo 163
Saunière, Bérenger 282, 283, 284–5, 286
Saunière, Jacques 287–8
Schellenberger, Paul *see* Andrews, Richard
Schlechter, Armin 81–2
Schnorr von Carolsfeld, Julius 171
Schröder, Klaus Albrecht 153
Schultz, George 265
Scotsman (newspaper) 267, 268
Scripta Maneant 169, 170
Seated man..., and studies and notes on the movement of water 39
Seattle, Washington; Art Museum: *Codex Leicester* exhibition (1997) 236, 247; Harris Hydraulics Lab 245
Sections of the Human head... 45
Sède, Gérard de 283
Sforza, Bianca Maria 15, 163, 216–17; portrait *see* *Bella Principessa, La*
Sforza, Francesco 16, 163; equestrian memorial to 16
Sforza, Ludovico ('Il Moro') 15, 16, 17, 32, 36, 54, 56, 163, 170, 198, 216

Sforziada see Simonetta, Giovanni
sfumato 73, 219, 268
Sgarbi, Vittorio 170
Sharp, John 24, 26
Shearman, John 26, 389, 46
Short, George 131, 132, 133
Silverman, Kathy 136, 138–9, 148
Silverman, Peter 136, 138–9, 140, 141, 142, 144, 148–9, *149*, 152, 153, 156, 157, 163, 164, 165, 171, 172, 182, 198, 208, 227; *Leonardo's Lost Princess* 142
Simblet, Sarah 167; reconstruction of Leonardo's technique *168*, 169
Simon, Robert 186, 189, 190–92, 197, 198–9, 207, 208, 209
Simonetta, Giovanni: *Sforziada* *159*, *162*, 163, 164, *165*, 165–6, 169–70, 173
Sissons, Michael 48
skull sectioned, A *44*
Snow-Smith, Joanne 205
Soderini, Piero 81
Sodoma (Giovanni Antonio Bazzi) 116, 214
Sotheby's auction house 190, 206, 209, 234
South, Sidney 41
spolvero marks 213
Starnazzi, Carlo 305
Steadman, Philip 241
Steinberg, Leo 141
Stevenson, Lesley 127
Stolen Stuff Reunited 131
Stone, Captain John 192
Stone, Nicholas 192
Strinati, Claudio 167
Strong, Sir Roy 261
Suida, Wilhelm 214
Sunday Times 125, 199–200
Syson, Luke 99, 184, 197–8, 199, 201, 202, 203

Teniers, David 285
Times 33, 267
Titian 11, 28, 32, 78
Tradescant, John: rock crystal sphere *193*, 194–5
Treatise on Painting 77, 251
Trivulzio, Gian Giacomo 50; equestrian monument to 20
Turin: Centro di Conservazione e Restauro 181
Turner, Jane Shoaf 155, 173
Turner, Nicholas (Nick) 136, 139, 140, 141–2, 143, 155, 173

Ulivi, Elisabetta 86
Universal Leonardo project 7, 122–3, 214, 215, 251, 271
Urbino: Galleria Nazionale delle Marche 170

Varvel, William 299–300
Vasari, Giorgio: *Lives...* 73–5, 79, 94
Vascular, Respiratory, and Urino-Genital Systems of a Woman, The 75, 76–7
Velázquez, Diego 100
Venice 17, 27–8, 30 196, 197; Gallerie dell'Accademia 143
Vermeer, Jan 100
Verrocchio, Andrea 13, 14, 216; *Baptism* (with Leonardo) 13
Vespucci, Agostino di Matteo 81, 86
Vettise, Tony 267
Vezzosi, Alessandro 86, 95, 99, 156; *Leonardo Infinito* 142–3, 144
Victoria and Albert Museum, London 48, 190, 198, 271; Leonardo exhibition (2006) 251, 260–61, 271–9, *274, 276*
Vienna: Albertina 153

Villa Vignamaggio, Chianti, Tuscany 102, 104, 124
Vinceti, Silvano 295–6, 305
Vinci 13, 83–6, 206; Biblioteca Leonardiana 86; Museo Ideale Leonardo da Vinci 86, 95
Virgin, Child, St Anne and St John the Baptist 22, 307
Virgin, Child and St Anne with a Lamb (oil) *222*, 227; *Pfister's vulture* 296, 297; restoration 218–21, *223*
Virgin, Child, St Anne and a Lamb (drawing) 269–71, 270
Virgin, Child, St Anne and St John the Baptist ('Burlington House Cartoon') *17*, 32–3, *33*, 120–21, 203
Virgin of the Rocks; Louvre version (1483–5) 15, 32, 198, 204, *216*, 216–18, 224, 290–92, *291*; National Gallery version (*c.* 1491–1508) 15, 19, 32, 129, 184, 186, *186*, 204, *217*, 218, 261, 291
Vitruvian Man 8

Wallace, Marina 7, 122, 214, 251
Warburg Institute, London University 38, 41, 50, 196, 204; *Journal...* (author's articles) 47–8
Washington, D. C., National Gallery of Art 141, 213; 'Circa 1492: Art in the Age of Exploration' (1991–2) 261, 265–6
water, studies of 17, 20, 38, 39, *39*, 41–2, 118, 240, 245, 277
Wells, Thereza (*née* Crowe) 106, 107, 109,

117, 122, 123, 124, 214, 218, 221
Whistler, James McNeill 212
Whitney, Catherine: *Leonardo's Lost Princess* (with Silverman) 142
Wildenstein & Co. 116, 119, 122, 214, 268
Williams, Paul: exhibitions 264, *265*, 273–4, *274*
Windsor 26, 30, 47; Royal Library 21, 39, 42, 46–7, 175, 192, 252, 261, 270, 273, 304
Windsor Grammar School 24, 26–7, 35, 40, 41, 78
Wink, James: Flying Machine 262–3, *263*
Wolfram Math World (website) 301
Wong, Curtis 244–5, 247
Woodstock Literary Festival 155
Woolford, Harry 212, 213
Wosniak, Kasia 164, 166
Wright, D.R. Edward (David) 163, 164, 166

X-rays 210, 212–16, 225–6

Yale University Press 199
Young, Andrew McLaren 210, 212

Zamoyski, Stanisław 167
Zamoyski family 166
Zöllner, Frank 204